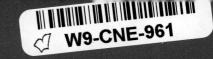

IRELAND'S
TREASURES

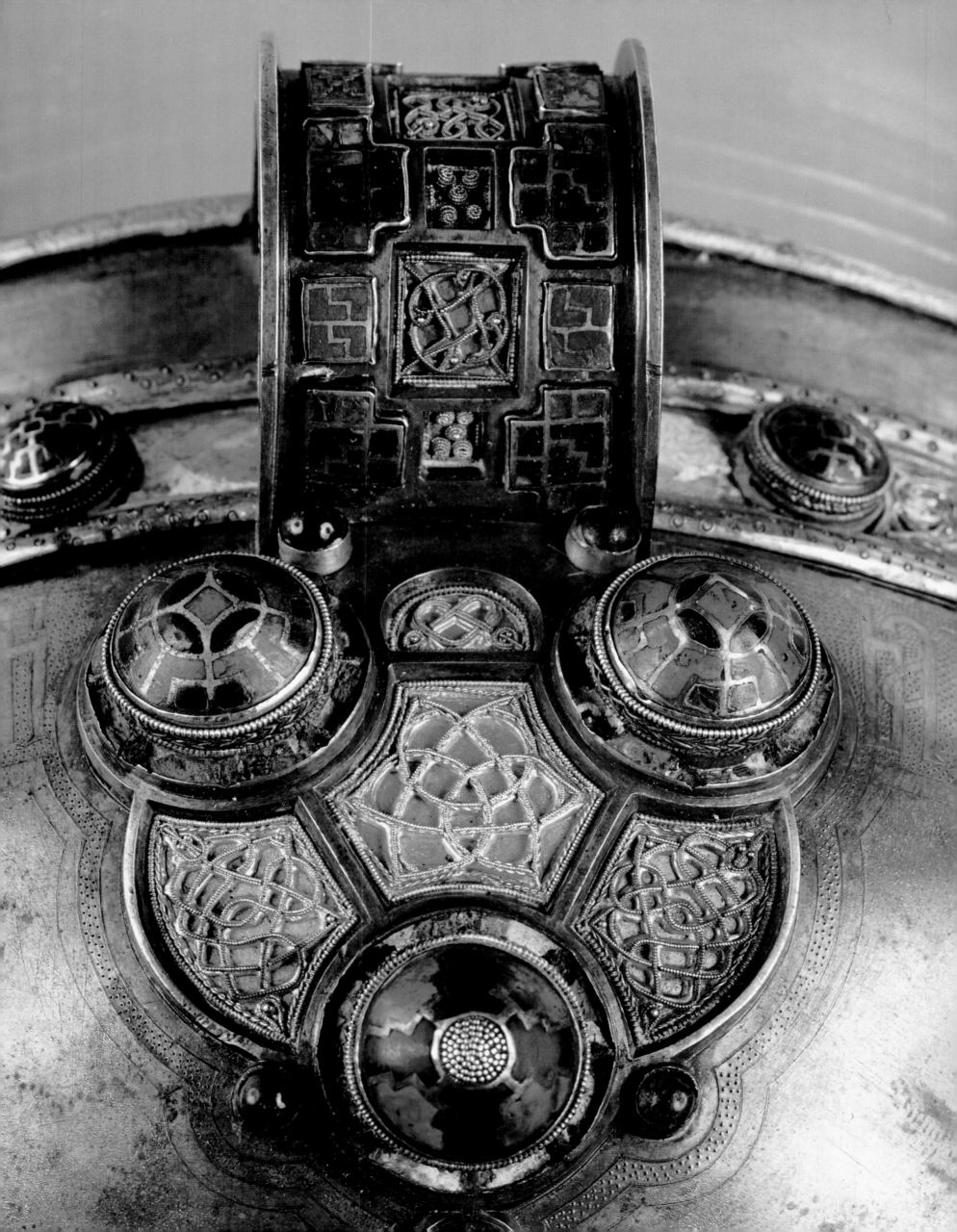

IRELAND'S TREASURES

5000 YEARS OF ARTISTIC EXPRESSION

PETER HARBISON

BEAUX ARTS EDITIONS

ISBN: 0-88363-676-x

Editor and Photo Researcher: Leslie Conron Carola
Design: Charles Ziga and Chris Berlingo, Ziga Design, LLC
Copy Editor: Deborah Teipel Zindell

Acknowledgments:
The publisher gratefully acknowledges the assistance of Tourism Ireland,
and the following for assistance with acquiring photographs: Tony Roche, Department of the
Environment, Heritage, and Local Government Photographic Unit; Michael Diggin,
Michael Diggin Photography; Fiona Davern, The Hunt Museum, Limerick; George Munday,
Irish Image Collection; David Davison and Edwin Davison, The Irish Picture Library;
Michelle Dawson and Claire McNamara, The Merrion, Dublin; Marie McFeely, The National
Gallery of Ireland; Alex Ward, The National Museum of Ireland; Stuart O'Seanoir, Trinity
College Library and Linda Montgomery, Trinity College Library; Ruth Moran, Tourism
Ireland; Pat McLean, Ulster Museum, Belfast.

Peter Harbison thanks Roisín Jones of The Royal Irish Academy in Dublin,
for help with the typing, Letitia Pollard, Editor of *Ireland of the Welcomes,* for assistance in
locating images to accompany this volume, Mairead Dunlevy,
for helpful hints in researching it, and Melissa Payne, for facilitating its production.

Beaux Arts Editions
Printed in China

Page 2: A handle and escutcheon of the eighth-century Ardagh Chalice in the National Museum.

CONTENTS

INTRODUCTION

Ireland has all too often been seen as a land richly endowed with writers of great international renown, but lacking in good practitioners of the visual arts since the days of the *Book of Kells* twelve hundred years ago. To be sure, with Yeats, Beckett, and Heaney that small country could pride itself on being honored with three Nobel prizes for literature in the space of seventy-five years, and a thousand years before Jonathan Swift and Oscar Wilde wrote in English in the eighteenth and nineteenth centuries respectively, Ireland had had its own rich storehouse of heroic tales and lyric and bardic poetry written in Gaelic. But nothing could be further from the truth than to claim that the stars of Irish literature had the Hibernian heavens all to themselves, for they shared the honors with a celestial host of artists and craftsmen, anonymous or well-known, who have brought lustre to the Emerald Isle down the centuries. In the introduction to his book *Irish Art 1830–1990*, Brian Fallon could claim convincingly that, in recent times, the artists can even be shown to have been the precursors of the already visually conscious writers.

During the period he surveyed, Ireland can be seen to have gone through an artistic development that outstrips in breadth and range anything that had gone before, though it was not without its valleys as well as its peaks. But as with any mountains, those peaks were breathtaking—one only has to think of the stained glass of a Harry Clarke or the paintings of a Jack B. Yeats to realize what a mark Ireland was capable of making on the international scene. That status was achieved by strong personalities drawing strength from a variety of sources, both foreign and local. Artists and craftsmen of the century just past were able to get inspiration from the deep well of old native traditions and have it impregnated with fresh ideas coming from overseas, though it often took a little time for the newest fashions to reach Ireland, the *finis terra*, the ultimate outpost of Atlantic Europe. Nevertheless, Ireland is living proof of the truth of the old adage that the sea connects more than it divides in the sense that, through its maritime links, the island kept itself well informed of the latest developments in Britain and on the European continent. There had been times, such as when France and Britain became part of the exclusive Roman Empire,

ABOVE: *This detail of fol. 292r at the start of St. John's Gospel in the* Book of Kells *in the Library of Trinity College, Dublin, is a microcosm of the ingeniously constructed and impeccably executed interlace ornament that is one of the myriad remarkable features of this great manuscript, illuminated around A.D. 800. The ornament of this codex provided much visual inspiration for the Celtic Revival eleven hundred years later.*

OPPOSITE: *The twelfth-century Romanesque style is reflected in the portal of this modern church on an island in Gougane Barra, a romantic lake that forms the source of the river Lee. A hallowed spot, it is traditionally linked to Cork's patron saint, Finbar, who lived in the seventh century when the culture of monastic Ireland was beginning to reach its peak.*

that Ireland was cut off and can be seen to have stagnated somewhat for a number of centuries. But throughout prehistoric and historic times, Ireland usually benefited from the stimulation provided by contact with its neighbors, and even when World War II made travel difficult, it is amazing how inspiration still managed to trickle through to keep painting au courant without the soul of Ireland becoming too introspective, as had happened in Roman times.

There were, of course, periods in the twentieth century when Ireland's artistic world did look in on itself, such as during the time of economic war with England in the 1930s. But, before that, a spate of study in France was able to inspire two ladies, Mainie Jellett and Evie Hone, to bring the Modernist movement to Ireland in its Cubist dimension, demonstrating that some of the major French art movements around the turn of the twentieth century could be transported to Ireland and adapted there with great advantage and enrichment.

The more local source that both writers and artists were able to exploit in the twentieth century was the heritage of the ancient Celts, whose literature helped to inspire a nationalist movement that has left its traces, both artistically and politically, down to our own day. But at the same time that the

mythical and romantic tales of ancient Ireland were being rediscovered, the rich treasury of Celtic art in Ireland, both in its prehistoric and early medieval manifestations, also began to emerge from the mists of earlier ages, providing a remarkable impetus for what is known as the Celtic Revival in the decades on either side of 1900, which had such an electrifying effect on poetry, drama, and the visual arts—including stained glass, which became one of Ireland's greatest contributions to European art of the twentieth century. This Celtic art that was being rediscovered was not just practiced in manuscripts such as the *Book of Durrow* and the *Book of Kells*, but also on precious metalwork such as the Ardagh Chalice and the Tara brooch, which can now be seen, with hindsight, to have been equally at the forefront of European craftsmanship. Indeed, during the eighth century, the European continent had little of comparable quality to offer, and the art and craft of the old Irish monasteries was a world apart, a very distinctive shining light and a powerful Celtic counterbalance to the classical heritage of ancient Rome, which still managed to hold considerable parts of Europe in its thrall. But this stylized Celtic art had its abstract predecessors, too, reaching back to the Stone Age at a time when the Pyramids had not even been built.

It is the interplay of native talent and the constant flow of new ideas coming from outside over the last five thousand years that makes the study of Irish art such a fascinating pursuit. It is that magical brew of local and foreign, the happy mix of old and new, which emerges from the island's melting pot that makes Irish art and crafts so different and, in its varied expressions, such an engrossing pleasure to survey in the pages that follow. But, to introduce us to the first steps in Irish art, we need to set the scene that allowed them to be taken.

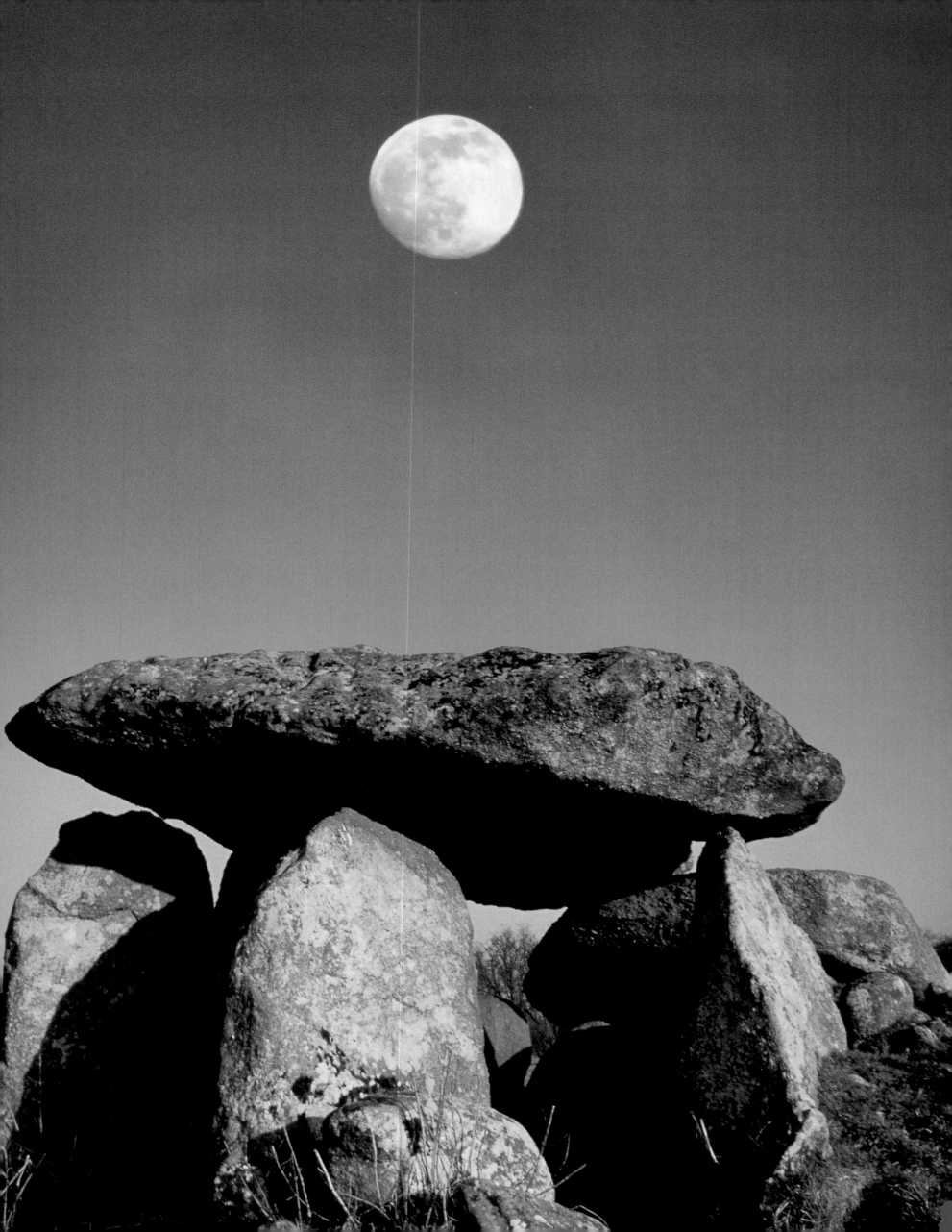

STONE AGE WONDERS

It is difficult to imagine that "the four green fields of Ireland" were almost entirely covered by an ice cap less than twenty thousand years ago, or that a mere 480 million years ago, Ireland and America were geographically one. It is only after what is now Ireland had unburdened itself completely of the glaciers that the first Irish men and women reached the country sometime around 8000 B.C. and forayed through the emerging scrub and forests. The umbilical cord that had joined Scotland and Ireland may only just have been broken, and so the first Irishmen would probably have had to travel in dugout canoes, a primitive but effective means of maritime transport that they would already have used to cross the English Channel from France to Britain. These people were hunter-gatherers, foragers whose protein had to be caught on the hoof and whose daily struggle to stay alive would have left little time to produce works of art or craft. Theirs was a very basic human existence, hunting and fishing and living in camps they would have moved seasonally from place to place as the demand for food required. Some of these sites have been discovered in various parts of the country—Mount Sandel in County Derry, Lough Boora in County Offaly, and on the Dingle Peninsula in County Kerry. Probably small in stature and slightly swarthy in complexion, these people would have come to Ireland's shores in comparatively small numbers and groupings, their gene pool making the first—and perhaps the most important—contribution to the Irish population today. They were, after all, the folk who lived and toiled in the country for almost half the time that man has been there—from, say, 8000 to around 4000 B.C., more than time enough to make their mark in human terms on the country's physiognomy, but not to make the initial changes to the Irish landscape to start it off on the circuitous route that it has taken in the meantime down to our own day.

Those initial steps were to come sometime around, or even before, 4000 B.C., with the arrival of farmers, presumably directly from Britain (Scotland and Wales). They were to become sedentary, unlike their Middle Stone Age predecessors, but the two would have intermarried eventually, resulting in a new Stone Age population. There was more than enough land to go around, so

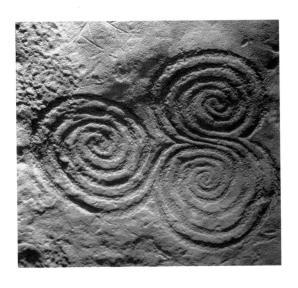

ABOVE: *The triple spiral decoration carved into the tomb wall of Newgrange in County Meath has become the logo of this massive monument, the most famous of all the passage graves of Ireland.*

OPPOSITE: *The moon presides like a goddess over Haroldstown dolmen, a Stone Age tomb that rises majestically in the Carlow countryside.*

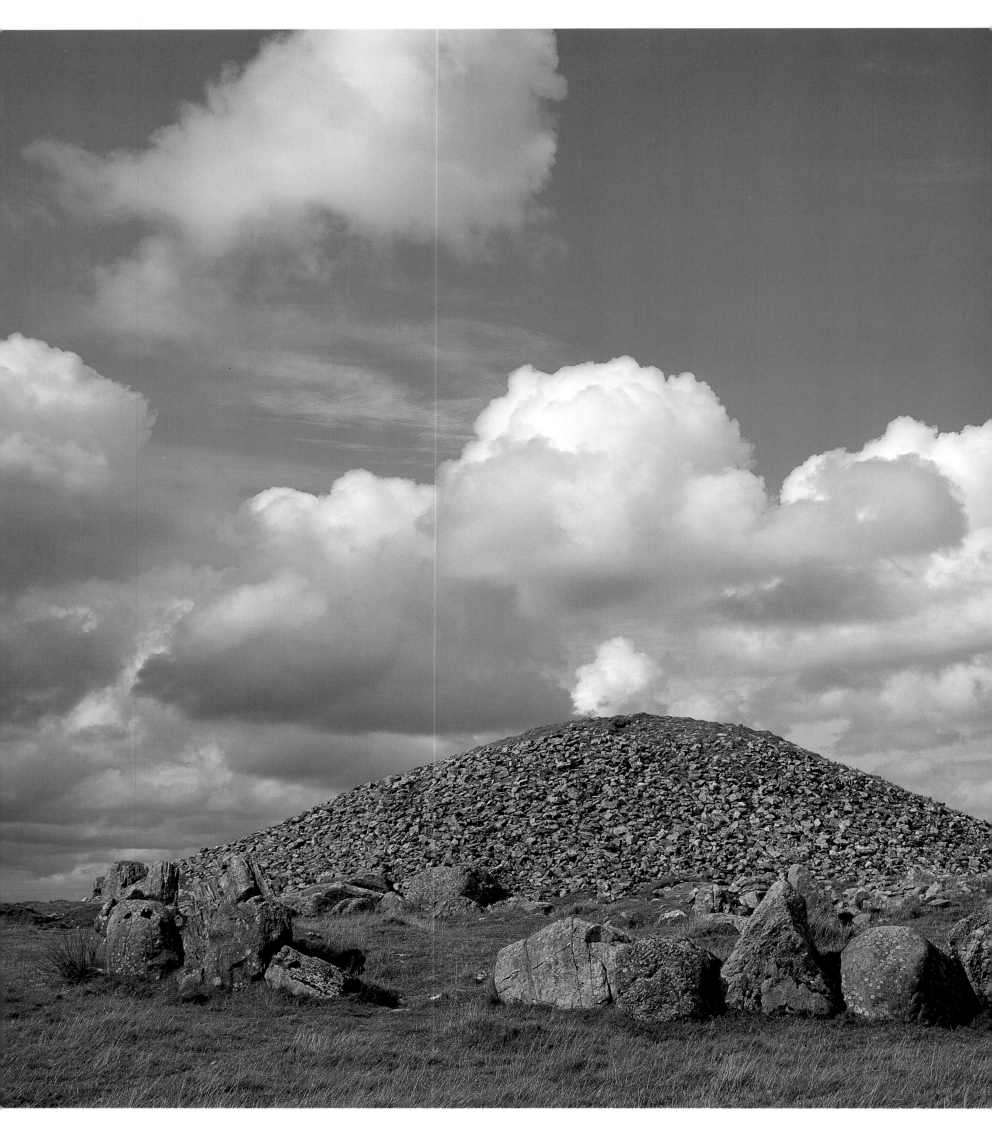

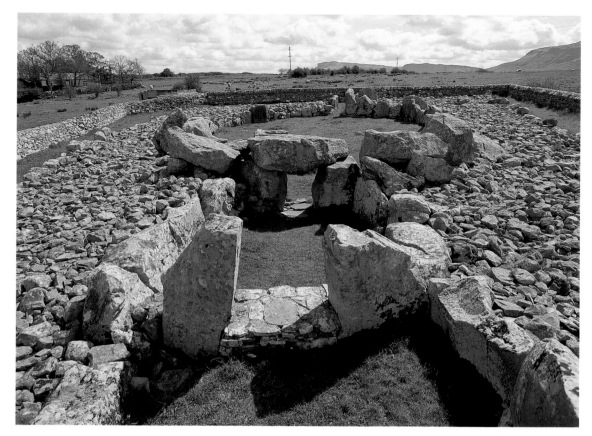

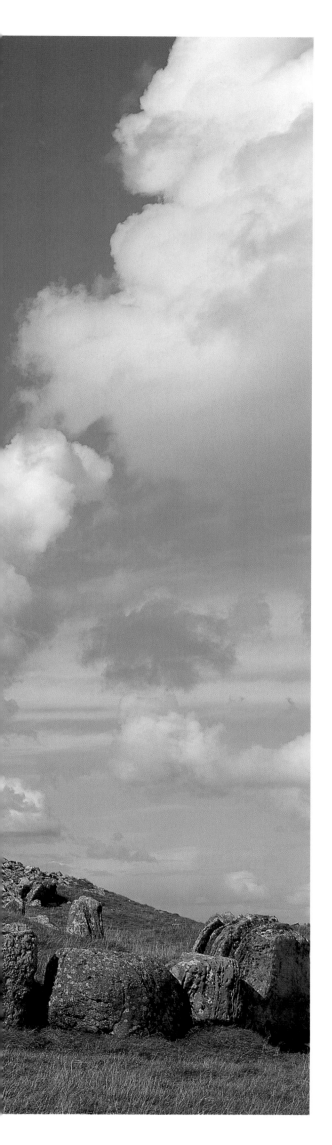

there was no necessity to get rid of the older population. But to make that land fruitful for crops, and to provide grass for the livestock, hard work was demanded of the newcomers, who would have had to clear trees and shrubs to create living and grazing space. By the fourth millennium B.C., Ireland's population had become sufficiently settled, with enough food to spare, to think beyond mere survival, stamping their identity on, and staking their claim to, the landscape by erecting monuments to the ancestral dead as well as those more recently deceased.

At first, such memorial monuments may have been made of wood, a material that would serve many purposes, practical and artistic, for many generations to come, though it is so ephemeral that its products are now lost. But in due course ideas worked out in wood were transformed into the much more durable medium of stone—and that was the magic moment when Ireland's monumental heritage was born, out of veneration by the living for the dead. This took the form of large stone tombs called megaliths, which, including those built during the ensuing Bronze Age, still number well over one thousand, many more having undoubtedly been destroyed because they were a handy source for building stone. These impressive structures come in various shapes and guises, all remarkable for the size of their great stone blocks,

ABOVE: *Almost two hundred feet long, Creevykeel is one of the largest and most elaborate of Irish court cairns. Cremated remains of only four individuals were discovered, and the pottery found suggested that this Stone Age monument continued to be used for burial into the Bronze Age.*

LEFT: *On a hill that goes by the Irish name of Slieve na Calliagh—the Hill of the Witch— an imposing mound composed of many thousands of stones, both great and small, covers the five-thousand-year-old remains of Ireland's early farmers at Loughcrew in County Meath.*

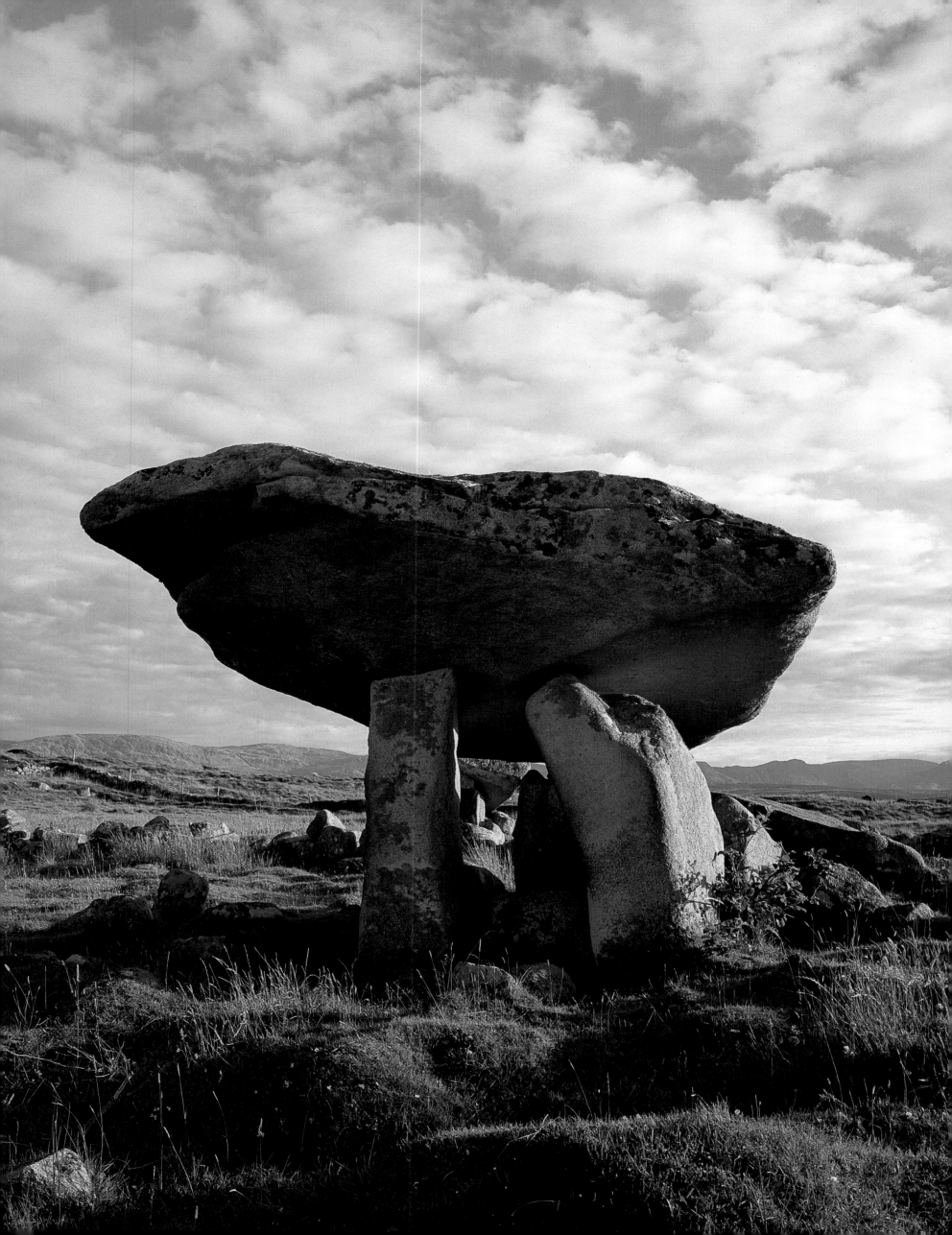

some weighing many tons. Their makers may have been small men, but they thought big. No wonder that, in Sardinia, similar tombs were considered to have been built by giants.

One of the oldest varieties are the so-called court cairns or court tombs. The court was an open-air space in front of the tomb, sometimes less and sometimes more than half a circle in shape, where presumably some burial ritual—a form of prayers for the dead—would have taken place before the body (or ashes) would have been laid in the grave (a gallery behind the court). Unlike the court, however, the gallery was covered with a mound of small stones, called a "cairn" in modern terminology. These court cairns were built mainly in the northern half of Ireland, particularly during the fourth millennium B.C.

Roughly contemporary, more compact, and certainly much more dramatic, are the dolmens, a name derived from two Breton words meaning

BELOW: *The dolmen overlooking the lowlands of County Down from a lofty site at Legananny in the Mourne mountains has its stones reduced to an absolute minimum, with all of them angular in shape. The heavy capstone performs a balancing act on the triangular upright at one end that aptly resembles a veiled widow bearing a coffin away for burial, preceded by her two taller sons who share her burden.*

OPPOSITE: *Like weight lifters of today, the upright stones of the dolmen at Kilclooney have been raising their massive capstone high above the uplands of County Donegal for over five millennia.*

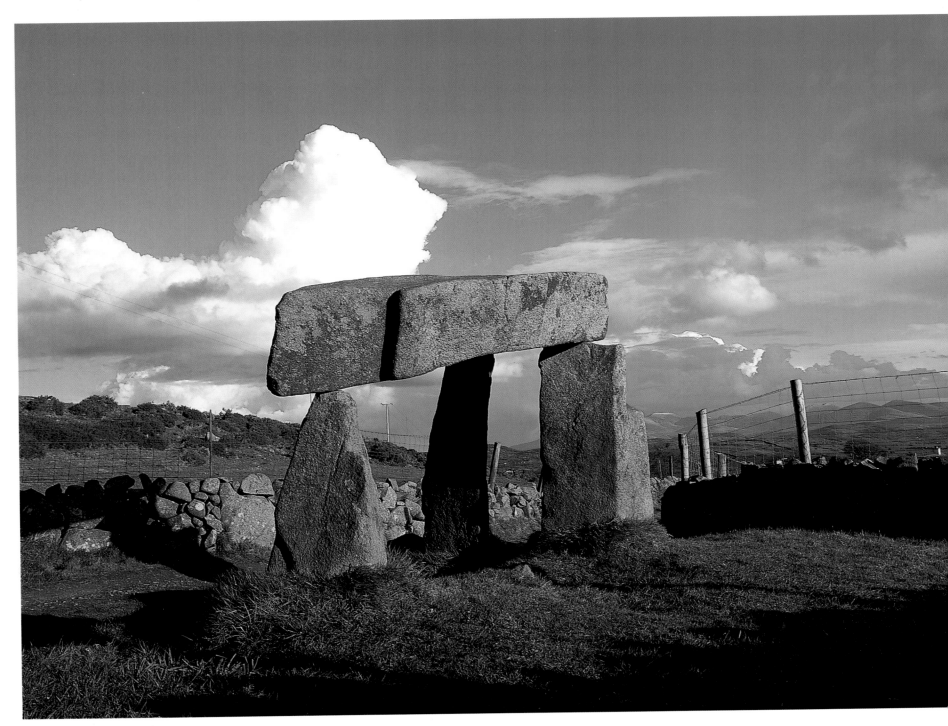

"stone table." Dolmens have been regarded, with justification, as Ireland's first pieces of public sculpture, for they stand upright in the landscape, abstract forms placed together to form an elegant whole. They are timeless memorials to the Stone Age dead and witness to the engineering ingenuity of their living survivors. The dilettanti of the eighteenth century loved to fantasize about the druids using them as altars for human sacrifice. Less gory and more romantically, local folklore made them into the beds of two of Ireland's greatest tragic lovers, Diarmaid and Gráinne, who used them as love nests on their headlong flight to keep one step ahead of an aged and jealous man to whom the maiden was unwillingly betrothed. Like a house of cards, a dolmen consists of a number of upright stones, rarely ever more than seven, on which usually one or two capstones were laid. It must have been some job to raise these mighty coverings—many were probably pulled into position by means of an earthen ramp built on the lowest side—for the capstones usually sloped upward toward the entrance front. But the real genius of their builders lay in getting the covering stones to balance on their legs without falling, and yet appearing to have the grace of a ballerina. One, at Kilclooney in County Donegal, when seen from a particular angle, is poised like a bird about to take flight, its projecting frontal stone resembling a beak—seeming like the Irish-designed prototype of the twentieth-century's Concorde airplane. Another dolmen, at Legananny in County Down, is appropriately similar to a coffin laid on stilts, and Poulnabrone, in the lunar landscape of the Burren in County Clare, which looks toward the far horizon and the heavens above it, is the resting place of over twenty individuals who raised and fed cattle on the nourishing grass of this remarkable limestone karst.

Farther north, in the county of Sligo—a paradise for those with megalithomania and one of the most underestimated scenic areas of Ireland—court cairns and dolmens are sometimes found in the middle of turf bogs. Not that they were purposely built for the protective covering of the peat, but, rather, they were built before the bogs even began to form. One-sixth of Ireland was once covered by bog, which developed when overabundant rains left so much standing water that vegetal material did not decompose. (During the last few centuries, the peat has provided Ireland with much-needed fuel.) Farther west, in Mayo, the bogs have recently revealed one of their remarkable secrets. At the Céide Fields, bordering the Atlantic to the west of Ballycastle, miles and miles of stone wall foundations have been laid bare, or at least their presence established. They are laid out in long, straight lines, in plains or up the sides of hills, and connected at widely spaced intervals by cross walls that create very sizeable fields. Preserved intact for millennia by the bogs that developed over them,

RIGHT: *Poulnabrone—literally The Hole of the Sorrows—is the fitfully named resting place for twenty-two individuals buried in this dramatic dolmen raised above the lunar limestone landscape of the Burren in northern County Clare more than five thousand years ago.*

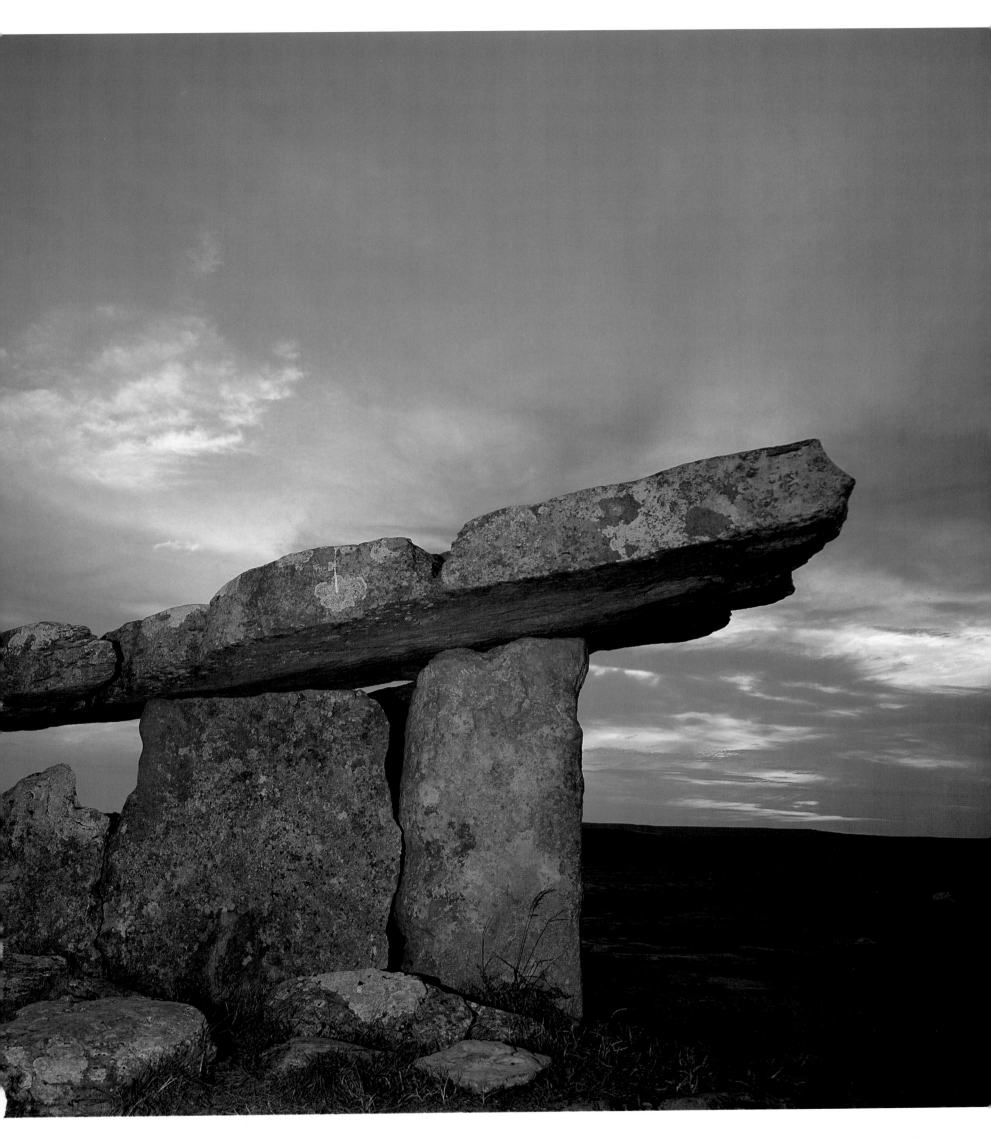

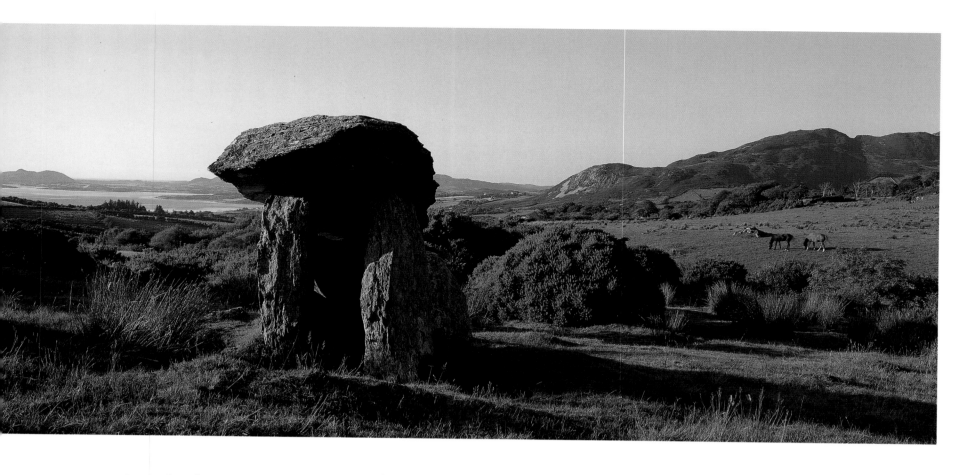

ABOVE: *Located in the valley of the Burnside river that drains into Mulroy Bay in the romantic landscape of Donegal, the dolmen at Gortnavern is marked on old maps as Grania's Bed, because Irish folklore explains such megaliths not as tombs but as the nocturnal resting places of the tragic couple Diarmaid and Gráinne, the latter a beautiful girl who had eloped from her much older fiancé, the legendary Finn mac Cumhail.*

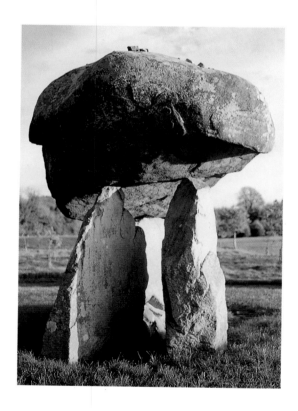

these walls indicate the existence of a high degree of social organization, since it must have required many teams of men—working together like the modern *meitheal* in rural Ireland—helping their neighbors to build the walls and organizing the land into units of varying sizes, probably for the protection of their animals. The humble, simple settlements of these people have been found among the walls together with the associated local graveyard in the form of a court cairn, suggesting communality in burial, as in pastoral practice.

When catalogued in the first half of the nineteenth century, Carrowmore, only a few miles west of Sligo town, was the site of one of the most extensive megalithic cemeteries in the whole of Europe. But the monuments were unfortunately built on gravel, which was a commercial commodity subsequently excavated away from beneath the megaliths. At first, they were left standing like mushrooms, but later they just fell as the ground collapsed under them. Fortunately, enough remains spread over a few square miles to reveal a sample of Carrowmore's vanished glory. These are dolmens, sometimes surrounded by a circle of stones, but occasionally having a passage leading to a central chamber. Sometimes cruciform in shape, this cemetery can be linked with the greatest of all megalith tomb types in Ireland—the passage grave.

Passage graves differ from the other megalithic tomb types in a number of respects. They are usually found on visually prominent locations, such as atop a hill or straddling a ridge, though Carrowmore, being on flat ground, does not fit into that definition. But it does nevertheless belong to the category in the sense that passage graves are often found clustered in groups, sometimes with monuments of roughly equal size and status, in certain instances—particularly in the Boyne Valley—with a main tomb surrounded by smaller satellites, like

chickens around a mother hen. Unlike the court cairns and dolmens, passage graves stand in a round mound made up of stones and often sods, usually encircled by a curb of large stones. As their very name implies, a passage leads from the perimeter to the central (or nearly central) burial chamber, which is of massive boulder construction. Like the other categories of tombs discussed earlier, these were communal burial places, used over many generations, which contained up to 125 individuals, as at Fourknocks in County Meath, though whether all belonged to a single extended family has never been established.

Admittedly there is a certain generic similarity between the Irish passage graves and the Pyramids of Egypt. Both stand out in the landscape and both have a passage leading into an important burial chamber. The obvious difference is in the shape of the mound—the hemispherical contrasting with the pyramidal—and the fact that the chamber was used like a family vault in the Irish tombs, but as the last resting place of a single deified Pharaoh in the pyramids. Another difference, of course, is the comparative dating. The pyramids are normally considered to have been built from around 2600 B.C., whereas Ireland's most famous passage grave at Newgrange is usually dated around 3100 B.C., and thus up to half a millennium earlier than the pyramids. But even earlier are some of the passage graves in Brittany, and it has been claimed that one of the Carrowmore graves may even date from before 4000 B.C. This is not to suggest that the Irish showed the Egyptians how to build passage graves, the Egyptians then adding a more angular touch. The idea behind both may well be Mediterranean in origin and passed by migrants northward up the Atlantic coast of Europe until the Irish took it and created

BELOW: *As if frozen in time, the upright stones of a megalithic tomb at the great Stone Age cemetery at Carrowmore, County Sligo, seem to huddle together for warmth and cluster together for strength to hold up a capstone tens of tons in weight, whose left-hand end in profile bears a fortuitous—if uncanny—likeness to a human face.*

OPPOSITE, BELOW: *Stones thrown up that then stay in position on top of the massive capstone of the macho dolmen at Proleek in County Louth are meant to bring the fulfillment of a wish—but fortunately have never been the last straw to break the camel's back, the Stone Age tomb's uprights having stoically borne their awesome burden for more than five thousand years.*

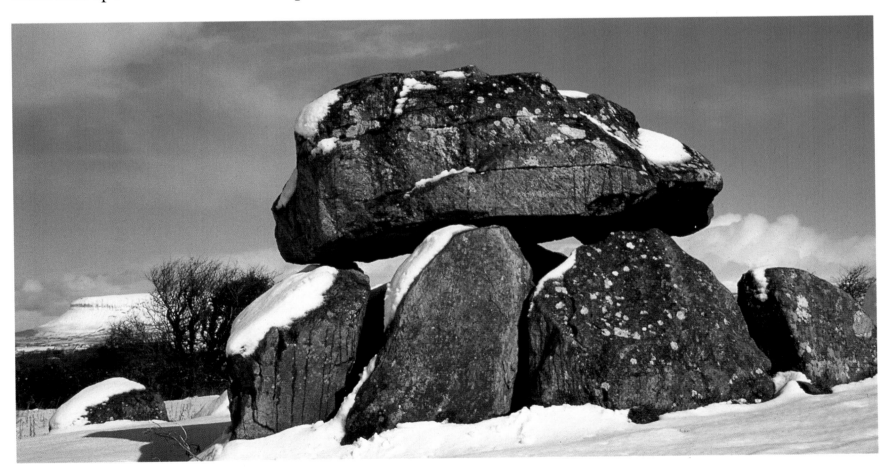

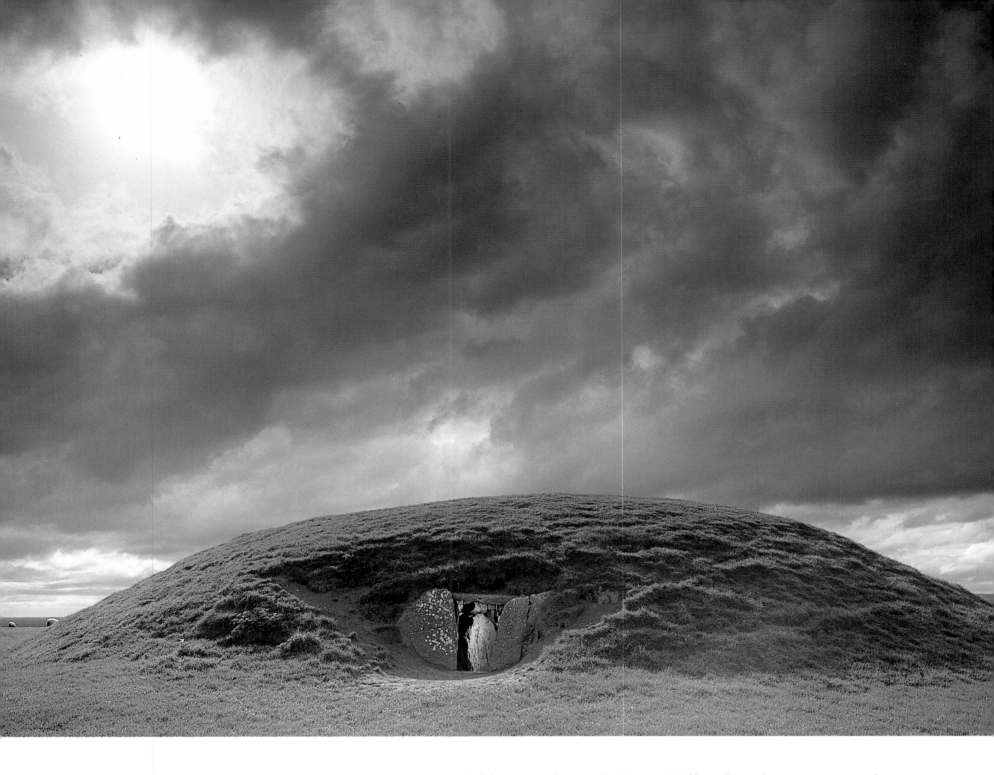

The oldest structure standing on Ireland's history-laden Hill of Tara is known as the Mound of the Hostages, so named since the Middle Ages when hostages must have been kept there by the kings of Tara. But it is, in fact, a passage grave dating from around the third millennium before Christ, its short tomb chamber proving on excavation to have been piled high with Stone and Bronze Age burials.

some remarkable examples in the Boyne Valley, though none is so perfect as that acme of passage grave building, the Treasury of Atreus in Mycenae, which, however, is probably more than a thousand years later than Newgrange. The idea, incidentally, passed even farther up the Atlantic face of Europe, where one of its most superbly crafted examples is at Maes Howe in Orkney in North Scotland. The passage grave can thus be seen as a phenomenon that spread widely throughout the Mediterranean and Atlantic and expresses a unifying and idealized form of burial. There is no clear evidence of direct contact between the major groupings—Iberian, Breton, Irish, and Scottish—suggesting that the idea was spread by only a small number of people, rather than, as might be imagined, by an invasive flotilla of doughty mariners coming long distances by boat from Spain or Brittany to force it on the inhabitants of Ireland, who had hitherto buried their dead in court cairns and dolmens, small box-like cists, or even simple unmarked holes in the ground.

One of the most extensive Irish passage graves is located on the top of Knocknarea, which overlooks Carrowmore and the land- and seascape of

County Sligo for miles around. At about one hundred feet in diameter, it has so far avoided excavation. W. B. Yeats eulogized the great hill on which it stands— "the wind bundles up the clouds high over Knocknarea . . . for all that Maeve can say"—the latter being a reference to the great Irish warrior-queen/goddess Maeve (Medhbh), heroine of the old Irish epic *Táin Bó Cuailnge* who, according to local tradition, is said to be buried there. Almost equally dramatic are the passage graves that pimple the skyline of the ridge of Carrowkeel, which can be seen from the shores of Lough Arrow in the same county. Here we find "classic" passage graves, with a plan in the shape of a cross, the central burial place and its side chambers corbeled over, the whole covered by a round stone cairn. One of the tombs has a rather large cairn with what looks somewhat like a court cairn at one end, suggesting that here, on this windswept and almost

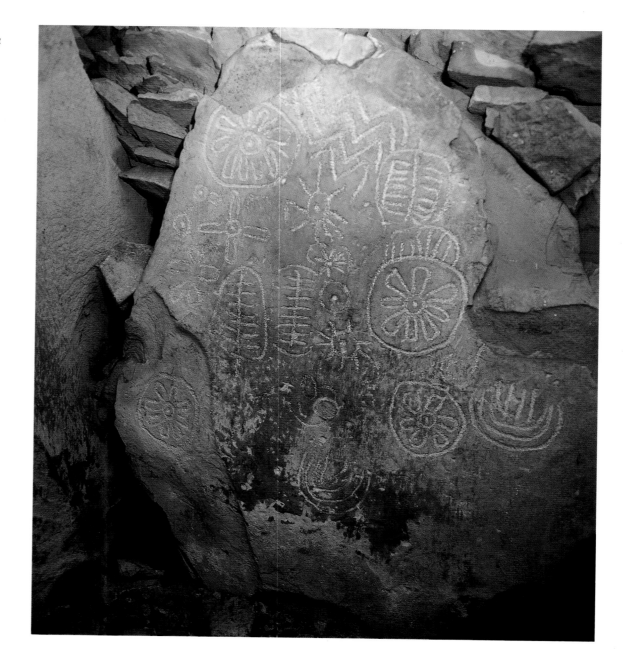

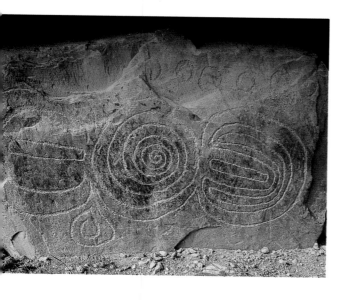

bleak mountain ridge, the court cairn and passage grave people met and communed together in death around five thousand years ago. Only marginally farther west is Keshcorran, with another large passage grave on top of a hill, which has caves on its side that play a magical role in the world of medieval Irish storytelling.

The idea of a cave also springs readily to mind when we come to look at the passage graves in the eastern half of the island, particularly in the county of Meath, where the three great tombs of Knowth, Dowth, and Newgrange represent—both in construction and in time—the apogee of Irish passage grave building. These three are massive mounds stretched out for almost two miles along a ridge that overlooks the river Boyne between Slane and Drogheda. They stand on sites carefully chosen so as to be visible from a considerable distance, Newgrange apparently having had a cladding of quartz brought from many miles away that shines white like the Taj Mahal. Not far away are other earthworks and henges—similar to Stonehenge, but in wood—that were probably ritual in nature, which has led to the suggestion that the whole area of the "bend of the Boyne" may have been a very sacred one. After

all, three of the largest passage graves in the country being concentrated within a few miles of one another is, in Christian terms, like having a trio of major cathedrals in the same city.

Dowth is the Cinderella of the three, since it is the only one not to have been extensively excavated in the twentieth century, though large holes (which cannot even be dignified by the name "diggings") were burrowed into the mound in the mid-nineteenth century, revealing two tombs near the edge of one side of the mound that augur well for the finding of more—if a major excavation were ever to be mounted there. But that is best left for future generations.

Archaeologists have been very active in the other two mounds during the second half of the twentieth century. Knowth produced a major surprise in having not one but two passage graves within a single mound, very different in kind but almost touching each other at the center of the mound. One has a long passage that expands gradually to become a burial chamber; in the other, a passage leads to a central chamber, cross-shaped in plan, similar to some of those at Carrowkeel in Sligo and at Newgrange. Smaller satellite tombs cluster

BELOW: *The great passage grave at Knowth in the valley of the river Boyne has more Stone Age decoration than any other of its kind. One of the large boulders surrounding the stone-and-earthen mound bears what may be the world's oldest surviving sundial—even accompanied by the telltale hole for the gnomon—and was carved before an Egyptian pyramid was even a twinkle in a Pharaoh's eye.*

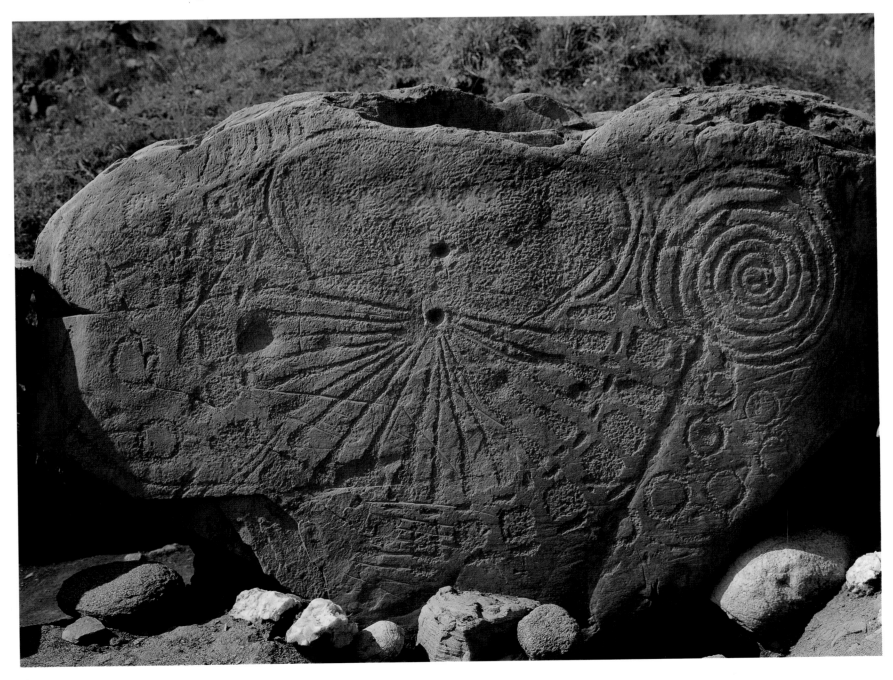

23

BELOW: *Perhaps the most supreme expression of the art of the passage grave people is the so-called mace head of flint found in one of the burial chambers at Knowth in County Meath. The spirals, holes, and strands of hair combine to make a stylized human head carved with most delicate modeling that shows the Stone Age craftsmen's ability to create a masterpiece out of such an unyielding medium.*

around the main mound. One of the smaller tombs clearly preceded the building (or at least final completion) of the main mound. The other major surprise produced by Knowth was the amount of art preserved on its stone surfaces both in the tomb and on the peripheral curbstones. In fact, it is the proud possessor of two-thirds of all known passage grave art in the whole of Europe. A wide variety of motifs, angular or rounded, were pecked into the surfaces by sharply pointed stones, and these include circles, spirals, zigzags, triangles, lozenges, or diamonds, some of which are also found on the other major Meath passage graves such as Loughcrew and Fourknocks. Like Loughcrew, at Knowth a symbol of rays radiates from a central point to a surrounding circle, making it look uncommonly like a stylized sunburst, something that is not surprising when we come to consider the importance of the sun at Newgrange. But Knowth also has some fascinating stones with very individual motifs not occurring elsewhere. One looks like a not-so-primitive sundial, with lines radiating in a semicircle beneath a central hole where a

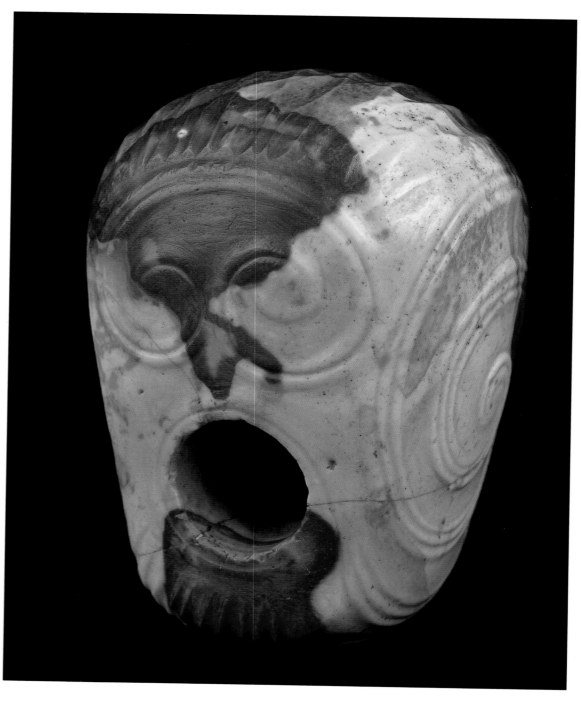

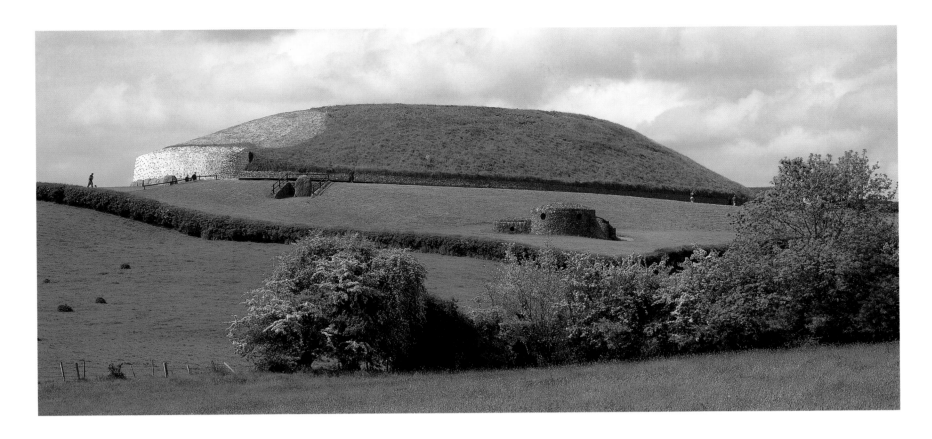

gnomon (pin) would be placed in medieval and more modern versions. Other motifs include what could be horns (or even boats), and one stone at the innermost end of the gallery-shaped chamber bears what looks to me uncannily like a bear with a dribbling nose. The same chamber preserves a stone with what seem to be two eyes above and boxed rectangles beneath, owl-like perhaps, but for me a premonition of Edvard Munch's *The Scream*. Whatever the original intention, there does seem to be something human here, and one stone at Fourknocks must surely represent the human face, stylized in a combination of angular and curving motifs, and with a charm that cannot but bring a smile to the face of the beholder.

The various motifs that individually and collectively make up passage grave art are, at least in part, products of a stylization that was the last of a long succession of designs that may well have been at first intended to represent natural objects or human beings on materials other than stone, but which ended up in the stylized form we see today. What might those materials have been? Some of the more angular motifs might have developed from weavings of the kind found in folk art in many parts of the world, but the rounded motifs might have been more difficult to produce in woven form. The more obvious answer would be wood. If we take the tombs to be "the houses of the dead," where the departed should be more comfortable and secure than in life, might not passage grave art reflect the decoration that could have been carved on the wooden walls of the houses of the living, an area that would have provided plenty of possibilities to the inventive artistic mind? But these designs should hardly be understood just as "art for art's sake." A surprisingly sophisticated society built the tombs, and these symbols, arranged in the combinations they formulate on the stones, must have had some religious,

ABOVE: *The reconstructed white quartz façade on the left of the colossal mound that covers the passage grave at Newgrange reminds us that such monuments were designed to stand out in the landscape, making a statement about honoring, but also possessing, the spirits of the dead—and the land they had won while alive.*

ritual, or social message. If mute stones could speak, passage grave art would tell us a great deal about these people who were producing very advanced art motifs with nothing but primitive tools, and whose weird and wonderful imaginations—it has even been suggested that they used hallucinogens—resulted in the development of such motifs.

One supreme product of this stylization is the flint mace head that came to light in one of the Knowth chambers. Its origins unknown, it is an irregularly shaped four-sided block of flint with a rounded hole extending its whole length, into which a handle is presumed to have fitted. But that hole can also be seen as the mouth of a face created by spiraled eyes and swept-back hair above and a beard below. What can be seen as ears on the side of the head are spirals formed by sets of raised ridges alternating with broad grooves and carved with a sophistication that was not to be seen again until the Aeolian capitals of classical Greece. We know not from where the flint came, nor where it was carved, but this head must be taken as one of the supreme creations of stylized passage grave art and a testimony to the high quality of its craftsmen. (In stark contrast, the pottery created at the time was extraordinarily crude.) The head makes us regret all the more what we may be missing in the form of carved wood, a material sadly so ephemeral in the Irish climate.

Newgrange is the most famous of all the passage graves of Ireland and, indeed, probably the country's most internationally renowned monument. Each year, at the winter solstice, as the sun creeps over the horizon on the shortest day of the year, it sends its rays into the depths of the burial chamber—not through the doorway, but through a small aperture above it created specially for the purpose. The whole long passage and burial chamber under the great mound were clearly designed around this annual happening, suggesting the importance of the sun to its builders, whose major god it may have been. The sun's rays must have been perceived as sending a message not only to the dead buried within, but also to the living who would presumably have penetrated the tomb at the solstice to experience the sun illuminating the stygian gloom for a mere seventeen minutes before it disappeared as stealthily and as quietly as it had come. No medium was needed at such a séance to understand the universal message that as the winter's nadir is followed by nature's regeneration in spring, so also the soul is reanimated after death to a new life, surely the country's earliest testimony to a belief in the afterlife. It is not surprising that ancient lore recorded in the eleventh century saw Newgrange as the deified personification of the river Boyne. Newgrange was known as the *Brú* or abode of the pre-Celtic people (the Tuatha Dé Danann) led by the good god Daghda and his wife Bóann. It was also the burial place of many of the kings of Tara and of the slain Diarmaid, laid to rest where he and his beloved Gráinne are said to have spent loving nights.

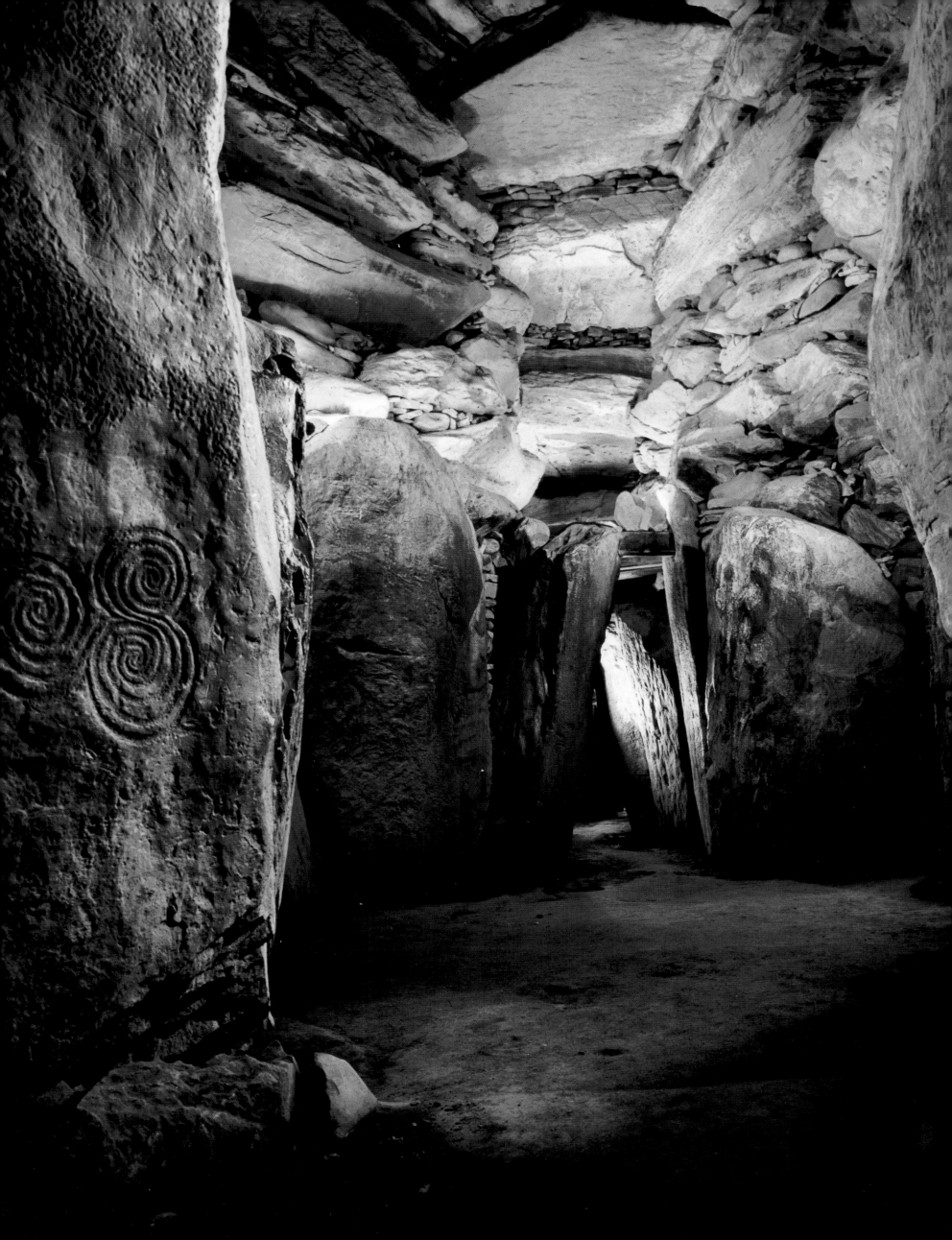

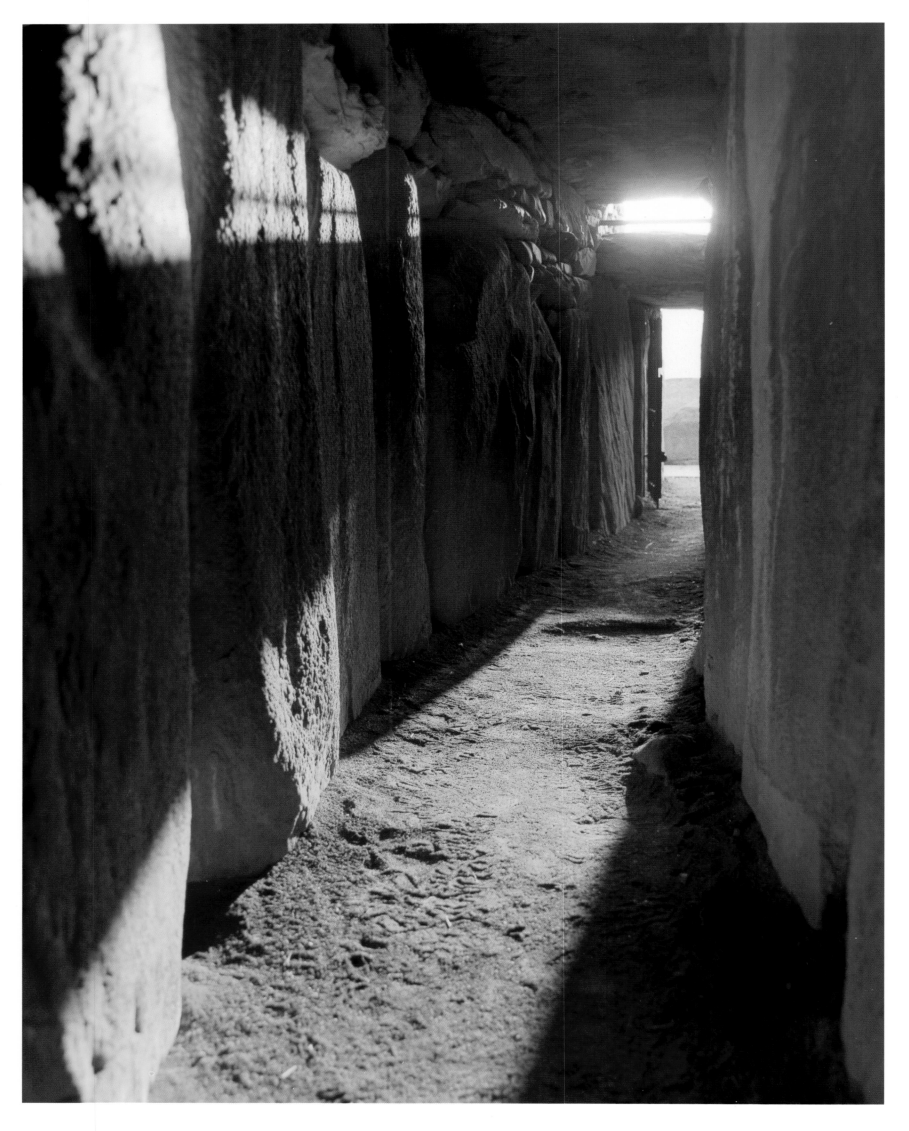

Newgrange, too, has its stone satellite tombs, as well as a striking collection of carved stones, none so remarkable as that in front of the entrance. Its swirling spirals—one triple, others double—and a collection of lozenge or diamond shapes are all cleverly integrated and fitted to the slightly undulating surface of the stone, making it one of the most monumental pieces of stone carving found anywhere in Stone Age Europe. Some of these motifs are also found on a stone of even greater complexity at the back of the mound, and the triple spiral that is the "logo" of Newgrange appears yet again on a stone in the back chamber of the tomb. The most intricately carved stone of all is that covering the burial niche seen at the right-hand side on entering the tomb chamber. It is doubtless more than mere coincidence that this is also the location of the only side chamber in the Treasury of Atreus in Mycenae, where the corbeled roof of Newgrange finds its final perfection. The large boulders used in the Newgrange roof are tilted slightly upward above the chamber to allow water to drain off from the mound above, which—like the channels on the upper surface of the roof stones created for the same purpose—give eloquent testimony to the engineering capabilities of these remarkable builders. These were no "noble savages," but a highly sophisticated people who were able to use all the simple Stone Age technology at their disposal to create some of the world's first great architectural masterpieces with appropriate sculpture to match, much like the builders of the slightly earlier temples on the Mediterranean island of Malta.

BELOW: *Spirals double and treble billow like puffs of smoke over the carefully designed surface of the majestic stone outside the entrance to the five-thousand-year-old tomb at Newgrange in County Meath— one of the finest pieces of Stone Age carving to be found anywhere in Europe. The vertical groove in the center top points to the doorway behind it, above which is the white quartz-framed aperture through which the sun's rays shine to penetrate into the tomb's sanctuary at the winter solstice on December 21 each year.*

OPPOSITE: *The passage grave at Newgrange in the bend of the river Boyne some miles above Drogheda has become internationally known as one of the wonders of the European Stone Age since it was discovered that the sun shines along its sixty-two-foot passage into the very center of the burial chamber on the shortest day of the year—the winter solstice—and on a few days surrounding it. When the sun emerges over the horizon and shines along the passage into the chamber at Newgrange for a mere seventeen minutes at the annual winter solstice, the message for all humanity is that, in the same way that nature reaches its nadir point on the shortest day of the year, only to revive again for the spring, so also death should not be seen as an end but rather as the beginning of a new life.*

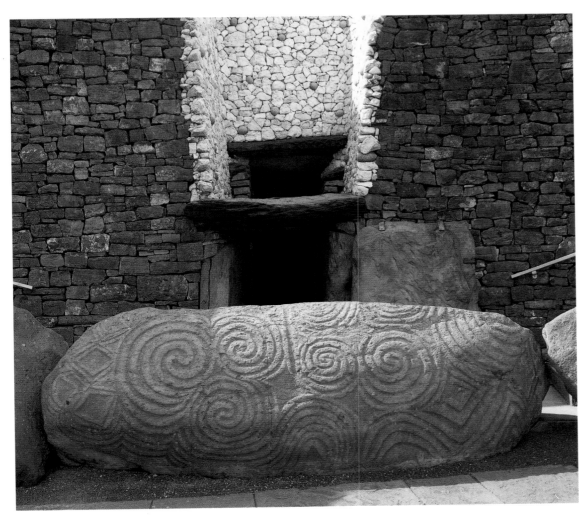

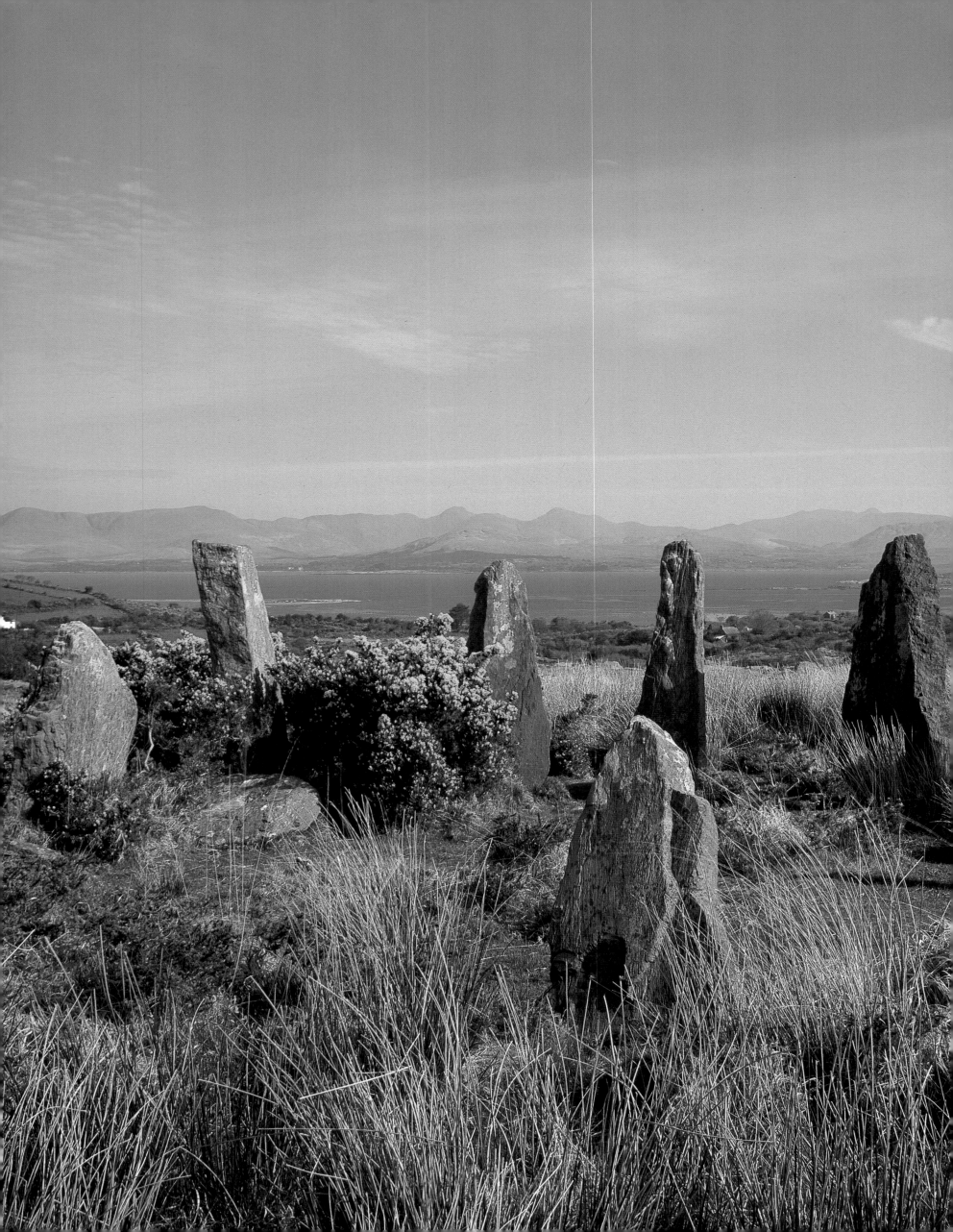

The "El Dorado" of the West

The sun god presumably remained supreme at least into the Bronze Age, which, after a brief overlap, followed the Stone Age around 2000 B.C. This period lasted roughly fifteen hundred years, during which the most visible monument created in the Irish landscape was the stone circle. As the name implies, it was a circle of large stones, most upright, but sometimes with one recumbent, lying horizontally on the ground. What is perhaps the largest of its kind—in Grange townland not far from Lough Gur in southeast Limerick—was excavated half a century ago and turned out to have been built at the end of the Stone Age. It is curious to note that local lore suggests that it was built by Crom Dubh, a small black pagan figure who was credited with having brought the first sheaf of wheat to Ireland, which would fit in well with the notion that Stone Age farmers built the stone circle. But most stone circles were probably built during the Bronze Age. Their purpose and function are enigmatic, wrapped up in the mists of time. Part of a fragmentary circle surrounding Newgrange that seems to be a thousand years younger than the great mound it encloses suggests almost a girdle-like guard of honor outside and around the mound—large, raw boulders striking awe into any onlooker daring to approach the sacred precinct. The sun and its movement may have something to do with the placement of the stones, as may have been the case with some of the other stone circles.

The circles are located in certain parts of Ireland—in Wicklow, in the Cork/Kerry area, and in various places in northern Ireland. Some have one recumbent slab as part of the circle, with an upright stone outside the opposite arc of the circle. To join the two and follow the straight line thus created to a point on the horizon may show where a celestial body—sun or star—was observed to rise or set through a notch in a line of hills or some notable natural landmark on a day of the year that may have been of particular importance—high summer, low winter, or May Day. The circles, therefore, could have been a kind of observatory from which the paths of certain celestial bodies were studied. But to mark a day or observe some astronomical phenomenon, all that would have been required was two stakes placed in the correct position in the ground. There must, therefore, have been more to stone circles than that.

ABOVE: *The Hunt Museum in Limerick houses this splendid Bronze Age shield of c. 700 B.C., with its central raised boss surrounded by concentric circles filled with hundreds of smaller bosses in raised relief— all demonstrating the high level of craftsmanship practiced by Irish metalsmiths at a time before the rise of Classical Greece.*

OPPOSITE: *Like children stopped in the middle of a game of musical chairs, the upright slabs forming a circle at Ardgroom in County Cork stand sentinel admiring the landscape of Bantry Bay, as they have done since they were set up probably more than three thousand years ago. The original purpose of such stone circles has been the subject of much inconclusive archaeological debate—but their very mystery is one of their attractions.*

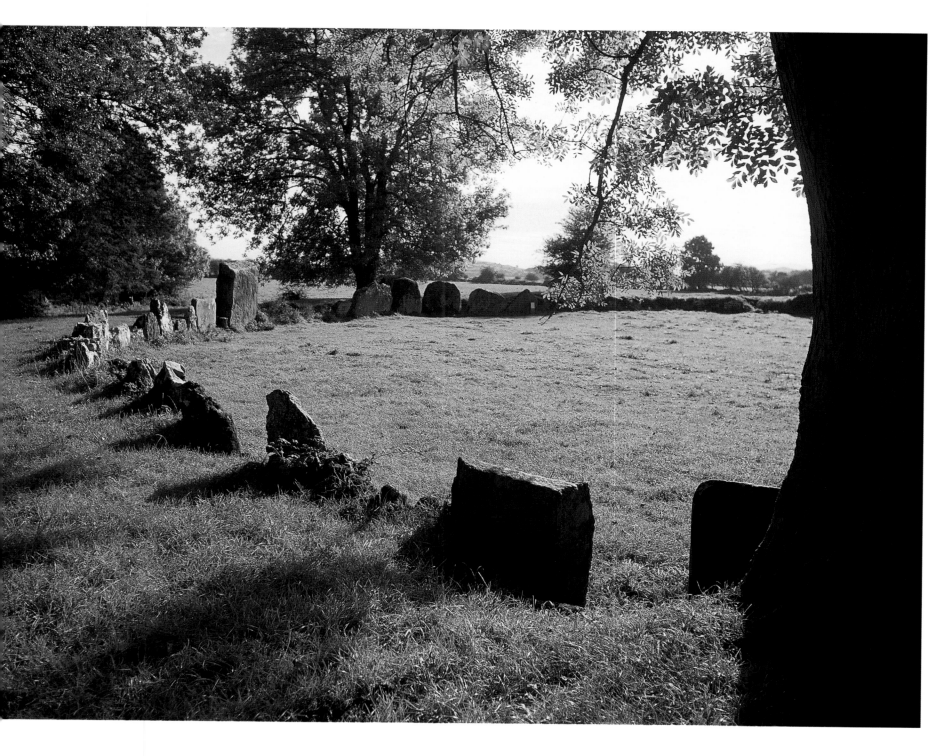

ABOVE: *One of Ireland's most impressive stone circles is that at Grange beside the road from Limerick to Bruff, which belongs to the rich and varied treasury of stone monuments in the area around Lough Gur. It has a diameter of 150 feet, and outside the circle is a stout earthen bank more than 25 feet wide and almost four feet high. The largest stone, seen in the left background, is more than twice the height of a human figure and was traditionally associated with Crom Dubh— a little black (Gaelic dubh) man credited with having brought the first sheaf of wheat to Ireland. Perhaps it is more than mere coincidence that excavation proved the stone circle to have belonged to the Late Stone Age, the period when agriculture was first practiced in Ireland some five to six thousand years ago.*

Perhaps they were a meeting place for local people to gather, dance together, or experience some ritual event—annually, or more frequently. But whatever their intended use, their circular form evokes the orb of the sun, suggesting some celestial link.

Not surprisingly, a certain amount of folklore surrounds these very striking round monuments, often found in particularly scenic locations, as in West Cork. That great archaeological polymath, Sir William Wilde, father of Oscar, tells of a legend associated with the site of the mythological Battle of Moytura. One of the antagonists was Balor of the Evil Eye, whose glance could kill an opponent in an instant. His enemies erected a stone circle and painted its stones with figures of warriors, and when Balor realized that his eye contact was having no effect, he retreated in confusion.

Two Wicklow stone circles with stones standing upright outside them have produced rather different explanations. The native version tells of three

musicians, pipers by profession, who competed in a stone-throwing contest. They threw their stones up Brewel Hill near Dunlavin with such accidental precision that they formed a circle. But a younger piper who wanted to show his mettle threw one too; it landed behind the others and, thus, outside the circle. No wonder it was called the Piper's Stone. But another stone circle, with the same nickname, located between Blessington and Baltinglass, has a very different story attached to it, which smacks of seventeenth-century puritan England. It relates how a piper went out with dancers one Sunday, but because they violated the Sabbath, the dancers were turned into stone as they pirouetted in a circle, while the accompanying piper was literally petrified into a standing stone, like Lot's wife being turned into a pillar of salt.

Single standing stones are also a feature of the countryside and have been the subject of much speculation within the last century. Some, it was suggested—and probably not without some justification—were put up so that cattle could scratch their backs on them. Others, it was thought, were road markers, particularly where they were grouped together in a straight line to form what is known as an alignment (the more romantic version is that they

BELOW: Drombeg stone circle is one of the best preserved and most appealing of its kind in Ireland. Situated about two miles east of the village of Glandore, it stands on a terrace that looks over the gentle landscape of West Cork toward the Atlantic Ocean beyond. Compact and virtually complete, the circle consisted originally of seventeen stones that gradually diminished in height from the tall entrance stone (seen here to the left of the center foreground) to a single flat stone opposite it. This is one of the few circles of its kind to have contained a human burial, which dated from the early centuries of the Christian era, suggesting that the body may have been inserted many hundreds of years after the prehistoric circle was built.

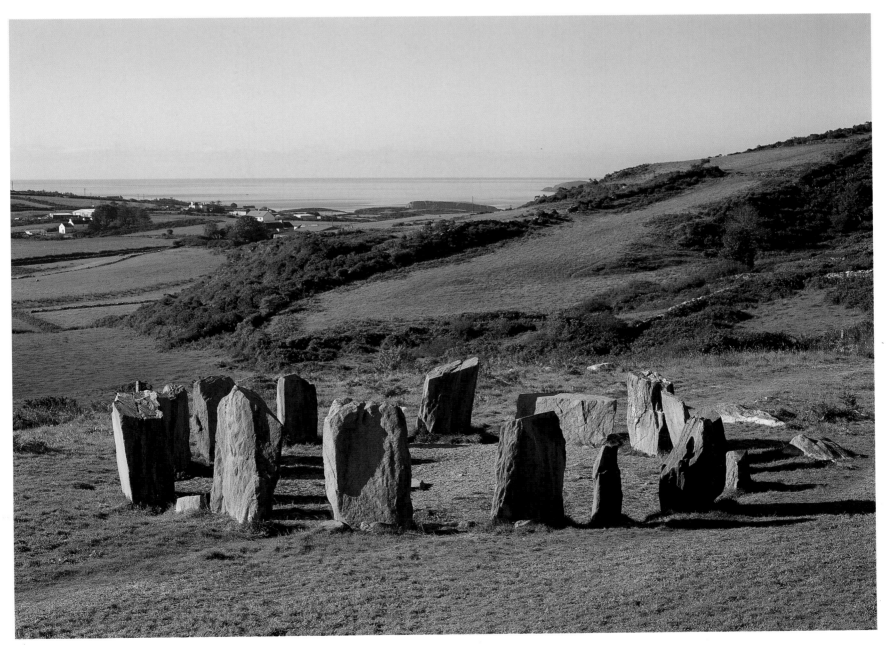

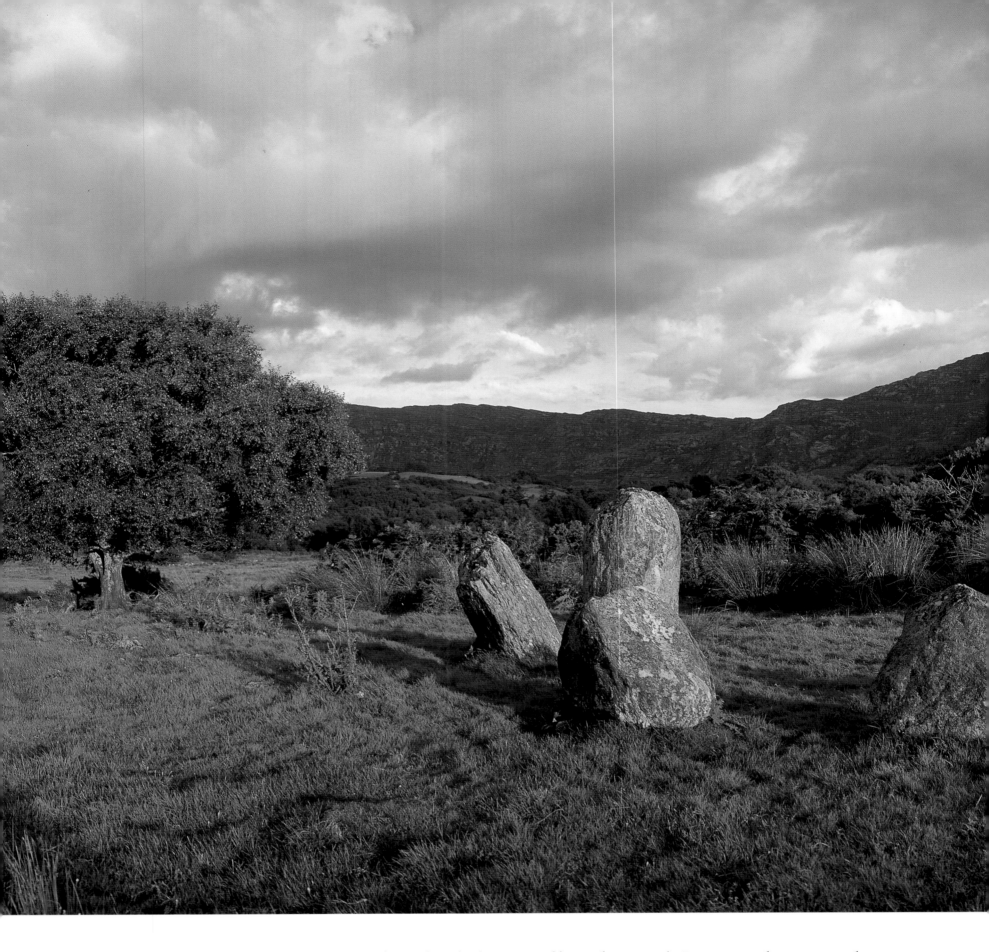

ABOVE: *The stone circles of the southwest of Ireland have the advantage of bringing the adventurous traveler up unexpected and seldom-trodden byways in search of them. That at Dromroe, four miles southeast of Kenmare in County Kerry, is encountered on the western side of the valley on the Dromought river, where it was built more than three thousand years ago. Its purpose may have been to honor the person buried beneath a boulder within.*

hinted at the location of buried treasure). One or two, however, such as at Punchestown, County Kildare—at twenty-three feet, the tallest in the country—appear to mark a Bronze Age burial, and thus probably acted as tombstones.

Some stones or rocks have dots that form circles carved into their surfaces, the so-called cup-and-ring marks. These are thought to have been developed during the Bronze Age, independently of passage grave art, and to have been linked to the exploitation of copper, particularly in the southwest of Ireland. Another example, at Boheh in County Mayo, has been shown to mark the spot

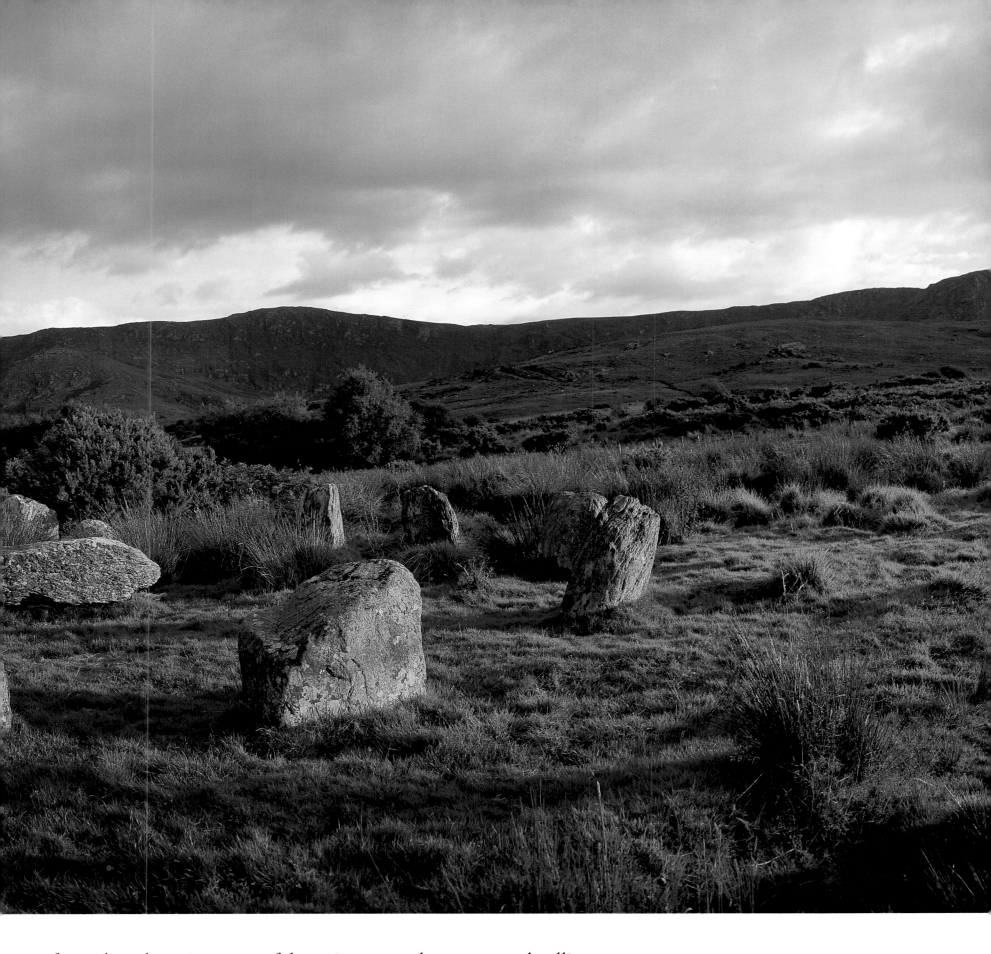

from where the various stages of the setting sun can be seen as an orb rolling
down the side of Croagh Patrick—a sacred Irish mountain if ever there was
one—though the two days when this phenomenon can be experienced—
April 18 and August 24—do not appear to have any astronomical significance
attached to them. Nor, it should be said, has anything of the kind been observed
in other locations in Ireland or elsewhere.

One of the most ubiquitous of Bronze Age monuments is the *fulacht fiadh*,
two Irish words denoting a cooking place for meat. Nearly always found close
to a stream, it is characterized by a rectangular trough, wood-lined when first

BELOW: *It was through the fortuitous cutting of turf decades ago in the extensive peat bogs of County Tyrone that the most extensive cluster of stone circles anywhere in Ireland came to light. They were presumably abandoned when the bog began to grow over them, and may even have been constructed to appease the weather gods whose over-abundant rainfall created the conditions conducive to bog development that, in time, was to cover one-sixth of the whole of Ireland. Because the Beaghmore stone circles—and their accompanying stone alignments—were so well preserved in the bog, they were ideal for testing theories about their potential astronomical purpose when built, though such theories have never been proved conclusively.*

built and now known to have been enclosed by a mound in the shape of a U. How this widespread earthwork was used is explained by the great seventeenth-century Irish historian Geoffrey Keating, whose *Foras Feasa* relates how the Fianna, that somewhat mythological band of peerless warriors, took stones and heated them in a fire before throwing them into water to make it boil. When the water bubbled, a roast of beef or a haunch of venison wrapped in straw was placed in the water that was kept boiling by the continuous addition of hot stones until such time as the meat was ready for eating. (Our usual recipe of twenty minutes to the pound and twenty minutes over has been proven adequate by modern experiments—so what is new under the sun!) It took a considerable number of stones to maintain the right water temperature and if the procedure had to be repeated for subsequent meals the stones would have been removed from the trough and heated up

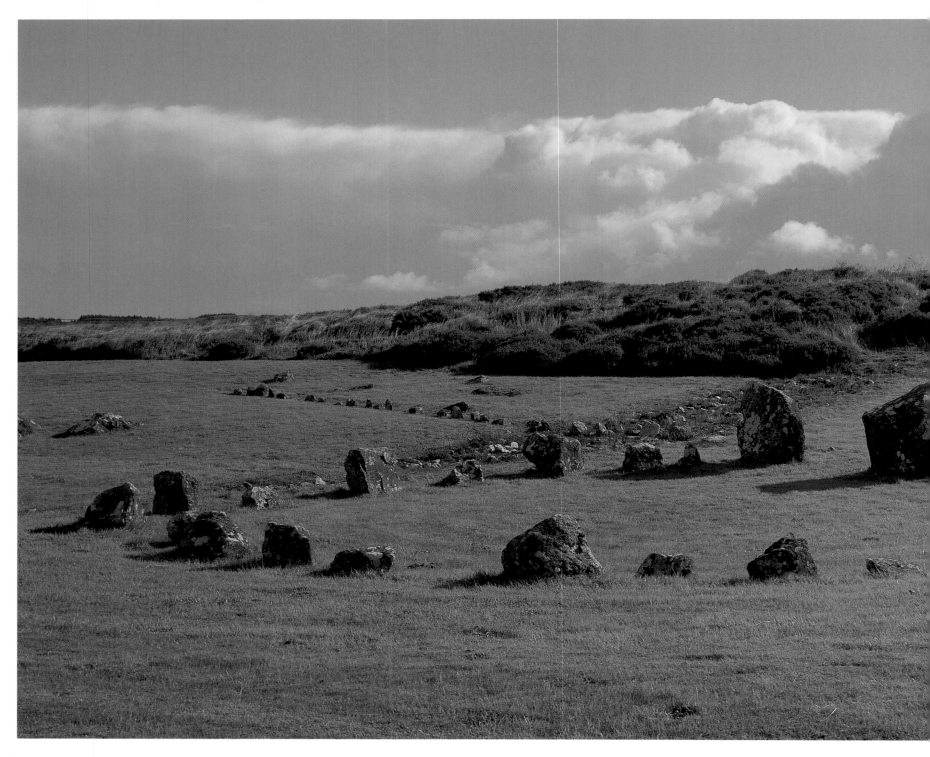

again later. Stones broken by heat may have been thrown away and piled up on one another, thus creating the U-shaped mound. A number of excavated examples of these *fulachta fiadha* date to the Bronze Age, some three or four thousand years ago, suggesting a remarkably long tradition before Keating recorded the practice in the seventeenth century. The absence of animal bones in the excavations suggests that they might have been given to the old Irish wolfhounds to gnaw! An alternative suggestion is that the water was not used to boil animal meat at all, but, rather, as bath water, a notion that, even though the Celts are thought to have invented soap, might be proof of an early introduction of personal hygiene into Ireland!

The Bronze Age was immediately preceded by a short copper age, before tin was added to make bronze. Copper was used to make the earliest metal axes used in Ireland, which would probably have been more useful and

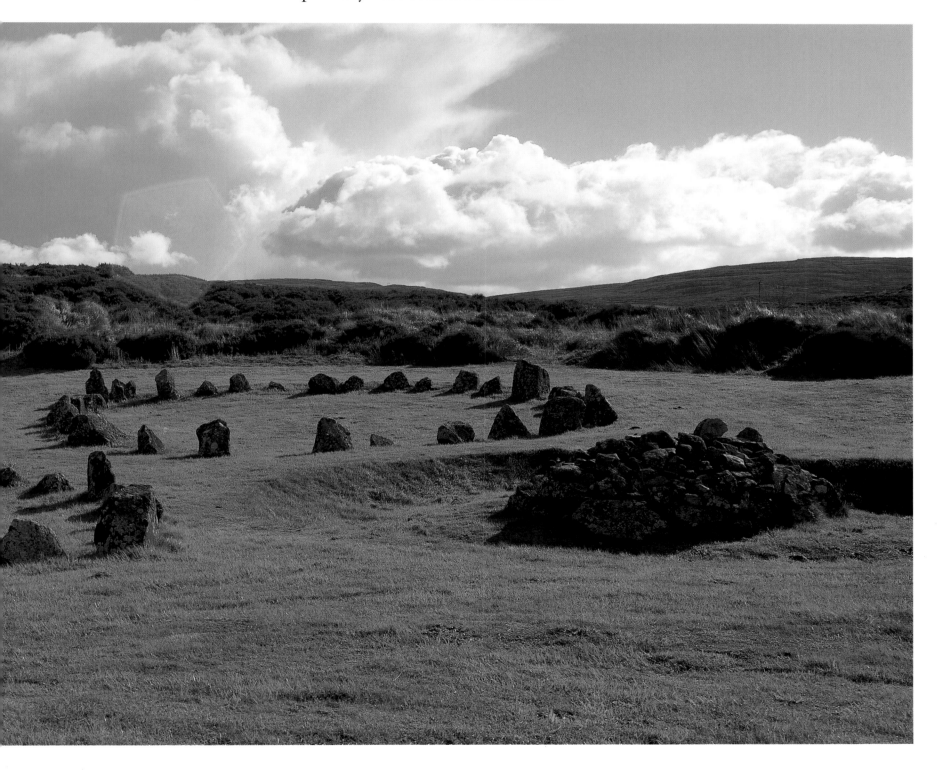

certainly more valuable than their stone counterparts. More than twenty thousand stone axes have been found, quarried at places like Tievebulliagh and Rathlin Island in County Antrim, and Lambay Island off the coast of Dublin. But the copper mines on Mount Gabriel north of Bantry in County Cork and on Ross Island near Killarney in the neighboring county of Kerry have been shown to be among the oldest known examples of their kind in Europe. The addition of tin to the raw copper would certainly have hardened the metal and made it less easy to fracture, and the patina that bronze axes have achieved over the millennia make them quite beautiful, particularly those decorated with geometric motifs, which suggest some spiritual or magical enhancement to their performance.

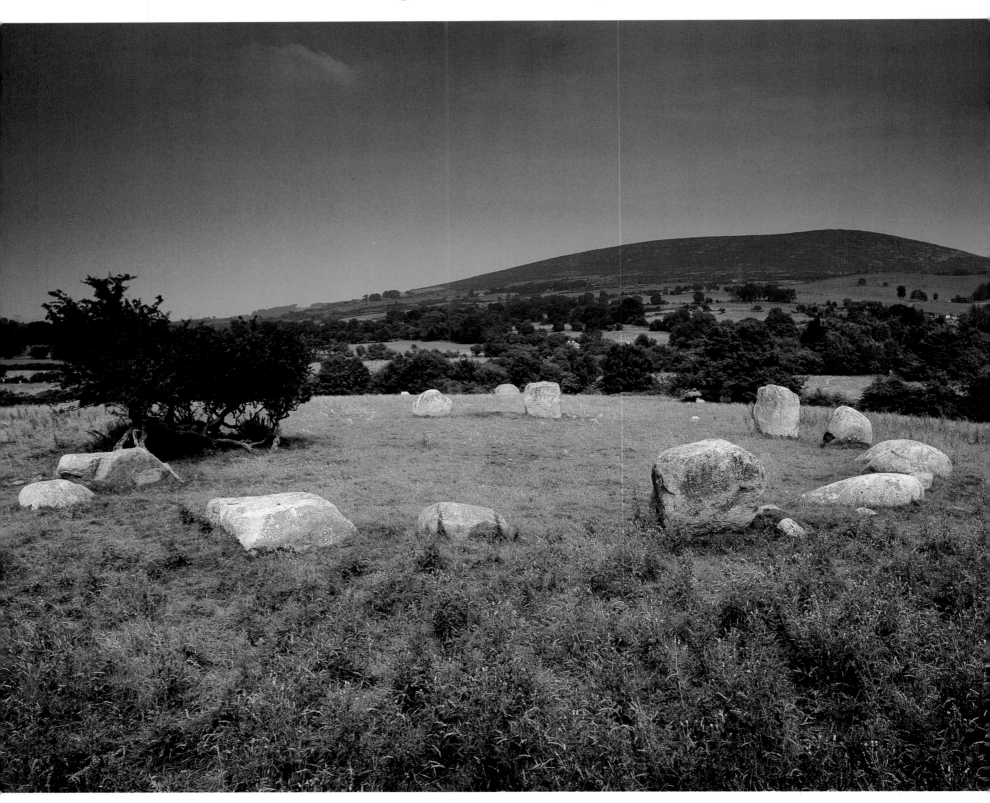

Use of the name "Bronze Age," however, takes away from the brilliance of the main metal that made it—and Ireland—famous far beyond the island's shores, namely, gold. Surpassed only by the national museums of Greece and Hungary, the National Museum in Dublin houses the richest collection of native prehistoric gold in Europe. The collection would be even more voluminous had Europe's largest hoard of prehistoric gold—discovered during the construction of the West Clare railway in 1854—survived intact; only a few samples remain, the rest having gone into the jeweler's melting pot, though, happily, not before plaster casts were made of several originals. No gold mines are known to have existed in Ireland, so we can only presume that the gold was panned in streams and rivers, such as the aptly named County Wicklow's Goldmines river, or in water flowing down from the Sperrin mountains in County Tyrone. Gold sources have recently been located as well on the slopes of Croagh Patrick, but to what extent they may have been exploited in prehistoric times is not known.

Initially, the amount of gold available must have been limited, as the earliest Irish objects made of the metal consist of wafer-thin sheets. These include small, round objects called sun discs, decorated with a cross motif (millennia before the appearance of the Christian symbol) and small pellet-like ornament, all executed in the repoussé technique, hammered up from the back. Two small holes pierced near the center suggest the disc was probably attached to a garment, perhaps on the breast. Since they have never been found in graves, we have no way of knowing whether these impressively crafted objects were worn by males or females. The same is true of the best-known gold ornament from the Early Bronze Age, the lunula, which, as its name implies, is shaped like a half-moon and was almost certainly hung around the neck as an ornament. The ends, or horns, of lunulae are usually, though not always, decorated with straightforward geometrical ornament in the form of zigzags and hatched triangles, though a sufficient length of time separates them from passage grave decoration to argue against the latter as a source of the lunula decoration. But its precise source remains obscure. Ireland must have been famous for its gold during the Bronze Age because at least one lunula of Irish gold is known to have been exported to Germany at the time.

As the Bronze Age progressed, the Irish must have become more efficient in discovering further sources of gold, for the amount of raw gold increased as the centuries passed, reaching a climax in the period around 700 B.C. But the conclusion that all that gold was Irish in origin has not gone unchallenged. Tiny samples of Irish gold ornaments were analyzed in the late 1960s, along

ABOVE: *The gold lunulae of the Early Bronze Age in Ireland get their name from the Latin word* luna, *or moon, because their shapes resemble that of the waxing or waning half-moon. Most were probably made from gold panned in the rivers of County Wicklow, and a few were exported to places as far away as Germany. The decoration on the "horns" of these pieces of jewelry consists of geometrical shapes—triangles, diamonds, and zigzags—which resemble, but which are not necessarily directly derived from, the art of the passage graves of the preceding Stone Age.*

OPPOSITE: *Surprisingly few of Ireland's many intriguing stone circles have any old folk tales attached to them. Athgreany, in the gently undulating countryside of West Wicklow, is one, however, which does have a story behind its nickname, "The Piper's Stone," which tries to explain the presence of a single stone visible in the distance outside the circle. Tradition says that a piper went out one Sunday to play for some dancers, but because they all dared to do so on the Sabbath, the Lord turned them into stone just as the piper was playing a tune and the dancers were pirouetting near him in a circle—doubtless an echo of some puritannical admonition from three or four hundred years ago.*

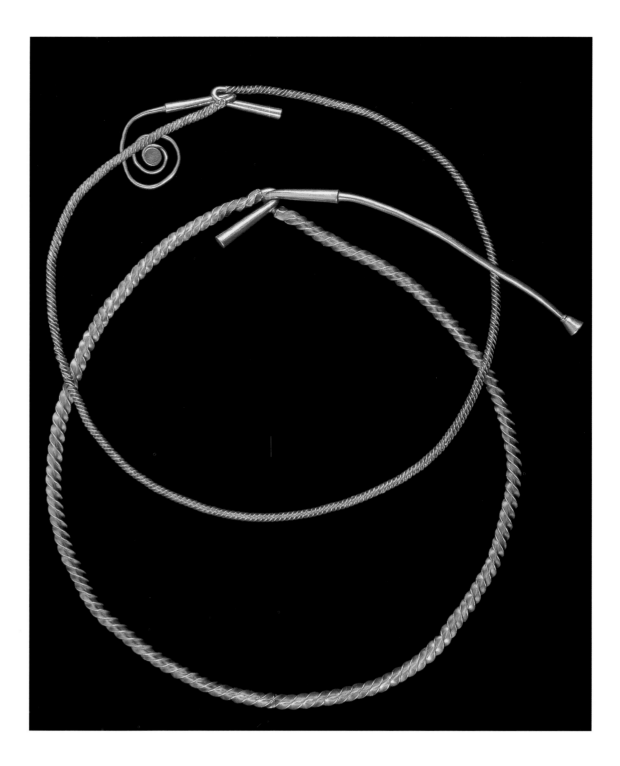

with a nugget discovered in County Wicklow in 1796. It turned out that the nugget had the same composition as the gold used for making most of the lunulae, leading to the conclusion that the early, thin gold ornaments were made from gold panned in the Wicklow hills. But the fact that the later Bronze Age gold had a different makeup from the nugget led to the idea that all the later gold was from a non-Irish source, without it being possible to pinpoint precisely from where, or even from which country. The simplest explanation is that the Wicklow river from which the nugget came was almost certainly not the only source of Irish gold, and that the prehistoric panners were so adept at discovering the precious metal that they have left modern generations nothing left to discover! As there is no other obvious source of gold in any of the neighboring lands of northwestern Europe, it is reasonable to assume that most of the prehistoric gold ornaments discovered in Ireland must have come from Irish sources, even though the exhaustive extraction of the gold in prehistoric

times has made it impossible to fix locations beyond the Wicklow hills.

As the supply of gold increased, individual gold ornaments could become much more weighty. One of the pieces, called a fibula, a clasp that functioned like cuff links to hold the two sides of a cloak together, weighed almost three pounds. Obviously too cumbersome for everyday wear, it was most probably worn on ceremonial occasions or at some special event that called for the ostentatious display of one's wealth.

In addition, there are many smaller objects, known as "ring money"—a term which is, of course, of modern derivation—which have varying weights as well as gold content, leading to the conclusion that they may have been used as some kind of medium of exchange more than fifteen hundred years before the first coinage was minted in Ireland in A.D. 997. Another explanation is that they were some type of ear decoration.

There are also some rather "exotic" objects among the gold collection in the National Museum in Dublin. One of these, the *bulla*, is heart-shaped, with a leaden core and decorated with circles, dots, and zigzags, which may have been hung around the neck as an amulet. Then there are the lock rings, double cones of gold with a gap in the circle, thought to have been worn as hair ornaments. From the technical point of view, they are masterpieces of the jeweler's art. The cones are covered with a series of concentric grooves, like those on an old vinyl

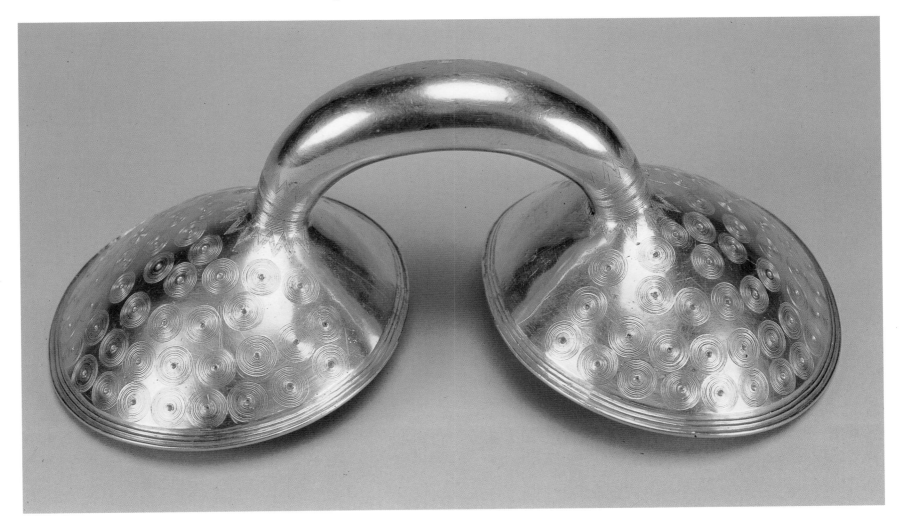

When discovered in a rock cleft at Gleninsheen, County Clare, some seventy years ago, the finder thought that this wonderful gold object was part of an old coffin. Instead, it turned out to be one of the most complete and beautiful examples of what is called a gorget—a neck ornament made around 700 B.C. and unique to Ireland. Continuing the Stone Age love of abstract geometric ornament, the main part of the gorget was hammered into shape on a mold probably of wood, whereas the discs on the terminals would have had their circles and bosses hammered out from behind and were attached to the main body by means of thin gold wire.

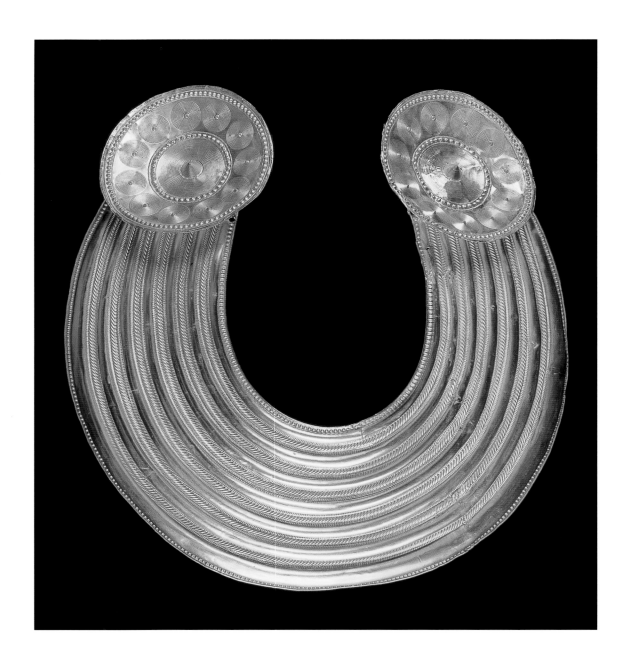

gramophone record. At first sight the grooves seem to be engraved into the metal, but closer inspection reveals that the grooves are the gaps between a myriad of tiny wires cleverly soldered together in a way that a modern jeweler would find difficult to emulate. Then there are the closed boxes or spools that long defied explanation until they were recently identified as spools to ornament the ear, confirming that most of the gold objects from prehistoric Ireland consisted of personal jewelry, which was doubtless the best way to show off one's valuable possessions. These spools are decorated with small bosses or cones in relief, surrounded by a series of concentric circles.

Similar decoration adorns the discs found on the ends of gold gorgets, the best-known of all Late Bronze Age gold objects from Ireland. Like the much earlier lunulae, gold gorgets were neck ornaments made of a comparatively thin sheet of gold decorated with a number of roughly concentric ribs created by hammering the gold sheet onto a mold (probably made of wood). Their similarity to a series of metal half rings of increasing size and extent found in the north Germanic areas of Europe is evidence that Late Bronze Age Irish smiths must have been keeping in touch with the latest developments in northern Europe. The suggestion has also been made that the circular gorget

terminals may owe something to the flower decoration on jewelry of the Phoenicians, who had come westward across the Mediterranean, through the Strait of Gibraltar, and up the Atlantic coast of Europe—at least as far as Cornwall—in search of tin. But trade is always a two-way affair, and it is interesting to note that an Irish spearhead was found in the river Huelva in southwestern Spain, probably part of the cargo of a ship that had sunk around 700 B.C. As the Vikings were to find out over a thousand years later, Ireland lay in a central position along the Atlantic coast of Europe, and it is therefore not surprising that, in a boom period such as the Late Bronze Age, this small island was in contact with parts of Europe far to the north and far to the south along the Atlantic littoral. We forget all too often just how far people voyaged in those days, probably in primitive craft, encouraging trade, but also spreading ideas of mutual benefit.

The same widespread connections can be seen in the various bronze vessels crafted toward the end of the Bronze Age. One of these was the cauldron, which was made up of rectangular sheets of bronze riveted together to provide a container of considerable capacity that could have been brought into great feasts on the shoulders of two carriers. Later mythology was to speak of cauldrons that would never run dry, and perhaps these Late Bronze Age

BELOW: *Gorgets are gold collar ornaments found mainly in the South of Ireland, and particularly in the area on both sides of the lower Shannon river. This one comes from Ardcrony in County Tipperary and is similar to that from Gleninsheen, illustrated opposite, both of them preserved in the National Museum in Dublin. One interesting difference between the two, however, is the lack of the upper part of one of the terminal discs on this example, allowing us an insight into the decoration of the lower part and how it was stitched on with gold wire to the main part of the collar.*

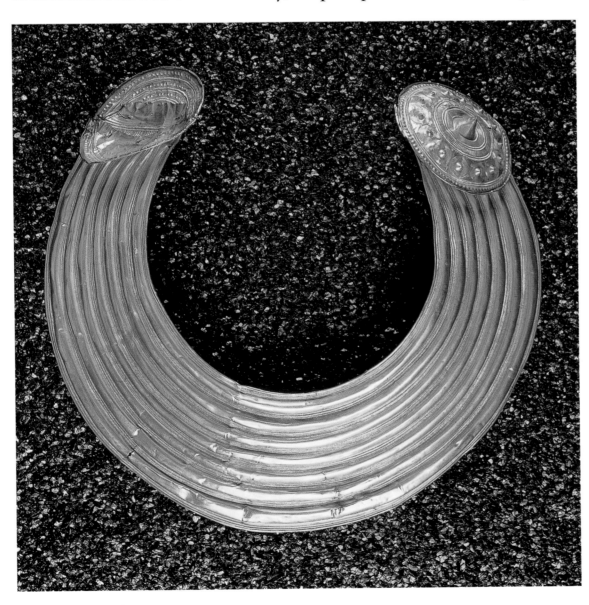

objects acted as inspiration for such tales. One such cauldron was found near Santander on the Cantabrian coast of Spain and it, together with the Irish examples, may ultimately harken back to specimens from eastern Turkey that could have been traded—and copied—westward across the Mediterranean and then up the Atlantic coast of Europe.

Further exotic bronze objects are the trumpets, end- or side-blown, that emit a somewhat deep and mournful tone, and that may be in some way related to the Nordic *lurer* that emerged at about the same time across the North Sea. These Irish horns could well have been sounded on the same ceremonial occasions where the cauldrons were used. A most unusual bucket found in Capecastle Bog in County Antrim, now in the Hunt Museum in Limerick, is decorated with small triangles created by pimple-like dots hammered out from the inside. Parallels for this object stretch across central Europe as far as Hungary, suggesting that Ireland may have been trading not only up and down the Atlantic seaboard, but also along routes leading to central Europe.

ABOVE: Bulla *is a Latin word that describes an amulet or charm against evil, and is used to describe the gold ornaments illustrated here that came from different locations but are all now preserved in the National Museum of Ireland. They are roughly heart-shaped and are filled with either lead or clay, the resulting weight suggesting that they were hung around the neck. The largest, on the left, was found in the Bog of Allen and could be compared to a stylized feline face or a helmet of ancient Greek style with a noseguard coming down between two eyes—which would fit in well with the idea that it protected against injury.*

RIGHT: *A masterpiece of Late Bronze Age metalwork in the Hunt Museum in Limerick is the beaten-bronze bucket discovered in Cape Castle Bog in County Antrim. Its tall shape with short shoulder and neck finds its best parallels in Hungary, and the decoration of repoussé pendant triangles would also suggest inspiration from central Europe, where it was made sometime around 700 B.C. But despite these distant connections, its individual characteristics, such as the wheel-shaped base (not visible in the illustration), suggest that it was entirely of Irish manufacture.*

OPPOSITE: *The large bronze cauldron found at Ballyscullion in County Antrim in 1880, and now preserved in the Hunt Collection in Limerick, is a splendid example of the bronzesmith's craft in the period around 700 B.C. Approximately sixteen inches high and two feet across, it is made up a number of rectangular sheets assembled together with conical-capped rivets. Although the metal used is thinner than in modern cooking vessels, it must have been effective in heating and containing food or drink that would probably have been consumed in the course of some great prehistoric feast. A stick carried on the shoulders of two men would have been passed through the large movable rings on the rim in order to carry the weight of the cauldron when filled.*

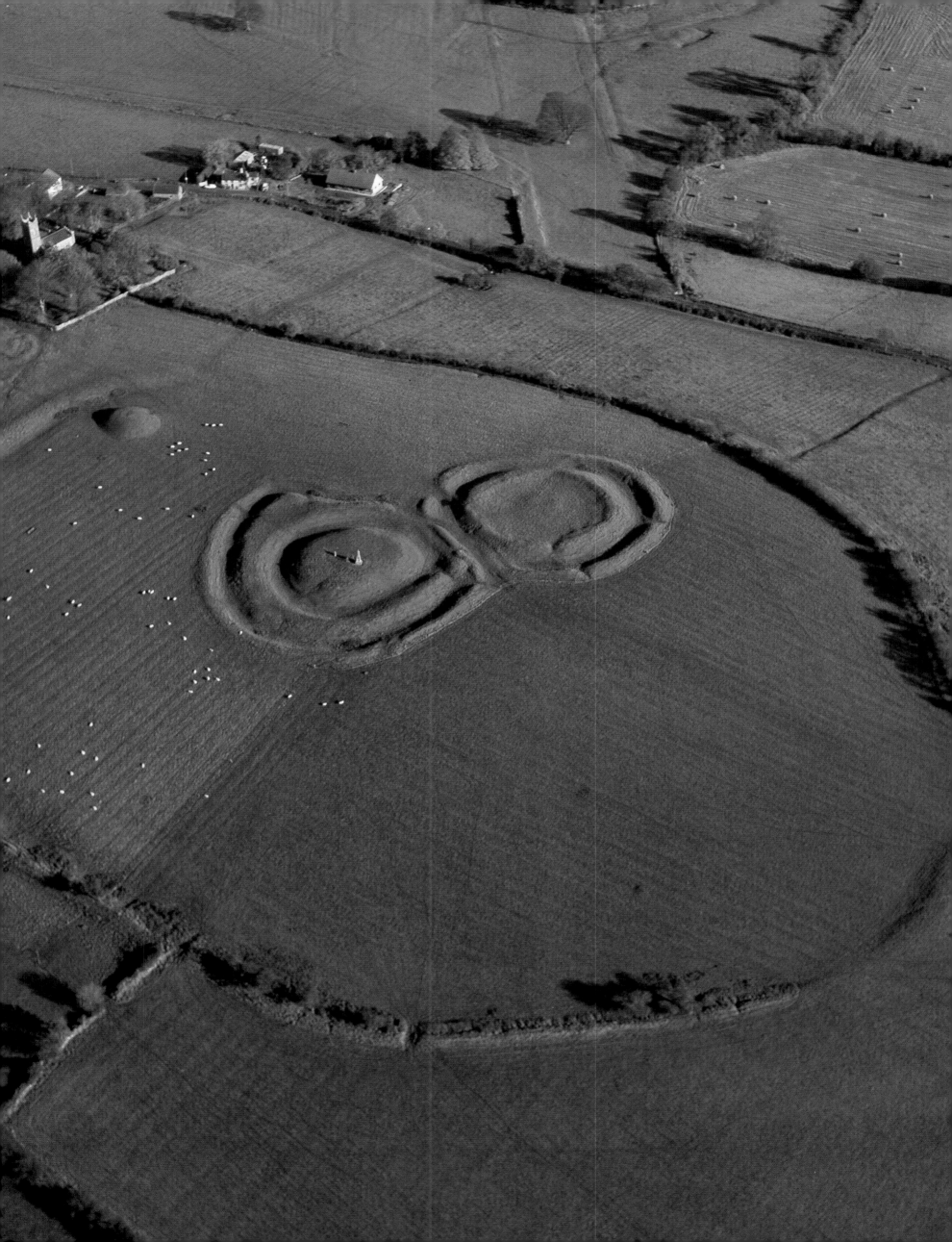

THE COMING OF THE CELTS

The Celts are most likely to have come to Ireland from central Europe. The very thorny question of when they first arrived has given rise to considerable discussion among linguists and archaeologists for generations, without any definitive answer being reached. The name *Celt* is first encountered in the works of the Greek historian Herodotus, who speaks of Celts north of the Alps around 480 B.C. Archaeologically, these people were the bearers of the Hallstatt and burgeoning La Tène cultures, named after the locations in Austria and Switzerland respectively where their remains have been identified. Of these, the Hallstatt people dominate much of the seventh and sixth centuries B.C., after which the La Tène culture emerges, with its very distinctive art, in a wide band stretching across central Europe from Bohemia to the Paris basin and farther east to Hungary. But the archaeological record shows little sign of any major incursion of people into Ireland during these centuries, and there is comparatively little Irish material that can be associated with the Hallstatt culture north of the Alps in the time of Herodotus. So when did speakers of a Celtic language, or a language ancestral to the Gaelic spoken in parts of Ireland today, first arrive in the country? Allowing for the fact that linguistic and archaeological evidence does not create any satisfactory match, estimates have ranged from the beginning of the metal age around or even before 2000 B.C. down to the centuries immediately preceding the arrival of Christianity into Ireland, by which time the country was almost entirely Celtic in its language, laws, and institutions. Best guesses put the arrival of a Celtic language in the centuries around 1000 B.C., but that will have to remain no more than hypothesis until extensive DNA testing may be able to clarify the matter.

What is fairly certain, however, is that the art style of the continental La Tène Celts was being adapted by Irish bronzesmiths during the last few centuries before Christ, though by that time the main material used for implements and weapons was no longer bronze, but iron—a hardier material for work, and for war, which had by then become widespread over many parts of Europe. One of the art style's earliest expressions in Ireland is seen on the domed granite stone at Turoe in County Galway. Topping a simple step pattern,

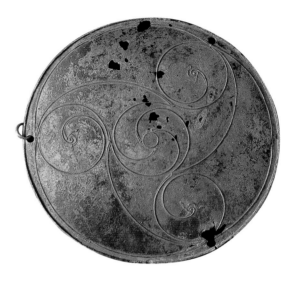

ABOVE: *A bronze disc found in 1939 on Loughan Island in the river Bann, County Derry, bears a beautiful design on a very gently domed surface only about four inches in diameter. From a central spiral, three others uncoil to form slightly looser spirals that end internally with bird heads. More astounding than the remarkable precision of the lines is the method of execution—the painstaking grinding-down of the undecorated surfaces of the metal until the design stands out from it in a uniformly raised relief.*

OPPOSITE: *The Hill of Tara in County Meath must have been one of the most revered sites in all Ireland during the prehistoric period and on into the early centuries of Christianity, and the kingship of Tara was the most coveted prize for aspirants to political power in the early medieval period. Much of the hilltop was delimited by an extensive curving bank of earth, near the center of which are two spectacle-like concentric rings of earth, one traditionally associated with the legendary king Cormac mac Airt. Near the top left of the enclosure is the Mound of the Hostages, a passage grave showing that the site was already hallowed as far back as the Stone Age.*

BELOW: *The Iron Age in Ireland that started in the last five hundred years before Christ brought with it Celtic art, introduced by consummate craftsmen who had seen it practiced in bronze, gold, and stone on the European continent. The Turoe Stone in County Galway, almost reminiscent of the omphalos stone in Greek Delphi, has its domed upper section decorated with swirling Celtic ornament in the Waldalgesheim style of the Middle Rhine of about 300 B.C. and was divided up into four separate quadrants, suggesting that the stone may have had some ritual significance having to do with the four corners of the earth.*

the whole upper part of the stone is taken up with swirling, never-ending curving motifs ebbing and flowing across the surface in a manner reminiscent of the so-called Waldalgesheim style practiced by La Tène craftsmen in the Middle Rhine area during the fourth and part of the third century B.C. This was a style that, in itself, was an adaptation of a Greek type of vegetal ornament that was brought northward across the Alps on metal and ceramics. Expert examination of the Turoe Stone has revealed that the whole design can be divided into four separate parts, suggesting that the layout of the ornament was conceived for a four-sided, or even pyramidal, object, possibly made of wood. The subdivision into four parts doubtless had a symbolic meaning, now lost to us, but perhaps related to the old notion of the four corners of the earth, making it into some kind of cosmic symbol. Speculation is at all times to be encouraged, but a satisfactory explanation will, in the end, be difficult if no meaningful parallel can be found, though Brittany, in northwestern France, has so far produced the closest counterparts.

There are, however, other stones from various parts of Ireland that bear La Tène ornament of one sort or another and that may be dated with a fair degree of certainty within the two or three centuries on either side of the birth of Christ.

One of these is a rounded stone at Castlestrange, County Roscommon, smaller, squatter, and more ovular than the Turoe Stone, with curves and triskele patterns spread freehand across the surface without the same organization of design displayed on the Turoe. Spindly spirals dominate the domed surface of a stone formerly at Killycluggin, County Cavan, and now in the National Museum of Ireland in Dublin, and less-tightly wound spirals orchestrate the design on a stone found built into a church wall at Derrykeighan in County Antrim. This last has stylistic affinities to decorated bone plaques produced in a workshop operating in a much older Stone Age passage grave at Loughcrew, County Meath. These enigmatic carved stones are certainly testimony to the vitality of the Irish adaptation of continental La Tène patterns.

A further potential Breton link appears in connection with one of the most remarkable Iron Age finds—the Broighter hoard, discovered over a hundred years ago near the shore of Lough Foyle in County Derry. One of the hoard's most important components—a golden boat—suggests that the hoard's function may have been votive, related to the Celtic sea god Manannán Mac Lir. This tiny masterpiece is only about four inches long, with eight surviving

ABOVE: *The Castlestrange stone, which gets its name from the eighteenth-century estate in County Roscommon where it is situated, is certainly mysterious—covered as it is with swirling curvilinear designs typical of the art of the prehistoric Celts—and it continues to show the Irish craftsmen's love of geometric ornament already well developed in the Stone Age. The motifs on the stone must have had some kind of ritual and religious significance for those who gazed upon its patterns when they were first carved sometime during the last few centuries before Christ, but their meaning is now sadly lost to us, as is also the knowledge of what purpose this granite boulder, looking like a giant egg that had welled up from the earth below, originally served when it was first created.*

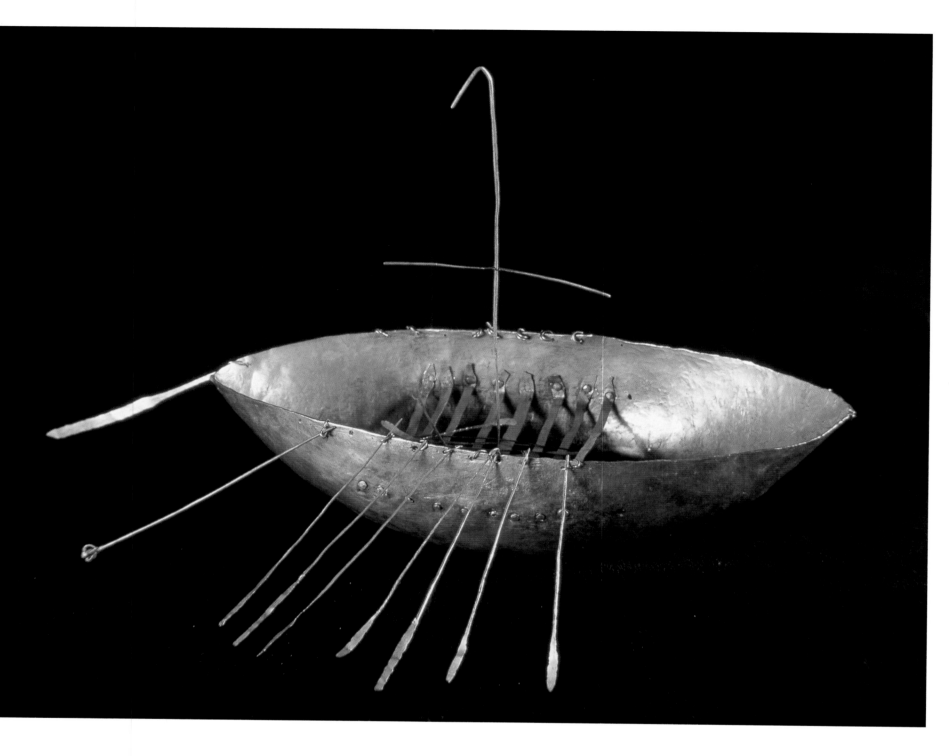

ABOVE: *The most fascinating component of a hoard of gold objects found at Broighter in County Derry over a hundred years ago is a miniature boat originally with eight seats, eighteen oars, a rudder, and a mast—the first evidence we have for the use of sail in Irish waters. It was probably based on a vessel up to forty feet long that would have been made of wood or wicker and animal hides and was capable of sailing the ocean waves, perhaps as far as Brittany in northwestern France, where Julius Caesar encountered tribesmen who were masters of the use of sail.*

seats and probably eighteen oars originally. But this was no mere rowing boat; it was supplied with a mast and a yardarm, thus making it probably the earliest known representation of a sailing boat in either Britain or Ireland. The only other people of the first century B.C. who are known to have had sailing boats in northwestern Europe are the Veneti, a Celtic tribe who were defeated on sea off the Breton coast by no less an adversary than Julius Caesar. While the Broighter boat might, therefore, suggest links with Brittany, the hoard itself is unlikely to be anything but Irish, as the gold from which the boat was made had a platinum content similar to that of the few Irish gold objects surviving from the prehistoric Iron Age.

Prime among these is a superbly crafted torc or neck ring, also from the Broighter hoard, of a type that might have been used by a Celtic warrior going into battle. We can assume this was common practice from the statue in the Capitoline Museum in Rome of the Dying Gaul, a Celt who wears a torc and

nothing else as he sinks mortally wounded to the ground. The Broighter torc is one of a small number of elite so-called buffer torcs with a distinct closing mechanism that are thinly distributed over a wide area of Europe stretching as far as Italy, all of which are likely to have been deposited in the ground during the last century B.C. The hollow body of the torc is decorated with raised decoration of the La Tène style consisting of spirals in relief like a snail shell and forming part of a fluidly flowing design of curvilinear ornaments often terminating in trumpet ends, all placed in a cross-hatched setting. Its irregular rhythm is the very essence of the asymmetry of La Tène art and surely makes the torc the masterpiece of Irish Iron Age jewelry in the style. But not far behind come the two gold-wire necklaces, which, however, may be of Roman-Mediterranean origin. There are also two twisted bar torcs from the same hoard whose origins have not yet been satisfactorily established, but probably Irish is the deep gold bowl that accompanied the other items in the Broighter find. The gold-wire necklaces show that Iron Age Ireland was in contact with the European continent at just about the same time that Julius Caesar was extending his empire there and even crossing the channel to England.

BELOW: *Arguably the finest achievement of Celtic goldsmiths in prehistoric Ireland was the gold collar found along with the miniature boat at Broighter in County Derry in 1896 and dating from a century or two before the time of Christ. Its ring is delicately ornamented with Celtic spirals, some reaching such high relief that they resemble snails crawling along in formation. The collar was closed by a complicated mechanism of a kind developed and widespread on the European continent. We know that such neck rings, or torcs as they are called, may have been the only body covering worn by Celtic warriors going into battle, so we could imagine the Broighter torc having been shown off proudly by its Irish owner as he went headlong into combat.*

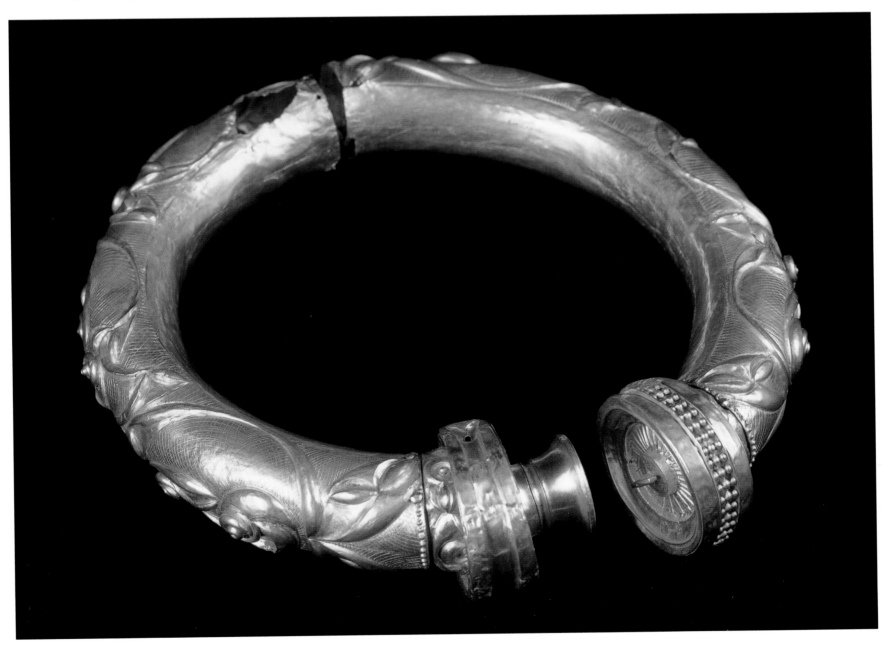

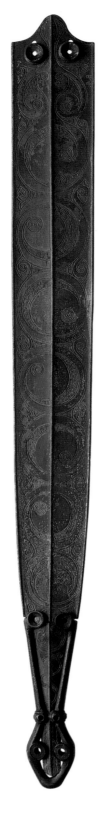

Irish contact with Gaul—basically modern-day France—had also been active two centuries before Caesar's occupation, as is shown by a fine gold torc of French origin dating from around the fourth or third century B.C. that came to light at Clonmacnois, the very center of Ireland. Eastern France may have influenced the development of more war-like equipment such as swords and, in particular, the sword scabbards that came to light in northeastern Ireland, most notably at Lisnacrogher, County Antrim. These bronze sword-covers or sheaths are engraved with a considerable variety of ornament in the La Tène style, dominated by S motifs and curves curling up into spirals, sometimes with hatched or cross-hatched background. Precisely how these County Antrim

BELOW: *The "Petrie Crown" is an enigmatic bronze object that gets its modern name from the nineteenth-century antiquary George Petrie in whose collection it once was, and who is widely regarded as the father or Irish archaeology. Probably made sometime during the first few centuries of the Christian era, it consists of two noteworthy discs attached to an openwork frieze, a hollow conical horn rising out of one of them. Could this have been part of a headdress, or was it designed to hang like a chandelier, or to add lustre to a chariot or throne? Its silence will long keep us guessing. While doing so, we must wonder at the intricate decoration, more symmetrical than in earlier Celtic art, using bird heads at the end of the discs' spirals. This ornament was executed with superb exactitude by filing away the background surface so as to leave the sinuous patterns standing out in relief, their shadows allowing us to appreciate the interplay of positive and negative in its overall design.*

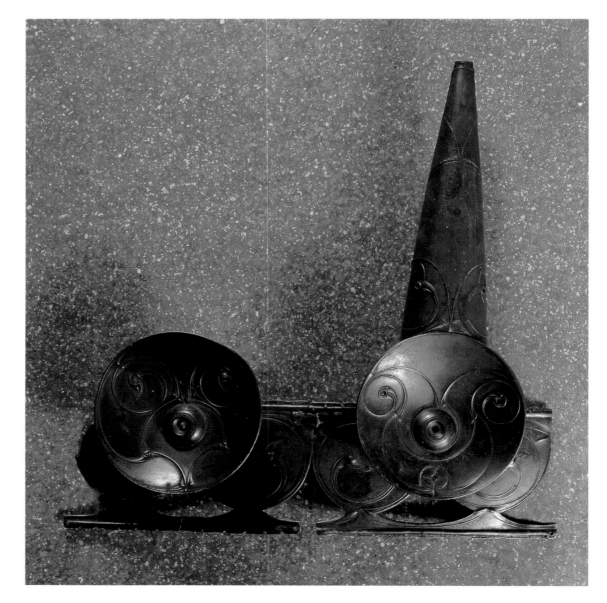

ABOVE: *The Celts were nothing if not war-like, and the "Fighting Irish" of the Iron Age have left us attractive remains of their vainglorious attitude toward combat in the highly decorative scabbards that sheathed their swords. Most came from the northeast of Ireland, including this one from Lisnacrogher, County Antrim, that is now preserved in the Ulster Museum in Belfast. Like much of the art of prehistoric Celtic Ireland, its graceful curves and spiraling movement show local inventiveness in designs that can ultimately be traced back to continental European forebears.*

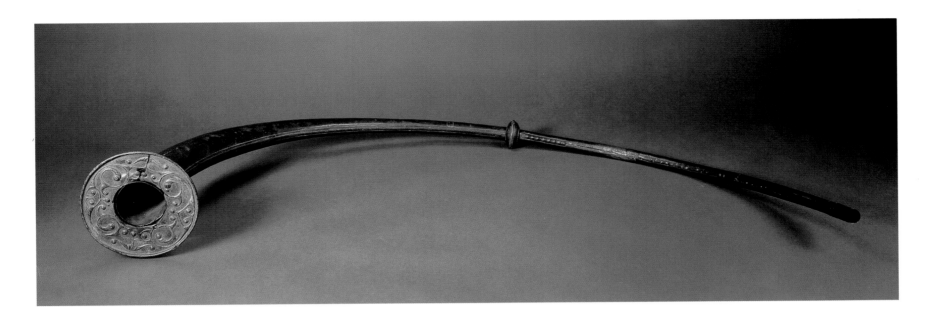

scabbard sheaths came to be influenced by continental examples—directly or via England—is as yet unknown, but their existence does show that craftsmen active in northern Ireland during the last few pre-Christian centuries knew what was going on in workshops west of the Rhine.

Though only a small number of decorated pieces have been found that represent a period lasting many hundreds of years, it is likely that the La Tène art found on the scabbards in the last few centuries B.C. continues on in varied forms, and on objects of differing kinds, in the centuries after the birth of Christ. But the style and the techniques changed somewhat. A bronze disc from Loughan Island in County Derry has more delicate, refined, but also more symmetrical spirals ending in a very stylized bird head, all standing out in relief, apparently created by the laborious method of scraping away the surrounding areas until the main motifs stood out sufficiently from their background. The same technique is used in the Petrie Crown, an enigmatic object of unknown purpose consisting of a metal frieze (originally applied to another—wooden?—surface) with an attached disc, above which rise horns decorated in the La Tène style, the whole possibly suspended from the ceiling (of a temple rather than a church, perhaps), similar to the crown from Guarazzar in Spain, which is, however, Christian rather than pagan. The discs have two spirals with bird-head terminations, which, within the subtle composition, curiously resemble eyes. The whole gives the impression of a highly stylized face in the tradition of, but totally unconnected to, the stylized faces of passage grave art, as at Fourknocks. Here, the features are in relief and the stylization shares the imaginative approach of Celtic art on the Continent. The same applies to the bronze discs, such as that from Monasterevan, County Kildare, which were probably used for ritual purposes. Here, one cannot avoid the impression that the Celtic craftsmen are trying to make us look at a human face in a very different way—artistic but not distorted. The craftsmen want us to use our imaginations, and not to see things naturalistically, as was true of their Greek and Roman counterparts. Curiously, the use of the La Tène

ABOVE AND BELOW: *The six-foot-long trumpet found at Loughnashade, County Armagh, may have been part of a votive deposit along with three other lost examples, because its find-spot is very close to Navan Fort* (Eamhain Macha), *the prehistoric cult and power center of the Ulstermen that is associated with King Conor mac Nessa and the hero CúChulainn. We could imagine the trumpet being blown ceremonially at regal banquets in the presence of Conor's renowned Red Branch Knights, and its bronze ring at the mouth with symmetrical scroll ornament in relief suggests a date for it around the first century before Christ.*

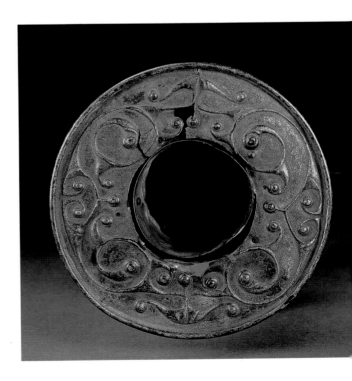

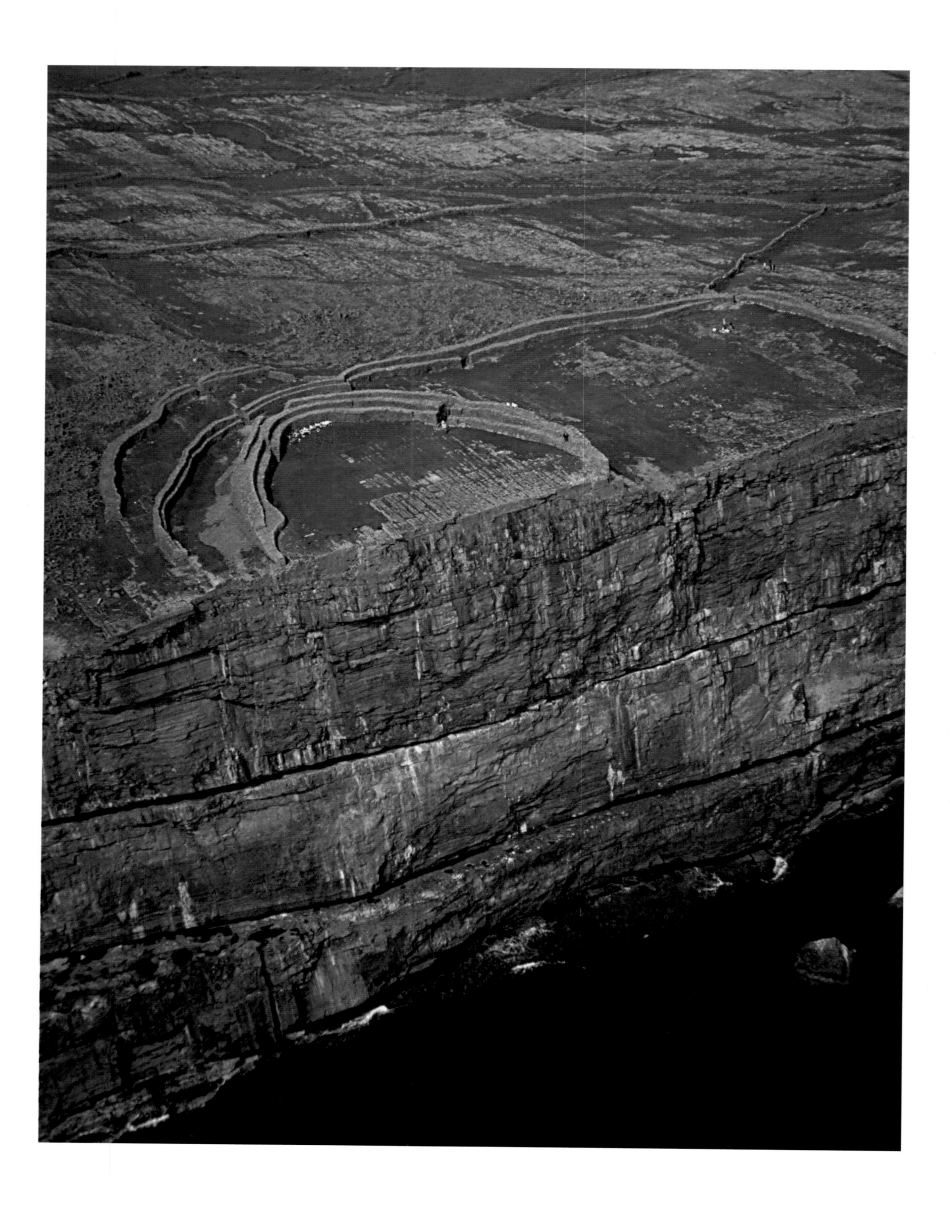

BELOW: *Staigue Fort on the Right of Kerry was built in a beautiful secluded valley that looks out toward Kenmare Bay and the end of the Durrus Peninsula beyond. Its circular stonework was built without mortar probably within a few centuries of the birth of Christ, and its sloping walls and internal stairs leading to the parapet resemble such features found in other great stone forts such as Dún Aengus and the Grianán of Aileach.*

OPPOSITE: *The most dramatically sited of Ireland's ancient monuments is the fort of Dún Aengus, a half circle perched so perilously on the edge of a cliff that drops three hundred feet sheer to the Atlantic Ocean below on the Aran Island of Inishmore that the question has been posed as to whether the other half had fallen into the sea since it was built over two thousand years ago. However, the likelihood is that the builders used the cliffs as a natural defense to avoid having to complete the circle, and its location exposed to Atlantic gales probably meant that it was used only in times of danger or on ceremonial occasions, scarcely as a permanent habitation. The aerial view shows half-completed walls and changes of plan, as well as stones stuck in the ground outside the innermost wall to stave off attack from the landward side. Like other lesser forts on the same Aran group of islands, Dún Aengus is called after one of a number of mythical overlords who came to settle on these western islands in Galway Bay after they had allegedly been thrown out of the eastern county of Meath for not having paid their taxes.*

art style in Ireland is largely confined to the northern half of Ireland—which is strange, because the people of the southern half of the country were scarcely less Celtic-speaking than their northern counterparts when the historic period dawned with the coming of Christianity around A.D. 400.

When we start searching for stone structures of the Iron Age in Ireland, north and south, we run into difficulties. The most striking of all monuments that have been ascribed to this period is the great fort of Dún Aengus on the Aran island of Inis Mór. A daunting group of irregularly concentric walls, one outside the other, are protected by *chevaux-de-frise*, crude stone stakes stuck upright in the ground to prevent oncoming enemies from gaining easy access. A small fibula found in its wall in the nineteenth century is of the La Tène type, but recent excavations in the interior show evidence of use dating from the Bronze Age, though this does not necessarily indicate the date of construction, which could well be later. Other fortifications on the Aran Islands, also bearing the names of alleged mythological invaders, are equally difficult to date, as are some of their major round counterparts on the mainland, such as Staigue Fort in Kerry or the Grianán of Aileach in Donegal. The latter, with a superb view over Loughs Foyle and Swilly, at least has associations with one of the branches of the royal dynasty of the Uí Néill in the northwest of Ireland, suggesting that such stone forts could just as easily be of

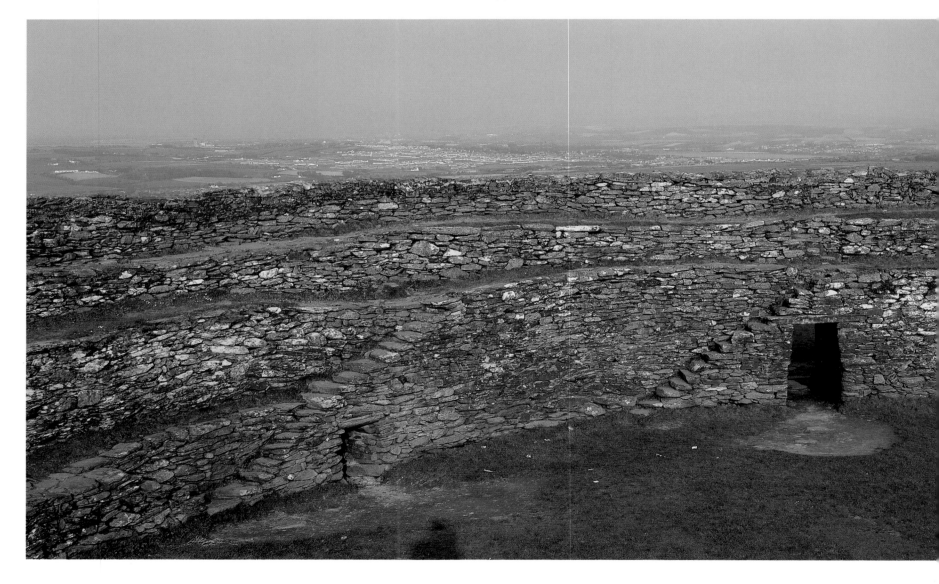

the Christian as of the pagan era. But all are certainly imposing, Dún Aengus being a splendidly barbaric monument marking the western boundary of Europe, a place where one group of people could fortify themselves against another coming from land or sea, but where, if they themselves were coming westward from the mainland (as ancient lore implies they did), they could settle—simply because they could go no farther west. Earthwork fortifications are equally difficult to date. The many promontory forts along the coast of Ireland could, like those used by the Veneti in Brittany, date from the Iron Age, but could just as well be later—and the same problem arises with the ring forts and the man-made islands known as crannogs, where it is often difficult to establish, even with the help of excavation, whether a particular site is pagan or Christian in date.

Some of the imposing hill forts, with one or more banks and ditches fortifying a summit, appear to have been started during the Bronze Age, but it is a type of earthwork that also continues to be used, and probably even continues to be built, down to the very threshold of the transition from the prehistoric to the Christian Iron Age. While the Iron Age way of life continued little changed over centuries, except for improvements in agriculture and the way corn was ground, changes were taking place outside Ireland that were, indirectly, going to have a significant impact on Ireland. These can be summed

BELOW: *The Grianán might be described as the peak of perfection because this great stone fort, with neatly rebuilt walls, crowns a hilltop that offers wide views over Loughs Foyle and Swilly and panoramas of its own county of Donegal and neighboring Derry. Its name Grianán indicates a place up near the sun, and Aileach was that part of the territory of the ancient kingly dynasty of Uí Néill that it dominated. Its lofty defensive location and the steps that would have facilitated soldiers reaching the internal parapets suggest that it was used as a fortification—probably throughout many centuries. We know that it was destroyed by a southern branch of the dynasty in 676 and, in the year 1101, the O'Brien king of Munster destroyed it again in an act of vengeance, each of his soldiers reputedly ordered to carry away a stone from it. That would perhaps explain why the walls were only six feet high before they were "restored" around 1879 to their present height of seventeen feet.*

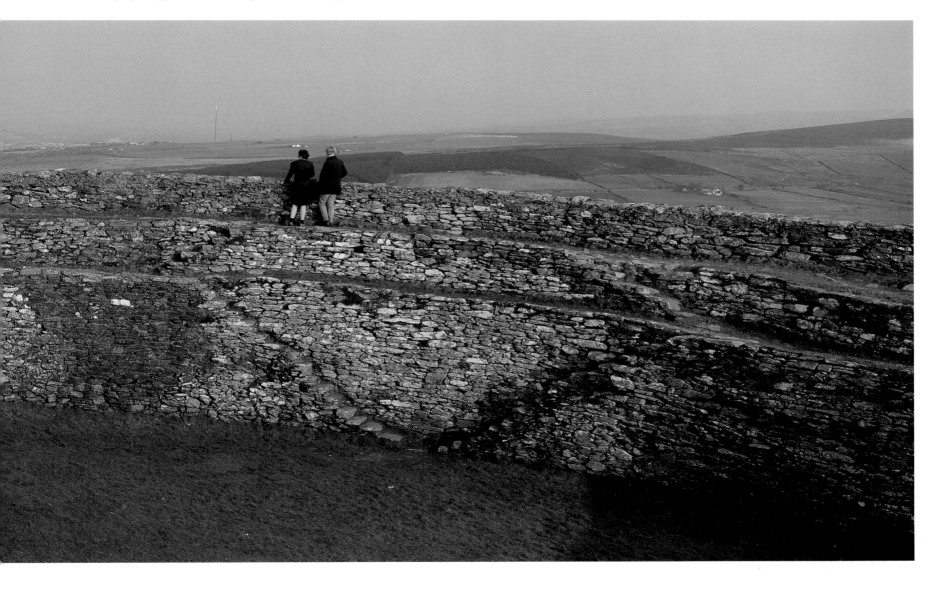

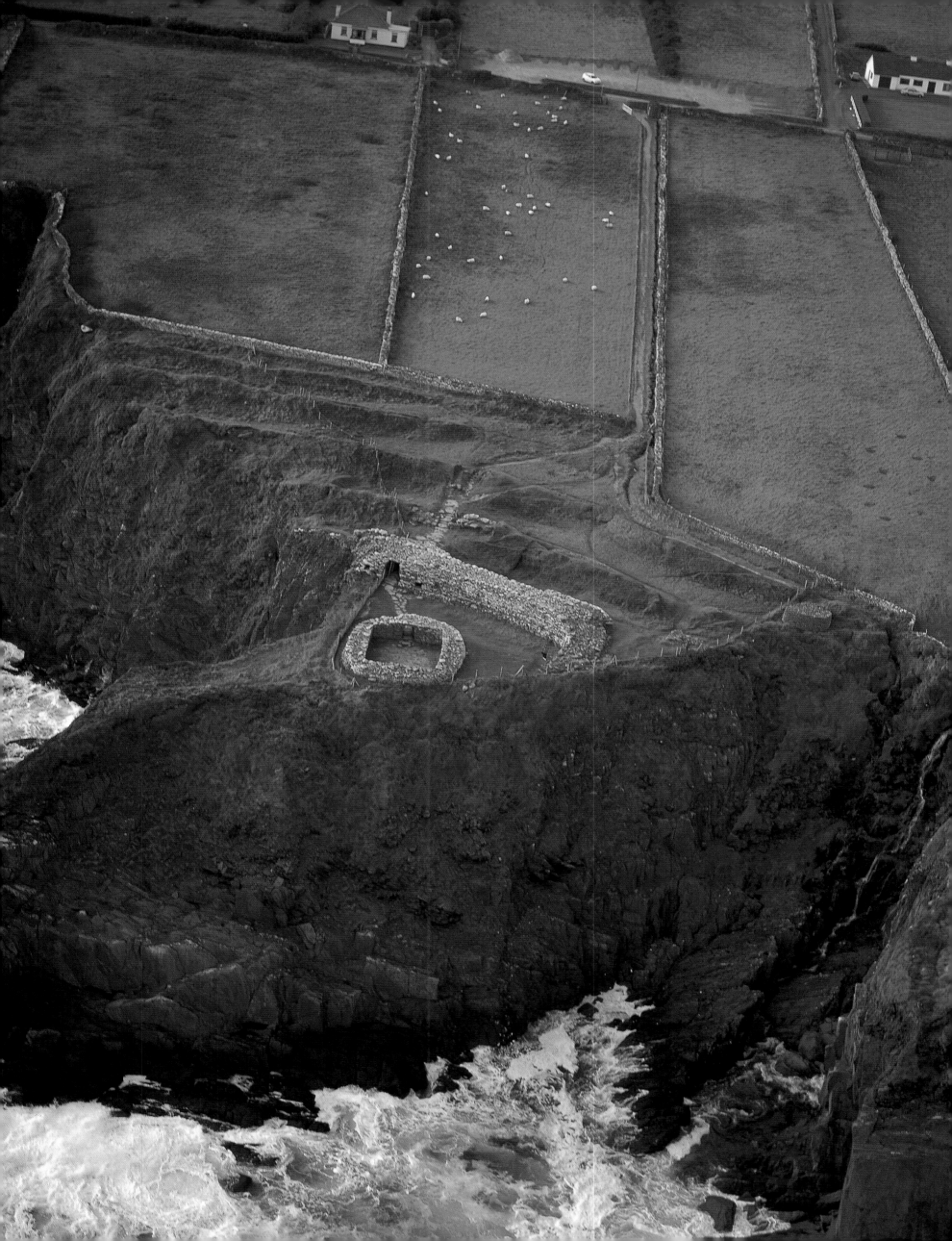

up in a single word—Romans. The power of Rome was expanding north of the Alps during the first century before Christ, and the Celtic world was so shattered by the defeat of so many Gaulish tribes at the hands of Julius Caesar in mid-century that their continental Celtic language and way of life were gradually subsumed into a Roman culture that became standardized over much of central and southern Europe. Human interaction and trade that had doubtless taken place between Ireland and Celtic Gaul were frustrated, if not downright terminated, and certainly not encouraged by the new Roman authorities. To make matters worse, the Romans began to conquer large parts of the neighboring island of Britain during the first century A.D., taking over and Romanizing much of the country except for parts of the Pictish territories in what is now Scotland. The effect of this spread of Roman influence was that Ireland, normally kept stimulated in various ways by contact beyond its shores, essentially turned in on itself and went to sleep—the Latin name for Ireland, "Hibernia," was spiritually not too far away from the word *hibernate*.

But to say that is to paint an unfair picture since seafarers must have kept Ireland abreast of what was going on in the world of Roman Britain. One of the empire's commanders, Agricola, nonchalantly tossed off to his son-in-law, Tacitus, the remark that Ireland could be conquered by a Roman legion and a few auxiliaries. Why he did not try to do so we shall never know, but he must have had some knowledge about the true geographical extent of his task. Furthermore, it must have been experienced sailors of the second century A.D. who supplied place and river names to Ptolemy of Alexandria, whose maps of the ancient world were to influence so many later generations that even Christopher Columbus consulted his *Geography*. The presence of graves with Roman-style artifacts on Lambay Island north of Dublin suggests links to and possibly even the presence of Romanized British immigrants at around the same period, and there are good grounds for thinking that some of its inhabitants made a good living as mercenaries in the Roman army serving in far-flung outposts of the Roman Empire.

But all things must come to an end and, inevitably, the Roman empire declined. Its weakness in Roman Britain in the period around A.D. 400 gave Irish pirates the opportunity to raid Britain and doubtless loot silver, some of which has turned up, literally hacked to bits, in hoards hidden in Irish soil. But it is at a very human level that we come face to face with those marauders in the form of St. Patrick's autobiography, the *Confessio*, in which he tells us that pirates forcibly removed him from his parents' comfortable villa somewhere not far from the western coast of Britain and brought him westward across the sea to Ireland, to be sold as a slave. Precisely when this happened has never been established, but it may have been shortly after the last Roman legionaries had been evacuated from Britain in 410 to protect the core of the collapsing empire nearer to home in Rome.

ABOVE AND OPPOSITE: *Peninsulas offered attractive possibilities as fortifications because the steep drops on all but one side reduced the number of walls that needed to be built. This was certainly the case with the small peninsula of Dunbeg jutting out into Dingle Bay in County Kerry, where the landward side only was defended by four earthen banks and an innermost stone wall protecting a single stone hut inside. While such promontory forts first began to be built in Ireland during prehistoric times, radiocarbon dates obtained during excavation of Dunbeg indicate that this particular example was, at least, occupied—if not first built—in the centuries around the end of the first Christian millennium. The date for the stone hut, or clochán (above), was even later, and it remains an open question as to whether it was roofed with stone or some more ephemeral material such as thatch.*

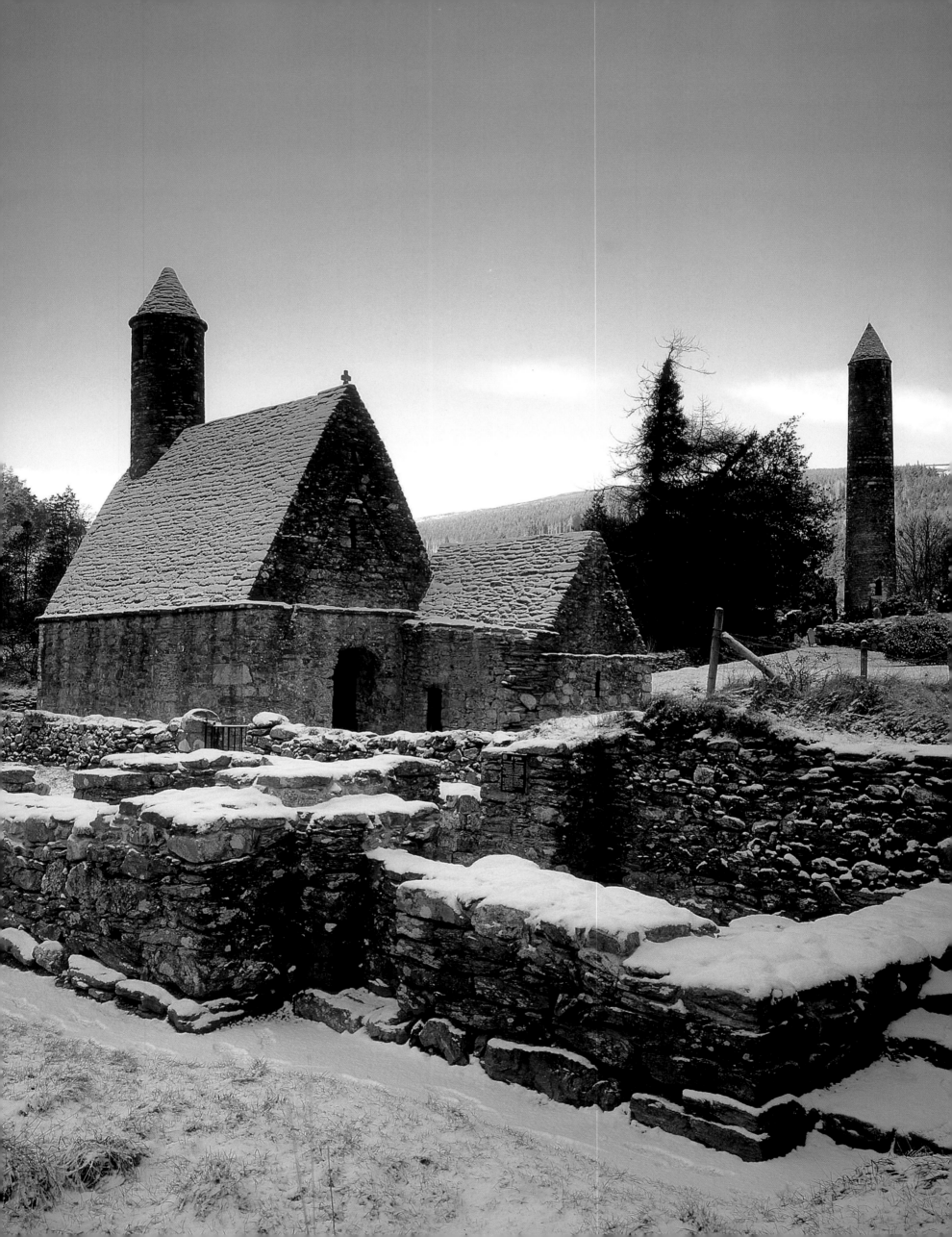

THE FLOWERING OF MONASTIC IRELAND

There must have been civilized contact between the islands of Britain and Ireland before the degrading departure of Roman forces southward across the English Channel. This we can surmise from what is the first snippet of historical information concerning Christianity in Ireland, as written by the French chronicler Prosper of Aquitaine in the fifth century. He tells us that in the year 431 Pope Celestine sent a man named Palladius to serve as bishop to the Irish believing in Christ. It was probably the first time in history that the papacy had agreed to send a bishop to people outside the bounds of the Roman Empire. The second part of Prosper's remark suggests that by 431 there must have been a sufficient number of Christians in Ireland to warrant the sending of a bishop to provide them with pastoral care, and that gradual Christianization must surely have been happening already in the late fourth century.

Even earlier, members of the Desi tribe in what is now Waterford probably had been settling in parts of western Britain—Wales and Cornwall—developing the first known Irish script, which they may have been responsible for introducing into Ireland. Known as Ogham, it is a system of writing consisting of one to five notches on either side of, on, or across a central line to give a total of nineteen letters (and one dipthong). Shy of some of the twenty-six letters that we use today, Ogham suited the Irish language well. The vowels AOUEI formed a category of their own, and another set of five letters seems to have been based on the first letters of the Irish-language version of the numbers one to five—HDTCQ. It does seem that Ogham could not have come into existence without knowledge of the Roman alphabet, and it is probably through those Irish who had settled in Britain that the idea of the script was passed back to develop in Ireland—at first on wood (as recorded in an old Irish epic) and later in stone, of which there are some hundreds of examples. Ogham writing survives almost exclusively on upright stones, one sharper edge of which acts as the central line for the inscription. After fifteen hundred years, Ogham inscriptions are not always easy to read. Ogham stones are not gravestones, but are nevertheless memorial inscriptions commemorating certain named individuals and often giving their relationship to other family members or

ABOVE: *The only medieval remnant of the famous old Irish monastery of Clonard that cradled so many of the early Irish saints is a charming baptismal font of c. 1500 now in the Catholic church in the village and showing, among others, carvings of a bishop or abbot and a book-holding angel.*

OPPOSITE: *The unusual church of St. Kevin's in the monastery he founded at Glendalough, deep in the Wicklow Hills sometime in the sixth or seventh century, combines two features characteristic of early Christian building in the country—the use of a stone roof and, emerging from it, a round tower added as a campanile or bell tower, an imitation of the full-height and well-preserved example in the background. The equally stone-roofed sacristy was also a later addition. The church was erected in the twelfth century and is known locally as "St. Kevin's Kitchen" because of the resemblance of the tower to a kitchen chimney. In the foreground of this snow scene are the ruins of another early church, dedicated to St. Ciarán, the founder of another great monastery at Clonmacnois on the Shannon.*

The earliest writing in the Irish language probably originated before the time of St. Patrick. It was written in Ogham script, which had a nineteen-letter alphabet consisting of up to five strokes or notches on, across, or on one or the other side of a central line that was usually the vertical corner of a standing stone, as on this example from Derrynane, County Kerry. Not always easy to decipher, the Ogham stones seem to be commemorative in character.

OPPOSITE: *Most of what we know about Ireland's national apostle, Saint Patrick, has been transmitted to us through the* Book of Armagh, *a manuscript now preserved in the Library of Trinity College, Dublin. Written in a clear hand by the scribe Ferdomnach at the bidding of Torbach, who was abbot of Armagh from 807 to 808, this is the only reliably dated old Irish manuscript. Its page 22 contains the beginning of the saint's* Confessio, *starting one-third of the way down the left-hand column with the words* Ego Patricius peccator — *"I, Patrick, a sinner."*

ancestors—none of whom has ever been satisfactorily correlated with historically identifiable persons. By about the seventh century, the Christian symbol of the cross was sometimes carved on Ogham stones.

Christianity was certainly one of the Roman Empire's greatest legacies to Ireland, and where Rome never succeeded in vanquishing the country by the sword, it did conquer Ireland symbolically through writing, not just in the Ogham script, but also through its transmission of the Latin language in its own alphabet. We can only presume that any religious texts St. Patrick would have brought with him in manuscript form would have been in Latin, the language in which he wrote his *Confessio*, or apologia for his own life. This is a book that shows him as a simple and humble man, having complete confidence in God, to whom he would have prayed daily. He tells us more of his early years than he does about his missionary activity in Ireland, which would have taken up the whole second half of his life. His cult was espoused by Armagh in the eighth and ninth centuries, and it is the *Book of Armagh* in the Library of Trinity College, Dublin, which provides us with most of the early material on his activities. Written two centuries after Patrick's death, his *Life* by Tirechán

The most dramatic of old Ireland's monastic sites, Skellig Michael is perched more than 500 feet above the Atlantic waves some eight miles off the southwest coast of Kerry. It stands on a terrace supporting a number of beehive huts built without mortar over a thousand years ago. These, and two small oratories built in a similar fashion, would also have served pilgrims who would have come to pray and stay on the island. For Kenneth Clarke, the historian of civilization, western Christianity survived for almost a hundred years by clinging to precipitous places like Skellig Michael.

and notes by Muirchú obviously had to rely heavily on a two-hundred-year-old oral tradition that had been preserved locally. This information was, however, duly embellished in order to boost Armagh's perceived right to various churches which it claims he founded. It was Armagh, too, that made St. Patrick the national apostle, who, with the assistance of only a few acolytes, was credited with converting Ireland from paganism to Christianity.

The reality was probably somewhat different, in that paganism undoubtedly survived, particularly in outlying areas, for some centuries after St. Patrick's death. We know that a pagan feast was revitalized at Tara by a High King in 560—almost exactly a century after the usually accepted date of death of St. Patrick (461), though some current opinion is beginning to favor the year 493, which is also given as the date of death of a Patrick in the *Annals of Ulster*. Armagh's efforts to boost the cult of Patrick may have been at the expense of his predecessor, Palladius, the man mentioned by Prosper of Aquitaine, on whose pioneering work Patrick would presumably have built. Their geographical spheres of operation may well have been different, Patrick more in the north and west, and Palladius more in the east and southeast. After the initial years of evangelization, it was Patrick who undertook the main task of organizing his

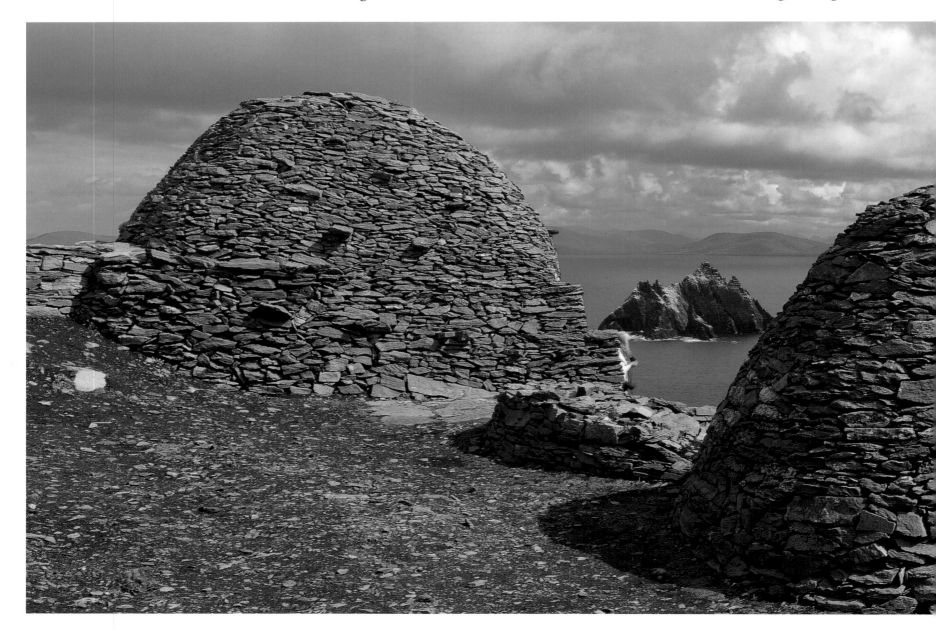

church into an institution, which he seems to have done by setting up a number of bishops, following the system he would have known in his homeland. But, in Britain, bishoprics had the populations of urban centers to support them. In contrast, Ireland, not having belonged to the Pax Romana, did not enjoy the advantage of towns for some centuries to come, and it seems that the early bishoprics became ineffective shortly after Patrick's death, like the seed in the Gospels that choked when it fell among thorns. Patrick did mention that some of his converts became monks and nuns, but we have little indication that monasteries or convents flourished in Ireland during his lifetime. Monasticism was becoming popular elsewhere in his day, however, spreading from the eastern Mediterranean through the island of Lérins off the south coast of France and then northward to Britain, where, from centers such as St. David's in Wales and Candida Casa (or Whithorn) in Scotland, it finally came to Ireland. St. Enda is traditionally supposed to have set up the first such monastery on the Aran Islands around 493, but strong historical evidence for this is lacking.

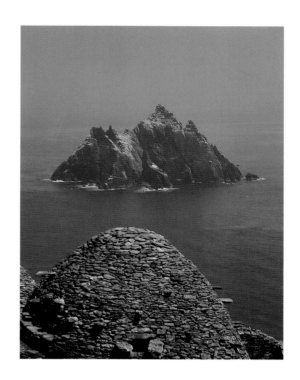

It is much more likely that it was not until around 540 that monasticism really sprang to life in Ireland, perhaps encouraged by the flight away from the Justinian "plague" of the period, but certainly helped by the need to fill the

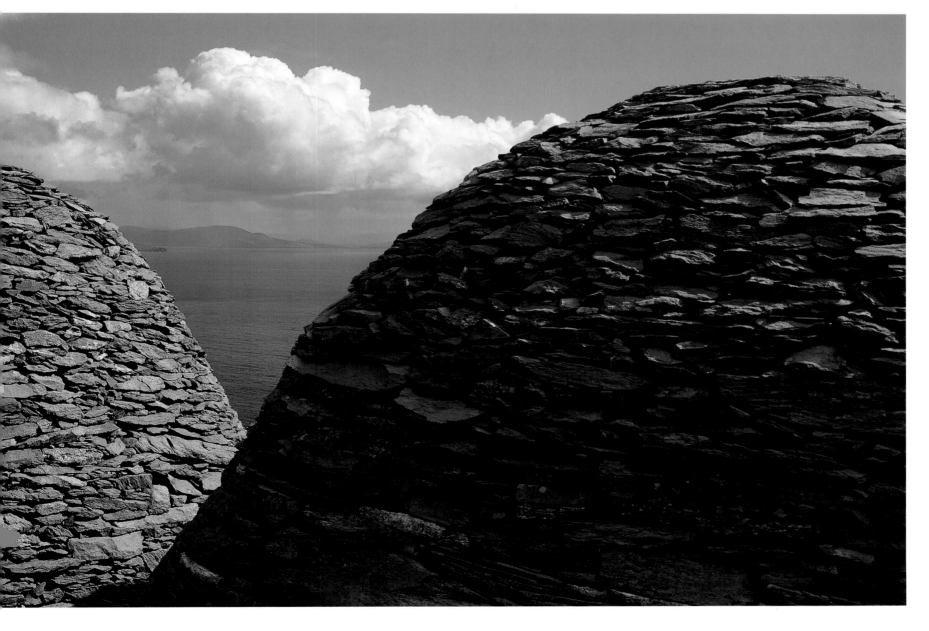

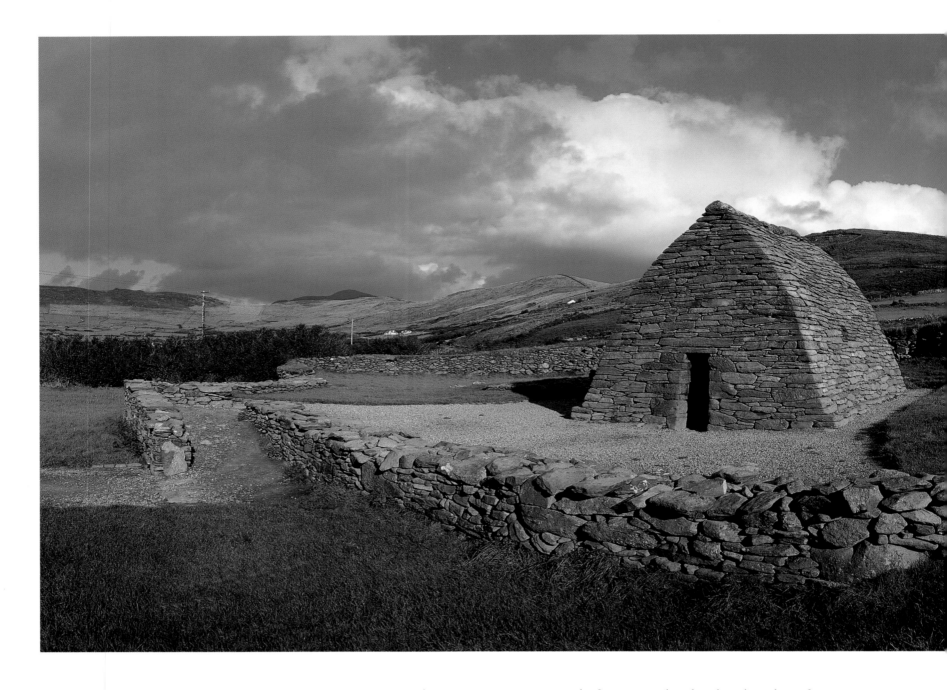

apparent religious vacuum created after Patrick's death. The idea of monasticism seems to have struck a spiritual chord among the Irish, whatever the reason for it may have been, though it may also have satisfied more social needs, such as what to do with children who were not going to become workers on the family land. Certainly, the ascetic lifestyle as practiced by the monks, if we are to believe the literary sources, was extremely harsh; the Irish penitentials ordered what seem to us to be very harsh punishments for the most minor peccadilloes—and the Irish were probably the first to introduce confession into Christian religious practice.

Clonard in County Meath was one of the first great monasteries in Ireland, founded in the early decades of the sixth century by St. Finnian, a man who must have had great charisma to attract so many of those who, themselves, were going to become the influential monastic founders of the next generation. Usually numbered as twelve, these important leaders are appropriately titled "the twelve apostles of Ireland." One of Finnian's pupils was Ciarán, who died at a comparatively young age in the 540s, but not before he founded Clonmacnois at the crossroads of Ireland—cleverly located where the major east-west traffic

artery crossed the main north-south waterway, namely the Shannon. This is a place of magical attraction and was the only Irish monastery chosen by Pope John Paul II for a special visit when he came to Ireland in September 1979.

Another who attended this "nursery of saints" was Brendan, the famous navigator, whose fame spread throughout Europe because of the *Navigatio Brendani*, a tale of adventure that was translated into many languages after it appeared in the ninth century (again, like St. Patrick's *Confessio*, many centuries after its subject's death). It tells of Brendan's journey hopping from one island to another, northward along the Atlantic coast of Europe. Though no recognizable names are mentioned, we can pick out likely landing places, as on the Faroe Islands, Iceland, probably Greenland, and a Vineland that may have been the east coast of North America, which thus may well have been "discovered" by Europeans before Leif Eriksson and Christopher Columbus. It is immaterial whether it was St. Brendan himself who did the traveling, or whether tales of other seamen were carefully integrated into the accounts of journeys he did undertake. He was certainly able to return to his native land to relate whatever tales he had to tell, and he is said to have been buried at Clonfert in County

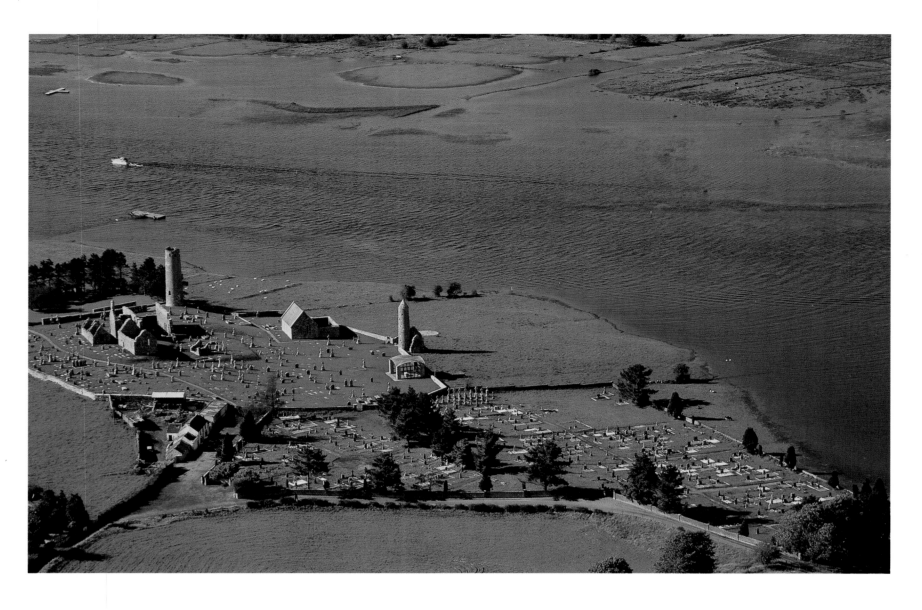

ABOVE: *The monastery of Clonmacnois on the banks of the Shannon was founded in the 540s by St. Ciarán at a very strategic crossroads location in the center of Ireland. Patronized by regal families on both sides of the river, it became in time a center of learning and the arts, as evidenced by the presence of three High Crosses and Ireland's greatest collection of cross-inscribed memorial stones. The churches and Round Towers in an irregularly shaped enclosure indicate where the core of the ancient monastery lay.*

Galway, where a great Romanesque doorway was erected in the west wall of the cathedral that was built around his supposed grave and dedicated in his honor.

Another of St. Finnian's pupils was Colmcille, also known as Columba, born into the noble Uí Néill group of families in 521. A native of Donegal, he too was to cross the sea to Scotland, some say because he was banished from Ireland after he had disgraced himself by raising a family army to fight against the High King at the battle of Culdreimne in 561, and causing the death of two thousand people in the process. He had already founded the monastery at Durrow in County Offaly before leaving, and probably also one at Derry, which is perennially associated with his name—Doire Cholmchille—the oak of Colmcille. Even more famous was the monastery he founded in 563 on the Scottish island of Iona in the Inner Hebrides, where he spent almost all of the rest of his life and where he died in 597. Columba was another man of great charisma, and his biography, written by his ninth successor as abbot, Adamnan, is regarded as an important literary work of the late seventh century. One of Columba's ideas was to mortify the flesh by departing from his native land forever, a kind of penance, which, however, was also linked to Christ's call to "[go] forth and teach all nations." In doing so, Columba became something of a trend-setter. In his footsteps followed many Irish *peregrini*, as those pilgrims for the faith were known. One of these travelers was Finian, who reached the east coast of England and there founded

the famous monastery of Lindisfarne. Others, such as Columbanus, went farther, to the European continent, founding monasteries such as Luxeuil in the kingdom of Burgundy, where Columbanus was thrown out for meddling in regal affairs, after which he moved on through St. Gall in Switzerland before ending up in Bobbio at the foothills of the Alps in northern Italy.

Columba did not stay outside Ireland for the rest of his life. One occasion is recorded when he did return at the request of the poets of Ireland, of whom he himself was one. The High King at the time was becoming exasperated at the high fees the poets were demanding for laudatory poems in praise of the king, who finally decreed that they should all be banished from the country's shores. Not happy about the prospect of eternal exclusion, the poets banded together and called on Columba to return to Ireland to calm the literary storm, which he did at the Council of Drumceat in 575. Consummate diplomat that he was, he worked out a compromise that, if the poets would considerably reduce their charges, the king would relent and let them stay. In this way, Columba was the savior of Ireland's literary tradition. For not only would the lore the poets transmitted orally be retained for posterity, but indeed the whole literary tradition of Ireland would be preserved—without which we would not have the bards of the Middle Ages and the great contribution made to world literature by men like Yeats, Joyce, Shaw, and, in our own day, Seamus Heaney.

But we owe even more to Columba, for without him and the monasteries he founded, we would quite simply not have the great early manuscripts such as the *Book of Durrow* that emanated from that midland monastery, or the *Book of Kells*, named after the religious foundation created in County Meath by his monks of Iona as an escape from the Vikings, who had killed many of them in raids on the island in 802 and 806. The very earliest Irish manuscript—the *Cathach*—is also associated with Columba, and tradition avers that it was the saint himself who wrote it before his demise in 597. It is easy to create such a tradition—the *Book of Kells* was also ascribed to his hand until it was realized that the manuscript was written probably two hundred or more years after his death—but there is nothing inherently improbable in ascribing the *Cathach* to Columba, as it could conceivably have been written toward the end of the sixth century.

The manuscript gets is name *Cathach*, an Irish word for a "battler," because it was apparently carried into battle as a talisman by Columba's kinsmen, the O'Donnells. It is a copy of the Psalms, each of which—where preserved—is introduced by an enlarged capital letter that shows a variety of designs culled from various sources. Some of these, such as the D on fol. 19a or the M on fol. 21a, are clearly derived from the pagan La Tène motifs of earlier centuries, though in the absence of intervening material, we cannot say whether they were handed down in Ireland or Britain, or in which media. But the old La Tène motifs were certainly revived at this time and presumably given a new symbolic meaning that we can no longer understand. Alongside

ABOVE: *The* Cathach, *now preserved in the library of the Royal Irish Academy in Dublin, is Ireland's oldest surviving manuscript and the earliest known step on the embellishment of Irish religious texts that was to culminate in the* Book of Kells. *Dating from sometime around the year 600, it is traditionally said to have been written by the great St. Columba himself, who died in 597 and whose O'Donnell family have helped to preserve it down to our own day. A monochrome psalter, the beginning of each of its surviving psalms has an enlarged initial letter enhanced with decorative motifs from the ancestral world of pagan Celtic art (as on folio 19a, illustrated here) or imported from the Mediterranean.*

these older-established elements, which the manuscript illuminators were obviously not afraid to use despite their heathen background, there were other new designs whose origins have to be sought farther afield. Such are the little fish that are found on N letters, or the animal in the Q on fol. 48a, both being combined with crosses resembling metal processional crosses found in the Mediterranean area. The *Cathach*'s illuminators, thus, probably had access to Late Antique manuscripts from lands bordering the Mediterranean, which also stressed initial letters. Clearly there is a whole century of Irish manuscripts scribed between St. Patrick and the *Cathach* that are missing; it is probably these lost manuscripts that developed the Irish script from Late Antique forebears into the already well-formed and characteristic majuscule seen in the *Cathach*. It is difficult to ascertain the nature of the connection with the Late Antique, but cultural exchange with the Mediterranean probably existed before St. Columbanus founded his monastery at Bobbio in northern Italy around 612. Nevertheless, Bobbio is likely to have played a role in transmitting Mediterranean ideas over the Alps and beyond to Europe's northwestern frontier.

One of the features most noticeable in the *Cathach* is the way in which the letters of the first line of each psalm decrease in size until they are the same size as the remaining letters of the text. This so-called diminuendo effect is repeated—but in a very different way—in the next important manuscript that we encounter with Columban associations.

The Book of Durrow

The *Book of Durrow*, Ms. 57 in the Library of Trinity College, Dublin, may have been created anywhere up to a century after St. Columba's death. It gets its name from the monastery the saint founded in what is now County Offaly and was acquired by Henry Jones, the bishop of Meath, before it was bequeathed to the college in the seventeenth century. The book is a copy of the Gospels using St. Jerome's Vulgate text, though it also contains elements of the earlier, so-called Old Latin version. It is written in an Irish majuscule of long lines rather than the Northumbrian system of two columns per page. In comparison to the *Cathach*, the initials have grown greatly in size, on occasion taking up almost the whole height of the page, followed by words which then get progressively smaller until they conform in size to the remainder of the text. These initials make full use of the old La Tène tightly coiled spirals, which create designs that are often symmetrical, but can also be asymmetrical depending on the particular layout in which they are used. These old pagan motifs are now combined with a new element—interlace—which was probably introduced from Lombardic Italy, where it was widely used in stonework. Frequently given a narrow border on each side, the ribbons of interlace vary considerably in style, at times tightly compressed and at other times with breathing space

between the individual strands. Because the patterns had to fit into rectangular panels, the interlace often creates angles at the corners, whereas the remainder rolls in even curves. Color, usually orange-red and yellow, but occasionally green, is used to separate the individual ribbons that make up the interlace, but one ribbon occasionally changes color when woven under another ribbon. These interlacings generally act as the decoration framing the evangelist symbols, which, interestingly, betray a pre-Vulgate origin, containing the lion as

the emblem of St. John, whose customary eagle then acts as the symbol of St. Mark. The body of the eagle, *en face* and head in profile, is divided up into many colored cells, so redolent of metalwork, as is the whole contour of the bird. The metalwork inspiration for the limner's designs in the book is even more apparent in the male figure symbolizing St. Matthew, who wears a poncho-like garment lined like a chessboard with squares, many of which have alternating red and yellow colors that look as if they were copied from enamel motifs on metalwork objects. One unusual page (fol. 192v) has a cross in a circle

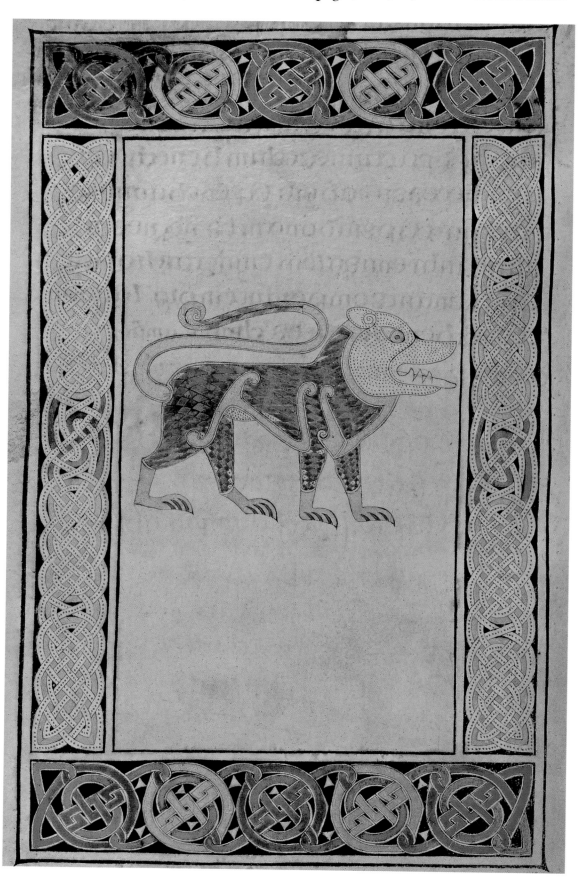

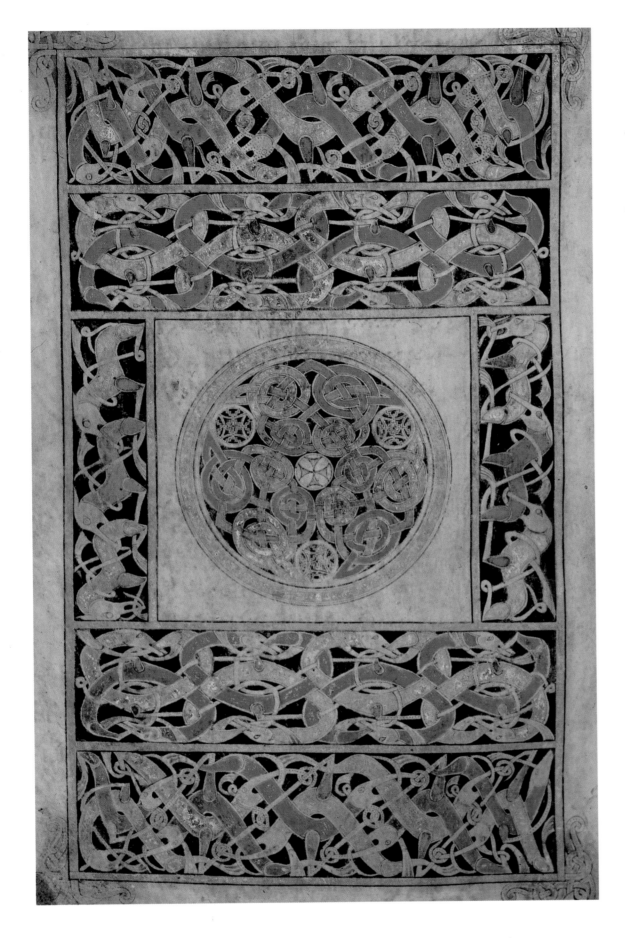

framed by vertical and horizontal bands of animals interlacing with one another, which may be compared with, but are not exactly the same as, Anglo-Saxon beasts. This is the first time that we encounter together the three motif categories that make up the main compendium of Early Christian ornament in Ireland—spirals, interlace, and animal interlace. The central circle also contains three discs decorated with patterns similar to those of the silver grilles of enamel bosses on metalwork.

BELOW: *The so-called Tara brooch, found on the seashore at Bettystown, County Meath, in 1850, could be described as "The* Book of Kells *of Irish Jewelry," for it is the most sumptuous piece of metalwork to survive from Europe of the eighth century. It is a riot of ornament comprising animals, spirals, interlace, and other designs executed in a considerable variety of techniques and materials.*

METALWORK

Because of its rarity and intrinsic value, early Irish metalwork was all too often melted down, so that we have today only a tiny portion of the rich treasury of metalwork that must once have existed. Reconstructing the story of Irish metalwork is much like assembling a jigsaw puzzle with many of its pieces missing. It is therefore hard to perceive how the old traditions of pagan metalwork practice survived into the Christian period, the dating of items such as the Petrie horns making the task even more difficult. What continuity did exist was aided by jewelry developing in Anglo-Saxon England and evolving from models surviving from the Roman Empire. The most obvious example was the penannular brooch, which was circular in shape with a break in the ring to allow passage of a pin that could fasten two ends of a cloak together and hold them in place. The new jewelry presumably followed the latest garment fashions, which made it chic to wear such brooches, some of which were decorated with chopped rods of glass known as millefiori, as on a specimen found at Ballinderry, County Offaly. But the presence of a cross on some early examples of these brooches dating prior to A.D. 600 suggests that the emerging monastic church was quick to be associated with metalwork production—as it was to remain for six centuries—and it helps to understand the metalwork influences on the

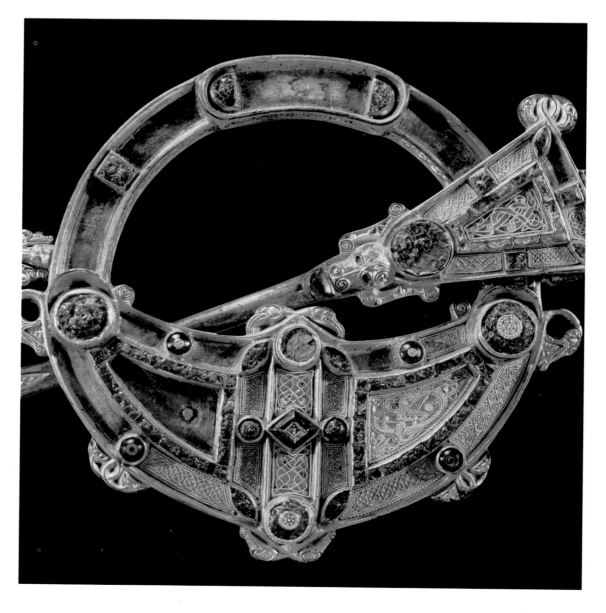

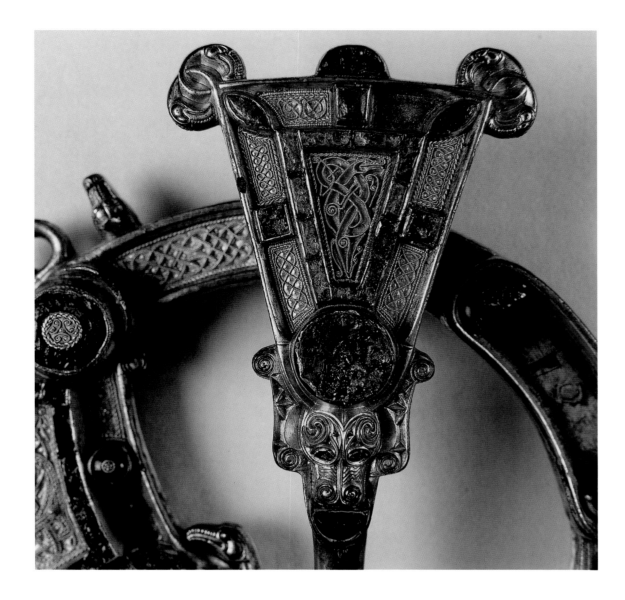

LEFT: *The front of the Tara brooch is a paragon of the jeweler's art, combining gold, silver, amber, and glass into an intricate design displaying birds, animals, snakes, and scrolls in an incomparable composition. It is no wonder, then, that the jeweler who bought it in the mid-nineteenth century gave it the name of Ireland's great royal site at Tara, rather than giving it its real provenance of Bettystown, County Meath, which would not have sounded nearly as imposing. It is now one of the greatest treasures of the National Museum in Dublin.*

Cathach initials. It was even possible that some of these brooches were made at the behest of, but possibly also worn by, high ecclesiastical dignitaries to keep the two sides of their heavy ecclesiastical copes together. The hooks or escutcheons for the suspension of so-called hanging bowls to which the escutcheons were attached, bear varied examples of Celtic spiral ornament and, though found mainly in pagan Anglo-Saxon graves in southern England, such as Sutton Hoo, some were Christian as they bear crosses, suggesting they may have emanated from ecclesiastical environments. Whether their origin is England or Ireland has been a matter of much debate during the last half century.

With the onset of the eighth century, the practical function of brooches as clothes fasteners was overtaken by the desire to use them as bearers of decorative ornament. They were used not only to show off the technical prowess of their creators, or the wealth of their wearers, but also possibly to heighten the importance of liturgical occasions during which they may have been worn. The ecclesiastical element in the composition of such brooches is suggested by the presence of a cross shape on the so-called Hunterston brooch, which, though found in southwestern Scotland, may have been made in Ireland. A cross shape can be read into the center of the front of the other great brooch of similar, if not even greater quality, the so-called Tara brooch in the National Museum in Dublin. Both show the absence of the break in the ring present in

ABOVE: *The only early medieval Irish brooch to have been made entirely of gold was discovered in 1855 at a ford on the river Bann in County Derry and is now preserved in the National Museum in Dublin. A mere two inches in diameter, its ring is delicately ornamented back and front with birds and animals that indicate a date early in the ninth century. It achieves its effect through its glistening material, varied techniques, and refined ornament, and was attached to the front of a garment by means of its decorative, curling pin.*

the older penannular brooches that allowed the pin to pass through; instead, the ring is closed, so that the pin, instead of fastening two parts of a garment together, is now merely used to stick into one part of the garment to hold the by-now ornate closed ring. This can be seen clearly in the Tara brooch, which must surely be regarded as one of the supreme pieces of eighth-century jewelry to survive from anywhere in Europe. The back of the brooch, seen only by the wearer, whoever he or she may have been, is dominated by two trapezoidal panels with Celtic La Tène ornament, the design formulated by narrow grooves cut into the silver surface and filled with a material now black, but originally a radiant red. These panels set off beautifully the surrounding goldwork of animals and birds, whose hatched bodies create an undulating pattern that adds greatly to the movement of the whole composition. The otherwise flat surfaces are interrupted by domed studs of red and dark-colored enamel made into curving and annular patterns with the aid of a silver grille. The impression of the back of the brooch is one of ornament everywhere, confirming the Celtic horror of empty spaces—the same *horror vacui* also sensed in the *Book of Kells*, to be discussed below.

The front of the Tara brooch is even more remarkable because the overriding richness of the gold is interspersed with decorated studs and strips of glass, the latter of which framed two panels of animal ornament (one now missing), like the dark outlines of a Rouault painting. The central area—guarded above and below by a pair of animal heads with crossed necks—can be seen to have the cross shape, if we take the central diamond-shaped stud as the meeting place of shaft and arms, and the decorative circular studs adjoining it as the arm ends. The diagonally placed glass studs top and bottom, and the angular endings of the panel strips adjoining them, give the impression that the whole central design of the brooch is based on a three-dimensional model in perspective, without it being possible to discover its nature. The motifs on the panel strips are repeated on those framing the whole lower portion of the brooch. Fashioned by ingeniously twisted gold wire, the panel strips, when taken together with the variety of decorated studs, make the Tara brooch a piece of virtuosic brilliance in both composition and execution.

Equally exotic is the Ardagh Chalice, a squat altar vessel combining the same techniques as the Tara brooch. Worked in both gold and silver, as well as enamel, the chalice studs with silver grille may be more domed than those on the brooch, but show an undeniable affinity, if not identity, of workshop. The unusual chalice form, with two handles, must go back to Mediterranean models of Late Roman inspiration, but the ornament is certainly northwest European in its concept. Enamel bosses project not only from the triangular escutcheon beneath the handle, but also from a band of gold panels arranged like a diadem beneath the rim—as well as from a medallion in the form of a cross of arcs on

the body of the chalice. There is further intricate goldwork on the neck, and the flat rim around the foot has an arrangement of low rectangular studs punctuating a series of curving panels with geometric ornament—present not only on the upper side, but also on the underside of this vessel that was used for distributing the altar wine. But the most remarkable hidden part of the chalice is the decoration at the top of the underside of the base, where it must have spent most of its time wasting its sweetness upon the desert air, as it were, because it would only have been seen when wine was being drunk out of the chalice. At the center is a striking piece of rock crystal, which is surrounded by three concentric circles of varying widths that represent a copybook example of the three major designs used in Early Christian Irish metalwork and manuscript decoration. The innermost ring features animals of Germanic origin following each other in perpetual circular motion, biting each others' tails; it is ringed by a broad circle of Celtic spiral ornament enclosing five individual decorated enamel studs, and the outside ring is a rhythmical band of never-ending interlace.

The fineness of execution of the Ardagh Chalice, conventionally dated to the eighth century, is not matched by the only other Irish chalice of its kind and calibre—that found in a hoard at Derrynaflan, County Tipperary, in 1980 and probably dating to the ninth century. In comparison, the patterns on this later example look to be disintegrating, but are doing so in the way that designs on continental Gaulish coins dated many centuries earlier became more diffuse and less understandable the further away they got from the original model. Of higher artistic quality and style are some of the other unique objects found at Derrynaflan—a paten and the ring it stood on. Here, on the circular form of the

BELOW: *The two earliest-known Irish metalwork reliquaries have recently come to light in places far apart—Bobbio in northern Italy and Clonmore beside the river Blackwater in County Armagh—and their similarities shed light on connections between the Mediterranean and Ireland in the seventh century, when both objects are likely to have been manufactured. The Clonmore example illustrated here is only about three inches long and is now preserved in the Ulster Museum in Belfast. It consists of four bronze plates decorated with Celtic scrolls and spirals, which, together, form the shape of a house with a steep and concave-sided roof that was designed to hold the relic of some unknown northern Irish saint that was lost when the shrine was thrown into the river probably many centuries ago.*

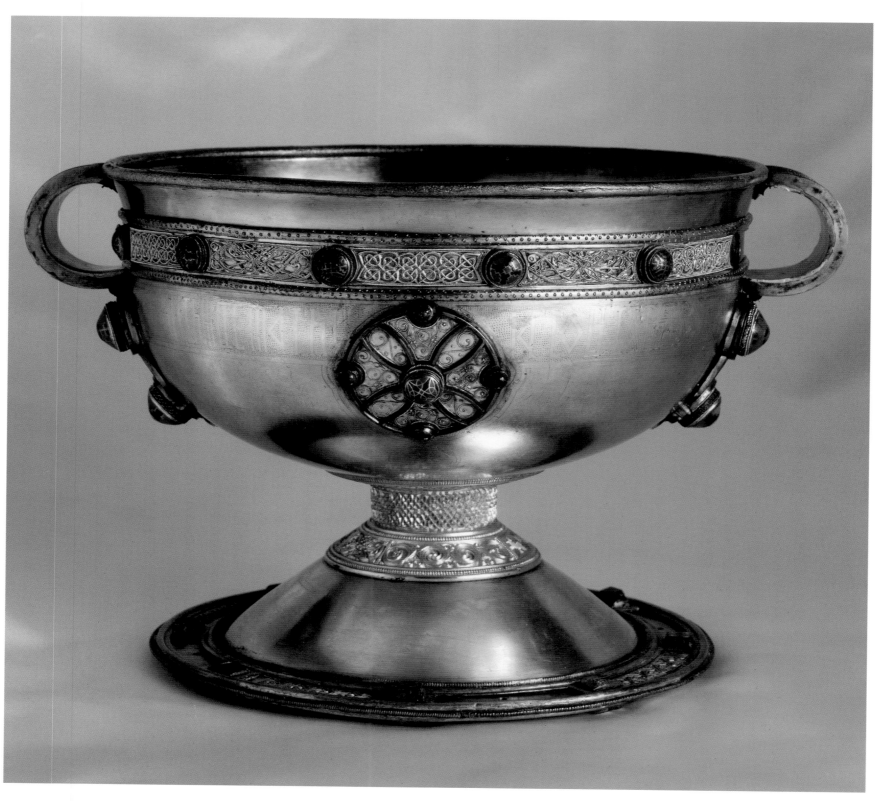

ABOVE, LEFT, AND OPPOSITE: *Found by a boy hunting rabbits in 1868, this great silver chalice from Ardagh, County Limerick, dating from the eighth century, is the most beautiful piece of Irish religious metalwork. Brilliantly ornamented with panels of gold wire forming animals and interlace, and with ingenious enameled bosses and studs, the chalice was decorated even under the conical foot (opposite). There it has a central rock crystal surrounded by circles of interlace, Celtic spirals, and Germanic-inspired animals, all of which could only have been seen by onlookers as the wine was administered through the tilting of the gracefully shaped bowl.*

paten, we have, once again, domed enamel studs with even more complicated grilles than on the Ardagh Chalice, and panels of twisted gold wire illustrating animals and humans. Its stand is remarkable for the long panels of silver with geometrical motifs die-stamped upon them. This hoard of liturgical vessels—which also includes a baptismal spoon-shaped strainer—is a unique combination of objects, probably made over a period of a hundred years or more. The same can also be said of the Ardagh hoard, which included not only the chalice, but also brooches, one of which may be up to two hundred years younger than the chalice.

Four years after the discovery of the Derrynaflan hoard, another group of metal objects came to light at Donore, County Meath, which, though very different in purpose, also show the heights that bronzesmiths could attain in eighth-century Ireland. The group comprises two discs and what may be taken to be the ring of a doorknob. The more complete disc of the two is decorated with concentric bands—one of animal ornament, and the other of Celtic spirals etched into the surface—while the second and less complete disc is taken up entirely with similar La Tène spirals, tightly coiled and exploding with energy near the center, though loosening as they approach the perimeter. Swirling all the time, as if choreographing an Irish dervish's dance, they are one of the most supreme expressions of the latest phase of these old pagan motifs—which were shortly to go out of fashion. The ring handle, which fits into the more complete disc, also has spirals that act as part of the hair of a lion whose toothful jaws entrap a movable ring that must have been used to open a door. A similar mechanism was used by Charlemagne closer to A.D. 800 for the great bronze door of the cathedral at Aachen, though the idea for both may have to be sought in imperial Rome.

The elements of the eighth-century Donore hoard must surely have served as the furnishings for the door of a local church. Such a church would almost certainly have been of wood, since it was not until the ninth century that stone churches began to gain any popularity in Ireland. It is somewhat ironic that these masterly pieces of metalwork as well as the great manuscripts were

ABOVE: *In recent decades, the mysterious figures on White Island in Lough Erne, County Fermanagh, have been ranged along the wall of a twelfth-century church, but are, themselves, three or four centuries older. This we can judge by the man with sword and shield who proudly demonstrates how a penannular brooch of c. 800 was worn below the left shoulder. The identity of all the figures remains as obscure as the function for which they were carved.*

produced in monasteries where the physical surroundings must have been comparatively simple, the buildings, generally made of wood and subject to the Irish climate, long since vanished. Monasteries were usually within a roughly circular area, surrounded by a wall, sometimes of earth, sometimes of stone, as at Nendrum, County Down, where we get the best look at an old Irish monastery. Nendrum, in fact, had three roughly concentric walls—the innermost being the sanctuary, the holy ground, with church and Round Tower; the middle one probably enclosing the wooden huts of the monks; and the third perhaps containing gardens and cattle pens. A tidal mill has recently been discovered near the monastery, showing that the monks knew how to use—and were apparently at the forefront in developing—the latest technology. Another watermill on the island of Ardoileán (High Island) off the Galway coast is further evidence that the Irish monastic community was one of the leaders in Europe in inventing ways to harness energy from natural resources. These mills were used to grind corn, some of which would have been grown on the island, but some probably brought from the mainland and hauled up the relatively steep cliffs of the island before being ground. The monks, however, were not building such mills just for themselves—they would have been servicing the wider community, some of whose members, though lay, would have been attached to the monastery. Through donations and other means, the monastic landholdings often extended far beyond the monastic

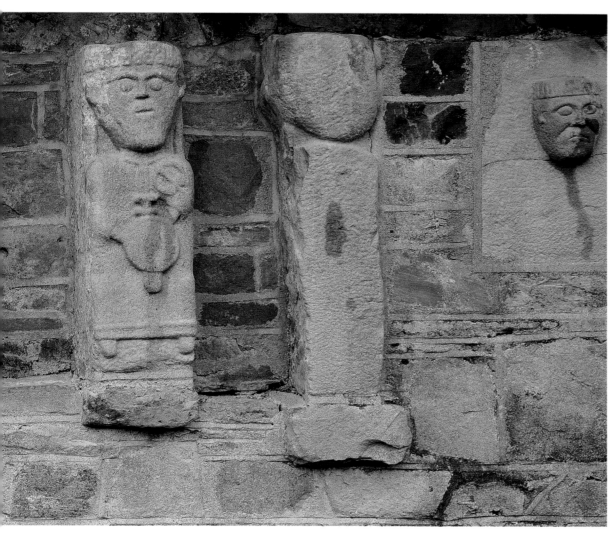

walls. Clonmacnois is known to have had possessions in quite a number of counties.

We have a description of one monastic church, that at Kildare, where St. Brigid's seventh-century biographer Cogitosus tells us of a church that served both men and women in what was one of the very few double monasteries known anywhere in Europe. His description of the church, as translated by Ludwig Bieler, is as follows:

> The church … is not the original one: a new church has been erected in the place of the old one, in order to hold the increased number of the faithful. Its ground-plan is large, and it rises to a dizzy height. It is adorned with painted tablets. The interior contains three large oratories, divided from one another by walls of timber, but all under one roof. One wall, covered with linen curtains and decorated with paintings, traverses the eastern part of the church from one side to the other. There are doors in it at either end. The one door gives access to the sanctuary and the altar, where the bishop, with his school of clerics (*regularis schola*) and those who are called to the celebration of the holy mysteries, offers the divine sacrifice to the Lord. By the other door of the

dividing wall, the abbess enters with her virgins and with pious widows in order to participate in the Supper of Jesus Christ, which is His flesh and blood. The remainder of the building is divided lengthwise into two equal parts by another wall, which runs from the western side to the transverse wall. The church has many windows.

The great majority of Irish churches would, however, have been much smaller in comparison. A church like that on St. MacDara's Island off the coast of Connemara probably gives us a clue as to the outward appearance of a more typical early Irish church because it is a translation into stone of a wooden church, reproducing as it does the corner posts of the wooden structure in the form of antae, projections of the long walls out beyond the end gable. Evidence that the church was copied from a wooden model is found in the stones of the roof, which have squares carved into them that must surely be copies of wooden shingles used to cover the wooden structure on which the church was modeled. Similar shingles appear on the roof of the finial of Muiredach's Cross at Monasterboice, which may also show us some of the details of an early wooden

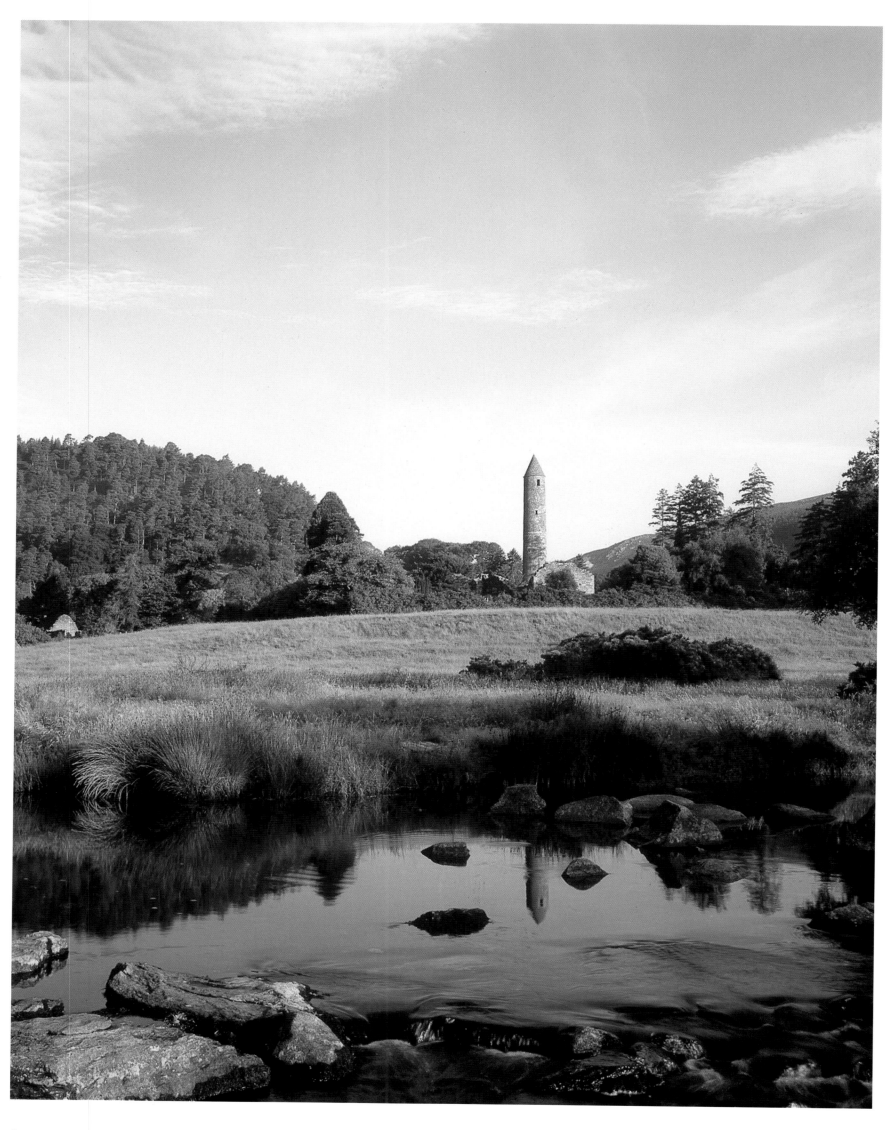

church in Ireland. The stone-roofed church, which is a feature of twelfth-century architecture in Ireland, would seem to be one of Ireland's minor contributions to European architecture. When the community grew, as was doubtless the case at Kildare, a larger church might have been built, as can be seen at two of Ireland's most important early monasteries, Clonmacnois, County Offaly, and Glendalough, County Wicklow. In both instances, a number of smaller churches may have been built, which would have helped the pilgrimage traffic that must have been an important part of monastic life, pilgrims' alms in whichever form helping to keep the monastery alive.

The early Irish monasteries did not adopt the continental plan of placing a church at one end of an open, roughly square cloister garth, as is found in the idealized layout preserved in the ninth-century plan of St. Gall in Switzerland. Indeed, the circular enclosure of the Irish monastery was divided up into different sections, one of which contained the church, and others containing the monks' cells, probably the monastic scriptorium, and other practical buildings. In front of the church there would have been an open area where a cross would normally have been placed.

BELOW: *The early Christian site at Reask near the end of the Dingle Peninsula is marked with this tall pillar bearing a cross in a circle that is supported on a stand of Celtic spiral ornament that may have had an iron prototype. The stone may have been set up for pilgrims to pray at some twelve hundred or more years ago.*

OPPOSITE: *Glendalough, literally the valley of two lakes, in the depths of the Wicklow hills, is the epitome of the desire of the old Irish monks to get away from the madding crowds and seek peace and quiet in nature, where they could commune with their maker. Founded in the seventh century, the monastery's core lay between the church with the Round Tower to the left of center (called St. Kevin's, after the founder) and the Round Tower, the top of which emerges like a rocket from the surrounding trees. St. Kevin's original hermit retreat was probably near the upper lake.*

CROSS-CARVED STONES AND METALWORK SHRINES

Some of the stone pillars decorated with crosses, as found particularly in the western half of Ireland, may reflect the kind of wooden cross-decorated pillar or stele that might have stood within the monastic enclosures, though they are extraordinarily difficult to date. Only one—at Kilnasaggart, County Armagh—can be ascribed with some, though not complete, confidence to the early eighth century on the basis of an inscription. It is decorated with a Latin cross, as well as equal-armed crosses in circles, but some other examples are richer in their decoration. One, at Reask, in County Kerry, inscribed with the letters DNE (presumably an abbreviation of the word *Domine*, meaning "Lord"), has a cross-of-arcs in a circle and a stem that looks to have been copied from a processional cross flanked by spiraling curves that grow out of the old La Tène tradition. Another, not far away, at Kilmalkedar, may have had a more pedagogic function, as it has an alphabet on the narrow side that was dated by Ludwig Bieler to around the seventh century. A further example, at Kildreenagh in the same county, has the Greek letters Alpha and Omega hanging from the cross-arms, doubtless in imitation of a metal forebear. Stone is usually the last, but also the

most endurable, artistic medium, standing at the end of a long line of ornament development starting with metalwork and proceeding through manuscripts and probably also through wood, until the ornament ends up decorating a stone. These early stone cross-decorated pillars are probably thus copied from slabs in other media, particularly wood (about which we can only surmise), and almost certainly metal. This may well be exemplified by a pillar at Carndonagh, County Donegal, which has on one face two figures, one on each side of a curious object with a long stem (from which two loops hang), and a circular head enclosing a marigold. This object is thought to be a *flabellum*, a fly swatter of a kind once used in the Mediterranean and adopted by the church to keep any small winged creatures away from the altar wine in the chalice. Two such *flabella* are known to have been the relics of St. Colmcille, or Columba,

BELOW: *What seems like a marigold in a circle at the top of this carved pillar at Carndonagh in County Donegal is the head of a stone copy of a liturgical instrument known as a* flabellum, *probably the one preserved as a relic of Saint Columba, who came from the county. Flanking its meander-decorated stem are two figures, the right-hand one probably to be identified as a pilgrim because of the staff he carries and a satchel that hangs waist-high from his neck. Beneath them is a cross of arcs in relief, probably sculpted sometime around A.D. 800.*

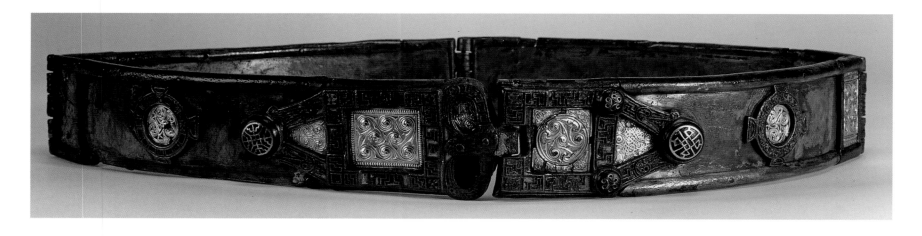

and this Carndonagh stone may be a copy of one of them. Neither survives, so that we do not know what material they were originally made of, but whether of bronze or wood, they would probably have been hung up when not in use by the two thongs at the bottom, which may well have been of leather. The two flanking figures, the one on the right carrying a staff and satchel, can probably be taken as pilgrims come to venerate the relic of the great saint of Donegal, a county that also has many other carved stones of importance. One is the tall pedimented stele at Fahan Mura, which has a cross with interlace decoration carved in relief on each face, but with a Greek inscription "Glory and honor to the father...." The formula, adopted by the Council of Toledo in 633, gives us the earliest possible date for the stone, but it could be one or more centuries younger. This stone, which has rudimentary arms jutting out from the sides, has often been seen to have played a role in a Darwinian sequence portraying the development of the Irish High Cross because its arms were thought to be breaking out of the bounds of the upright stone to make a stone cross with free-standing arms. But because the High Crosses were not necessarily developed in stone, but, rather, in other media before they were carved in stone, and because the Fahan stele finds its best counterparts in Scotland, it is best to see Fahan—and possibly other Donegal carvings as well—as being an outlier of Scottish stone carving, and to understand the High Crosses as having developed independently of the Donegal monuments.

The period around 800 saw events happening in various parts of Europe that were to affect Ireland in one way or another. In central Europe, the strengthening of Charlemagne's rule culminated in his coronation as emperor in Rome on Christmas Day 800, followed by a kind of Roman renaissance north of the Alps. As emperor, Charlemagne put old Mediterranean ideas to work in workshops revitalizing the old crafts of ivory-carving and setting up scriptoria to create manuscripts that would find inspiration in the Late Antique; he even had himself buried in a Roman sarcophagus brought specially to his new capital at Aachen. But, to the north, the Scandinavian peoples were beginning to travel in considerable numbers, using newly acquired boat-building skills to cross the Baltic and the North seas, and to venture south, eventually even reaching the Mediterranean through the Strait of Gibraltar, but

not before they had wrought havoc among (but also contributed to) the life of the island populations of Britain and Ireland.

The native population would have been kept informed about developments on the European mainland through wandering Irish monks, and no doubt there was a two-way flow of ideas. One of Ireland's greatest intellects, Johannes Scotus Eriugena, placed his learning at the disposal of the Carolingian court, astounding its members with his knowledge of Greek, which he can only have learned at home. But other wandering pilgrims, or *peregrini* as they were called, fared less well. Many of them had been made bishops in Ireland, but Charlemagne's churchmen were not prepared to accept their ordinations as proper according to the rules of Rome, and so gradually a number of those whose predecessors had helped to introduce (or reintroduce) Christianity to central Europe were banished from the emperor's realms and would have returned home. The Irish church, however, appears to have turned the misfortune to its own advantage by getting the Irish, lay or religious, to go on pilgrimage within Ireland. To provide a focus for such pilgrimage, the relics of old Irish saints—hermits or monastic founders—were given splendid new shrines that the domestic pilgrims could go and venerate. One such was the belt of an unknown saint that was given a new metal casing probably long before it was deposited for safekeeping in a bog at Moylough, County Sligo, where it was discovered in 1945. It continued the traditions of using the La Tène spirals among its ornaments, notably on silver plaques stamped from the back, and using studs with silver grilles similar to those on the Ardagh Chalice. To this ornament was added millefiori, those rods of cut glass already encountered on the Ballinderry brooch, as well as angular fields of raised enamel in L, T, and S shapes. Also applied to its surface were circular medallions, two in the shape of the cross in a circle of a kind that we find used on the heads of stone High Crosses, themselves heavily influenced by metalwork. A metal cross from County Antrim, now in the Hunt Museum in Limerick, which also uses millefiori in the decoration of its bosses in the form of truncated pyramids, may well have decorated the sides of a reliquary shrine. These shrines often took the shape of a house and were frequently small enough to have been carried around on the person. Two other such shrines were found in different locations in Italy, but, rather than having been used to carry relics

ABOVE AND BELOW: *Roughly contemporary with the belt shrine is a metal cross from County Antrim, now in the Hunt Museum in Limerick. Its central boss, in the shape of a truncated pyramid, bears an animal with back-turned head and wide-open mouth, while the other (slightly flatter) bosses at the ends of the arms are decorated with angular enameled designs on the sides looking like prefigurations of modern traffic symbols!*

RIGHT: *The rather dilapidated state of this small building at Clonmacnois in County Offaly is due to its having been rebuilt so many times during the twelve centuries of its existence. The necessity to do so arose from the thousands (and probably millions) of pilgrims who flocked to this building to venerate the monastic founder, St. Ciarán, who was buried inside it after his premature death in the late 540s. The erection of such small but important reliquary shrines in the ninth century may have given a fillip to the construction of larger churches in stone, instead of the wooden structures that had previously prevailed in Ireland.*

of Irish saints abroad, these may have been manufactured for pilgrims to Rome so that they could bring relics back home that had been extracted from the catacombs in the Eternal City and offered for sale as the relics of early saints. But two bronze finials of presumed Irish origin in the French Musée des Antiquités Nationales in Saint-Germain-en-Laye, together with another similar pair found at Gausel in Norway, show that there were also considerably larger shrines containing the relics of Irish saints that have not managed to survive.

The discovery of the pair of Gausel finials tells us that the Vikings plundered Irish monasteries for the shiny metal treasures and brought them back home to Scandinavia to be dismantled for the making of trinkets for themselves and their womenfolk. One house-shaped shrine found in Norway, and now in the Danish National Museum in Copenhagen, had the Nordic name Ranvaig inscribed in the Runic alphabet on it. In fact, the Scandinavian museums—at Oslo, Bergen, and Stockholm in particular—when taken together have a fine collection of Irish religious metalwork of the eighth and ninth centuries that is second only to that in the National Museum in Dublin. Nowadays, we should be thankful to the Vikings for having taken these religious objects home with them to Scandinavia, since otherwise they might have landed up in the melting pot, as did so many others that were retained in Ireland. But, in the ninth century, the Vikings would have been regarded as a continuing scourge, robbing the churches of their valuable shrines. Here, too, this may have been, at least to some extent, a blessing in disguise, as it may have furthered the development of Irish stone building—in the form of tomb-shrines like those of St. Ciarán at Clonmacnois or St. Molaise on the island of Inishmurray off the Sligo coast. These shrines may then have given a fillip to the building of stone churches that would have been less vulnerable to damage

by fire than the earlier wooden churches in the face of a Viking onslaught.

These violent Norsemen not only raided in Ireland, they inflicted considerable harm in Britain as well, among their notable attacks being two on the island of Iona in the Inner Hebrides, the foundation and burial place of St. Columba, in the years 802 and 806 respectively, during which many monks were slain.

THE BOOK OF KELLS

Iona is one of the likely candidates for the location of the scriptorium that produced the most famous of all "Irish" manuscripts, the *Book of Kells*, now manuscript 58 in the Library of Trinity College, Dublin, and which, when it was stolen from Kells in County Meath and fortunately recovered in the years 1006/1007, was described as "the chief relic of the western world." After only about three centuries in existence, it had become a relic associated with the founding saint, and even up until the nineteenth century was still regarded as a product of the hand of St. Colmcille himself. The saint had died in 597, but modern scholarship would ascribe the manuscript to the later eighth or early ninth century. If the former, it is most likely to have been written at Iona, because it was not until 807—the year after the second Viking raid on the island monastery—that its monks decided to found a monastery inland where they— and their relics—could escape Viking depredation, and this they did at Kells in

BELOW: *Brian O'Halloran's imaginative watercolor reconstruction of the monastery at Kells in County Meath shows it as it was around 1006 when the famous* Book of Kells *was stolen from it, fortunately to be recovered a year later. It brings out the typical round or sub-circular shape of an old Irish monastery, enclosing its special monuments: a church, a Round Tower, High Crosses, and the small stone shrine to house the relics of St. Columba in the foreground. Because we do not know the physical appearance of the monks' living quarters, the artist has reconstructed many of them here on the basis of the Skellig Michael beehive huts.*

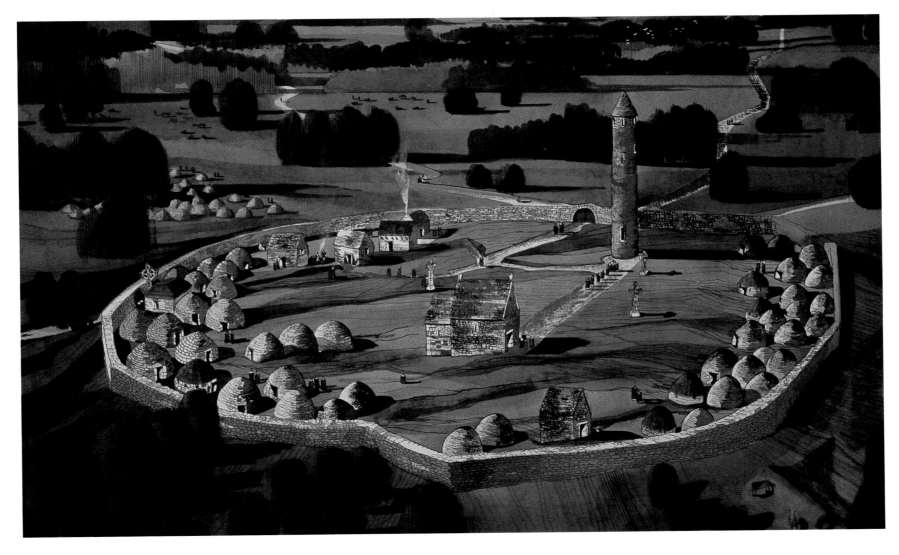

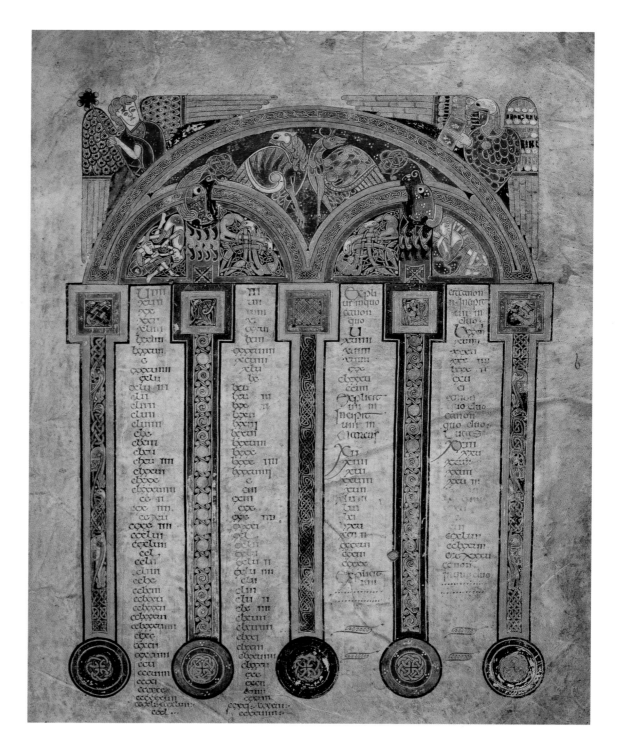

County Meath. But if the book could ever be proven to have been written after 807, then Kells would be the most likely place of origin. The matter may never be settled, though it is always possible that the manuscript could have been started on Iona (conceivably, as Françoise Henry suggested, to commemorate the bicentenary of Colmcille's death) and then continued at Kells, the monastery which has given it its name, and where it was preserved for centuries before coming to its present resting place in Trinity College, Dublin. But the open question as to where the *Book of Kells* was written (and the same, let it be said, also goes for that other great Columban manuscript, the *Book of Durrow*) shows how Ireland, Scotland, and even Northumbria in northern England formed one unit artistically, so that it is often very difficult to credit any one object or manuscript to either side of St. George's Channel between Scotland and Ireland.

The *Book of Kells* is not just a chief relic, it is also one of the wonders of the western medieval world, a manuscript on which one can but heap superlatives

when standing in front of it in the display case in the Library of Trinity College (where two of the four Gospels into which the manuscript has been divided are usually on display). For sheer technical brilliance, inventiveness of design, range of color, and intricacy of execution, it has won the reputation of being the zenith of insular manuscript illumination. In comparison to the more disciplined and controlled ornamentation of the century-older *Book of Lindisfarne*, painted in northern England and now in the British Library in London, the *Book of Kells* shows a fierce but harnessed wildness, an exuberance of joy in filling page after page with large or small motifs, La Tène spirals, and prancing animals in a fanfare of fantasy that overflows with freshness, beauty, and even, on occasions, a sense of humor.

Being a book of the Gospels, it is naturally largely taken up with text, but on almost every opening of the book, this text is enlivened by imaginary and imaginative animals gamboling on and between the lines and making somersaults in the capitals at the beginning of each paragraph. These small vignettes are too infrequently appreciated sufficiently for their variety and their ingenuity, but the real joys of the book are, nevertheless, the extraordinary color pages devoted to the human figures or overall designs. The theft of the manuscript almost exactly a thousand years ago, which left it without its bejeweled box-covering, also robbed it of some of its pages at start and finish. The opening pages are now largely (though not entirely) taken up with canon tables, which were normally used to correlate and identify the placing of the same material in the various Gospels, each Gospel allotted a column to itself, and the verse numbers of the relevant passage duly listed one beneath the other in order of appearance. But the text of the *Book of Kells* was never given verse numbers, so that its canon tables have no practical purpose, giving us our first hint that this was no ordinary manuscript for daily use, but one that was decorative and ceremonial for display on special occasions and kept largely closed so that the colors would not deteriorate.

The canon tables are a classical design of an arcade consisting of columns joined at the top by an arch or a circular motif, and altogether spanned like an umbrella by an overriding arch. The device came from antique times in the Mediterranean, but the Celtic artists have, as it were, hijacked the classical framework and provided their very own Celtic "insular" ornament, which would be inconceivable in a Mediterranean manuscript. Far from being naturalistic, the animals are products of the illuminator's fantasy; asymmetry is substituted for Roman symmetry—a device to enliven the design and a clever artist's trick to bring the eye back again and again to what it sees as something purposely unbalanced, in the tradition of pagan Celtic art. The *Book of Kells* can be interpreted, therefore, like much of the rest of early Irish art, as anti-classical, a reaction to the Roman-inspired classicism of Italy. The *Book of Kells* could also be interpreted as the Celtic artists' response to the classical style practiced by

ABOVE: *Discussion on the* Book of Kells *understandably, but all too often, concentrates on the pages of major decoration, some of which are illustrated in the pages that follow. But, in the same context, what is often overlooked is that most of the codex is made up of the texts of the four Gospels, which are not so lavishly decorated. Yet, there is only one opening in the whole manuscript that does not have some kind of decoration, the reminder of the text pages having the first letters of paragraphs given some special treatment, such as contorting animals or humans making up the initial—which are usually fun to behold and which show the inexhaustible fund of fantasy that the manuscript illuminators had. Here, on fol. 40r, there is also the addition of a prancing lion in the middle of the text and a few flourishes between the two paragraphs and on the bottom.*

RIGHT: *The sole portrait of Christ in the* Book of Kells *is found on fol. 32v, where it acts as an introduction to St. Matthew's Gospel, the first of the four that fill the pages of this astounding, colorful, and complex codex. Placed in a keyhole frame, the Savior sits enthroned, holding a book in his hands, flanked above by two symbolic peacocks resting on vines that grow out of chalices on a ledge. In separate frames beside him are a pair of angels, looking more at each other than at Christ, whose lovely curly locks bear favorable comparison to today's hairstyles.*

OPPOSITE: *Though the Virgin Mary was the subject of much devotion in early Ireland, her portrait holding the Christ child on fol. 7v of the* Book of Kells *is one of the rare representations of her in early Irish art. Appearing as the first full-page illustration in the book, and before the start of the first Gospel, she is shown seated on a high-backed chair (with animal head at the top) holding the Christ child in profile on her lap, as she is attended by a quartet of admiring angels. The sideways positioning of the child and the way he places his hands on her breast and hand belongs to a well-known type of the Tender Madonna popular in late Byzantine art, suggesting that the model for the* Book of Kells *Virgin may have been an icon from Rome, Greece, or somewhere bordering on the Mediterranean. The group of six male busts curiously turning their backs to the Virgin in the right-hand frame may give us some idea of what early Irish monks looked like.*

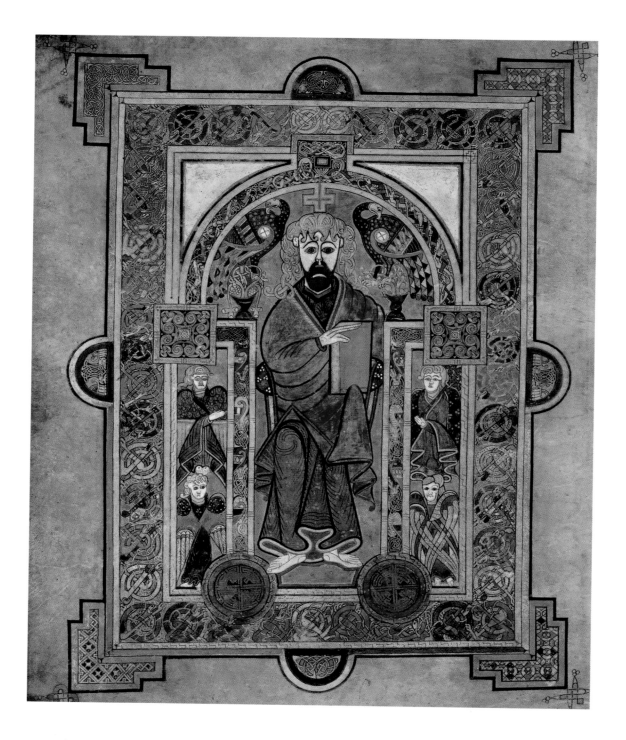

Carolingian scriptoria, a de luxe manuscript to match theirs, and a statement of artistic independence that is the product of a long history of stylized figures and animals that goes back to the pagan Celtic period. The Greeks and the Romans long to represent the human figure in all its beauty and natural shape. That idea was foreign to the Celtic artists; they made their figures stylized so as to present the eye with a different view, as many more recent artists and sculptors have done. The same features can be seen in some of the figures in the *Book of Kells*—the Virgin and child, for instance, looking stiff as an icon with only subtle signs of movement visible, looking naturally uncomfortable. Other figures given full-page treatment in the *Book of Kells*—Christ himself, or the evangelist John—together with the very few narrative scenes, such as the so-called Arrest of Christ or the Temptation of Christ on the temple roof, are of course modeled on classical prototypes emanating from Early Christian Rome. They have all been subtly changed, however—either in their faces, hair locks, or beard, their garments or limb movements— to conform more to the Celtic

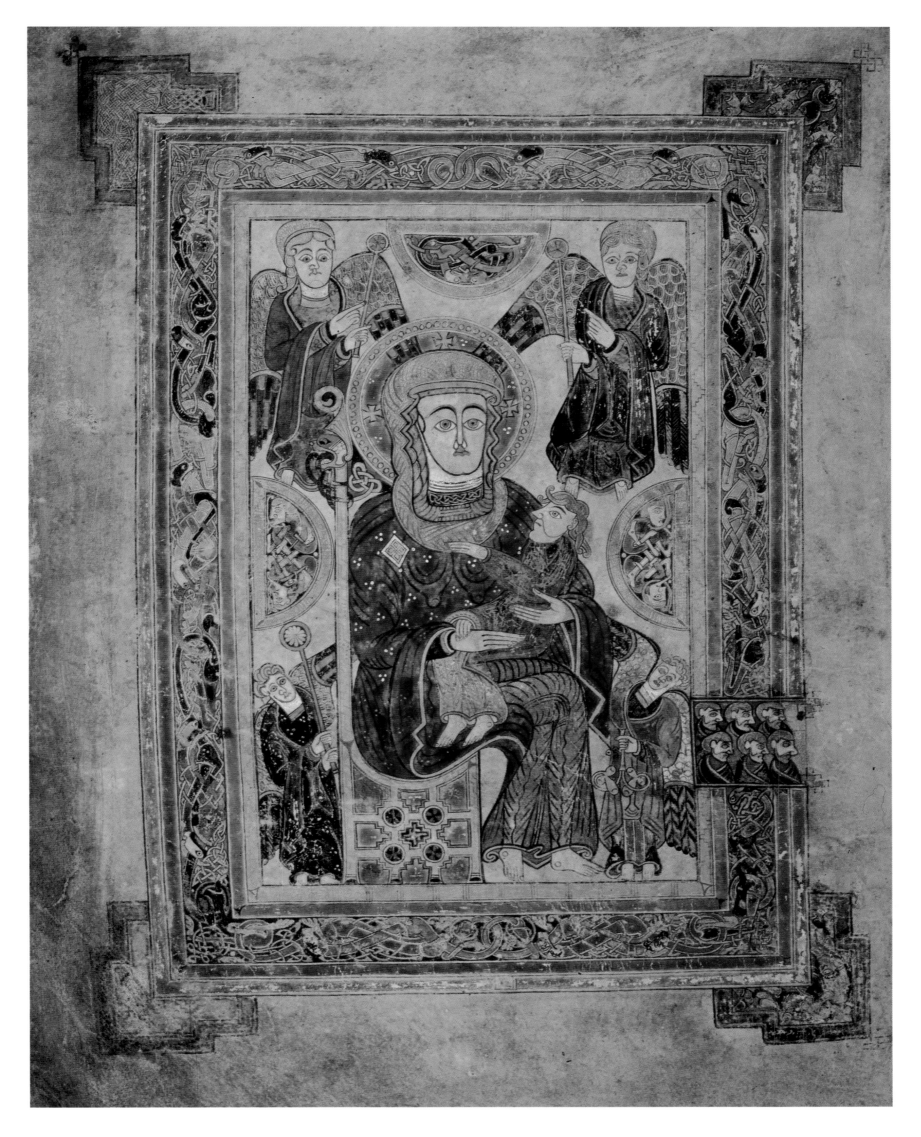

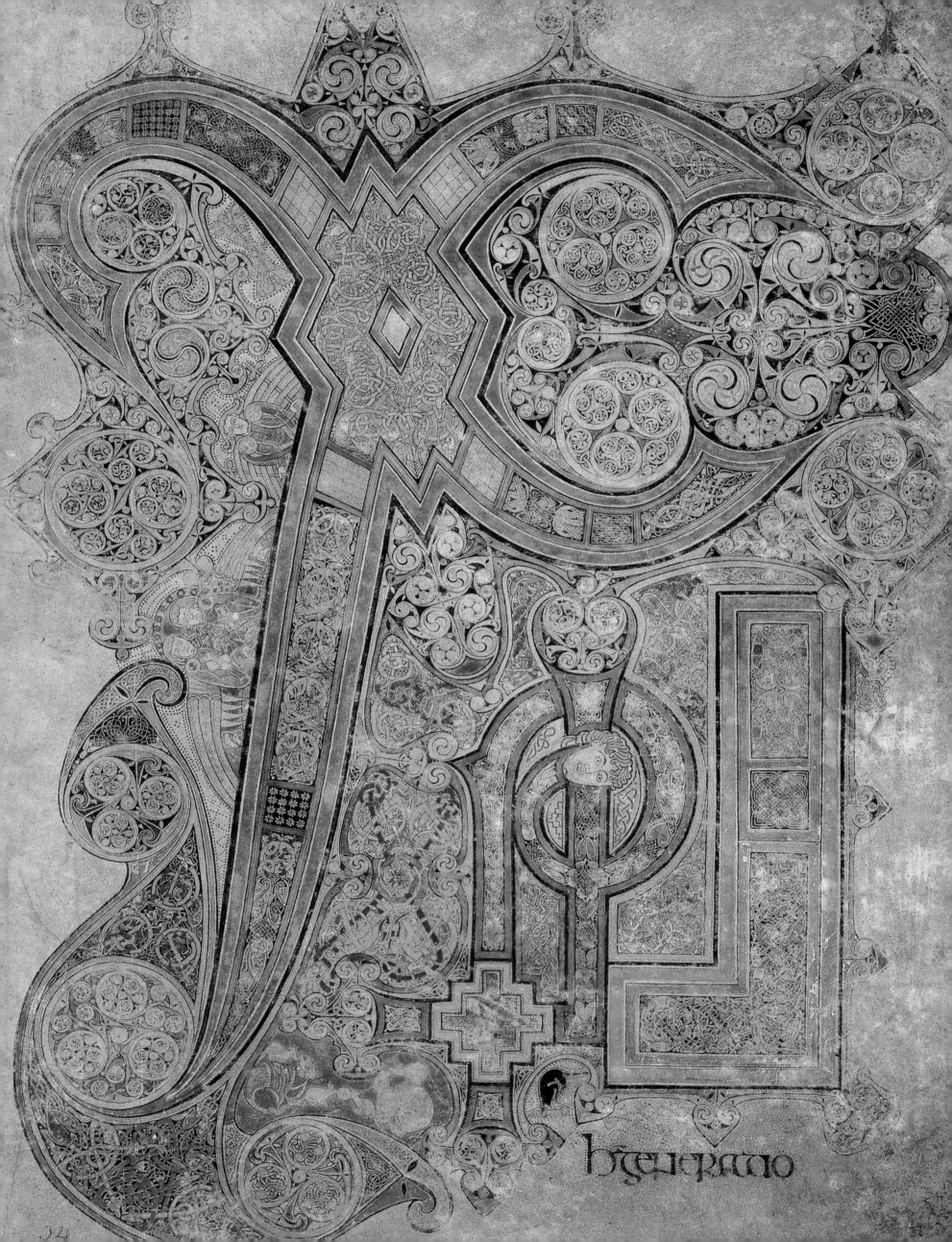

idea of stylization, with large expressive almond-shaped eyes, sometimes seen Picasso-like in profile, as in Egyptian art.

These figures are usually contained in frames filled with an interlace of ribbons or animals, never repetitious, and usually at such a minute scale that one may well ask how the monks could have done it all so perfectly without magnification. Perhaps this team of at least three or four people who were responsible for the work were all near-sighted so that their eyes would not be too damaged in the process. The artists used a variety of colors—red and blue, one coming from a Mediterranean insect, and some of the blue being extracted from lapis lazuli from Afghanistan, showing what expensive materials were being used and to what lengths the scriptorium must have gone to get them. The yellow would have been a substitute for gold leaf, which was never used in the manuscript, though it was applied occasionally in Carolingian scriptoria. The miniature scale is best appreciated on one page, fol. 34ro, which has a design with what looks like a large letter P, but is, in fact, the Greek letter Chi, followed by R and I, the first letters of Christ's name, which are given special embellishment because it is the first mention of the Savior's name in the Gospel text. Impossible to describe or analyze satisfactorily, it is a mass of varied ornaments, brilliantly assembled, asymmetry par excellence, execution superb in its minuteness—the whole an ocean of ornament being relieved by a small scene of cats and mice playing with one another, which may be more a reflection of life on the floor of the monastic scriptorium than of the allegorical scriptural content that has so often been read into it.

The animals are also a reflection of the manuscript makers' love of nature, as exemplified in the lovely poem, now in an Irish manuscript in St. Paul in Carinthia, about the poet-monk's cat Pangur Bán, whose proficiency in catching mice is compared to his master's acuity in discovering new meanings in the words he reads and writes. This is just one of the many examples of early Irish lyric poetry—the first of its kind in Europe to have been written in a non-Latin vernacular tongue—which forcefully evokes a closeness with the world of nature as expressed in a poem preserved in an Irish manuscript in St. Gall in Switzerland (as translated by Máire MacNeill):

> Over me green branches hang
> A blackbird leads the loud song;
> Above my pen-lined booklet
> I hear a fluting bird throng.
> The cuckoo pipes a clear call
> Its dun cloak hid in deep dell;
> Praise to God for this goodness
> That in woodland I write well.

OPPOSITE: *The most fantastic page of the* Book of Kells *is that which introduces the name of Christ for the first time in this manuscript of the Four Gospels, written probably in Iona or Kells (or both) sometime around 800. The overall design is dominated by a letter looking like a* P, *but in reality is the Greek letter* Chi *or* C, *which partially rests on the much smaller letters* Rho *(for* R *) and* I, *which follow in the name of Christ. Within this overall framework is a veritable ocean of ornament—tidal waves of spirals, animal and ribbon interlace, and even a trio of angels, which are all subservient to the overall design but never lose their impact or identity. Such a page could only have been executed by a genius with a tortuous mind that was well able to see the wood for the trees, as it were, and whose relaxing placebo in the midst of this tumultuous swirl was to depict near the bottom of the page the cats and the mice as he saw them frolicking on the scriptorium floor.*

OPPOSITE: *The* Book of Kells *is a book of the four Gospels originally bound together into a single volume, but when repaired in 1953, each Gospel was separated. St. John's was the most beloved of the four in the early Irish church, and its opening verse of the first chapter is highlighted by being given a special page to itself. With all the effusive decoration, you have to look carefully to identify the Latin words* In Principio erat Verbum *("In the beginning was the Word"), with the first three letters making up the left side and top half of the page. Then follows* rinci *in a fascinatingly decorated line just below the middle (with the* r *looking like a* B, *and the* i *formed by a seated figure), and the text continues with* pio *(with the* o *looking like a* D*), and finally,* erat, *followed on the last line by* Verbum et Verbum. *The figure at the top may represent the evangelist holding his Gospel in the right hand.*

The Irish also had the fortunate habit of bringing small Gospel books around with them. These were not the large codices like the *Book of Kells* to place on altars or to display before the public on ceremonial occasions. These were Gospel texts in small volumes, designed to encourage personal prayer and private devotion. They were easily held in the hand and, packed in a leather satchel, equally portable around the neck. The surviving examples illustrate wistful-looking evangelists, protected above by their calf or lion as the case may be or holding books of their own Gospels.

We regard the *Book of Kells* as the high point of manuscript illumination, a virtuoso performance acting as the pinnacle of a pyramid, rising up to it on one side and declining on the other. But it was not alone. Giraldus Cambrensis, the Norman-Welsh writer who was otherwise no particular friend of Ireland or its culture, went into such raptures over a manuscript that he saw in Kildare that some people think he was actually describing the *Book of Kells* (which seems very unlikely) in the following words (as translated by John J. O'Meara):

> Among all the miracles of Kildare nothing seems to me more miraculous than that wonderful book which they say was written at the dictation of an angel during the lifetime of the virgin.
>
> This book contains the concordance of the four gospels according to Saint Jerome, with almost as many drawings as pages, and all of them in marvelous colors. Here you can look upon the face of the divine majesty drawn in a miraculous way; here too upon the mystical representations of the Evangelists, now having six, now four, now two wings. Here you will see the eagle; there the calf. Here the face of a man; there that of a lion. And there are almost innumerable other drawings. If you look at them carelessly and casually and not too closely, you may judge them to be mere daubs rather than careful compositions. You will see nothing subtle where everything is subtle. But if you take the trouble to look very closely, and penetrate with your eyes to the secrets of the artistry, you will notice such intricacies, so delicate and subtle, so close together and well-knitted, so involved and bound together, and so fresh still in their colorings that you will not hesitate to declare that all these things must have been the result of the work, not of men, but of angels.

The loss of this Kildare manuscript, which must have rivaled the *Book of Kells* in its beauty and complexity, makes us only too well aware that we are trying to tell the story of early Irish art with a handful of surviving manuscripts, probably only a small proportion of those that once existed, and had they survived they would emphasize all the more what masters the Irish

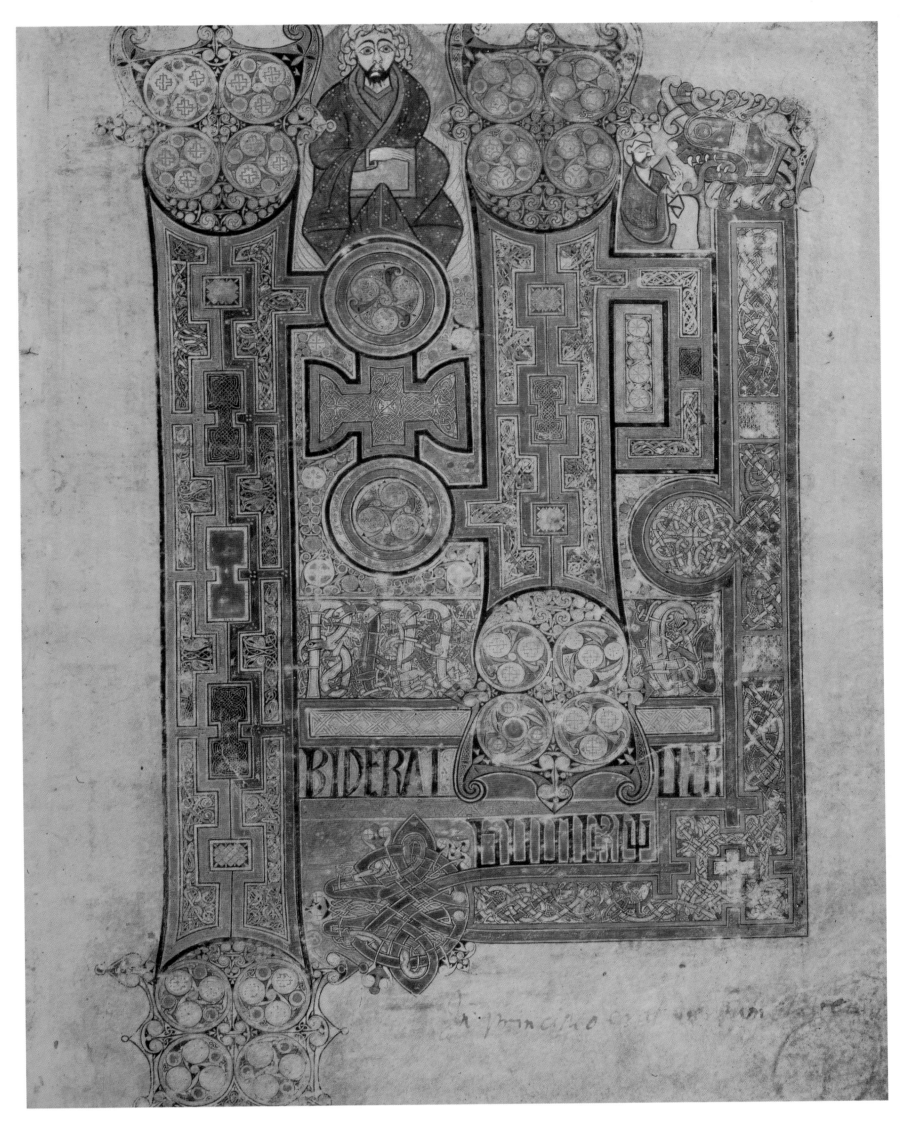

BELOW: *The monastic library in St. Gall in Switzerland possesses a remarkable collection of illuminated manuscripts, complete or fragmentary, that were brought by Irish monks to this monastery named after a disciple of St. Columbanus or written by Irish scribes on the Continent. One of these is manuscript 51, which is roughly contemporary with the* Book of Kells, *without reaching the same outstanding standard of illumination. Its endearing evangelist figures include that of St. Mark, whose steadfast eyes peer out from his bearded face and who has to squat to stay within the bounds of his frame, which includes an evangelist symbol in each corner.*

were in illuminating the manuscript page. But we are fortunate that the monastic library of St. Gall (housing the Priscian grammar text that is accompanied by the poem quoted above) also preserved other valuable Irish manuscripts, some of which were brought by monks traveling from Ireland to Switzerland in the ninth century. These include manuscript 51, a copy of the Gospels that stands second only to the *Book of Kells* in ornamentation of Irish manuscripts in the period around 800. From the historical point of view, of greater importance is the *Book of Armagh* in Trinity College, which contains the early material about Ireland's national apostle, St. Patrick. The *Book of Armagh*, written around 807, has attractive monochrome drawings of the four evangelists, but the St. Gall manuscript 51 has a much more colorful palette, differing from that in the *Book of Kells*, including a light blue in two of its miniatures illustrating two biblical scenes not found in the *Book of Kells*. Facing each other, these are the Crucifixion of Christ and his Second Coming, both with a charming set of angels guarding the figure of Jesus. The Crucifixion has

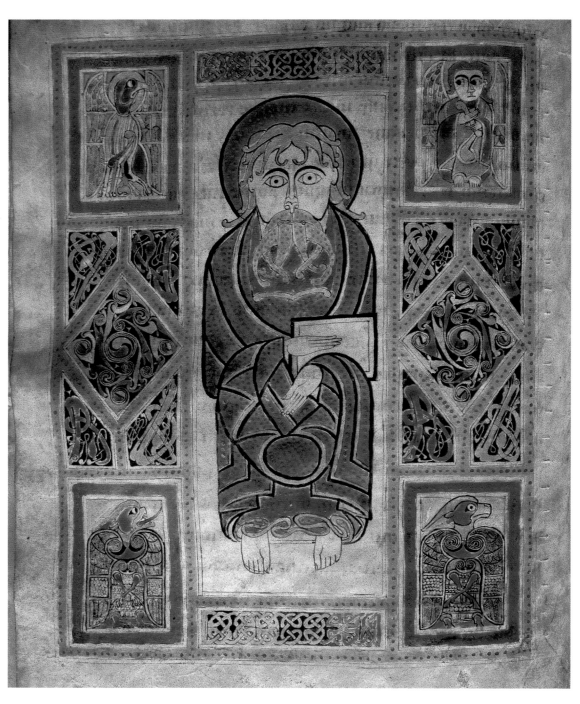

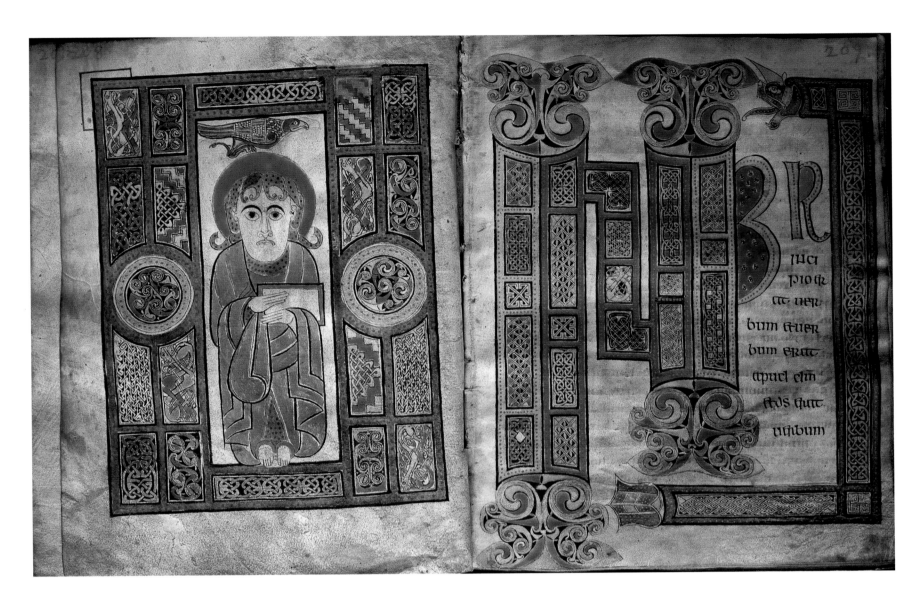

the Savior clad in a swirl of ribbons beneath which his disproportionately small legs emerge, while from his side emerges a stream of blood on to the eyes of Longinus, the lance-bearer. According to tradition, Longinus was thereby cured of his blindness, as he pierced Christ's *left* side, where the heart lies, in contrast to most western art, where it is Christ's *right* side that is pierced.

The emphasis on the size of Christ's head in contrast to the jointless arms and curiously articulated legs of the crucified Christ finds a correspondent in a remarkable bronze plaque from St. John's (Rinnagan), near Athlone, on which attention is drawn to Christ's large round—and slightly asymmetrical—face, while his limbs play a correspondingly subordinate role. The head of Longinus with his spear on one side, and that of Stephaton offering Christ the hyssop in a vessel on a long pole on the other, are turned sideways in a fashion similar to those figures in the St. Gall manuscript. But what surprises here is the way in which the breast of Christ's long garment is decorated with spiral ornament standing out in relief. It is interspersed with small domed circles, which are probably imitations of the heads of nails that would have been used to hammer a bronze plaque to a wooden original on which the metal crucifix was modeled. This habit of attaching decorated metal plaques to probable wooden originals is something that is also encountered on the High Crosses, as on those at Castlebernard and Dromiskin, showing that these impressive monuments were

ABOVE, LEFT PAGE: *Whether the manuscript 51 in the library of St. Gall in Switzerland was written in Ireland or on the European continent, it could only have been written by someone totally conversant with the décor of Irish or English manuscripts. This can be seen in the typically Irish combination of animal and ribbon interlace, fretwork, spirals, and discs seen framing the figure on page 208 of St. John's Gospel. The evangelist has an oversized head from which he looks out at us with soulful eyes. He stands meekly holding his Gospel in his hands, tip-toeing on the frame that surrounds him, while above his halo the eagle, his symbol, timidly squeezes into the narrow space left for him.* RIGHT PAGE: *In Principio—"In the beginning was the Word"—is the famous start to St. John's Gospel. Here, the initial word* In *and the downstroke of the following* P *(which looks like a* B*) are enlarged and provided with a series of separate panels filled with interlace and fretwork motifs. The frame terminates near the top right in a fearsome animal head—sticking its tongue out.*

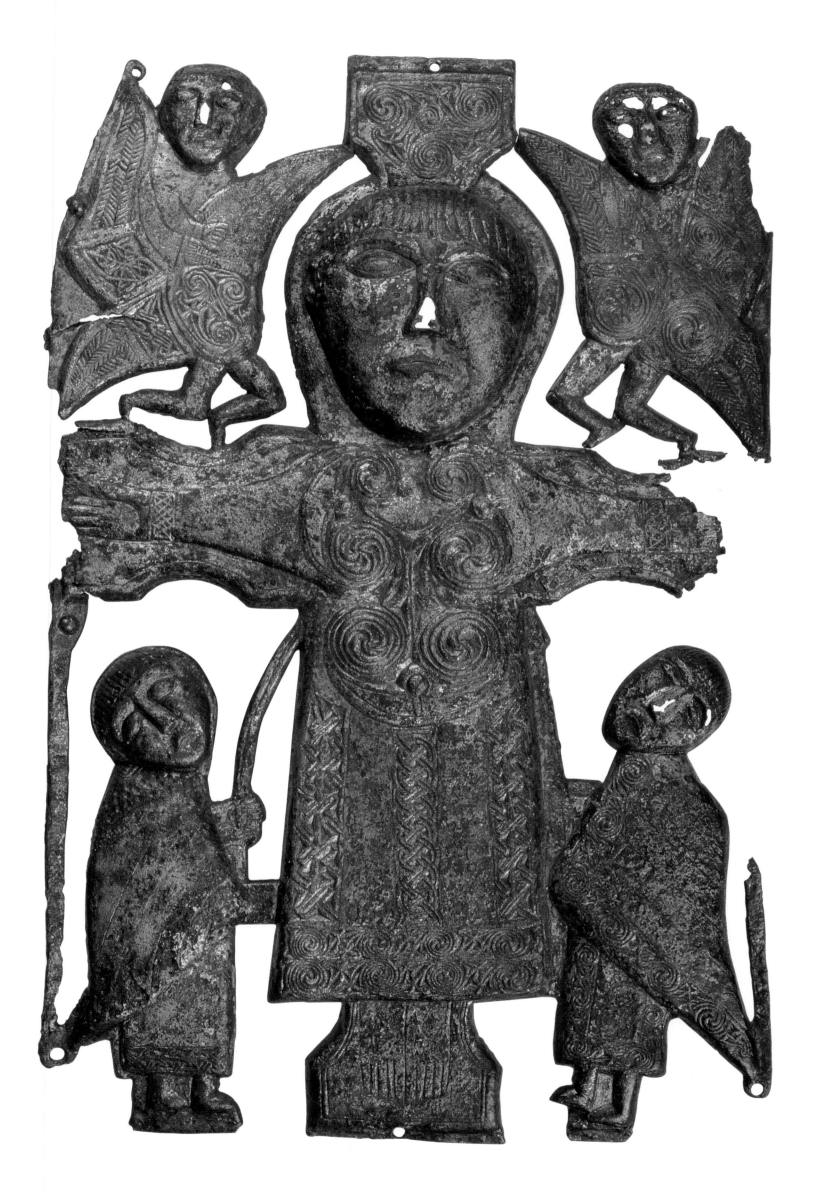

not conceived in their present stone form, but are copies of crosses in other materials that would have included wood and bronze. The most original contribution to the sculpture of Europe in the first Christian millennium, High Crosses were to become a veritable symbol of Ireland toward the end of the second.

High Crosses justifiably got their name from the old Irish annalists, who, in their rare references, used the adjective "tall" or "high" to describe these monuments, which reached a height of over twenty feet. The typical examples have a ring around the junction of shaft and arms; because they are found mainly in the Celtic-speaking lands of Ireland and Scotland, such crosses got the name "Celtic." The ring would have had a practical function in preventing the heavy cross arms from falling off, particularly since they have a narrowing notch halfway along their length that would have made them more prone to fracture. But the ring doubtless also carried symbolism, probably cosmic, because the crucifixion of Christ, whose figure is placed nearly always at the center of the ring, was seen by early Christians as, literally, the most crucial and most central event in the whole history of the universe, or cosmos.

The earliest stone crosses may not, however, have borne the ring, nor did they have a figure of Christ carved on them. To judge by its inscription, one of the earliest stone crosses, dating probably from the earlier eighth century, is that at Toureen Peakaun in County Tipperary, which has some inscribed cross ornament and is clearly a stone version of a wooden cross, as it copies carpentry techniques. But, leaving aside the Donegal examples at Fahan and Carndonagh mentioned earlier, the first truly sculpted monuments of the kind without biblical imagery form a group located in and around Clonmacnois in County Offaly. Most of these are in the form of pillars, with heads missing, but one of the group, at Bealin, County Westmeath, does have a ringed head. This small cluster of monuments lacks the biblical scenes associated with the fully developed High Crosses. Instead, they are decorated with human interlace, a deer, a horseman, or a lion, which doubtless had symbolic meaning now lost to us. It is, however, probably more than mere coincidence that at roughly the period when the Clonmacnois monuments were carved, around the year 800, the papal throne was occupied by Pope Leo III (795–816), whose Latin name means "lion." It would follow that the animals on these stone pillars or cross shafts in the center of Ireland may have been making a bow toward papal authority in Rome, which the Irish always respected even if their church did not always conform to its practices.

Analogous animal symbolism is found on a broken cross at Moone, County Kildare, which has a curious hole at the center. It was probably carved by the master hand that created the unique tall, thin cross on the same site, whose base introduces us to one of the main preoccupations of those who carved the sculpted crosses, namely the representation of narrative scenes from the Old and the

OPPOSITE: *The bronze Crucifixion plaque found at St. John's (Rinnagan), near Athlone, is one of the most intriguing pieces of figurative metalwork to survive from early medieval Ireland. Dating from around 800, and originally attached to a board or perhaps a book cover, it shows the crucified Christ attended by two angels who walk on the upper surface of the arms of the cross. Below, Longinus, on the right, pierces Christ's left side, while Stephaton offers Christ the hyssop from a small vessel beneath the Savior's chin; it is to be imagined as placed on top of the pole that Stephaton holds aloft. Christ's large head, asymmetrically tilted in death, is in much higher relief than the remainder of the plaque, thereby heightening the spiritual effect, but unexpected is the spiral ornament on his breast—doubtless imitated from a metalwork original that would have been nailed to a long-lost wooden cross.*

BELOW: *The early-ninth-century cross at Moone in County Kildare has most of its scriptural sculpture on the base, where the charmingly graphic apostle figures were carved with a naive grace by one of the master sculptors of early medieval Ireland. While all twelve appear similar, each seems to be imbued with a slightly different facial expression, and they would have originally looked much more colorful as their square bodies were almost certainly painted.*

New Testaments. These are placed one above the other on a cross, like a film strip, in order to elucidate the Gospel story or to illustrate a church dogma for those who may not have been able to read the sacred scriptures. Unlike most of the other, presumably later scriptural crosses, the scenes on the base of the tall Moone cross are to be read from the top downward. On one face, we have Adam and Eve, whose original sin described in the Book of Genesis led to Christ giving his life for mankind on the cross, which is precisely the representation that is placed back-to-back with it on the Moone base. Next beneath our first parents comes another parent, Abraham, who is shown as he is about to sacrifice his son Isaac on an altar to prove how much he loved God, when an angel appears, telling him

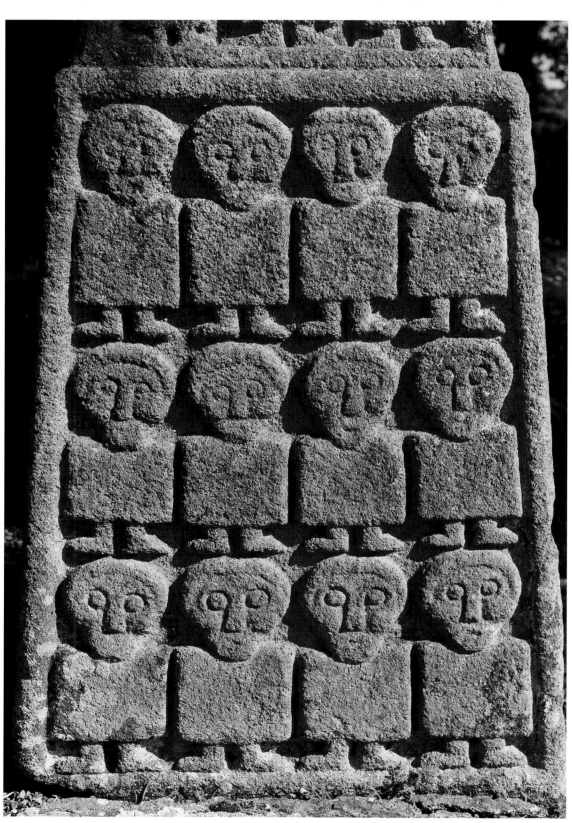

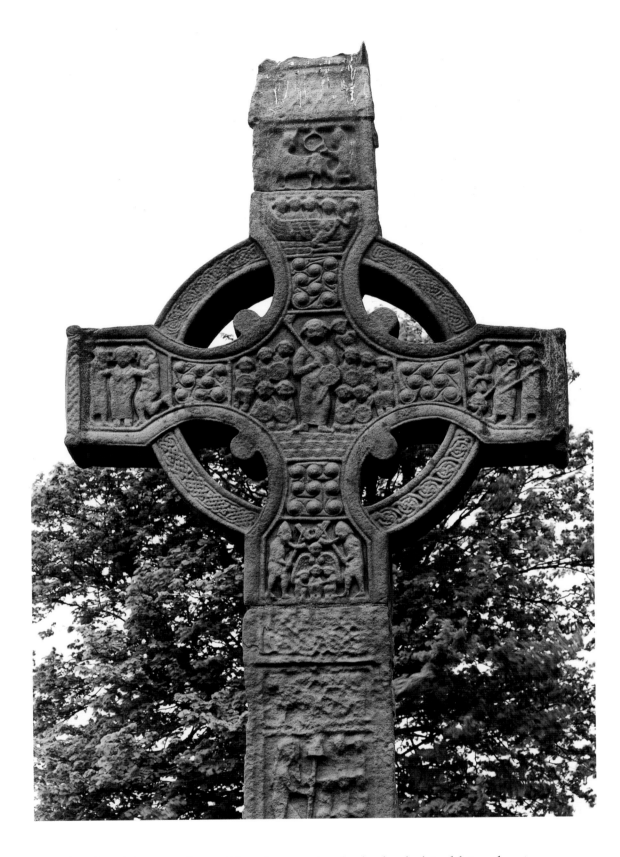

that he should, instead, sacrifice the ram in the hedge behind him that is represented above Isaac's back. Beneath is Daniel in the lions' den, saved once again by the intervention of the Lord. These latter two scenes were chosen to show how the Lord could save those of his faithful followers who were in mortal danger—in this instance, Isaac and Daniel. The same theme is repeated at right angles to these scenes through one other Old Testament example—The Three Hebrew Children in the Fiery Furnace—and two others from the New Testament—the Flight into Egypt, where the child in danger was Christ himself, saved from the spears and swords of Herod's soldiers by the angel appearing in a

BELOW: *Granite, the hard stone used for the Moone cross, also served as the material for two related crosses at Castledermot, not far away in the same county of Kildare. The South Cross shown here has the Crucifixion at its center, flanked on the right by the Sacrifice of Isaac and, on the left, King David playing his harp. The other scenes on the head are not easily interpretable, but the lowest panel seen here shows the only non-biblical figures that can be identified with certainty on the Irish crosses. These are the desert fathers Paul and Anthony portrayed in the act of breaking a loaf of bread that a bird had just brought down to them as they met in the desert. Their presence is appropriate on an Irish monastic site because they can be seen to be among the first to have practiced the ascetic life of the hermit monk.*

dream to Joseph, and the Miracle of the Loaves and Fishes, where the Lord helped those listening to the word of God by providing them with food lest they die from starvation. The help of God is one of the major themes found on Irish crosses and is present in its simplest and most direct form on the base of the Moone cross. The Flight into Egypt panel shows the Virgin riding sidesaddle on the ass, with the head of the Christ child nestling diagonally close to hers, but without any sign of his body being visible. As it is virtually inconceivable that the Christ child would be shown through his head alone, it is almost certain that his body would have been painted across his mother's square torso, pointing to the likelihood that the crosses we see as carved grey stones today were probably painted originally. An almost identical composition painted on the wall of a Carolingian church at Müstair in the eastern Swiss Alps suggests that High Cross panels and central European church frescoes went back to the same sources (probably Roman) and were transmitted by means of artists' pattern books, which would have indicated the details of how—and probably also the colors with which—each subject should be represented.

The tall cross at Moone may have been the inspiration for crosses at other sites in the Barrow valley, such as Castledermot, where the west face of the north cross has a panel of spiral ornament interspersed with imitation nail heads like those on the St. John plaque, giving further proof that High Crosses were copied from those in other materials, including bronze and wood. But the "classic" High Crosses emerge close to the middle of the ninth century in areas farther north and west, at Kells, Monasterboice, Durrow, and Clonmacnois. Kells has a fine collection of crosses, with the biblical figures standing out in higher relief than those in the flattened, graphic—and very appealing—style of the Moone cross base. Here, and on crosses at the other three locations just mentioned, we find a feeling of fleshy three-dimensionality in the figures, quite often placed in threes, which is typical of Carolingian art on the Continent. These figures are the only ones in Irish art of the first millennium that go out of their way to be represented naturalistically, albeit in an often squat format, showing themselves to be derived from a tradition of classical sculpture as practiced in ancient Rome (and probably transmitted to Ireland somehow through a Carolingian filter on the European mainland). They are, thus, the obvious exception to the general trend in Ireland to stylize the human figure, as we have seen in the manuscripts and in bronze on the St. John's (Rinnagan) crucifix plaque. Thus, both composition and sculpture found on

LEFT: *Adam and Eve strive coyly to hide their shame on the ninth-century Broken Cross at Kells in County Meath, as the apple-laden branches of the tree curve gently around the figures of our first parents after they had been banished from the Garden of Eden. They are frequently encountered on Irish High Crosses, illustrating the fall of man, which necessitated Christ giving his life for mankind on the cross, a subject nearly always present at the center of the other face of the cross.*

the Irish High Crosses are likely to be of continental origin, coming possibly directly from France rather than through England, where biblical sculpture does not have the same richness.

This richness is particularly noticeable in the Irish crosses at the four locations mentioned above, where special care was taken to choose the individual Bible stories represented. One cross, at Kells, sadly incomplete and therefore known as the Broken Cross, has a fascinating selection of sometimes obscure and even apocryphal subjects, many concerning water, that were apparently chosen in order to illustrate the advantages of baptism, one of only two sacraments recognized by the Christian church at the time.

One unexpected fact that has been emerging in recent decades through the decipherment of fragmentary inscriptions on some of the crosses is that they were set up not just by religious but also by political authorities, with patronage coming from no less a person than the High King of Ireland himself. This is attested to on one cross at Castlebernard, County Offaly, where the name of Maelsechlainn I (846–862) has been discovered, while on the Cross of the Scriptures at Clonmacnois, that of his son Flann Sinna (879–916) has emerged, showing that it was one particular regal dynasty, the Clann Cholmáin division of the widespread Uí Néill family, that were involved in setting up the crosses—not only at Clonmacnois, but at Durrow as well. The lack of any clearly identifiable names on the crosses of the east midlands, at Kells and Monasterboice, and the apparent lack of inscriptions on the northern Irish crosses, makes it unclear whether cousins of the Clann Cholmáin were involved

BELOW: *The Cross of the Scriptures at Clonmacnois, erected in the ninth or tenth century by the High King Flann Sinna and the abbot of the monastery, unusually has the ring projecting out beyond the surface of the cross face. Perhaps this was to emphasize the significance of the circle, which can be taken to have been a symbol of the cosmos. It is not surprising, therefore, to find the figure of Christ at its center because, for early Christians, the Crucifixion was the most central and crucial event in the whole history of the cosmos. The ring, however, also had a practical function in supporting the arms of the cross, preventing them from falling.*

in erecting crosses there, at places like Armagh, and Arboe in County Tyrone.

The fine group of crosses best known from those at Ahenny on the borders of Munster and Leinster were long thought to have played a seminal role in the development of the biblical crosses just discussed because they were dated on stylistic grounds to the eighth century and showed only the rudiments of biblical sculpture, otherwise being largely ornamented with geometrical motifs clearly derived from metalwork. But the pendulum has now swung more toward the notion that they were roughly contemporary with some of the larger

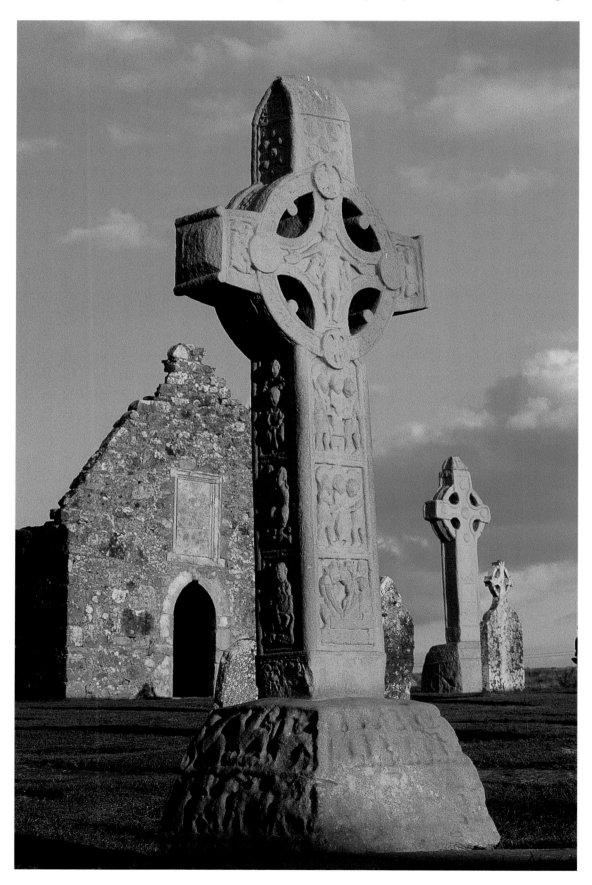

LEFT AND BELOW: *Muiredach's Cross, at Monasterboice gives us an idea of the original crispness of the High Cross carvings. At the bottom of the cross shaft, we find two seated men pulling at each others' beards* (left)—*perhaps a symbol of discord, as they are on the northern side of the cross, which is the direction from which evil was considered to have come in the medieval mind. We are also shown the hand of God emerging from the clouds and three heads mysteriously enmeshed between two intertwining serpents* (below).

scripture crosses and possibly attributable to the patronage of Maelsechlainn or his brother-in-law, Cearbhall Mac Dunlainge, King of Ossory. Like the cross at Moone, their biblical iconography is largely confined to the bases, though one or two do have figure sculpture that clearly plays a secondary role to the more geometrical patterns taking up most of the surfaces of the crosses.

Interpretation of the fragmentary inscriptions leaves open the possibility that the sculptural crosses were still erected in the first half of the tenth century, but we have little evidence that they continued into the second half of what is regarded as a dark century in European art. Lack of patronage, a dearth of capable sculptors, or a change in fashion in the way scripture was expounded, may have contributed to the end of these scriptural crosses, but it is interesting that the same fate befell manuscript production.

In the wake of the *Book of Kells*, or the St. Gall manuscripts, one of the few quality codices to survive is the *Gospel of MacRegol of Birr* in the Bodleian Library in Oxford, which may have been completed before the death in 822 of the abbot of Birr, after which it is named. The impossibly high standard of the *Book of Kells* could no longer be maintained; the bubble burst and the tension of the interlace at *Kells* is relaxed in *MacRegol*. Later, too, the drawing is less exact though, interestingly, some of the marginal designs are remarkably close to those of the metalwork grilles in Charlemagne's octagonal church at Aachen, dating from the very end of the eighth century. The greater stylization of the evangelist figures in the late-ninth-century(?) *Book of MacDurnan* in Lambeth Palace Library in London leads us to figures of almost comic caricature in manuscripts such as the *Southampton Psalter* in St. John's College, Cambridge, which may date from the tenth century. Some would ascribe it to the eleventh, but whether the tenth or the eleventh, the psalter was a swan song, a last gasp of the great Irish manuscript tradition going back to the *Cathach* around 600 before it was revived again briefly in the twelfth century in a somewhat different form.

ROUND TOWERS, RELIQUARIES & ROMANESQUE

The dispute is ongoing about the effect the Viking raids had on Irish art and culture in the centuries after their first descent on the northeastern island of Rathlin in 795. That these Norsemen raided monasteries and took religious metalwork back as booty to their Scandinavian homelands is a known fact, and these very acts may conceivably have led the Irish to create the great crosses in stone, which not even the strongest Viking could remove to Norway. The monumental power of stone these crosses display in the first half of the ninth century may also be seen on the reliquary shrines such as Teach Molaise on the Sligo island of Inishmurray, which could have been constructed to protect saintly relics more permanently from the hands of the Viking marauders. By the middle of the tenth century, when the crosses began to lose popularity and the quality of manuscript production faded, the worst of the Viking raids had passed, so we need not blame the Vikings directly for the decline, though Norse raids may have weakened the resolve—and reduced the wealth—of the monasteries to continue to work in decorative stone and vellum.

The Viking raids have also frequently been invoked as the reason for the erection of one of Ireland's greatest contributions to architecture, the Round Tower, thought to have been put up to save the Irish monks from the Viking monk-bashers. The old Irish name for these towers, however, was *cloig-theach*, or bell house. They were, therefore, not seen at the time as fortified citadels for a religious community in time of danger, but rather, as the name states, as bell towers, like their Mediterranean forebears, the Italian campaniles, which must have played some role in their development. Round Towers, which can reach a height of one hundred feet, have tapering sides and conical tops like a well-sharpened pencil. The doorway is usually ten feet or more off the ground; there are four windows on the top floor and one each for the wooden landings in between, which were connected by wooden ladders—fire hazards that would have made the structures very unsuitable as fortifications. Much ink has been spilled arguing over their function, but in an Ireland much more wooded than it is today, the towers would have been easily visible above the treetops, giving monks and pilgrims a directional indicator toward their monastery goal—for

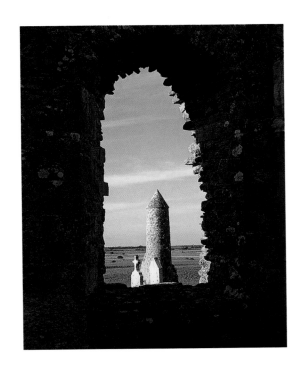

ABOVE: *The twelfth-century Round Tower attached to Finghin's church at Clonmacnois is like a beacon, symbolizing how the old Irish monasteries spread Christian light and learning across many parts of Europe during the Early Middle Ages.*

OPPOSITE: *The sword was the Vikings' mightiest weapon, and a number of them came to light in what may have been the first of their Irish cemeteries discovered in the nineteenth century in the Dublin suburb of Kilmainham. But the finest sword ever found in Ireland is that from Ballinderry, County Westmeath, now in the National Museum. Dating from the ninth century, it has a silver-mounted handle and an iron blade, which had inlaid on it the name of the maker VLFBEHRT, who lived in the Rhineland, so that the blade at least was probably German in origin and would have been bought—or taken as booty— by a Viking.*

RIGHT AND BELOW: *The slender tower at Ardmore, County Waterford (right), stands watch over the Celtic Sea close to the south coast of Ireland on the site of a monastery founded by St. Declan, who is alleged to have preached Christianity in Ireland even before St. Patrick. With its graceful and regularly spaced off-sets, it was probably built in the twelfth century, possibly one of the very last of its kind to have been constructed. The tower that lords it over the Tall or West Cross at Monasterboice, County Louth (below), has lost its conical cap—perhaps damaged in a disastrous fire that burned the books and treasures it contained in the year 1097.*

such towers were always on monastic sites. Our first reference to a tower (that at Slane, now long vanished) dates from the middle of the tenth century, but such towers may have been constructed many decades, if not indeed a century, before that. A number are mentioned in the old Irish Annals, one reference telling us that a lector, but also a book and a crosier, were burned inside the tower at Monasterboice in 1097. The very presence of these objects in a tower suggests that the towers were also used as monastic treasuries, the height of the door above ground being, perhaps, intended to keep marauders—Irish or foreign—from getting their hands on the sacred relics contained within. These towers continued to be built certainly into the twelfth century, and probably beyond, and they act as a valuable link between the first and the second Christian millennia.

What was, however, a Viking *contribution* to Irish arts and crafts is found in silver brooches. The Ardagh Chalice shows that silver was available in Ireland, at least in small quantities, before the Vikings descended on Hibernian shores, but with their arrival came a considerable increase in the amount of silver available, some of it possibly derived from Baghdad, to which eastern Viking trade routes stretched. Some of the ninth-century brooches found along with—but not dated the same as—the Ardagh Chalice were made partly of silver, with one—a so-called thistle brooch—made largely of silver with the valuable addition of gold. This was a very typical Viking brooch, as were those that are characterized by a number of interlinked bosses on their surfaces, and that have been found not only in Ireland, but in other Viking territories as well.

The Norse town of Dublin, founded in 841, quickly became an important trading station up and down the European Atlantic seaboard and was the entry

point for much of the Viking silver. The first Viking settlement there was a mile or two up the Liffey from the present city, but it was abandoned when the Vikings were ejected from the town at the beginning of the tenth century. However, when they returned less than two decades later, it was in the area much closer to the center of the modern city—around Christ Church Cathedral—that they chose to settle, ply their trades, and beach boats, which kept them in contact with foreign markets. The Vikings learned to integrate with Irish society, progressing from monk-bashers to military allies and marriage partners. In time, they became Christian, learned Irish (as some Irish also learned Old Norse), showed the Irish how to build and sail boats, and were the first to introduce coinage into Ireland, in 997. The Battle of Clontarf in 1014 is traditionally taken to be the culmination of the struggle by the Irish to rid the country of the fretful Viking invaders, but it was, in reality, more a battle among Norsemen that involved the death of the one man who came nearest to uniting all Ireland under one banner, namely Brian Boru, the High King of Ireland at the time of the battle. His family dynasty, the O'Briens, squabbled ceaselessly and vainly for a century to try to regain their progenitor's powerful position, but the real victor was to be Dublin, which, if anything, was to thrive even more after the battle and was finally to become the key to power in Ireland in the late Viking period and beyond. Excavations undertaken from the

BELOW: *The free-standing tower at the beautiful island monastery at Devenish, County Fermanagh is one of the few examples that can now be climbed to the top, giving a wonderful view over the Lough Erne scenery. The decoration (including human heads) at the foot of the conical cap fit neatly into the Romanesque canon. The foundation of a second tower was unearthed beside it thirty years ago.*

FOLLOWING PAGE: *During the ninth and tenth centuries, the Norse Vikings brought much silver to Ireland and had smiths fashion new kinds of pinned brooches for them. Those seen here on the top right and bottom left, with four little balls on each terminal, follow the pattern of earlier Irish brooches in their form and animal decoration, but the brambled brooches across the center are more a Viking innovation.*

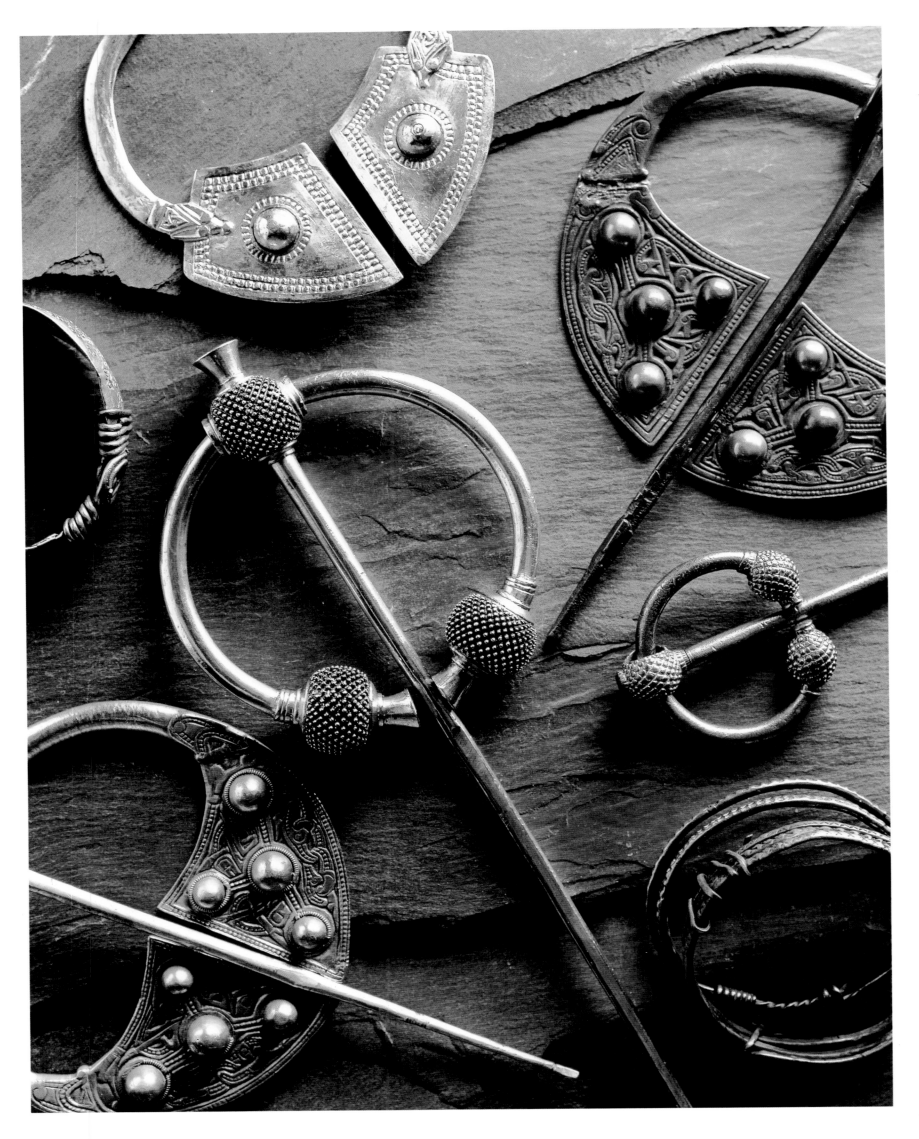

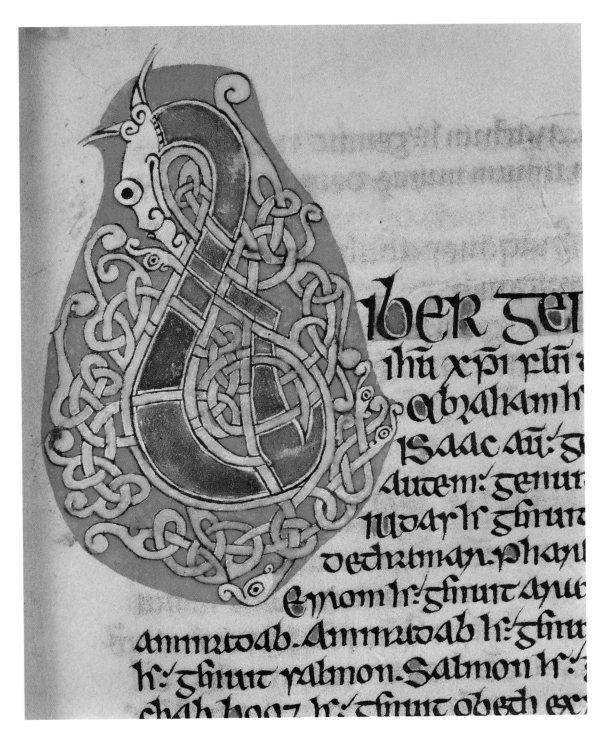

1960s to the 1980s have uncovered the wood and wicker houses of the Vikings, which were built one on top of another as each became no longer habitable, one generation after another maintaining the same plot of land.

In the old Viking city of Dublin, archaeologists discovered workshops that concentrated on the manufacture of leather for shoes and bone or antler for combs. We can be sure there must also have been important metalwork workshops, which would have helped to disseminate a new Viking style of animal ornament full of vitality that was to infiltrate Irish art in metal, stone, and even manuscript decoration during the eleventh and twelfth centuries. This style developed in the south of England, but the Dublin workshops were quick to respond to the new fashions from across the Irish Sea and executed their new patterns on wood, some of which was sufficiently well preserved to survive until unearthed in the Old Dublin excavations. But the Vikings also practiced their art on bone surfaces, some doubtless used by apprentices

RIGHT: *The* Soiscél Molaisse, *the shrine of a lost book of St. Molaisse of Devenish in County Fermanagh, has the symbols of the four evangelists framing a ringed cross on its front face. A fragmentary inscription intimates that the shrine was made at the behest of Cennfailad, who became abbot of the monastery in 1001, so that the shrine must be counted among the first pieces of surviving Irish metalwork to have been created in the second millennium. Its craftsman must have been of sufficient renown to have been permitted to inscribe his own name, Gillabaithin, on it—a respect for artists and craftsmen in medieval Ireland that manifests itself on other objects where the smith's name is also mentioned.*

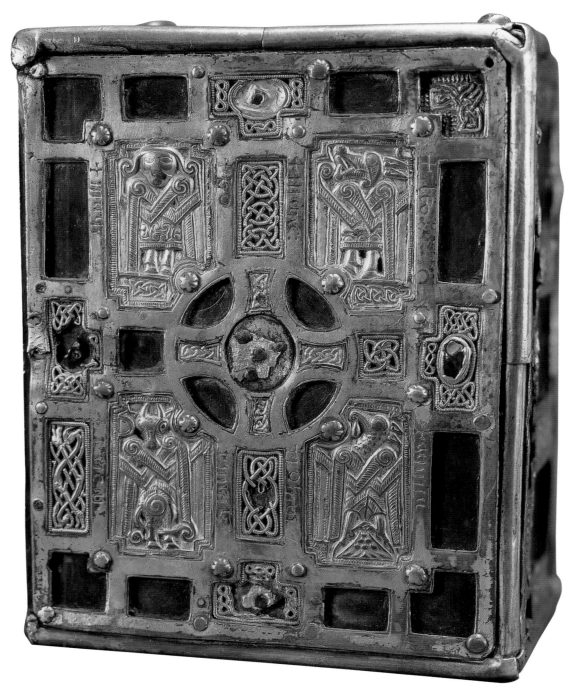

learning their trade in a malleable material before trying out the real thing on complicated metalwork pieces, such as the late-eleventh-century shrine of the *Cathach* manuscript, which reveals a fully developed Viking-style pattern on one side. The *Cathach* shrine was made, perhaps in Kells, by the son of an Irishman who bore the good Viking name of Sitric! This reliquary, which held one of Ireland's oldest manuscripts, is only one of a number of such shrines created to house important books during the eleventh century. This obviously became something of a specialty of the metalsmiths during that century, as much of the religious metalwork that survives from the period went into the making of containers for valuable manuscripts, only a few of which have survived. One of those manuscripts that did not survive was a Gospel book (*Soiscél*) of Molaisse of the island of Devenish in County Fermanagh, but fortunately its shrine or container has come down to us. It dates from around the first decade of the new millennium and it could, thus, be regarded as the first swallow of a new summer after the Christian world had survived the turn of the year 1000 unscathed, when many (though not, apparently, the Irish)

thought that the world was going to come to an end. The front is dominated by a ringed cross, with an evangelist symbol in each of the four quadrants of the whole panel that is divided by the cross. Many of the small panels decorating various surfaces have ribbon and animal interlace of a traditional kind, but the corners of the back panel do display Viking ornament in the form of a ring chain, suggesting that—as on the Isle of Man—the Vikings had been adding to the compendium of Christian art before the Battle of Clontarf.

From around 1030, we have another book shrine, that of the Stowe Missal, the shrine preserved now in the National Museum in Dublin, and the manuscript at the Royal Irish Academy. Because the top of the shrine dates from the fourteenth century, it is the narrow sides that are decorated with the usual eleventh-century ornament—a number of curious male figures, two with arms developing into wings and placed in a circular frame consisting of animals, another flanked by large and small animals, and a panel showing a harper flanked by two much taller men, one holding a bell and the other a crosier, with an angel above the musician's head. All of these figures are rather stylized in traditional fashion, but the very presence of human figures combined with long inscriptions detailing the names of those involved in commissioning or donating the shrine may well be following similar trends noticed on the European continent under Emperors Otto II and Otto III.

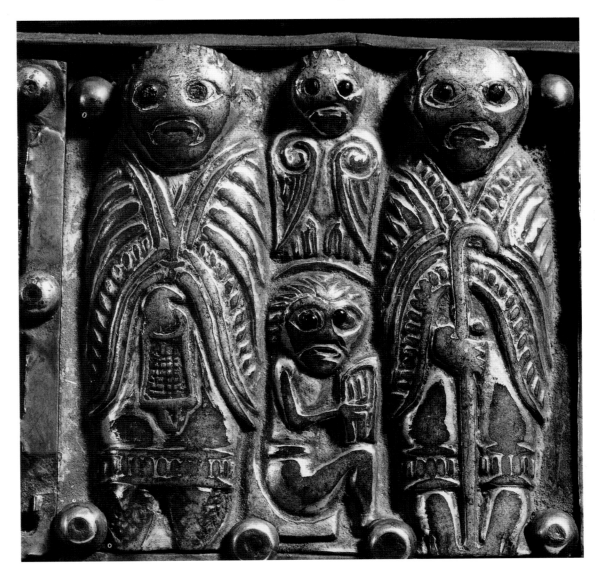

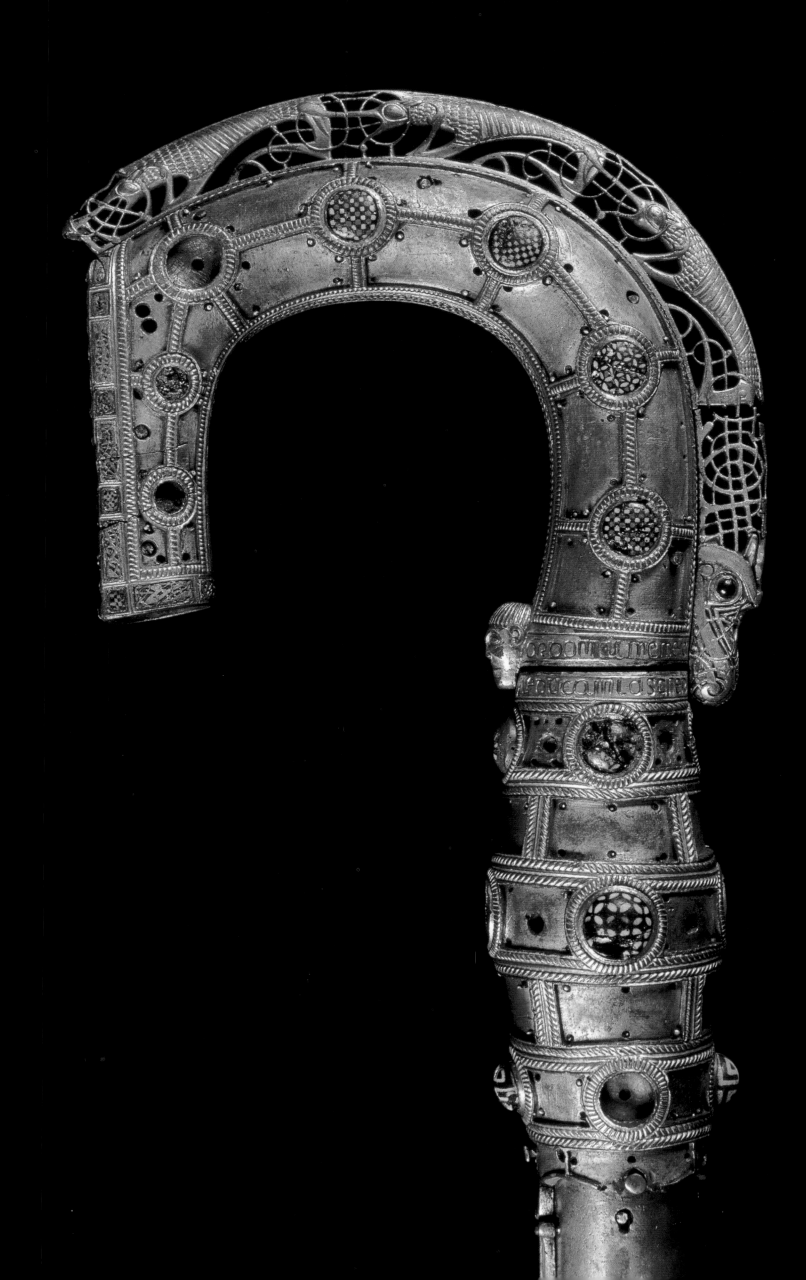

By the year 1100, those with money to commission shrines began looking to other types of objects to enshrine. The most notable example is St. Patrick's Bell, whose challenge to the bronze- and silversmiths was to fashion a new shape that would enclose it. This they met with great success, provided as they were with extensive surfaces on which to practice their craft and decorate with beautifully sinuous animals. A crosier, known as the *Bachall Iosa* or Christ's crosier and said to have been handed down from heaven to the national apostle, was sadly confined to the flames by Reformation zealots, so that we know nothing of the appearance of what must once have been Ireland's most precious relic. Despite that loss, however, there are numerous crosiers of various Irish saints that came to be enshrined in the eleventh and twelfth centuries. Indeed, no other European country has such a collection of crosier shrines as are displayed in the National Museum in Dublin. Two particularly fine examples are those of Lismore (County Waterford) and of Clonmacnois, both discovered in the nineteenth century. The latter shows new techniques such as the inlay of silver strips, while the former shows a reversion (in a different form) to the use of millefiori as practiced by Irish enamelers some centuries earlier. The business of enshrining crosiers of the founding saints of Irish monasteries goes back to at least 800, if not before.

More corporeal relics of saints were also encased in shining new metal during the first third of the twelfth century, one of the finest pieces of metalwork produced in the form of the shrine of St. Manchan, which is now preserved in the church of the parish of Boher in County Offaly. It is in the shape of a house roof and is provided with rings for poles that could be placed on the shoulders of those carrying the relics around the countryside (a good way of loosening up the population to open up their pockets and give alms and donations!). One face has an intricate equal-armed cross with domed bosses, which, like the side panels, are full of wonderfully inventive animal decoration in the Irish version of the Viking Urnes style that had developed in Norway in the preceding century. Beneath the arms of the cross, there are a number of curious men, some with forked beards and projecting ears, which are in a secondary position but reflect a curious Irish adaptation of Romanesque figures from the Continent while still retaining their Irish stylization and individuality. The arms of the cross are decorated with a yellow enamel that harks back to older techniques used four hundred years earlier. This is, perhaps, not surprising when one considers that this shrine, though lacking any informative inscriptions to tell us of its origins, may have been commissioned by the High King, Turlough O'Connor (1119–1156), of Connacht, whom one imagines considering himself an upholder of Irish traditional crafts, but who also wanted to be associated with a revitalization of the golden age of Irish art as represented by the *Book of Kells* or the Ardagh

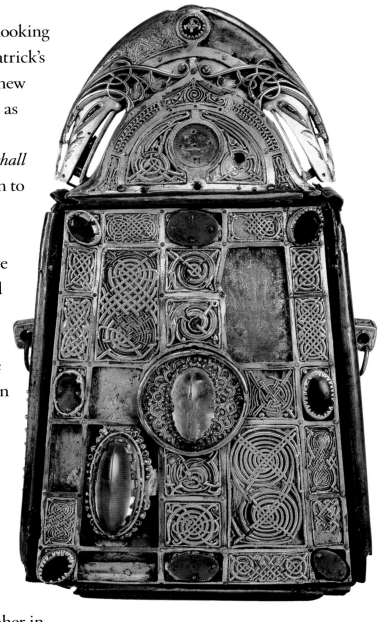

ABOVE: *One of the most revered relics in the Ireland of the later Middle Ages must have been the shrine of St. Patrick's bell because it contained one of the few objects that was considered to have been associated with the national apostle himself. In comparison to the crude workmanship of the bell itself, the well-crafted shrine enclosing it, made in Armagh around 1100, is topped by an ingenious semicircular device that features two graceful birds.*

The Cross of Cong in the National Museum represents the zenith of the metalworker's art in twelfth-century Ireland. It was intended for carrying in processions, and was so lavishly ornamented because it contained nothing less than a fragment of the True Cross—one of a number of such relics known from medieval Ireland. The fragment was preserved behind a rock crystal at the center, and the arms and shaft were decorated with a proliferation of panels bearing animal ornament (sometimes forming a figure of eight) of a kind adapted from Nordic Viking styles of the eleventh century. But this cross was made in the 1120s, to the order of the Connacht High King Turlough O'Conor, who showed his desire to revive the greatness of the golden age of the Ardagh Chalice and Tara brooch by using enameled bosses.

OPPOSITE, TOP: *Relics obviously played an inordinately important role in twelfth-century Ireland and much expense was incurred in placing them in decorative shrines where they could be presented to pious pilgrims who came to venerate them. One of the rare examples of an actual corporeal relic being thus enshrined is a fragment of the arm of St. Lachtin, said to have lived near Donaghmore, County Cork, in the sixth century. Commissioned by MacCarthy kings of Cashel between 1118 and 1121, it has the shape of an arm with clenched hand.*

Chalice. He certainly was involved in the creation of what is probably considered the masterpiece of Irish twelfth-century metalwork—the Cross of Cong, dating from around the 1120s, early in Turlough's reign. Its brilliance comes about because its purpose was to enshrine Ireland's most precious relic of all—a fragment of the True Cross on which Christ was crucified. It, too, harks back to older traditions in having arms with gently curving rather than straight sides, in using yellow and red enamel, and also in using the latest fashion in Irish-Viking animal ornament, but it differs from so many other Irish shrines in its striving for a much greater "classical" symmetry in the layout of the ornament. This was a processional cross that must have struck awe into the hearts of those who beheld it as it was carried high on important religious occasions, which would have gained added dignity by the High King's attendance. Lesser, but also very attractive, cross forms are found in the bronze crucifixion plaques—some solid, some in openwork—that may belong to this period, though valid reasons have been put forward for them to be dated earlier.

It should not be forgotten that there were also other minor masterpieces created by Irish craftsmen to impress the public with the importance of relics enshrined within. Such is the relic of St. Lachtin's Arm, dated around 1120, in the shape of a decorated arm and hand, or the Breac Maodhóg, a shrine from County Cavan that got its epithet "Breac" or "speckled" because of the multicolored saints' relics that it contained, and which is ornamented with a number of imaginative bronze figures, male and female, in various poses, holding a variety of objects—book, sword, and cross staff. Few of the figures, if any, have been satisfactorily identified, but they are probably imitating figures on British or continental shrines that its creators may have seen on their travels abroad. A solid stone sarcophagus at Clones, County Monaghan, is large enough to have contained a fully stretched body had it been hollow, and its imitation of straps and locks shows that it must be copying a bronze (or even gold?) original that has long disappeared, but which must have been modeled on a simpler version of the kind of German sarcophagi that contain the relics of Charlemagne in Aachen or the Three Magi in Cologne. It demonstrates, too, that there were once much larger twelfth-century shrines than those surviving in Ireland today.

Why all this concentration on crosiers and enshrining of relics, particularly in the twelfth century, in Ireland? Here one can but speculate that the production of these objects was in response to profound changes taking place in the Irish church during the first half of the twelfth century. Until that time, the Irish church had been operating under a system rather different from that in the rest of Christendom, organized—if such it may be called—around the monasteries that had been in existence for more than half a millennium. These were sometimes independent, sometimes grouped into families or *paruchiae*, dominated by the abbot, to whom monks and laymen associated with

the monastery would have been subservient. These monasteries had bishops who performed sacramental duties but who were not the men of religious power in the land. Elsewhere in Europe the bishops had their dioceses, which their Irish counterparts did not, and they met at synods and were responsible to the pope in Rome. The Irish monasteries venerated the papal dignity of the eternal city, but the pope did not dictate policy to the Irish monks, who, on the Atlantic periphery of Europe, lived their own lives according to their own rules. The high ideals of the original founders back in the sixth and seventh centuries became lax, and during the eighth and ninth centuries, the so-called Culdee ("servant of God") movement took hold. It attempted—successfully for a while—to bring back a sense of the asceticism and rigor of the early monks. But whether through the Vikings, or more likely for other reasons, the laxity returned and by 1100 the Irish church—which was not a single entity, but a whole number of individual units—had strayed so far from the religious precepts laid down by the early abbots that it was rife for reform once again. Property had become more important than prayer, hereditary families

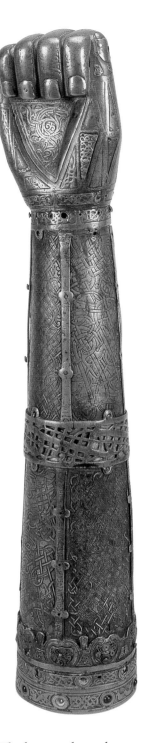

LEFT: *The bronze shrine known as the* Breac Maodhóg, *now in the National Museum in Dublin, originally came from Drumlane in County Cavan. It is decorated with a remarkable series of ornately draped figures, some male, others female, who cannot be identified satisfactorily. Many of the men are bearded and long-haired, the one shown here on the left putting his hand up to this face with such a sad expression that he seems to carry the worries of the world on his shoulders.*

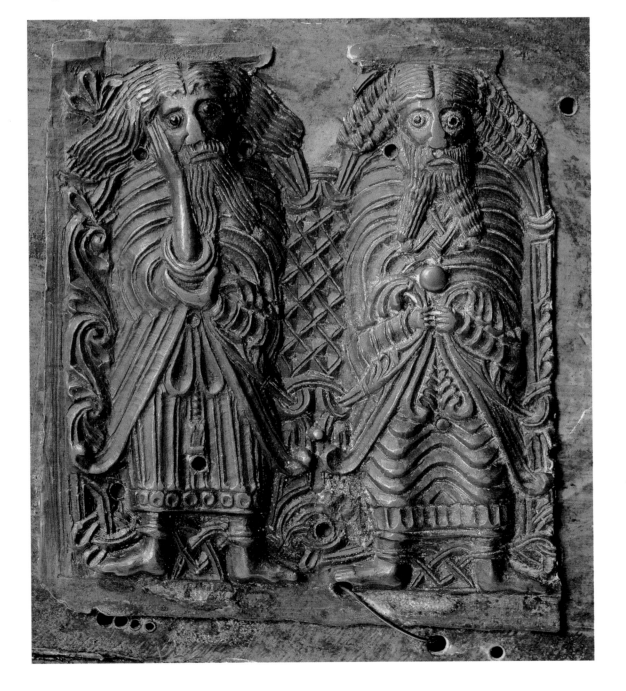

RIGHT: *The crosier of the abbots of Clonmacnois encloses a wooden staff that was probably venerated as that of the monastic founder, St. Ciarán, in whose oratory or tomb shrine it was found some two hundred years ago. Having the typical drop-head shape of early Irish crosiers, its crook is decorated with inlaid strips of silver forming animal designs in the form of figures of eight, typical of the Irish adaptation of the Scandinavian Urnes style, which suggests a date for it of around 1100. The crosier is now in the National Museum in Dublin.*

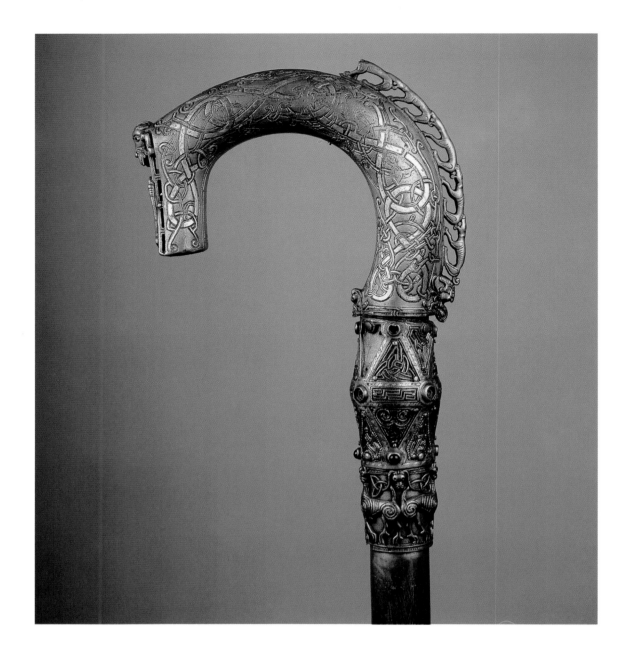

controlled the power to appoint abbots who were often not even ordained, and bishops played a subordinate role. Such a system came into conflict with the centralist tendency that had been increasing in Rome since the days of Hildebrand, who became Pope Gregory VII, whereby the pope stood at the top of an organizational pyramid that included bishops further down the line who were directly responsible to the Holy See. When this desire to extend such a standardized system of hierarchy to Ireland came via Canterbury, the Irish monasteries were seen to have been out of step, and the reformers determined that the Irish church should be brought into line. The process of reform started at a synod on the Rock of Cashel in 1101 and continued ten years later with another, not far away at Rathbreasail. Here, for the first time, Ireland was divided up into a number of bishoprics, their extent usually conforming to the political divisions current at the time. Two archbishoprics were to be created— Armagh and Cashel (in that order of seniority)—though two others (Dublin and Tuam) were carved out at the Synod of Kells/Mellifont in 1152. But the Irish monasteries did not fit into this episcopal scheme, and the existence of lay abbots and the practice of simony were such anathema to the reformists that they determined to make the monasteries subservient to the new Rome-

orientated reforming bishops. So to establish their new dioceses, the reformers gradually relieved the monasteries of their land and possessions to such an extent that they drained away the lifeblood of these venerable institutions, which had been the patrons of Irish arts, crafts, and culture for many centuries.

The monasteries were not going to give up without a fight. Their method of keeping alive must have been to attract pilgrims to their monasteries, which they must have done by dusting off the old relics and fashioning glittering new casings to impress the pilgrims. In encouraging pilgrimage, these monasteries were, however, not just preserving their very existence, but also following a trend in Europe. The twelfth century was the age of pilgrimage par excellence, when many thousands flocked to Rome and Santiago de Compostela, and when Ireland's most penitential pilgrimage, to St. Patrick's Purgatory in Lough Derg, County Donegal, began to become famous throughout Europe (at the same time the old Irish Annals recorded the highest numbers of deaths of pious people on pilgrimage in Ireland). Islands off the west coast, such as Skellig Michael or the Aran Islands, would have become popular destinations, and the island of Inishmurray off the Sligo coast was also undoubtedly a resort of pilgrims, at least one of the stone pilgrimage stations having been recently dated to the twelfth century. Pilgrimage certainly seems to be the most likely explanation for the large number of shrines of the relics of old Irish saints that can be dated to around the first third of the twelfth century—about the same time the church reformers were trying to squeeze out the old monasteries, take over their lands, and reduce their impact in order to re-design the religious landscape of Ireland. Pilgrimage also raises the question, however, as to whether some of the monuments we see standing on old Irish monastic sites were built

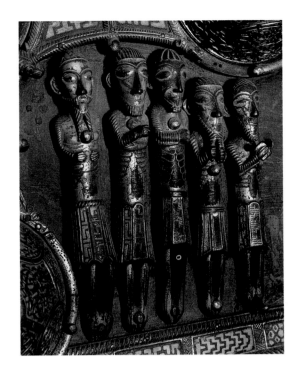

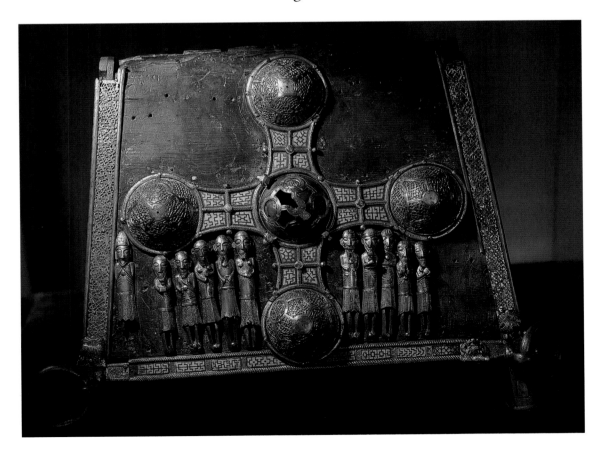

ABOVE AND LEFT: *The Catholic church of Boher in County Offaly houses one of the few medieval Irish shrines still preserved close to where it spent most of its lifetime since it was made around the 1120s. Shaped in the form of a house roof, it is fitted out with movable bronze rings at the base through which poles would have passed so that the relics of the obscure saint Manchán that it once contained could be brought on tour around the countryside. The sloping sides are dominated by an equal-armed Greek cross with animal-decorated bosses on the ends of the arms and at the center. The arms themselves are decorated with angular fields of yellow enamel that hark back to styles practiced during the "golden age" some three hundred years earlier. Beneath the arms are stylized men with varying facial traits and wearing short garments around the waist— but who they were meant to represent, or where they were originally placed on the shrine, is not known.*

The abbey of Mellifont in County Louth was founded in 1142 by St. Malachy of Armagh for French Cistercian monks whose help he needed in his efforts at church reform. Only small portions of the original monastic buildings survive, the two-story lavabo and the reconstructed cloister arcade seen here being scarcely much earlier than 1200, by which time the main thrust of the reform movement was already virtually complete— to the detriment of the old Irish monasteries, which had been the keepers of the best of Irish heritage up until then.

purely by and for the monks, or whether they were erected to service pilgrimage traffic. It is doubtful that the monks took such pains to prepare platforms for beehive huts and oratories on Skellig Michael purely for themselves—pilgrimage is a much more likely explanation for the nature of this prodigious site. The Round Towers are certainly one type of monument that may well have been erected for pilgrims, their height serving to guide the way for the devout to where the saints' remains lay.

Another type of monument that, at least in certain circumstances, would have been put up to attract pilgrims is the twelfth-century version of the High Cross. It differs from its ninth- and tenth-century predecessors in that much less emphasis is placed on biblical iconography. Adam and Eve and the Crucifixion are the only narrative scriptural subjects that can be verified without a doubt. Instead, the concentration is on high-relief figures of Christ and a bishop—either back-to-back with one another, or one above the other on the same face. The identity of the bishop figure should be the clue as to the purpose of the cross, but nowhere are we given any inscriptional information. It is unclear whether the crosses were put up by reformers or anti-reformers;

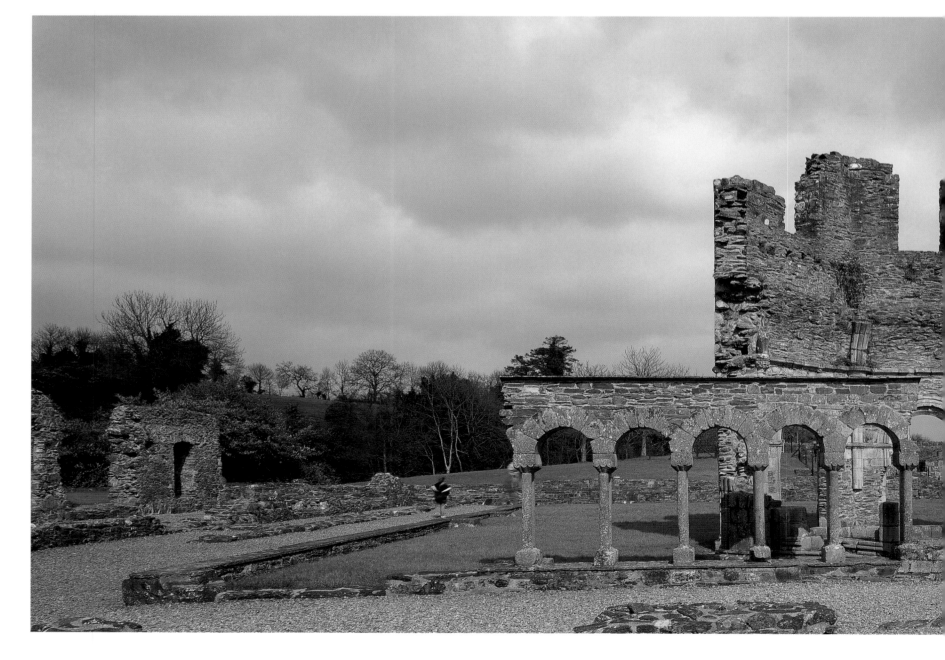

such crosses with bishop figures occur both at Cashel—where the reform movement began—and on the sites of old Irish monasteries, such as Glendalough and Dysert O'Dea in County Clare. At Cashel, the bishop could be seen as the symbol of the new episcopal church organization, whereas at the older locations he could represent the monastic founder whose relics would have been preserved on the site.

The proliferation of churches on a single site, rather than one centralized structure, is one other feature of some monasteries that could be related to pilgrimage. Such a plan could have facilitated pilgrims going from church to church doing the stations and saying a set of prescribed prayers at each one, just as pilgrims do today out in the open at Glencolmcille and St. Patrick's Purgatory in Lough Derg, both in County Donegal. The latter, in fact, made Ireland internationally known as a place of pilgrimage from around 1140 on. It is also worth noting that many of the old pilgrimage sites, which do happen to be old monasteries, have Romanesque churches, with doors, chancel arches, and sometimes even windows decorated in the round-headed style practiced by the Romans. Such churches first appeared in Ireland during the first third of

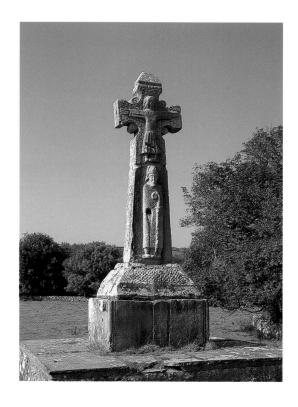

ABOVE: *The cross at Dysert O'Dea in County Clare is one of a number of examples that show how the twelfth-century crosses differ markedly from those in the ninth and tenth centuries. Other than Adam and Eve, and Daniel in the Lions' Den—both present on this cross—no Old Testament scenes recur. Instead, the twelfth-century High Crosses are characterized by high-relief figures of Christ—more in glory than in death—and a bishop or abbot who may symbolize the triumph of the new episcopal organization of the church or represent the founder of the monastery on which the cross stands.*

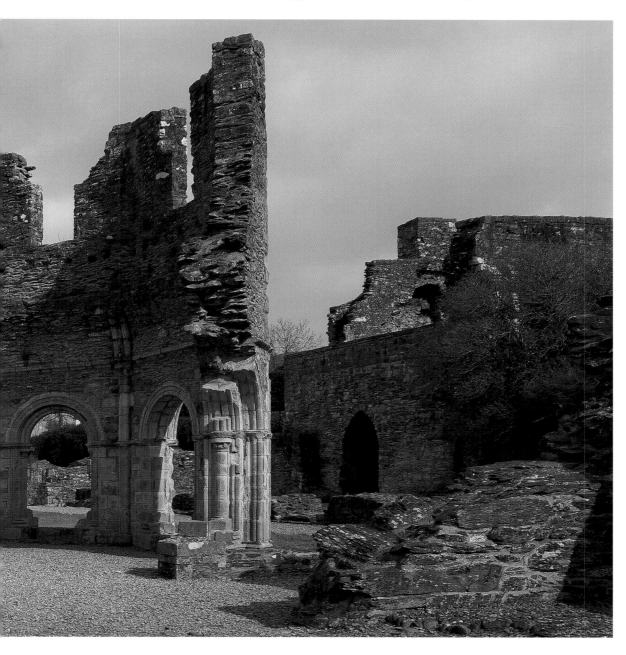

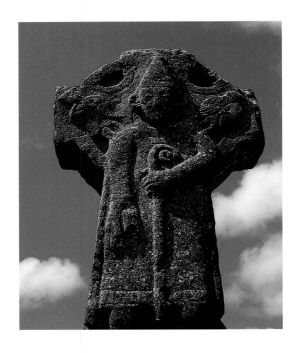

ABOVE: *The figure standing out on the so-called Doorty cross at Kelfenora in the heart of the Burren in County Clare bears a volute crosier of non-Irish type and, more importantly, a tiara miter of the kind only worn by the pope in Rome, but which may be representative here of the bishops newly established under the church reform movement of the twelfth century—to which period this cross is to be dated.*

RIGHT: *Irish Romanesque churches placed an arch over the entrance to the chancel where the altar stood, and one of the most decorative was that now preserved within the much larger nineteenth-century Protestant cathedral in Tuam in County Galway, seat of the O'Conor kings of Connacht and sometime High Kings of Ireland. With a span of eighteen feet, it is the largest of its kind in the country, reflecting its regal patronage. The quality of its carving, as seen in the detail, matches the good state of preservation for, though the church suffered a fire in 1777, it has the advantage over most other Irish churches of the period in that its chancel arch has been little exposed to the weather since it was first constructed in the 1180s. What a pity that not a trace survives of the entrance doorway of the church to which it belonged, which must have also been awe-inspiring.*

the twelfth century, St. Flannan's oratory at Killaloe being one of the earliest, according to the latest research by Richard Gem. Another is Cormac's Chapel on the Rock of Cashel, consecrated in 1134, which—like St. Flannan's—has a stone roof, a particularly Irish specialty. Cormac's Chapel is a unique structure, with three doorways, none of which is where we would expect one to be, namely in the west wall. The chapel has two square towers in place of transepts and is known to have the earliest surviving frescoes in Ireland, on which recent restoration has revealed very vivid colors, probably of English inspiration, as is much of the stone-carved decoration in the chapel. The building has been seen as the embodiment of church reform, but Roger Stalley has suggested that it is more probably seen as a kind of Chapel Royal built by Cormac MacCarthy (after whom it is called) for his own aggrandizement. It would have taken some time for the new style to become established, and doubtless the older type of church, with flat-headed doorways, would have been built until at least 1200, particularly in the West of Ireland. However, by the third quarter of the century, the Romanesque style had become widespread in church building, and the last quarter would have been its high point, with churches such as Monaincha, County Tipperary, as well as Tuam, County Galway. Clonfert would come around the end of the century, its highly ornamental portal beckoning the pilgrim to enter the cathedral to view the alleged burial place of St. Brendan the Navigator, who is credited with having discovered America.

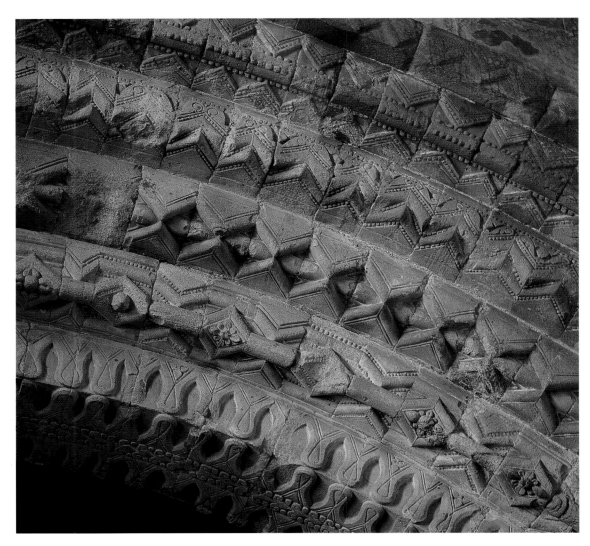

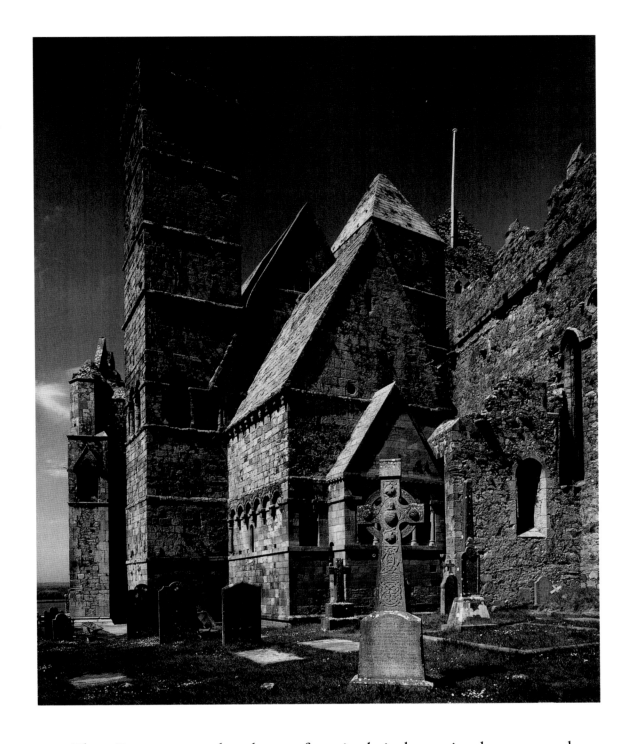

These Romanesque churches conform in their decorative doorways and chancel arches to a style found in England and on the European continent, but it is remarkable how little Ireland was otherwise influenced by the great flow of art and architecture in that style, which manifested itself in so many other parts of Europe during the eleventh and twelfth centuries. Instead of being filled with figures dressed in graceful, long garments with falling drapes and with an appealing, almost mystic, expression on their faces, the few twelfth-century manuscripts we have tend to revert back to older Irish traditions; initial letters are ornamented with interlacing animals or evangelist symbols that developed some centuries earlier, all with a noticeable lack of the human figure. But the human figure does, however, appear in architectural sculpture at places like Kilteel, County Kildare, and, more particularly, at Ardmore, County Waterford, where the west end of the cathedral is largely taken up with a jumbled assemblage of sculpted stones, some of recognizably biblical character and dating perhaps from around 1170. Much farther north in Maghera, County

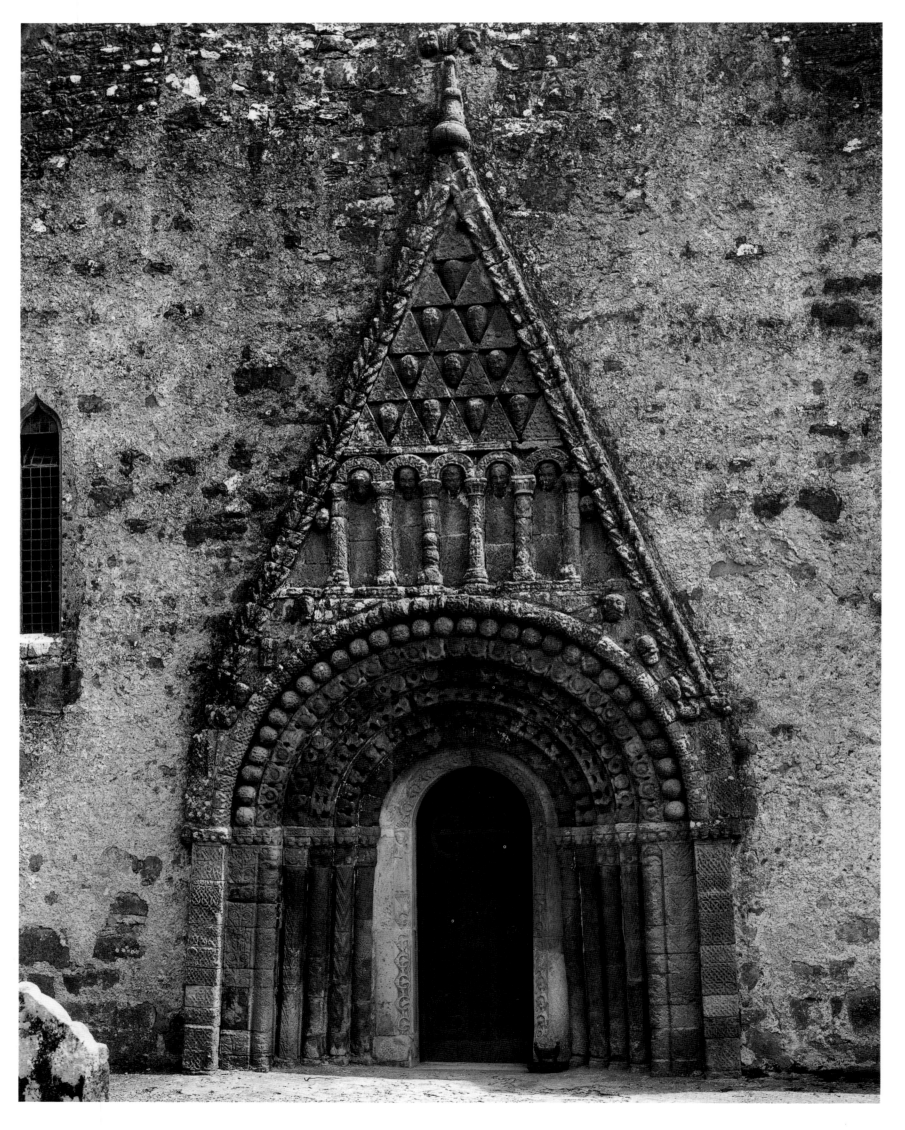

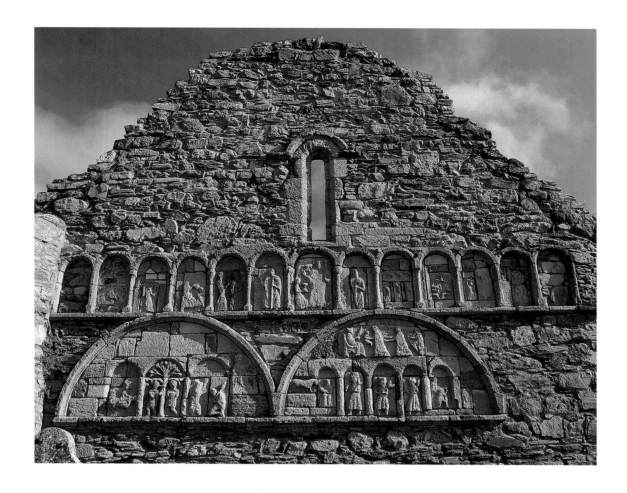

LEFT AND BELOW: *The west wall of the cathedral at Ardmore, County Waterford, has built into it a series of larger and smaller arches containing sculptures that are jumbled together out of context, so that it is difficult to make coherent sense out of them. However, one scene is easy to recognize—that of Adam and Eve beneath the tree in the large left-hand lunette. That on the right, better visible in the detail below, shows in its upper portion another recognizable event, the Judgment of Solomon, in which the king cleverly finds out which of the two women approaching him is the real mother of the child held out to him. Himself a temple-builder, Solomon was perhaps considered a suitable personage to adorn the walls of a cathedral that had been built anew apparently around 1170.*

OPPOSITE: *The apogee of Irish Romanesque church doorways is that at Clonfert, through which a multitude of pilgrims have passed down the centuries to pay their respects to the great maritime explorer St. Brendan, whose remains traditionally lie within. The doorway was built around 1200 (though its innermost order is three hundred years younger) and is so richly decorated that scarcely any of its surfaces are left unornamented. It displays proudly a rich compendium of animal, floral, and geometric designs. Human heads manifest themselves in the tangent gable above the arch, those in the triangle at the top being partially bearded, but one is clean-shaven, looking forward to the idealized Gothic style, which had just been introduced to the east of Ireland when this doorway was constructed.*

Derry, and Raphoe, County Donegal, there are Crucifixion scenes that form lintels of churches, a feature that is very rare on churches elsewhere in Europe, and one that combines the lintels typical of the older Irish churches with the figure sculpture of the Romanesque style.

The metalwork—the typical shrine types such as crosiers and those that are house-shaped—can be seen to be idiosyncratically Irish, as is much of the manuscript ornament. Arts and crafts of the period were remotely connected to developments in Britain and on the European continent, but the majority of Irish objects dating from the twelfth century could only have come from Ireland, so different is the character of Irish metalwork and manuscripts from that elsewhere in Europe. This is probably due to the fact that the Irish monasteries were fighting a rearguard action against the new church reformers, showing their independence and individuality, but also their conservatism by returning to older Irish traditions and even recording old lore and tales that go back to the beginnings of recorded Irish history. These would have been completely lost to posterity had the monasteries not written them down in great codices associated with monasteries such as Clonmacnois and Glendalough. It was these monasteries that made the Irish version of Romanesque so different and invigorating, and which preserved Irish culture against the influx of reformers whose main goal was the revitalization of religious life rather than the retention of old traditional styles in art and literature. The monasteries did their work of recording only just in time, as many of them were to fade away and die in the face of church reform and its related events.

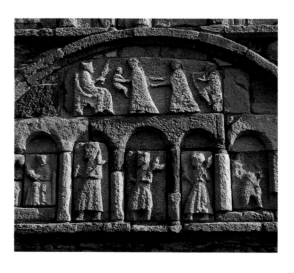

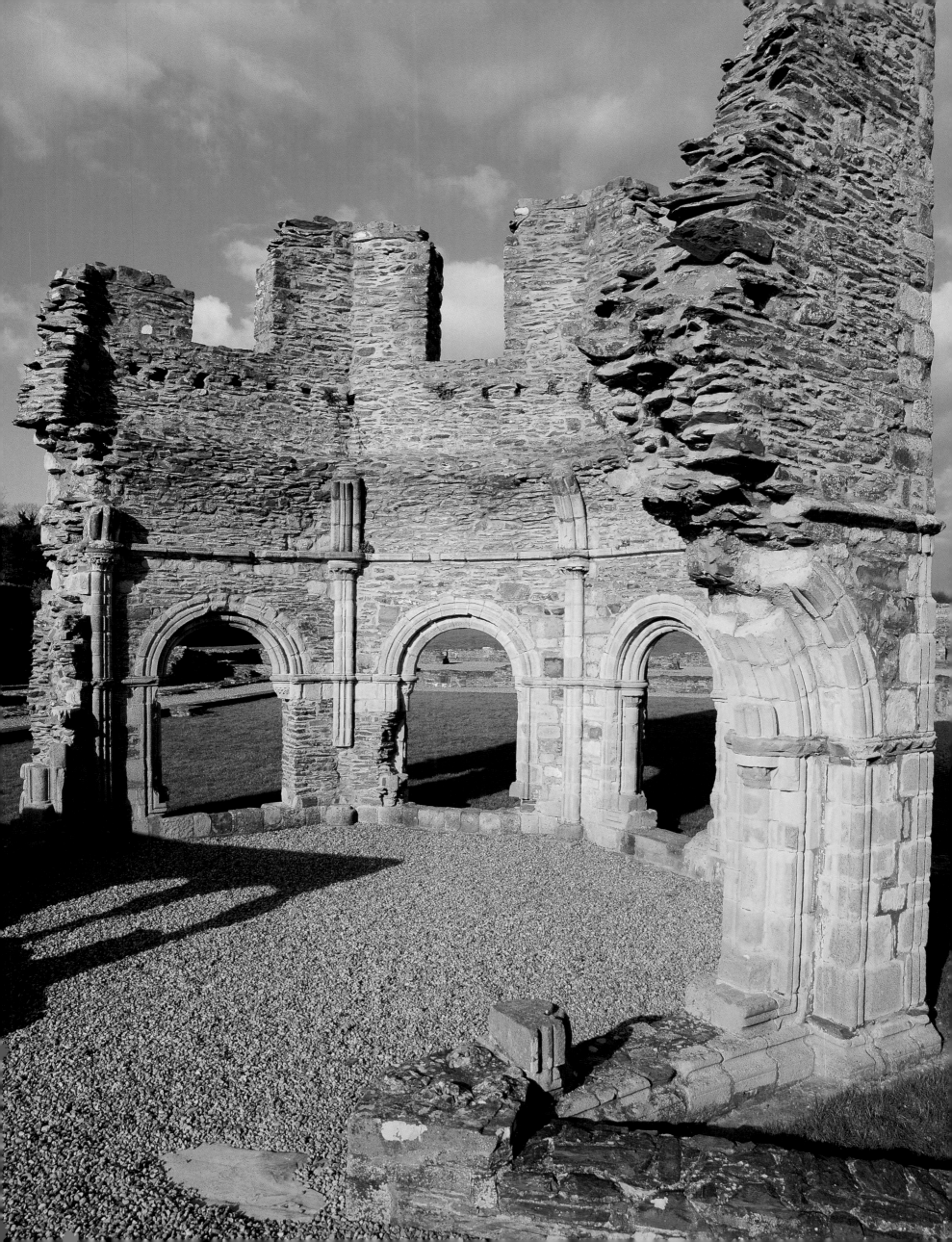

THE EARLIER GOTHIC PERIOD
Architecture and Craftsmanship

The first of the pivotal events that were to change the face of Ireland utterly in the twelfth century was the arrival of new continental monastic orders, prime among them the Cistercians and the Augustinians. The latter took over and kept alive many of the older Irish foundations, whereas the Cistercians started very much anew. This all came about because of the great Irish reformer St. Malachy of Armagh, who made it his mission to restore a spiritual dimension to the religious life of the Irish people. Malachy had been archbishop of Armagh, but resigned and later went traveling on the European continent, initially to study the rule of the Augustinians. Later, on his way to Rome, he called at Clairvaux, where he immediately struck up a lasting friendship with its famous preacher, St. Bernard, and was so impressed by the rule of his Cistercian order that Malachy requested the pope to allow him remain at Clairvaux for the rest of his life. This request the pope refused, on the grounds that Malachy would be of greater use in the mission fields of Ireland trying to convert the Irish to the Roman way of thinking. But Malachy did succeed in getting French monks to come to Ireland to help him found the first Cistercian house in the country at Mellifont on the banks of the Mattock in County Louth, which was to become a spearhead in the movement for monastic reform. Malachy was later to return to Clairvaux, again on his way to Rome, and died in the arms of St. Bernard, who was to write his biography and request that he be buried alongside his Irish friend in front of the high altar at Clairvaux.

In the same way that the ascetic ideals of the Irish monasteries had appealed to Irish minds in the sixth century, so also in the twelfth century the Irish took the new monastic order to their hearts, and Mellifont expanded to such an extent that within twenty years it had that number of daughter houses scattered throughout the four corners of the country. Wherever they went, the Cistercians introduced a new style of architectural monastic layout—a church on one side of an open-air cloister garth, the other sides being taken up with a chapter house for communal meetings, refectory, kitchen, stores, and dormitory. At first, in places such as Mellifont and Baltinglass, the order used the Romanesque building style, but by the end of the century, at houses like Inch in

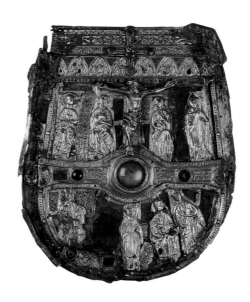

ABOVE: *The shrine of St. Patrick's tooth looks very un-dental and has more the shape of a purse to hold the money necessary to have it made, but it was nevertheless created to contain the tooth of the national apostle. It was around the 1370s that a venerable home was made for it, in the form of this shrine commissioned by Thomas de Bermingham, Baron of Athenry in County Galway, but utilizing older fragments in its decoration. St. Patrick features in episcopal robes on the front, beneath the figure of the crucified Christ, who is accompanied by the Virgin and St. John and some Irish saints. The shrine was used for curing sick animals into the nineteenth century.*

OPPOSITE: *The two-story lavabo at Mellifont, County Louth, built around 1200, once resounded to the sounds of water issuing from a fountain at its center to encourage the Cistercian monks to wash their hands before and after meals. Eight-sided with an open arcade giving access to a once-vaulted interior, this structure—despite its fragmentary state—is probably the most elegant building to survive from medieval Ireland.*

OPPOSITE: *The noble row of arches that once separated the nave and aisles of the twelfth-century Cistercian foundation at Baltinglass in County Wicklow is now dominated by the tower of a nineteenth-century church, which, like the original structure, is no longer in use. The monastery came into being under the patronage of Dermot McMurrough, King of Leinster, whose benefactions to churches such as this are all too often overlooked when weighed against his ill repute as the man who brought the Normans to Ireland.*

County Down, the new style of Gothic architecture emerged, with its pointed arches, and it was—with some interruptions—to remain popular in Ireland down to the nineteenth century. One of the most successful Cistercian buildings was the octagonal lavabo at Mellifont, dated to around 1200, with its delicately carved sandstone capitals, and which was strategically located opposite the refectory so that the monks could wash their hands before and after meals. The Cistercians are credited with being the first to introduce organized agriculture into Ireland; so much of their time was taken up with clearing the land around their new foundations and also in praying that they had little time for cultural pursuits. Other than having breathed a new spirit into Irish monasticism, their main contribution to Ireland was the introduction of the new architectural plan of the monastery—so different from the seemingly random nature of older Irish monastic layouts—and the fine, tall, aisled churches that went with it.

The introduction of Gothic architecture into Ireland was not achieved by the Cistercians alone; they did it along with the people who caused the second great upheaval in twelfth-century Ireland, this time in the political arena— the Normans. These adventurers were Vikings in origin, having come from Scandinavia to settle in Normandy (to which they gave the name), and then following William the Conqueror across the English Channel in 1066. A century later they were approached by the deposed Leinster king Dermot McMurrough to help him regain his kingdom. At the king's bidding, the Normans came to Ireland under Strongbow in 1169 and by the end of the century had overrun not only the province of Leinster, but also much of Munster and east Ulster. This they were able to do because the Irish were not at first sufficiently well organized to resist, nor were Irish weapons strong enough to penetrate the chain mail and armor of the Norman invaders. The Irish method of warfare at the time consisted more of cattle raids than the total conquest of the land, such as that practiced by the Normans. As a result, the Irish suddenly found themselves with new political masters and a feudal system, which, though not unknown earlier in Ireland, left the Irish no slice of the local political cake. To establish what they had won by the sword in the early years of conquest, the Normans built mottes, earthworks shaped like an upturned bowl, sometimes accompanied by a lower-lying flat area known as a bailey. But only fifteen years after their first landing, the Normans were already constructing more ambitious defenses, the largest of which is Trim Castle beside the Boyne. There they created a man-made island by rerouting some of the river's water and began to build the main tower, or donjon, in the shape of an equal-armed cross, designed as much to impress as to defend. The tower took more than twenty years to finish, and it was further protected by the building of an outer curtain wall interspersed with towers, two of which had elaborate drawbridges to control access. Next in size to Trim is Carrickfergus Castle in

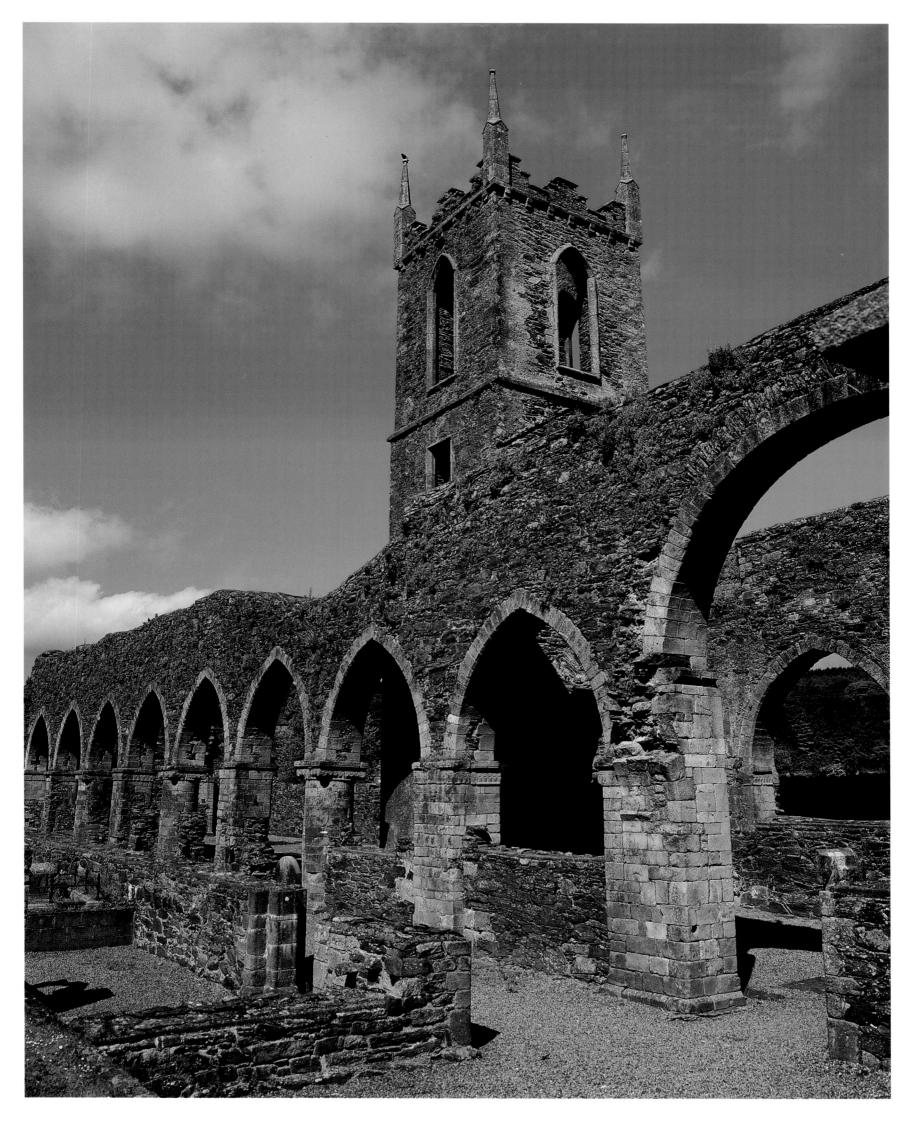

County Antrim, which dominates the shipping lanes in Belfast Lough and was built as the major fortification of the Norman baron John de Courcy, who had swept through the eastern counties of Ulster by 1180.

The English king Henry II became unhappy with the speed at which his barons were conquering Ireland, fearing that they might want to set themselves up independently of him, so he came to Ireland, established his capital at Dublin, and ensured that his barons would not create their own kingdoms. By 1204, Dublin Castle was begun, to create a center of English government, which was to last until handed over to the Irish Free State in 1922. Though the great hall of the castle was burned in the late seventeenth century, and much of the castle fabric refurbished in the eighteenth, the rounded bastions in the outer walls are still reminders of the royal presence in the capital city.

Before King John visited Ireland in 1210, he established other castles at places like Limerick, and was probably responsible for the earliest surviving portions of Carlingford Castle overlooking the County Louth Lough of the same name.

As part of establishing themselves in towns, the Normans also began the task of emulating their English and continental forebears by taking on the mammoth task of erecting noble cathedrals. Dublin's Christ Church is one of the oldest of these, located on a slope at the center of the old Viking city, though it was founded by the Norse king Sigtrygg in 1038. Its earliest upstanding parts date from around or shortly before 1190. Though its style was still Romanesque, with figured capitals and chevron-decorated doorways, by the year 1200 the Gothic style began to dominate the cathedral, doubtless aided by the employment of masons who would have been brought over from the West of

BELOW: *Trim Castle on the river Boyne, the mightiest and most extensive Norman fortress in Ireland, was built in the twelfth and early thirteenth centuries and is dominated by a tall central tower intended to be a status symbol as much as a protection for the Norman baronial family of De Lacy, who erected it against the native Irish whose lands they had taken by the sword. It was further fortified by a massive curtain wall with towers at intervals along its length and provided with drawbridges over the waters of the Boyne that were diverted to create a man-made island, making the castle more difficult to attack.*

England—probably through the port of Bristol, to whose citizens Henry II had granted the city of Dublin in 1172. There may well have been a gap in time from construction of the Romanesque east end to the commencement of the cathedral's nave, which belongs essentially to the second or third decade of the thirteenth century. The style used is Early English, with graceful pointed arches separating nave and side aisles, and vertical columns between the arches soaring to link the triforium and clerestory levels above them. It should be pointed out, however, that the vault of the nave, the south side of the nave, and the west end are all products of the nineteenth century, by which time the cathedral had become structurally unsound and in need of extensive rebuilding, a job undertaken by the English architect George Edmund Street in the 1870s.

The undercut chevron on the Romanesque doorways that was introduced from the West of England traveled farther westward into Gaelic territory in the

West of Ireland, where it was practiced by some masons who had worked on Christ Church, or those who had learned the technique from them, but also by others who may not have had any hand at all in the ornamentation of the cathedral. The undercut chevron was one of the most important elements in what H. G. Leask dubbed "The School of the West," a group of masons—perhaps a traveling workshop—who participated in the construction of a number of Connacht buildings as well as some in County Clare. This school is characterized, among other things, by the use of splendidly worked masonry, with flat surfaces where the stones fit so closely together that a knife could scarcely be inserted between them. The capitals are usually carved with foliage and animals, though also occasionally with human heads and figures.

The same transition from Romanesque to Gothic can be seen at Boyle Abbey, where building began with the chancel no earlier than the third quarter of the twelfth century and continued on until around 1220, by which time the western end of the nave would have been completed. It is in the nave in particular where the change from Romanesque to Gothic is most evident, the heavy Norman-style cylindrical drum columns supporting the arcade changing to the more delicately molded Gothic styles. Birds (but also human figures) decorate the capitals of this Cistercian abbey; they are also seen in the attractive

ABOVE: *It took the Cistercians almost twenty years after their first arrival in Ireland in 1142 to make a successful new foundation in the western province of Connacht, which they did at Boyle, County Roscommon, around 1161. Even then, it took more than half a century to finish the church, which started at the eastern end in Romanesque style and had gradually turned into a Gothic structure by the time the west gable was finished around 1220. Two stages in the process of development can be seen in the nave arcade, with the Norman drum pillars on the right giving way to more solid masonry supports further to the left with pointed Gothic arches visible beyond. The cloister in the foreground suffered heavily from the monastery having been used as a military barracks in the seventeenth and eighteenth centuries.*

capitals in the chancel of the Augustinian foundation at Ballintober, County Mayo, showing that in the West the school was not the monopoly of any one religious order. The Cistercians, however, did get the lion's share of their work, as the masons were busy practicing their style at Abbeyknockmoy in County Galway and—beyond the bounds of Connacht—in Corcomroe, in the Burren area of North Clare in Munster. This latter abbey is unusual not only in having large human heads (which could even be an attempt at portraiture) that fly in the face of St. Bernard's strictures against figural or demonic representations in Cistercian churches, but also in a series of capitals bearing identifiable, though unusual, plants, which may have been copied from those growing in the monastic herb garden. It is not surprising that the abbey bore the sobriquet "of the fertile rock"; Roger Stalley pointed out that Corcomroe's naturalistic foliage predates a similar movement toward naturalism in England by at least half a century. Corcomroe and Ballintober also show the way in which moldings of the windows, both exterior and interior, neatly tie the three lancet windows of the east wall together.

An animal figure at the southeast corner of the church recurs in almost exactly the same fashion in a doorway taken from an older church and inserted into the cathedral at Killaloe, County Clare, dated by Tessa Garton to around 1200. This may, indeed, be one of the earliest examples of the ornamental richness of the School of the West, the east windows of the cathedral showing the same undercut chevron effect found in Christ Church Cathedral. Two of the latest expressions of this fine school of sculpture in the West of Ireland

ABOVE AND BELOW: *The Cistercian abbey of Corcomroe was built around 1200–1220 in the hauntingly beautiful landscape of the Burren in northern County Clare, a botanist's stony paradise full of exotic flowers which doubtless inspired the abbey's name of "Saint Mary of the Fertile Rock." In and around the chancel area there are unexpectedly naturalistic carvings of plants, including the opium poppy, which the monks may have used for medicinal reasons. There are also some head capitals that seem to be portraits, like that illustrated here, which fly in the face of the exhortation of St. Bernard of Clairvaux to his Cistercian monks not to have carvings such as this in their churches lest they prove a distraction from prayer and pious thoughts.*

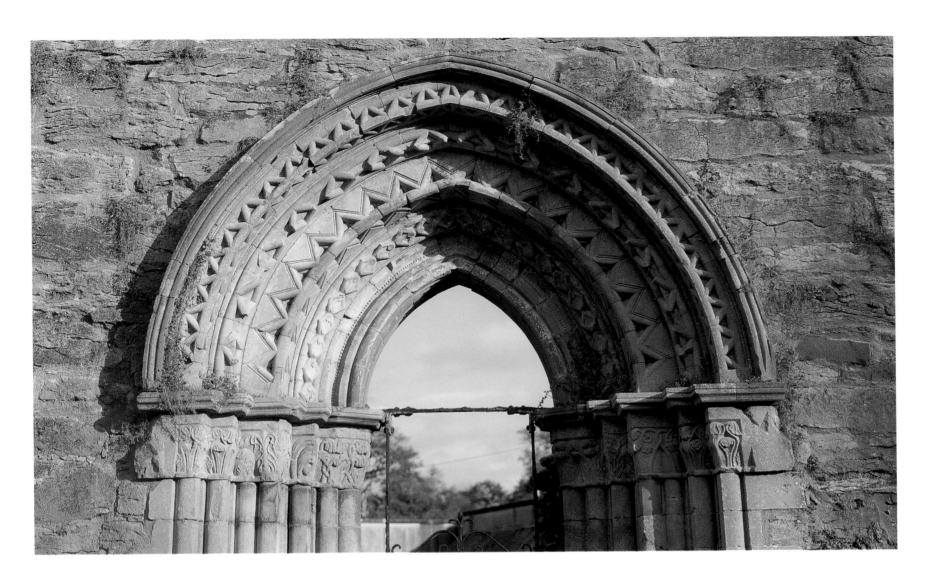

are the doorways at Drumacoo, near Galway Bay, and the abbey of Cong in County Mayo. At Cong, the old Romanesque chevron-style decoration is married to the new pointed arch of the emerging Gothic style, which was gradually percolating in still-Gaelic western Ireland. While war among the royal O'Conor family and the resulting banishment of *lucht eladna*, or people of the arts, to foreign parts in 1228 may have contributed to the decline of the School of the West, its end was marked by the successful Norman invasion of Connacht in 1235, which appears to have caused building activity among the native Irish to stagnate.

The Normans found it difficult to conquer the spirited population of Connacht and, before the end of the century, the Normans were forced to construct stout castles to continue the struggle—at Roscommon and Ballintober in County Roscommon and Ballymote in County Sligo. Of these, the most impressive was Roscommon, where a roughly square area was provided with tall, thick walls, projecting rounded towers at the corners, and a narrow front entrance flanked on each side by more rounded towers. A now dried-up lake beside the castle was also part of its defenses, in which the Dublin government invested a great deal of money implementing the latest fortificatory techniques, which were further developed in Wales under King Edward I. A fortress such as Roscommon was the height of Norman castle building in Ireland, but it should be seen as a later continuation of the series of

ABOVE AND BELOW: *The pointed Gothic doorway in the Augustinian monastery of Cong in County Mayo, of the 1220s, is one of the last expressions of Romanesque-style sculpture, which lasted in the West of Ireland long after it had gone out of fashion farther east. It is a product of the "School of the West" sculptors, whose plant-capitals on this Cong doorway have echoes of the somewhat earlier stylized foliate capitals at Corcomroe seen in the detail below.*

other castles built throughout the country, with a particular preponderance in Leinster—and also to very different designs. Some of these were simplified, smaller versions of Roscommon, rectangular in shape with corner turrets, as found, for instance, at Carlow. Others concentrated on outer enclosures with a tall tower within—angular at Roscrea, round at Nenagh and at Dundrum in County Down. Others were perched on top of hills, such as the now romantic ruin of Dunamase in County Laois (built on an earlier Irish fortification) or Castleroche in County Louth. Some castles defended river crossings, such as Limerick or Clonmacnois; others, such as Athlone, County Westmeath, or Rinndoon, County Roscommon, provided a Norman foothold on the west bank of the Shannon that could act as a base for further conquest.

While the Normans were building these individual fortifications, they were also entrenching themselves in the towns, which they used as their centers of power and commerce. Many of the medieval towns in Ireland were protected by a set of town walls, the building of which depended on grants given and rates levied. The town walls of Athenry in County Galway, Fethard in County Tipperary, and Youghal in County Cork, are still reasonably well preserved. The most impressive part of a town wall is found at Drogheda, where the fortifications north of the Boyne were protected by a barbican that stood in front of the main gate. The walls have disappeared, but the barbican—probably built around 1250 and known as St. Laurence's Gate—survives as a twin-towered defense that controlled access to and exit from the town.

The Normans were not just occupied with protecting themselves by erecting castles, or their property and vassals by building town walls, but also in providing for their souls by constructing churches and founding monasteries.

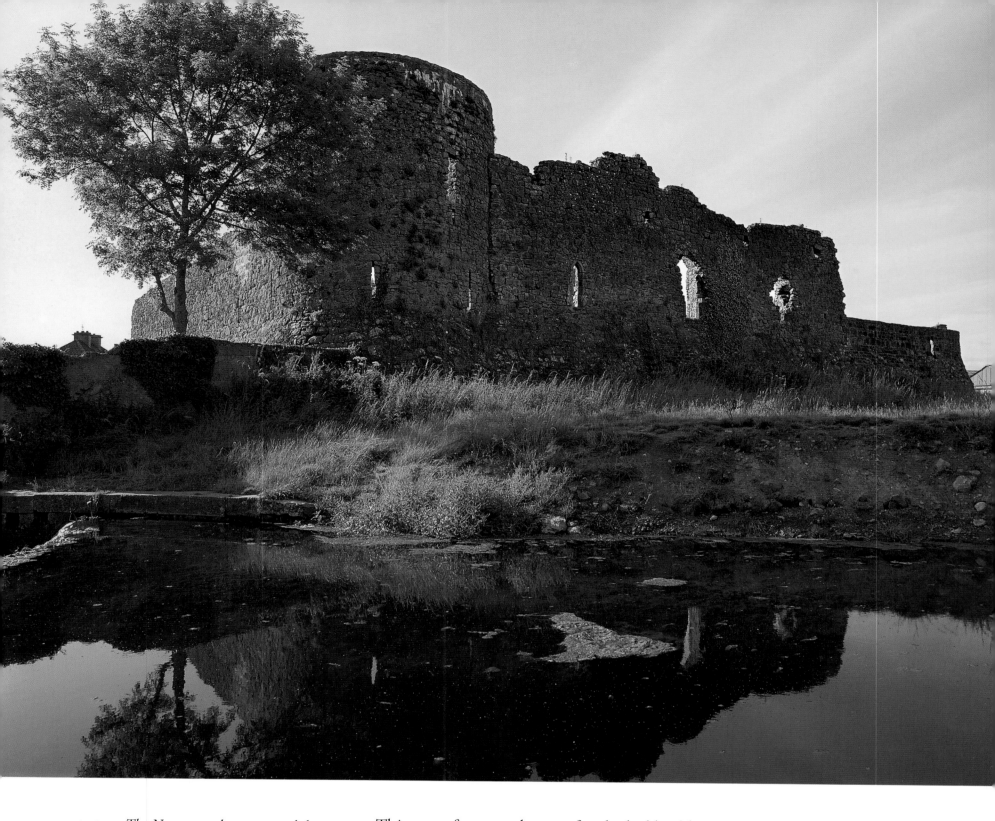

The Normans who penetrated the western province of Connacht in 1235 were quick to entrench themselves and to build castles to secure the lands that their swords had taken from the native Irish west of the Shannon. One of the more impressive examples was Athenry, which Meiler de Bermingham started to construct in 1238 beside the Clareen river in County Galway. The rounded corner tower seen here is one of the stoutest parts of the defenses of an irregularly shaped area in which there is a tall multistory keep (not visible here), which stood by itself within the enclosure and with a reception hall on its first floor. The hall has recently been restored and is open to the public.

This was, of course, the age of cathedral building in Europe, and the Normans' contribution to Irish architecture is the erection of these impressive places of worship and devotion. Christ Church in Dublin, already mentioned, was one of these and was finished around 1236, with the aid not only of English masons but also of stone imported from England. More than three decades ago Dudley Waterman discovered in a number of buildings in the eastern and southeastern parts of Ireland a cream-colored stone that had been imported from a quarry at Dundry near Bristol in the southwest of England, and which—because of its easy workability—was a popular building medium. Christ Church was attached to a priory of Augustinian canons who the archbishop of Dublin did not want to become involved in the administration of his diocese, and so he decided that he would award cathedral status to the church known as St. Patrick's, which was just outside Dublin's city walls. The result was the largest church in medieval Ireland, a purely Gothic edifice that is more

harmonious within than Christ Church because it was built in a uniform style (though, like Christ Church, it was necessarily but well restored in the nineteenth century). Also, like Christ Church, its stone vault collapsed centuries ago and has been replaced, though not with stone, as in the original. St. Patrick's is the noblest of the Gothic cathedrals still in use in Ireland, its nave and chancel structure with north and south transepts, and its lofty ceiling designed to lift the thoughts of the medieval faithful to the Lord above. It has been suggested that St. Patrick's owes something to the architecture of Salisbury Cathedral, and the music that would have been heard within was probably inspired by the same source. Today, St. Patrick's is also famous as being the burial place of its most illustrious dean, Jonathan Swift (1667–1745), who lies not far from the present entrance, close to his beloved "Stella."

One cathedral that was once almost as long as St. Patrick's, and only a few feet short of the length of Christ Church, is that at Newtown Trim in County Meath. Today, however, Newtown Trim is but a shadow of its former self. The cathedral was built by Simon de Rochfort for the Victorine Canons, but also for himself, from 1202 onward. It endured severe truncation when the western end was demolished presumably at the end of the Middle Ages, and it also suffered from not having the generous sponsorship of the drinks industry fund its restorations, as did the two Dublin cathedrals. Other provincial cathedrals that also benefited greatly from a nineteenth-century restoration are those at Kildare and Kilkenny. St. Brigid's at Kildare, the site of the double monastery founded by one of Ireland's three national saints, was restored by George Edmund Street at the same time as Christ Church and has a wide nave without side aisles, a chancel, and transepts presided over by a tall tower. The same kind of tower was built at the crossing of nave, aisle, and transepts in St. Canice's Cathedral in Kilkenny, which, however, unlike Kildare, has side aisles, linked to the nave by a set of elegant if low-slung arches. Above them are generous windows that flood the interior with light and also illuminate one of Ireland's greatest collection of medieval tombstones.

Built into the bottom of the exterior south wall of the transept of St. Canice's are some reused stones that must have come from an earlier Romanesque-style church that had stood on the site, only one of a number of examples where the Normans tore down whole or large parts of older churches in order to provide new cathedrals large enough for the expanding urban population. This is also true of Ardfert in County Kerry, where the Romanesque west façade was largely retained in the construction of the much larger thirteenth-century Gothic cathedral, though the retention of the old doorway caused the entrance of the cathedral to be off center. In Tuam, where the Normans did not play a role, the fine Romanesque arch (the widest of its kind in the country) and east window of the church were retained in a much later rebuilding.

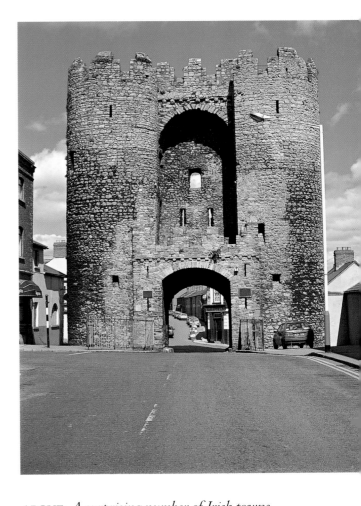

ABOVE: *A surprising number of Irish towns were surrounded with walls during the Middle Ages, though comparatively few of these urban defenses survive reasonably intact. But St. Laurence's Gate in Drogheda is widely regarded as the finest surviving feature of any of these, and it helped defend the town that had walls on both banks of the river Boyne. It may be called a gate, but St. Laurence's was, in fact, a barbican, a building placed in front of an entrance, the better to control ingress into the town. It consists of two almost circular drum towers flanking an archway and joined for defensive reasons both at first floor and parapet level. Built in the thirteenth century, the topmost section was added some two hundred years later, and the gate is still used for urban motor traffic today.*

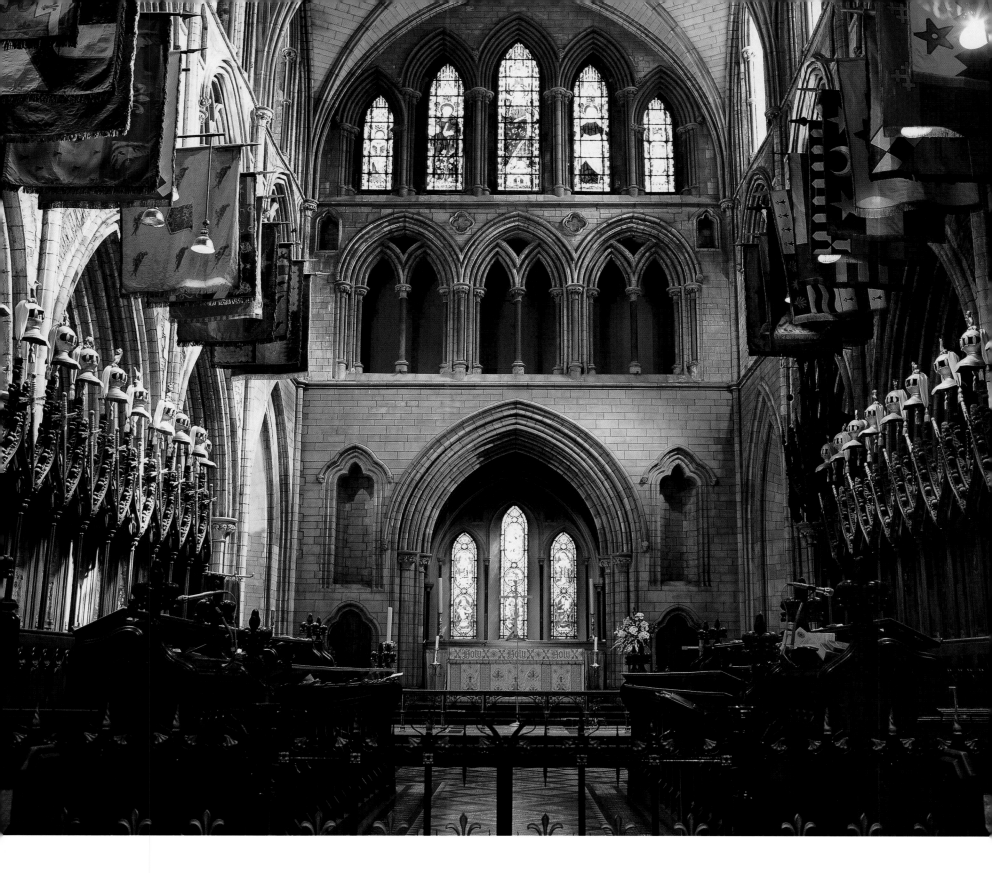

One mason who was involved in the later building stages of St. Canice's is a man who came from the West of England and whose work Roger Stalley has also traced on the large parish churches at Gowran and Thomastown in the same county of Kilkenny. While he was doubtless involved in the design and building of these two churches, this man was also a gifted sculptor—in Stalley's view, the most gifted craftsman at work in Ireland during the thirteenth century. His expertise was in carving foliage and human heads together, the latter expressive and portrait-like, often with a smiling countenance. The churches at Gowran and Thomastown are not the only Norman examples in the country. The two St. Mary's churches, at Youghal and New Ross respectively, St. Multose in Kinsale, and St. Nicholas in Galway reflect the maritime prosperity of the towns they ornament, but are also fine specimens of urban

parish churches and the only examples that can compete in size with their English counterparts of the period. Fortunately, three of these churches (New Ross excepted, having had a nineteenth-century church built inside it) are preserved in a way that approaches their original form, though obviously there are some later accretions. Regardless, they give us the best idea of what the larger provincial Irish urban medieval churches were like in the midst of bustling port life; one tradition has it that Christopher Columbus visited St. Nicholas in Galway to hear Mass before setting out on his voyage to America.

Another remarkable cathedral with fine head carvings sits dramatically on top of the Rock of Cashel. It stands between a pre-existing Round Tower on the one side and Cormac's Chapel on the other, and had it been built as it was doubtless originally intended, it would have surpassed the two Dublin cathedrals to become Ireland's largest church. As it is, only its very extensive chancel, with lancet windows in the side walls and taller ones (no longer extant) in the east wall, now stands, along with a tower where it and the completed transepts cross. The original nave was never built to its full extent due to lack of finance, the place of its western end taken a century later by a castle for the archbishop, who obviously felt the necessity to defend himself on his rock fortress. Nevertheless, what does survive shows what native patronage could do, for here it was native archbishops who initiated the building project, perhaps with an eye to compete with what the Normans were erecting in Dublin. The Rock of Cashel provides a more striking location, though it should be said that much of the cathedral's detail, if at times idiosyncratic, owes almost as much to architecture in the West of England as it does to the two Dublin cathedrals.

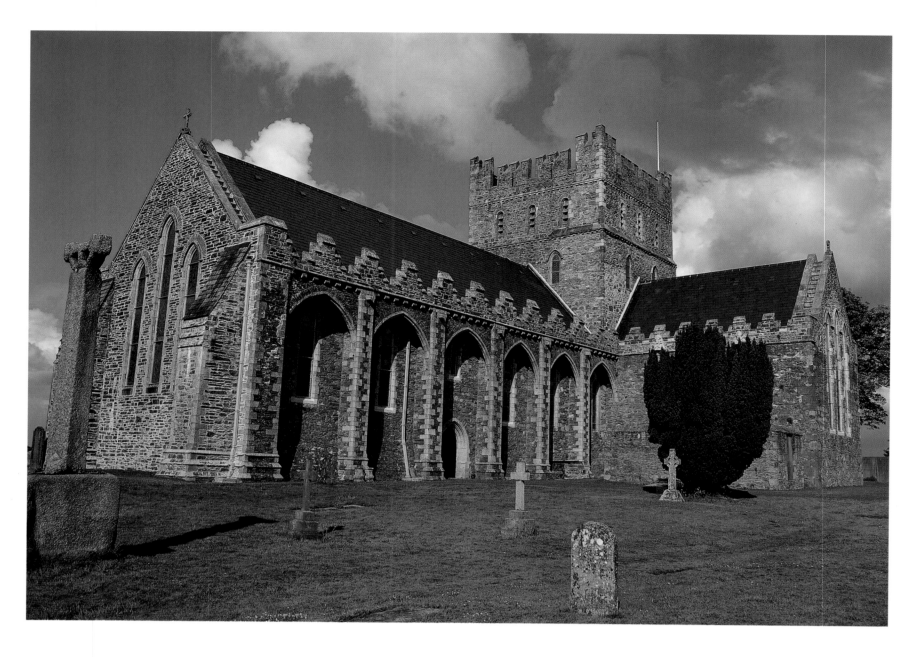

ABOVE: *The Protestant cathedral in Kildare town stands on the site of a famous monastery founded in the sixth century by St. Brigid, the only woman among the trio of Ireland's national saints. The cathedral itself was founded in the thirteenth century and was provided with a stout tower at the crossing and a wide nave without aisles. Both had deteriorated so much that a restoration was decided upon around 1870, and this was carried out by the famous Victorian architect G. E. Street, who gave the cathedral the imposing appearance that greets us today.*

The cathedral on St. Patrick's Rock at Cashel looks down on Hore Abbey outside the town, which was the last of the Irish Cistercian houses to have been founded, in 1272. As indicated already, many had been founded with support from one Norman baron or another, while other houses—particularly those associated with Mellifont—were more Gaelic in spirit. But the same dichotomy of political orientation is found in other orders, which by the later thirteenth century had begun to outshine the Cistercians. The latter were an enclosed order, and the popularity of the mendicants is to be explained by their efforts to serve the people both in towns and out in the countryside.

The Augustinian canons, who had been favored along with the Cistercian by St. Malachy of Armagh before the middle of the twelfth century, were distinguished from other orders by their willingness and ability to take over the running of a number of the older Irish monasteries, such as Clonmacnois or Devenish in County Fermanagh, thereby giving them a new lease of life, leaving many of the others to die out by the thirteenth century. But the Augustinians also founded their own monasteries, one of which—at Ballintober, County Mayo—was closely associated with the age-old pilgrimage to Croagh Patrick. Ballintober has already been mentioned as a fine example of

the work of masons of the School of the West, but its ground plan is clearly derived from the general principles of Cistercian layout—a church on one side of a cloister garth surrounded on the other three sides by a chapter room, refectory, kitchen, and other domestic buildings. The same could also be said of Cong, which—as suggested above—was also a product of the School of the West. Much of the same system was applied to the most extensive and impressive of all the Augustinian houses in Ireland, namely Athassel in County Tipperary. Athassel sprawls over a much wider area than either Cong or Ballintober, but that is because the complex of church and monastic buildings is contained within an irregular but much larger enclosure surrounded by water, to which access could be gained over a bridge and through a gate house. The site is somewhat reminiscent of Trim Castle in that some river water was siphoned off in order to create a man-made island, which was thereby physically and spiritually separated from the outside world. The aisled nave is considerably broader than the choir, and the size of the two transepts is quite remarkable. The doorway under the tower leading into them

ABOVE AND LEFT: *The cathedral of St. Canice in Kilkenny retains more of its original thirteenth-century fabric than most of its other Irish counterparts, but its interior was provided with a fine new wooden roof in the nineteenth century. The cathedral stands on the site of an early Christian monastery, whose pre-Norman tower stands outside its south transept.*

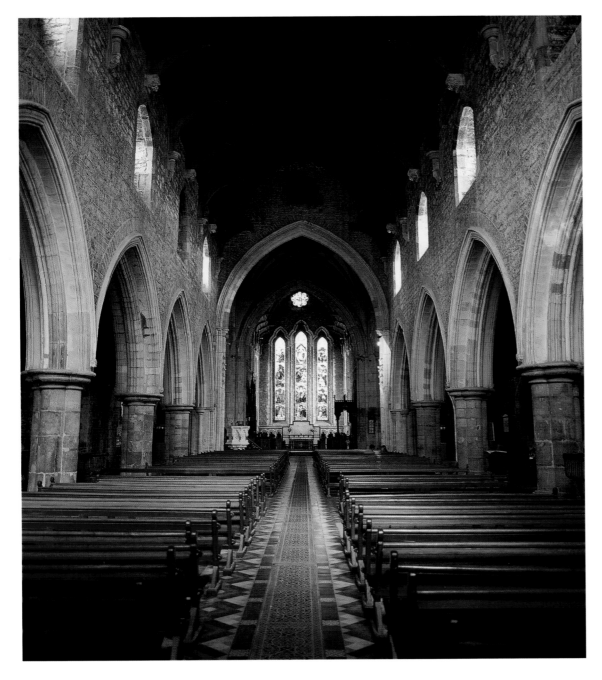

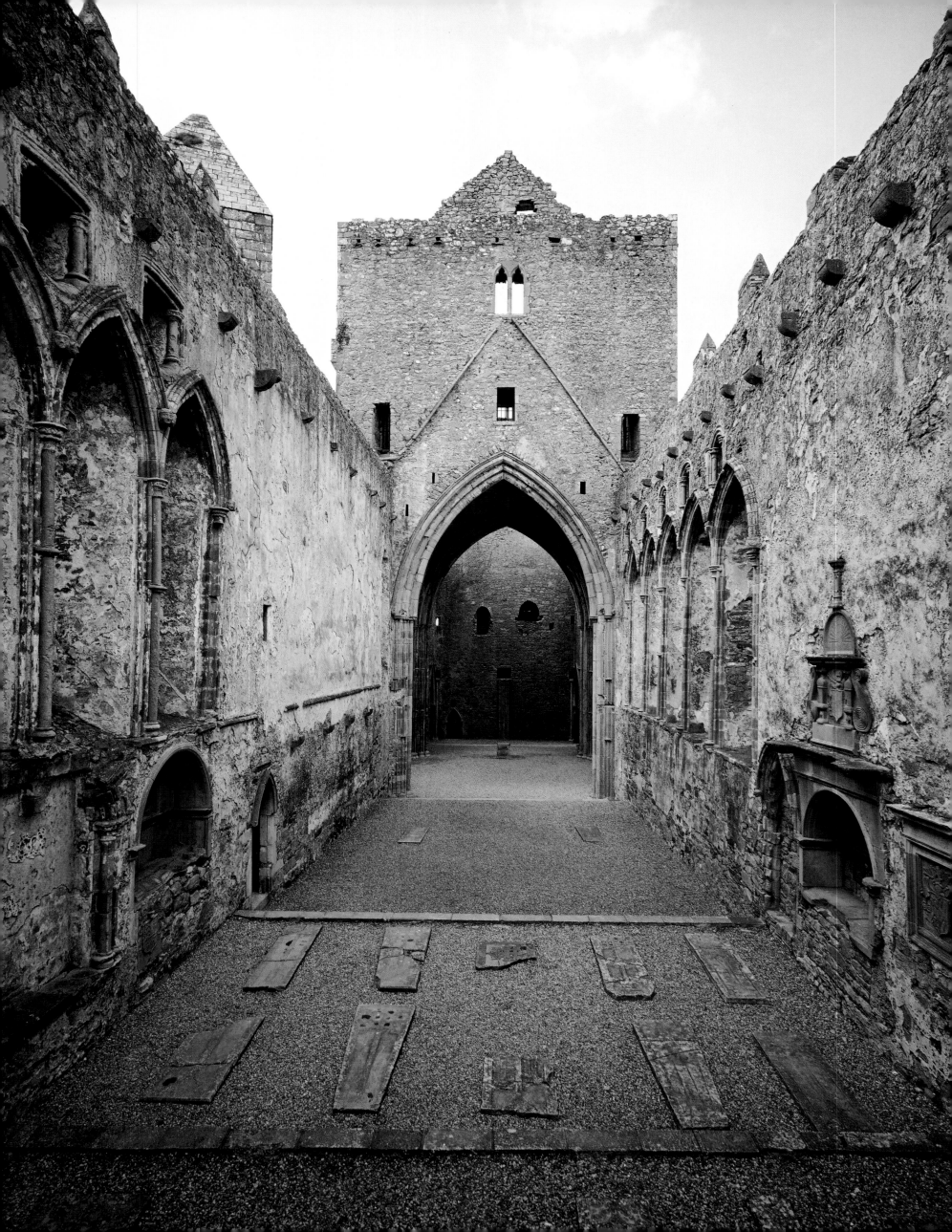

from the nave is a fine Gothic portal with intricate moldings and dog-tooth decoration in a rather English style, and above it is a large arch (later filled in) that was probably fitted with a wooden rood or crucifix grouping that must have made a considerable impression on anyone entering through the western doorway of the church. The other buildings around the cloister garth owe much to Cistercian design, as do the chapels and transepts.

Indeed, the Cistercian layout seems to have been the main influence in the design of abbeys, priories, and friaries of other continental orders that came to work, pray, and preach in thirteenth-century Ireland. The most notable of these are the mendicants, the Dominicans, the Franciscans, and the Carmelites, though there were others as well. Most of the important Dominican houses were already up and running by 1300, and the architecture of their houses retains much of the style of the period. Some of these were in or immediately adjacent to towns, such as Cashel and Kilmallock, the latter a fine example dating probably from around 1300, with fine windows and some sculpture. In Connacht in particular, the Dominicans occasionally built their houses in rural settings, showing that they were not just serving the population of towns under Norman domination, but also the scattered Gaelic communities, Rathfran and Strade in Mayo being good examples.

The Franciscans, also, tended to start constructing their houses in towns in the thirteenth century at places like Castledermot, Drogheda, and Roscommon, but their real heyday was the fifteenth century.

Only a comparatively few medieval cathedrals, abbeys, and friaries are still in use today in Ireland, giving us some idea of what the interiors were like when the medieval congregations came daily or weekly to hear the word of God. It is fortunate that during the Reformation many of the cathedrals that were taken over by the Protestants remained in use, unlike so many of the abbeys and friaries, which were sold off or given in grants to private individuals. It is, therefore, in the Protestant cathedrals of Dublin, Kilkenny, and Limerick in particular where we can best get a feel for the buildings as part of an existing institution. Sadly, the same Reformation discarded many of the interior furnishings, and wooden statuary of the thirteenth and fourteenth centuries remains a rarity. By good fortune, the museum attached to Loughrea Cathedral in County Galway preserves a number of wooden statues from the diocese that belong to this period. The best preserved is a Madonna from Kilcorban, a fifteenth-century Dominican foundation in the same county. The statue must have come from elsewhere, however, as it is in the style of a Romanesque Madonna of the twelfth century—Our Lady seated, holding the Christ child on her lap, both looking straight ahead at the beholder. But just as the School of the West continued to use the Romanesque style into the thirteenth century, it is quite possible that the Madonna may not have been carved until after 1200, and the same may be true for one of the few other

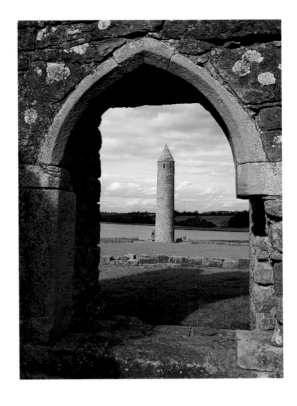

OPPOSITE: *Had the Gothic cathedral started on the Rock of Cashel in County Tipperary in the thirteenth century been completed according to its original design, it would undoubtedly have been the largest church ever built in Ireland. But financial stringency and political necessity led to the truncation of the planned nave and its replacement by a defensive castle that is visible through the arches of the cathedral's massive tower. But, at least, the tower, the transepts, and the fine chancel with its lancet windows seen here in the side walls were completed and, taken together, present a worthy ruin on this most dramatic of all cathedral sites in Ireland.*

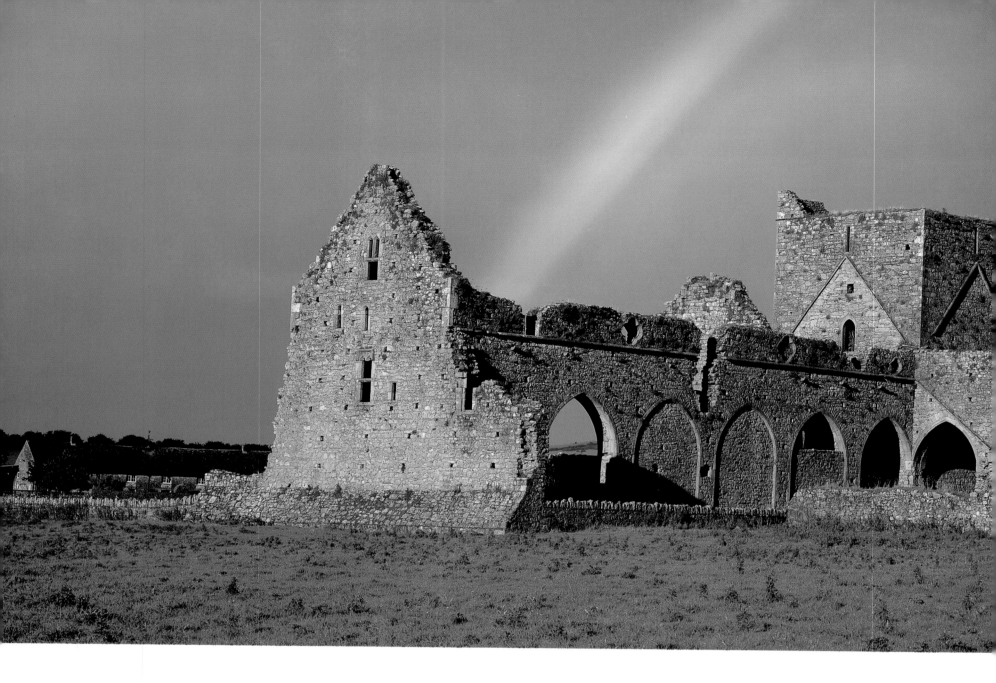

"early" carvings of a similar nature, a Madonna and Child from the Poor Clare convent in Athlone, where the Virgin holds the Christ child on the left knee. Another statue of the same group, now the object of veneration in the church at Clonfert only a mile or so away from the famous cathedral, dates from anywhere up to a century or more later. Unlike the others, the Virgin here is standing, holding the Christ child in her left arm and wearing a garment with long, graceful folds that suggest a date not far from the thirteenth century.

The wooden figure of St. Molaise, from the thirteenth or fourteenth century, was kept for hundreds of years on the island of Inishmurray off the Sligo coast and then over fifty years ago was removed to the National Museum in Dublin. Deeply venerated by the islanders, it is a tall statue of the saint in vestments but minus hands, its long, slender face and tonsured hair having survived weathering and allegedly also a slashing from the sword of an iconoclastic naval man who is said to have landed on the island. At least one other similar statue is recorded from another western island, that of Inishglora, off the Mayo coast, but it has sadly disappeared. The similarly garbed figure of St. Molua from Killaloe, County Kilkenny, has been preserved, while Ballyvourney in County Cork also has a figure from the thirteenth century that represents Saint Gobnait and which is displayed on one or two days a year

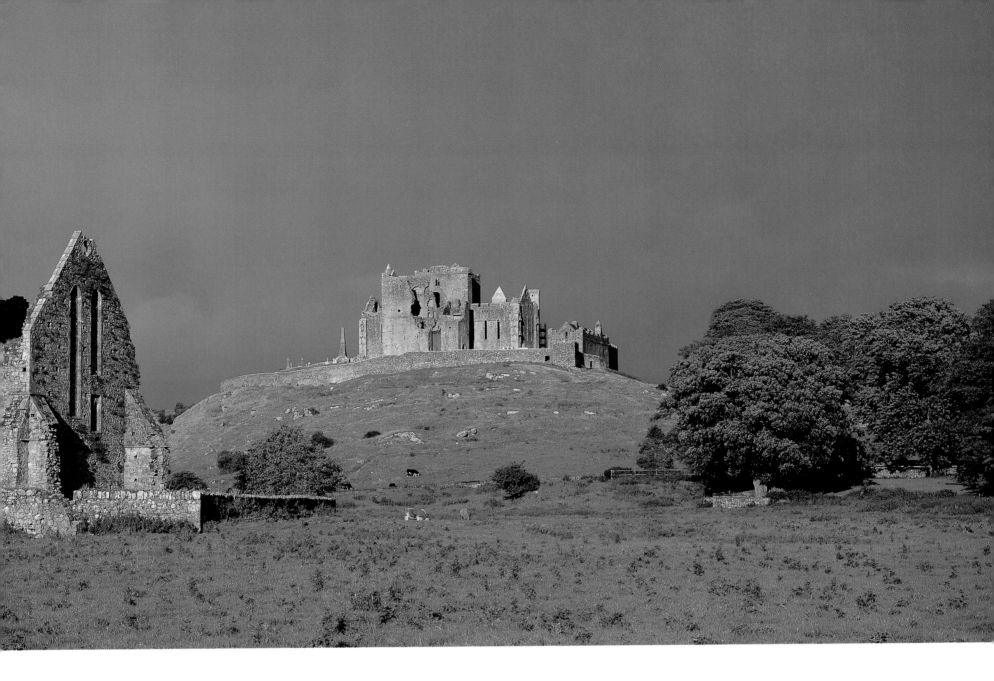

for pilgrims to venerate. Its face has been largely worn away, but the straight-falling folds and belt and raised left hand across the breast suggest some similarity to grave effigies of the period.

With the exception of carved figures at Roscommon and in the Cistercian abbey of Corcomroe in County Clare, the native Irish did not generally carve effigies of deceased relatives to be placed over their tombs. This practice, which started on the European continent around the eleventh century, had become widespread in Europe by the thirteenth—and Ireland was no exception. The Normans had introduced the custom a few decades after their arrival, and—where they can be identified—the effigies of the dead normally represent bishops, as well as knights and their ladies. Of these, the knights are by far the most striking and show the different techniques used. An incised slab at Jerpoint, County Kilkenny, showing a pair of knights clad in chain mail, one with a helmet, is a charming representation of two men who may have died in battle together. Kilfane in the same county preserves a high-relief carving of a self-assured and dominating knight of the best quality that characterizes so well what we imagine the attitude and appearance of the Norman knights to have been. His triumphal gait, his well-defended body clad in mail and a surcoat, and his shield with armorial bearings are all extremely well carved—so well, in fact,

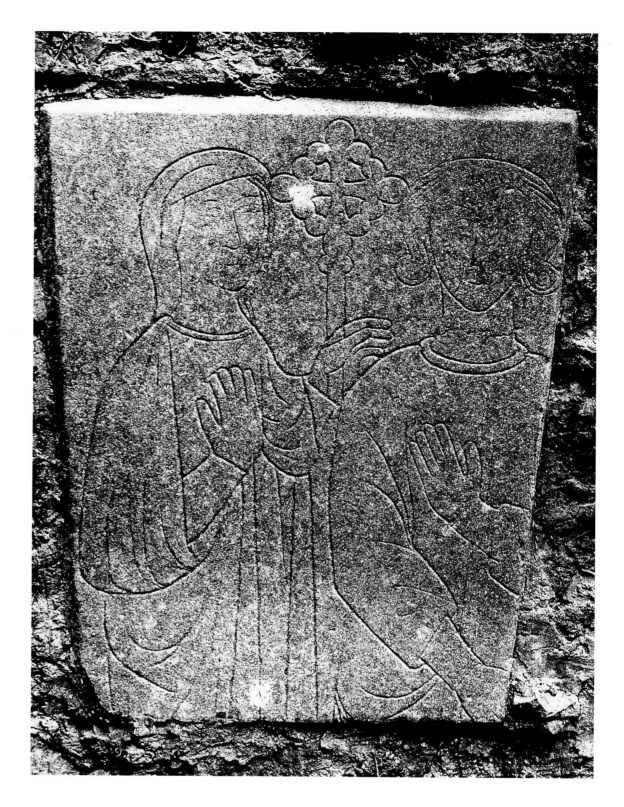

that it has been suggested that the figure may have been imported from Britain ready-carved in the thirteenth or fourteenth century. A somewhat similar effigy at Hospital in County Limerick is not as well preserved, but one other example worth mentioning is that wrongly said to be of Strongbow in Christ Church Cathedral in Dublin (the rowel spurs worn on the ankles prompted John Hunt to date the figure to the period around 1330, when Strongbow had been dead for almost a century and a half). At this time, ladies in Ireland were not portrayed side by side with their husbands in death; instead, they were given effigies by themselves, the most lively examples being preserved in the walls of the churchyard of the Protestant cathedral in Cashel, County Tipperary, where the lively drapery folds on the lower parts of the gowns, brought about by the two legs being placed one over the other, make it seem as if the ladies are dancing.

Unlike the upper classes, civilians were prepared to have themselves presented as husband and wife on the same tombstone, as was the case with an attractively incised wedge-shaped slab at Athassel Abbey. Higher up the social scale, James le Butler had his wife portrayed not on the same stone but at least on a twin slab, at Gowran in County Kilkenny around 1320–1340. Laymen were, of course, not averse to having their effigies represented individually, as on a fine example in New Ross of c. 1300 (another figure suspected of having been imported into Ireland in a finished state), and there are other examples in Dublin, Kilkenny, and Youghal, not all having weathered the centuries well.

Bishops and archbishops were clearly not willing to be outdone by their secular counterparts, and it may even have been before their deaths that they ensured their posterity by having their effigies carved. While some survive in Dublin, the better examples are found in churches outside the capital, as at Ferns in County Wexford, where the high-relief carving of a mid-thirteenth-century bishop (probably John St. John) gives a good idea of the quality of craftsmanship. The bishop is shown in his ecclesiastical vestments, holding his crosier and blessing, as he rests within a niche on a base that is carved with stylized foliage. In even higher relief is the figure possibly identified as John of Taunton in Kildare Cathedral, who is accompanied by censer-swinging angels, and whose almost smiling face is capped by a miter decorated with crosses and what are presumably imitations of precious stones.

The Gaelic Irish rarely adapted the custom of placing effigies on tombs, unless they were in long-vanished wood, which seems unlikely, but one Irish bishop, Felix O'Dullany, probably did adopt the Norman custom at Jerpoint,

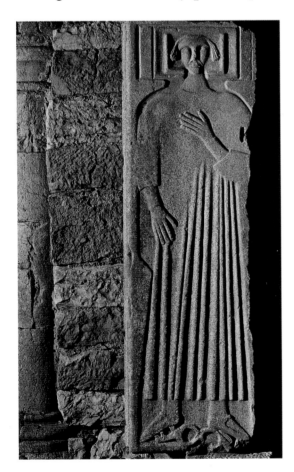
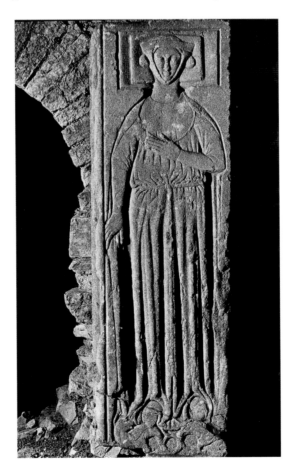

RIGHT: *It was customary in the first two centuries of the Norman occupation of Ireland for ladies to be given a separate tombstone for themselves, and there are few better examples of the genre than the three single effigies of women built into the wall of the Protestant Cathedral of St. John in Cashel, County Tipperary, one of which is shown here. Wearing ring brooches and pillbox headdresses of late thirteenth/early fourteenth century type, they are garbed in long, belted gowns that cover the feet, which seem to be crossed and thereby give the sculptor the opportunity of making swirling folds above the ankles, providing a sense of movement as if the ladies were portrayed in the act of dancing.*

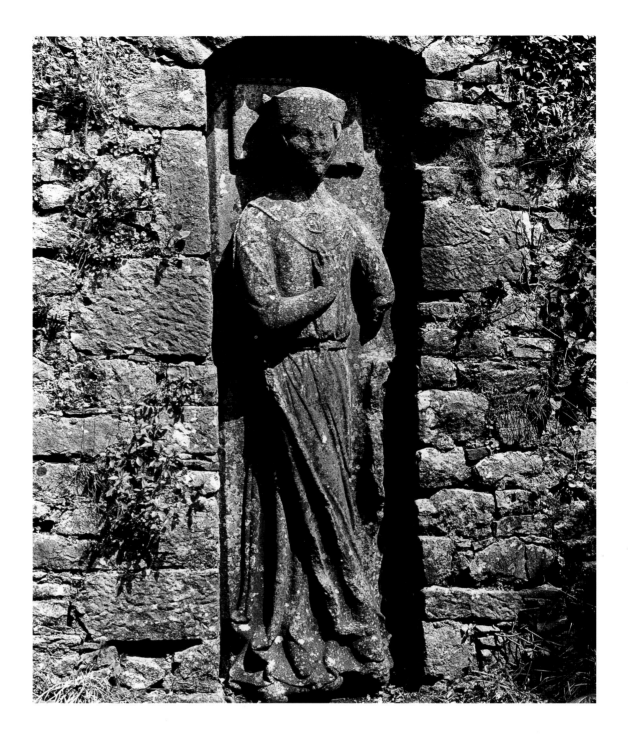

as he may well be the person carved in high relief dressed in abbatial attire. An unidentified bishop at Kilfenora had his image incised there on a flat slab, which, interestingly, shows him bearing a drop-headed crosier of a type common in Ireland before the thirteenth century, to which period the effigy is normally assigned. Not far away, at Corcomroe, also in the Burren area of County Clare, there is an unfinished effigy of another unidentified ecclesiastical figure carved in high relief, while in a niche beneath him lies the high-relief effigy said to be of Conor na Siudaine O'Brien, who, though an Irish king, was obviously desirous of being shown in the garb of English royalty of the second half of the thirteenth century. The same is also true of the O'Conor king of Connacht, whose effigy lies in the Dominican abbey in Roscommon town. Both wear long garments to the ankles and have a cape behind, the cord for which they hold with their hand.

All was to change in Ireland—as it did throughout much of Europe— with the devastation caused by the bubonic plague in the years 1348 to 1350.

Commonly known as the Black Death, it struck the urbanized communities with greater ferocity than it did the rural dwellers and, between the first and subsequent outbreaks of the plague over the next quarter of a century, it has been estimated that the population in the Norman "lordship" of Ireland may have dropped by up to 40 or even 50 percent by the end of the fourteenth century. The impact of this blow was felt not only in the loss of human life, but also in the decline in revenue, which in turn impacted the world of architecture and craftsmanship. Naturally, the Normanized area was the most affected. The high quality in effigy carving, for instance, suddenly halted, so that stonework—be it in the form of carving or building—seems to have stagnated for at least half a century, though efforts have been made to lessen the effect of the plague by redating certain structures to the second half of the fourteenth century rather than to the fifteenth.

Be that as it may, the Black Death appears to have been far less severe among the largely Gaelic-speaking elements in the Irish population. Indeed, in a curious way, it appears to have had, if anything, a stimulating effect. For example, one event described and praised in many of the contemporary annals was a great feast prepared by William Buidhe O Ceallaigh at Christmas 1351, only one year after the end of the plague, to which he invited all the Irish "brehons, bards, harpers, gamesters or common kearoghs, jesters and others of their kind." Presumably each group or individual would have joined in the general entertainment, but the event itself gave a tremendous fillip to Irish poetry and literature.

Though virtually no Irish manuscripts survive from the period between the Norman invasion and the Black Death, poetry was being written. It survives, but only in manuscripts later than 1350. The decline of the old monasteries as cultivators of a knowledge of history and patrons of craftsmanship created a gap that was filled in time by lay sponsors who supported a professional band of bards who produced poems in praise of their masters, but who were also capable of composing the Irish equivalent of the courtly love poems of the continental troubadors, showing that Ireland was still connected to developments in lands much closer to the Mediterranean. There was a certain diminution in the knowledge of Latin among the scribes, but the thrust of the new literature that followed the O'Kelly feast of 1351 is a nostalgic re-creation of the Ireland that existed before the Norman invasion.

This spirit is also found in metalwork of the period. As with manuscripts, Gaelic Ireland had little metalwork to show for itself between 1175 and 1350. But in the mid-fourteenth century we suddenly have Johannes O Barrdan putting his name as maker on the shrine known as the Domhnach Airgid, a yew-wood box that had been used to encase a sacred object (book?) now lost, and that was associated with Clones in County Monaghan. It presents us with a figure of the crucified Christ dividing one face of the box into four quadrants,

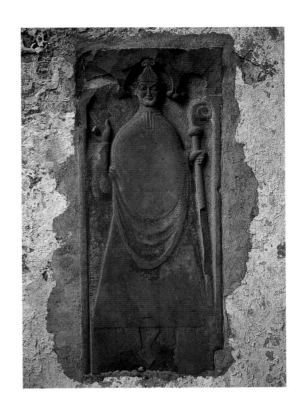

ABOVE: *The unfinished effigy of an abbot or bishop of the thirteenth or early fourteenth century carved in an unusual brownish stone was inserted over a century ago into the wall of the chancel of the Cistercian abbey at Corcomroe in County Clare. But the lack of any inscription makes it impossible to know who it was intended to represent—perhaps an Irish abbot of the monastery before it was placed under the jurisdiction of an English house in 1295 or, more likely, an abbot installed by the new English masters.*

Lying with his hands folded in prayer in Christ Church Cathedral, Dublin, is the effigy of a knight known traditionally as Strongbow, the mightiest of the Norman barons who came to conquer Ireland in 1169/70. But he is no Strongbow, for the coat of arms on the shield that he bears on his left side identifies him as a FitzOsbert, the family of Strongbow's first wife, while the rowel spurs he wears on his heels indicate a date of around 1330. Despite some damage caused when the cathedral's vaulted ceiling fell on it in 1562, the effigy vividly illustrates the quality of high-relief funerary sculpture of the time, but also the power and might of the Norman invaders. The history and nature of the small figure beside it is unknown.

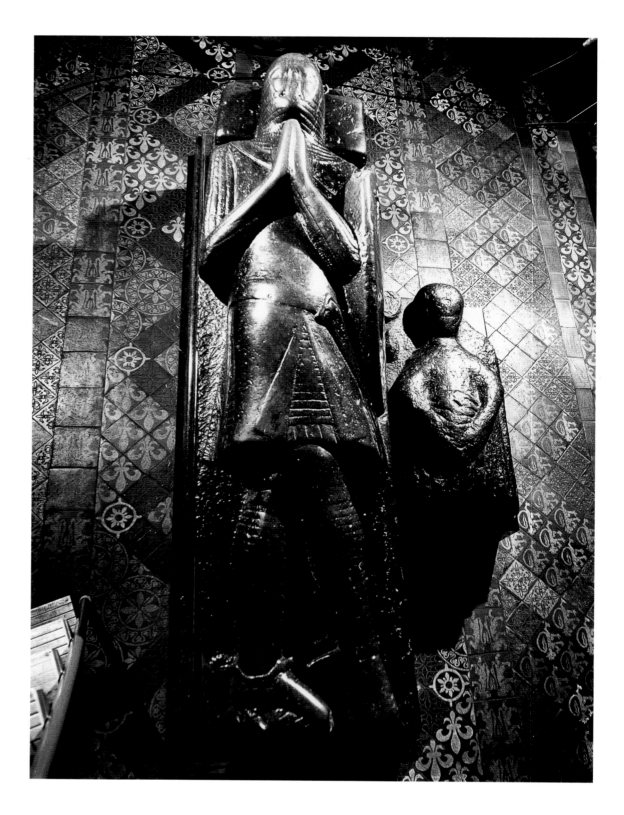

the top left quadrant of which is decorated with metal figures in high relief representing St. Michael the Archangel and the Virgin and child. At top right are Saints Peter and Paul (and another unidentified saint), while at bottom left we see a figure presenting a reliquary (this one?) to a seated figure, probably the abbot of Clones. The three figures on the bottom right are unidentified. This fine, competent piece of metalwork is not descended in style from the pre-Norman shrines discussed earlier and would have been unthinkable without some knowledge of sculptural developments outside Ireland. In other words, the redecoration of the shrine pays homage to a pre-existing Norman shrine, but uses the latest styles from outside the country to ornament it.

The figures on this shrine are in a markedly high relief, as if they were close in style to their models, wherever they may have originated. The figures

are presented under a series of arcades, a system used also on the renovation of another shrine, that of the *Cathach*, introduced earlier, which, like the Domhnach Airgid, is preserved in the National Museum in Dublin. However, the figures on the *Cathach* shrine are noticeably flatter, the crucified Christ present on both of the shrines pointing up the difference in workmanship between the two. In addition, the S-curve of the figure of the Virgin is a typical fourteenth-century trait that shows this period to have been heavily involved in the refurbishment of older shrines. This grouping of Crucifixion figures—comprised of Christ, the Virgin, and St. John—was added to the shrine of the eighth- to ninth-century *Book of Dimma* in Trinity College, Dublin, at about the same time.

The background to many of the figures—including the censer-swinging angels in the top corner of this face of the refurbished *Cathach* shrine—is incised with animals and beasts of various kinds. Incisings of a somewhat similar nature occur on two other shrines that might have been made by the same craftsman, Domhnall O Tolairi , who signed his name on one of them, the Shrine of the Stowe Missal. Made for Philip O'Kennedy, Lord of Ormond, it too is a redecoration of an earlier (eleventh-century) shrine for a missal of around 800. One side is divided into a cross shape with a setting of rock crystal in the center and four quadrants containing among other things the figures of the crucified Christ and the Virgin and child. The second shrine, unsigned, but possibly also from the hand of O Tolairi, is one of the few that was created new—in 1376—and is not the redecoration of an older shrine. The shrine allegedly holds the tooth of St. Patrick, an unusual relic for a shrine made at this time. A cross with a crystal at the center divides both of its faces into quadrants, each quadrant decorated with many figures, including a harper (David?) in comparatively high relief. Two episcopal figures—one probably representing the national apostle, whose tooth it is said to contain—are engraved on the back, showing the variety of techniques that were used on these shrines in the second half of the fourteenth century (a number of which were reworked again in the fifteenth century). The reworking of these shrines in the second half of the fourteenth century was not just an effort to revive and create a direct link with what was probably seen as a kind of golden age before the arrival of the Normans, but also to help local kings and families with larger national pretentions to lay claim to territories, which, after misappropriation by the Normans followed by the weakening of Norman power in Ireland through the Black Death, were now once more within reach.

Around 1400, these noble Irish families were inspired to assemble their scribes to create large books of lore and poetry—using older rather than contemporary texts. To some extent, this is what had happened with the creation of the *Book of the Dun Cow* and the *Book of Leinster* some three centuries earlier at Clonmacnois and Glendalough respectively. The texts were

RIGHT: *Lying with his hands folded in prayer in Christ Church Cathedral, Dublin, is the effigy of a knight known traditionally as Strongbow, the mightiest of the Norman barons who came to conquer Ireland in 1169/70. But he is no Strongbow, for the coat of arms on the shield that he bears on the left side identifies him as FitzOsbert, the family of Strongbow's first wife, while the rowel spurs he wears on his heels indicate a date of around 1330. Despite some damage caused when the cathedral's vaulted ceiling fell on it in 1562, the effigy vividly illustrates the quality of high-relief funerary sculpture of the time, but also the power and might of the Norman invaders. The history and nature of the small figure beside it is unknown.*

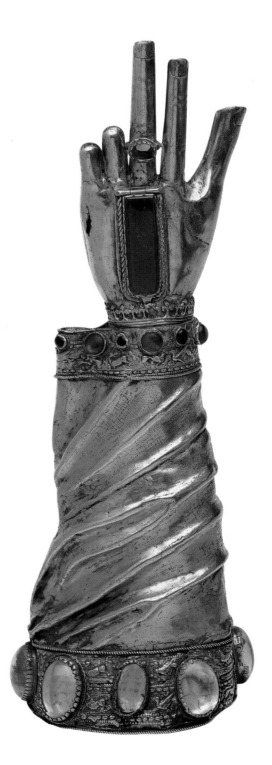

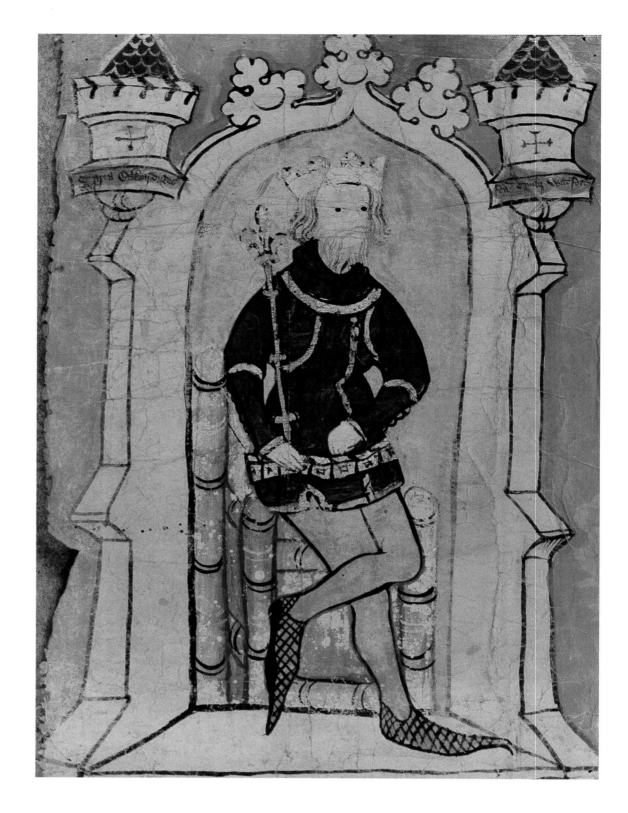

compilations of Irish tales, historical material, and lays of Finn and the Fianna, but this time they were recorded not just to prevent their extinction, but were written with the pride of someone showing off a treasure. Some of these manuscripts even bear decoration, though artistically of a lesser quality than their twelfth-century forebears. *The Book of Ballymote* (Ms. 23.P.12 in the Royal Irish Academy) bears a pen and ink drawing of Noah and the ark, the boat conceived as a contemporary sailing vessel showing its strakes carefully held together by nails with diamond-shaped heads, and Noah with an olive branch surrounded by his family. The roughly contemporary *Leabhar Breac*, or *Speckled Book*, has a harrowing figure of the crucified Christ, feet crossed and pierced with but a single nail in typical Gothic fashion, his emaciated body wasting away on the cross and his head pierced with the crown of thorns. Some initial

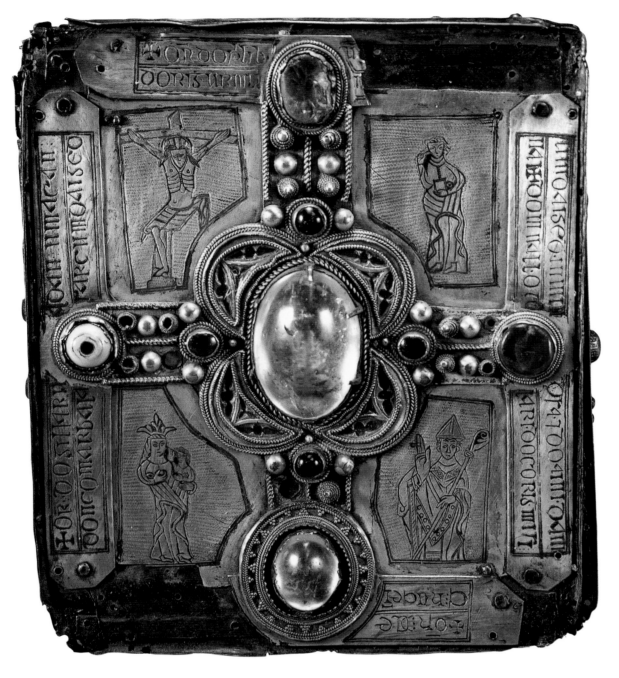

letters in the manuscript recall earlier generations, with animals playing a prominent role, as in the *Book of Ballymote*, but the influence of foreign decoration can be felt when, as in the *Yellow Book of Lecan*, the interlace and animal heads of older Irish tradition are united with a feel for the greater realism of the Gothic pictorial tradition of England and the Continent. The Gothic element is present even more strongly in a somewhat later manuscript from Saints Island in Lough Ree, now Ms. Rawlinson B 505 in the Bodleian Library in Oxford, where a cleric with crosier is painted under a cusped canopy, doubtless in imitation of an English manuscript. It should be pointed out that, at the same time, the denizens of the port of Waterford were painting representations of famous figures from the city's history into a charter roll that is still preserved among the city's muniments. These, too, are shown under cusped arches, and together with the decoration of the other books anticipate the preference during the fifteenth and sixteenth centuries for figures with arcading, the best preserved examples of which are on tomb chests of the period, usually found in abbeys, priories, and cathedrals throughout Ireland.

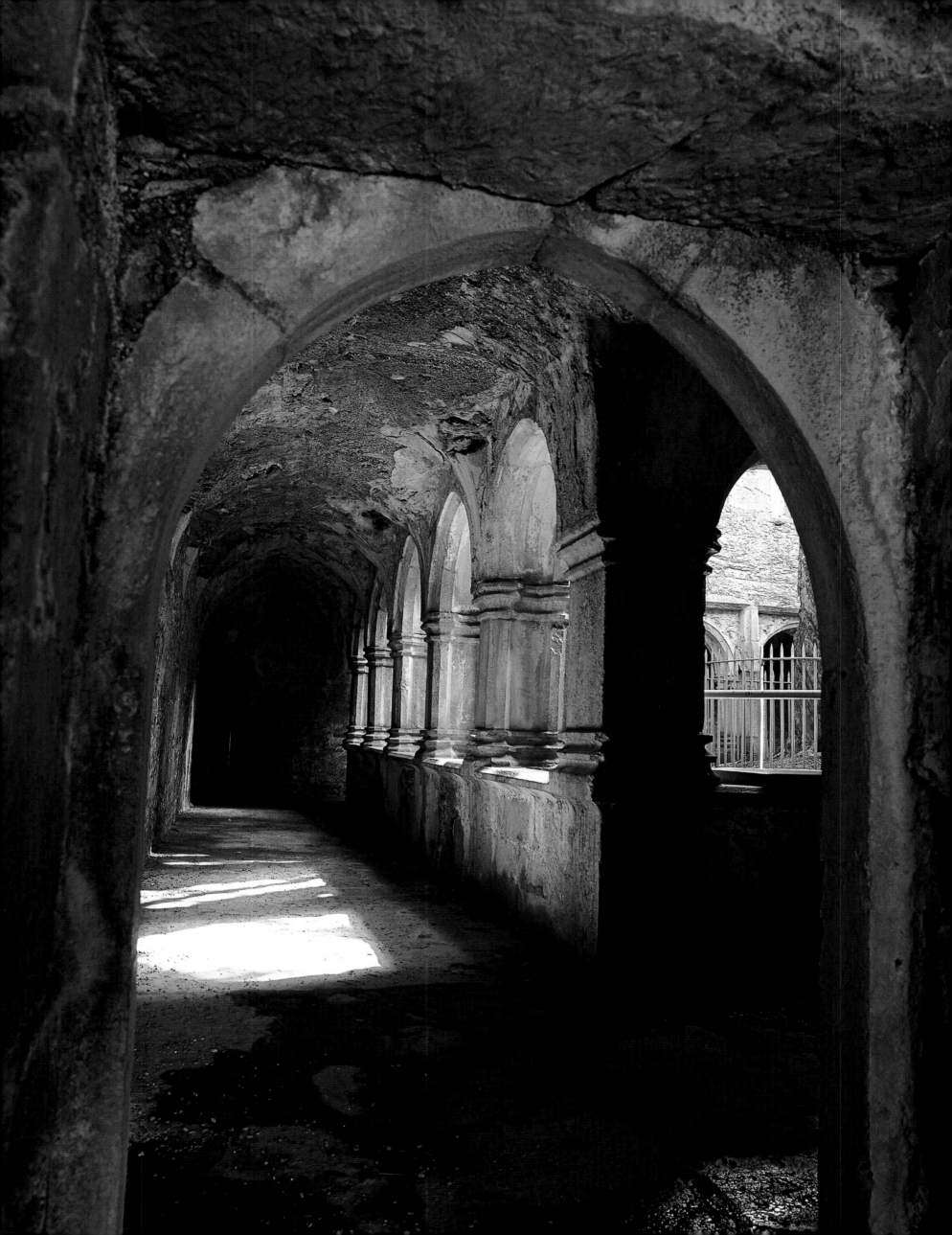

THE LATER MIDDLE AGES

Though not nearly as well known as they ought to be, the later medieval friaries of the Franciscans and other mendicant orders represent a uniquely Irish contribution to the architecture of Europe at the time. They follow the general layout introduced by the Cistercians over two centuries earlier—the church at one side of a cloister garth, the religious and domestic buildings around the other three sides, and a covered cloister all the way around. But there was one noticeable difference in that the Franciscan cloisters were not just lean-to structures. They were an integral part of the stone buildings—vaulted, with "dumbbell" pillars supporting not only an arcade, but also a first floor above, thereby creating more space in the domestic rooms and the dormitories upstairs. The yew tree in the center of the cloister at Muckross in Killarney creates an atmosphere of comparative darkness that was not entirely uncharacteristic of these cloisters, which really have no close parallels anywhere outside the country. Occasionally, they were decorated on one or another of the corners with sculptures of the order's founder, St. Francis of Assisi. At Creevelea, near Dromahair in County Leitrim, a stone mason of the early sixteenth century carved small figures on the undersides of the arches of St. Francis preaching and talking to the birds.

The other elegant feature of the Franciscan friaries was the presence of a tall, graceful tower with battlements placed halfway along the extended hall-like church. During the fifteenth century, these towers were often inserted into existing buildings. They stand out in the Irish landscape—particularly in the West of Ireland—dominating their surroundings in the same way that the Round Towers had begun to do half a millennium earlier. The Dominicans tended to build rather squatter, broader towers, as at the Black Abbey in Kilkenny City, and at Muckross the Franciscans followed the same pattern. These friaries are the architectural response to the poetic reawakening of Gaelic Ireland after the devastating toll of the Black Death among the Norman invaders. Some may have been started during the second half of the fourteenth century, but the majority belong to the fifteenth, the example at Creevelea, mentioned above, being one of the latest, dating from the early sixteenth

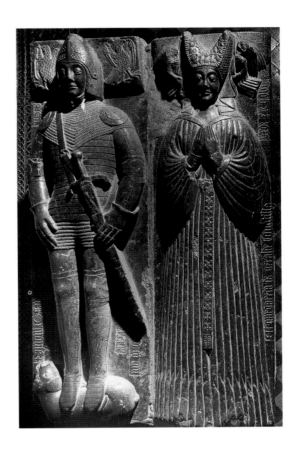

ABOVE: *The double-effigy of Piers Butler, eighth earl of Ormond (died 1539), and his wife, Margaret FitzGerald, in St. Canice's Cathedral, Kilkenny.*

OPPOSITE: *Franciscan friaries are among the most characteristically Irish buildings of the later Middle Ages. Attached to the church is a cloister, a haven of peace and quiet where the friars could walk and talk, away from the distractions of the outside world, and looking through an arcade of dumbbell columns into an open-air cloister garth. At Muckross, by the Lakes of Killarney, there is an old yew tree that still leaves room for the sun's rays to penetrate into the interior, which was built in the second half of the fifteenth century.*

century. But nowhere is the symbolism of renewal more evident than at Quin in County Clare. The Norman castle built there during the thirteenth century in the form of a square with round corner bastions had been rendered useless by fire in 1286. The Franciscans—under Macnamara patronage—built their friary on top of the damaged structure around the 1430s; it truly was a phoenix rising from the ashes and an inspiration to the country to rise up and reinvent itself. The fifteenth century was one of tremendous building activity, and there is scarcely an older church of any importance that did not have alterations carried out upon it, particularly in the replacement of their slender lancet windows with new, larger traceried windows intended to let in more light.

But while the 1400s was the Franciscan century par excellence, theirs was not the only religious order building new churches or altering or adding to older ones. Most worthy of note are the Cistercians, who, though they had opened no new houses in Ireland after 1272, were busy reshaping some of their earlier foundations, despite the fact that the Black Death had caused the loss of three-fifths of all Cistercian monks in northern Europe. The most striking example of their activity is Holy Cross Abbey in County Tipperary. Only a little of the fabric of this great monastery goes back as far as the late twelfth or thirteenth century, after it had been founded around 1185/86 by the great church builder Donal Mór O'Brien. Most of the church as it stands today is a product of a major rebuilding plan undertaken from the 1430s onward under the patronage of the Butler family, earls of Ormond. It conforms to the usual monastic layout, with domestic buildings around three sides of the open-air

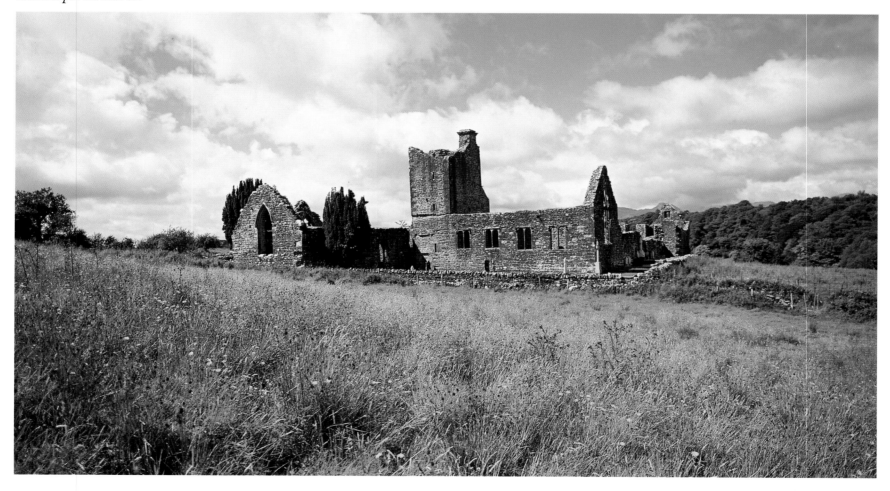

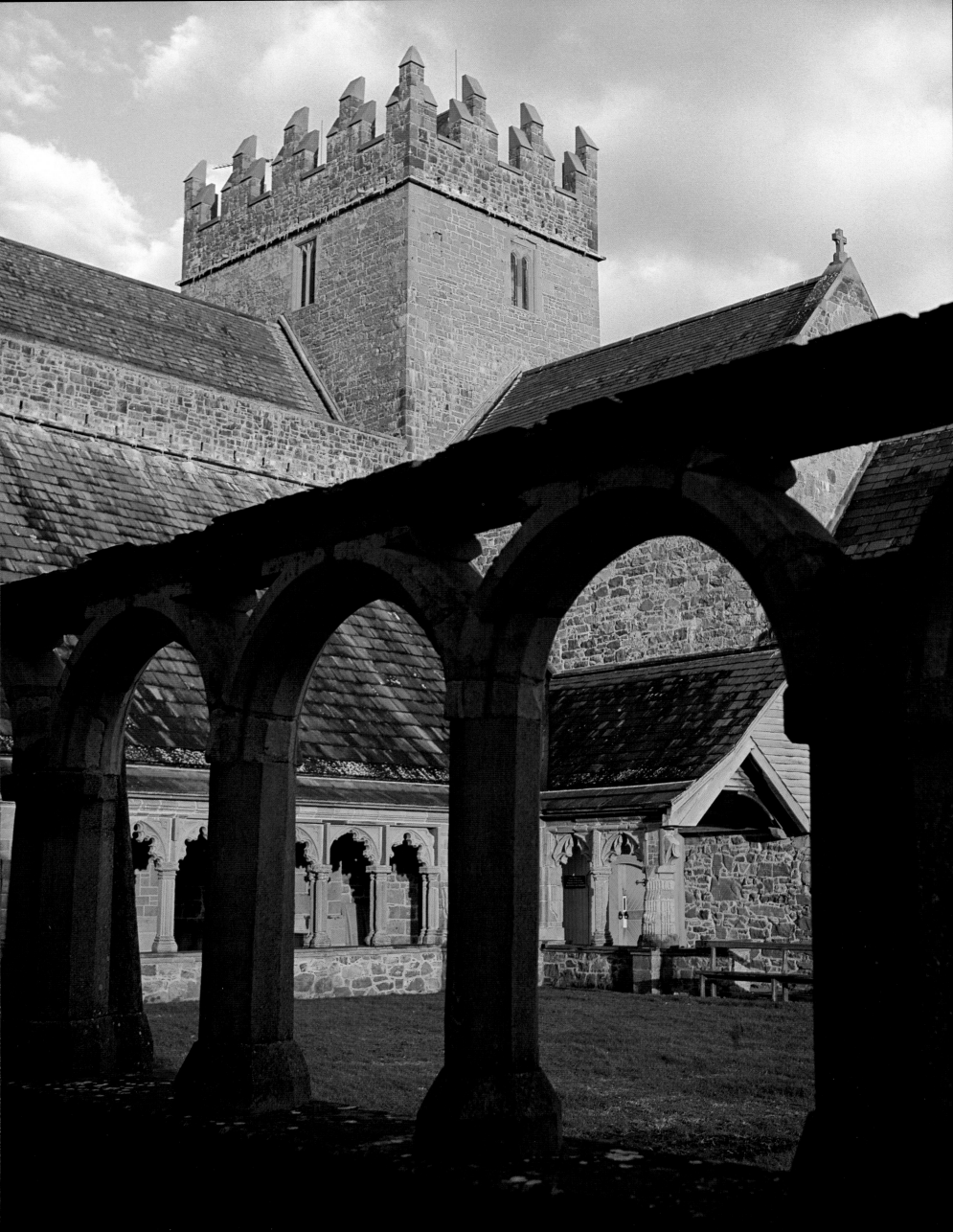

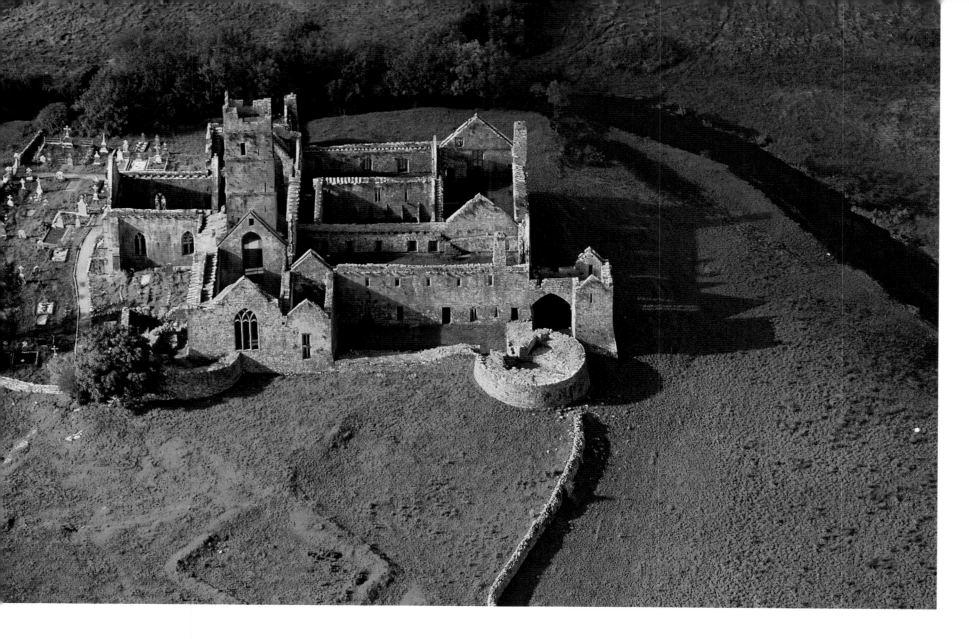

ABOVE AND OPPOSITE: *The friary at Quin, County Clare, might seem like the typical Irish Franciscan friary, with a tall tower straddling the church with its traceried east window, a transept to the left, and the domestic quarters to the right—dormitories, refectory, as well as the attractive cloister seen in the detail. But, in one respect, Quin is unique. The round foundation on the bottom right of the buildings was once one of the four corner bastions of a Norman castle that was burned in the later thirteenth century and built upon for the Franciscans by the Macnamaras in the 1430s. The ensemble of buildings is a wonderful visual symbol of how Gaelic Ireland rose like a phoenix from the ashes of the Norman conquest to revive monastic life and Irish culture after the devastating doldrums of the later fourteenth century.*

cloister garth, and the north side occupied by the church. The battlements on the tower and the east gable make it look like a fortified monastery, but the stonework inside shows the church to have been one of the best-crafted Irish buildings of the fifteenth century. The chancel, north transept, and crossing are carefully vaulted, and the sedilia in the south wall of the chancel or presbytery is the most elaborately decorated example in the country, bearing the Butler coat of arms and the royal arms of England. But the most extraordinary piece of masonry in the church is the shrine in the east wall of the south transept that serves to divide the two chapels. Open at the western end, its north and south sides consist of an arcade supported on fluted columns, and inside is a miniature vault of the highest quality, above which rise undecorated walls— all cut in a blue limestone. The purpose of this curious structure has been much discussed, but it is most likely to have been the repository of the relic of the True Cross, which gave the abbey its name. This lavish reconstruction was probably made possible largely by the income from pilgrims. The carving in the cloister is of an equally high standard, carried out during the abbacy of Dionysius O Congail around 1450, though work on the site may have continued for another half century. One of the delights of Holy Cross is discovering fine carved details of a human head or an owl where one would not necessarily expect them. Another is seeing the church and cloister having been so well restored for parish use during the years 1970–1975.

Two Cistercian abbeys, Kilcooley and Jerpoint, house further sculptural achievements adorning the architecture of late medieval Ireland. The first of these, in the private grounds of Kilcooley House in County Tipperary, is the abbey's most unusual feature—the screen wall leading from the transept into the sacristy, carved with a variety of subjects from a mermaid to the Crucifixion, and also including one of the rare appearances in Ireland of St. Christopher bearing a blessing Christ child on his back. The presence of a shield bearing the Butler coat of arms above the doorway again shows the family's patronage. The same is probably true of the second, and even greater, tour de force, which is in the cloister at Jerpoint Abbey, Kilcooley's mother-house in the neighboring county of Kilkenny. Unique in the Cistercian canon, and against the strictures of St. Bernard, who rejected sculptural decoration as a distraction for his Cistercian monks, the cloister must have been the result of some special commission, probably from the Butlers, who had bought Kilkenny Castle in 1391, and who, within the following decade, may have wanted to mark their patronage in a very special way. What makes the Jerpoint cloister so different from all the others is the rich assortment of figures— including St. Christopher, whom we have already met at Kilcooley—on the dumbbell piers that support the arcade. Four of the apostles survive; others were doubtless present, but have been lost, the cloister as it stands at the moment consisting only of those parts that were available when it was partially reconstructed in 1953. There were at least seven knights in armor, one bearing a shield with the Butler arms and another knight of the Walsh family. There are ladies, too, dressed in the long, buttoned garments that were in fashion during the later fourteenth century. There is also a bishop and an abbot, along with human faces, grotesque creatures, and flowers—all executed by masons who were given the liberty to carve out their own fantasies (some probably inspired by the drolleries they would have been seen in manuscripts of the period). The slightly stiff figures belong to a style common in England at the time and, in the absence of any other obvious Irish precursors, we may have to look across the Irish Sea for the origin of the master carvers who created the Jerpoint cloister. If so, they may have left the country after their work was finished, as no "school" continued the lively tradition created at Jerpoint. Nor are there really enough clues left as to how this rather eclectic collection of figures came to be carved in the first place.

It takes just a century before stone sculpture again makes its mark in the Butler lands in Kilkenny and Tipperary, though one must not forget the possibility that wooden sculpture destroyed at the Reformation may have helped to fill the gap. The one remaining set of wooden sculptures that has survived in the area do not evince a very high standard. These are the three figures of God the Father, St. John the Baptist, and Christ on Calvary from Fethard in County Tipperary, which are now displayed in the National

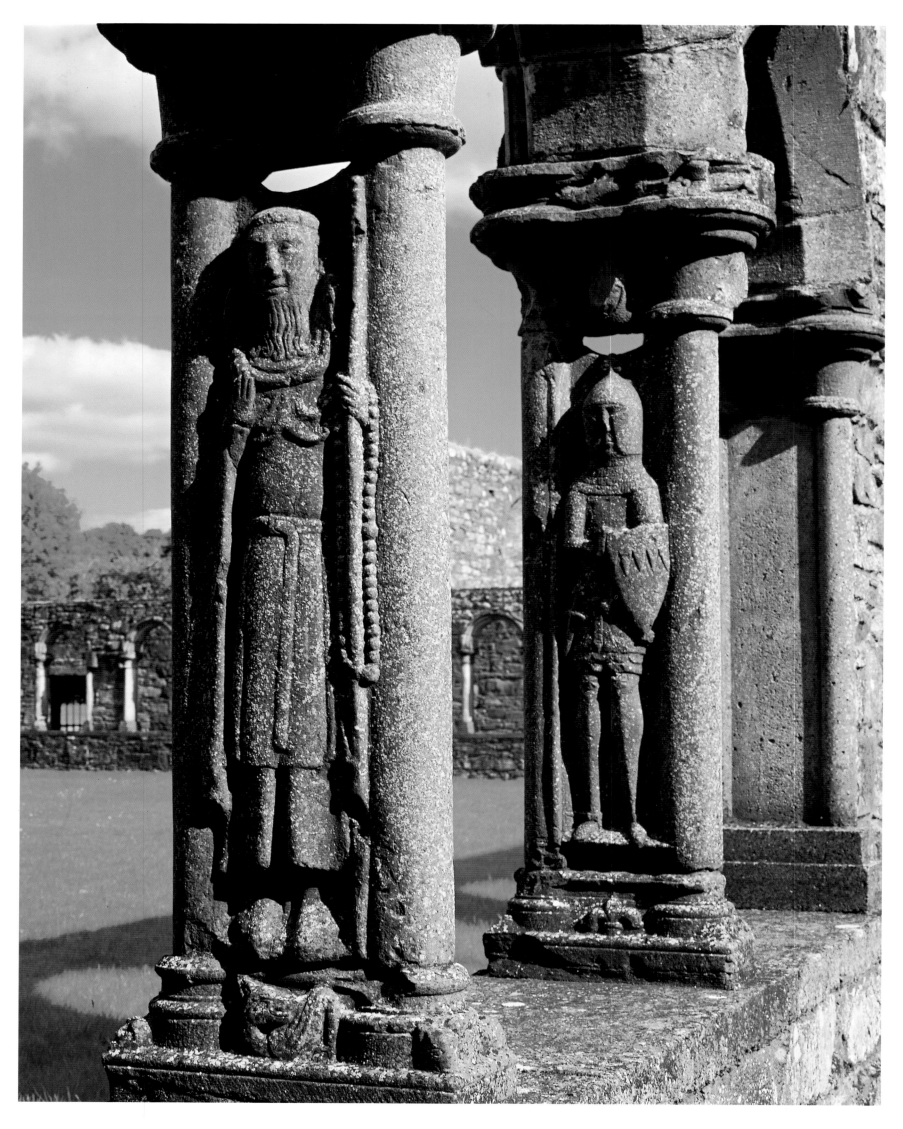

Museum in Dublin. They are comparatively simple statues of a kind that would have stood in the parish churches of late medieval Ireland, as laid down by a statute in a synod of Cashel in 1453. Presumably there were other wooden statues that once existed, a few perhaps imported and some copied in stone. Two such stone statues, of the *Pietà*, survive in County Clare—one at Kilmurray Ibrickane and the other in Ennis friary. The *Pietà*—Christ's mother mourning over his dead body laid across her lap—was a common subject among wood carvers of the fifteenth century throughout many parts of Europe, and whether these Clare examples were copied directly from originals imported from outside Ireland or from native work that copied foreign models, it is impossible to say. But what we can say is that even in their fragmentary state, they are of competent quality.

The chancel of Ennis friary certainly provides even clearer evidence that stone carvers copied models from outside the country in a group of carvings illustrating the Passion, Death, and Resurrection of Christ that were built into the Creagh tomb around 1843. The character and gestures of these figures demonstrate that they must have been modeled on English alabaster representations of the same subjects—such "tables," as they were called, having been exported from England to as far away as Iceland and the eastern Baltic,

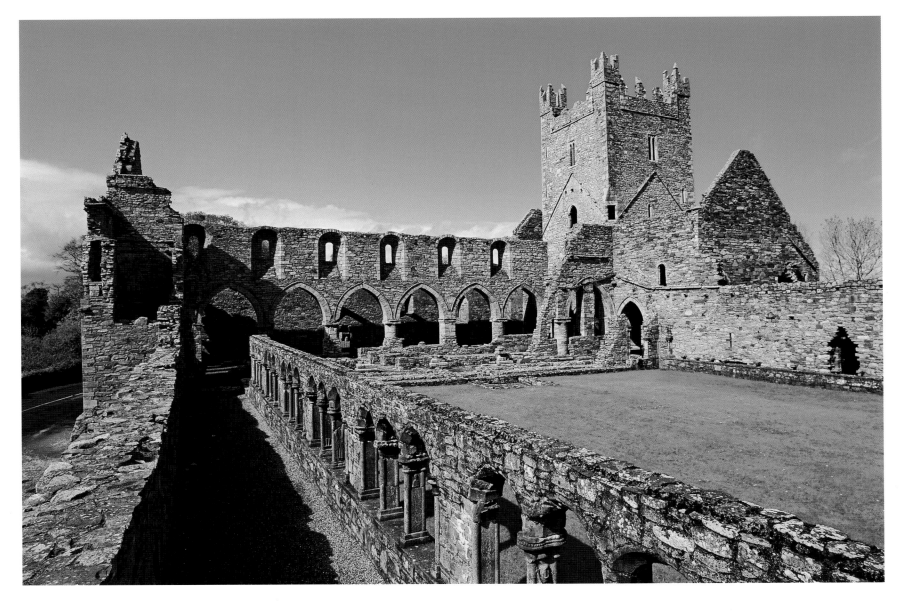

RIGHT: *The north doorway of the cathedral at Clonmacnois employs no capitals in its upward-sweeping lines, but its outermost order is a well-ordered jungle of ornament with fabulous beasts luxuriating in dense vine-scroll foliage covering the top arch of the doorway. The crockets rising from the extremities hold a lintel inscribed with the names of the three saints who are figured beneath them—Dominic on the left, Francis displaying his stigmata on the right, and St. Patrick in the middle. The doorway, the most delicate of the later medieval period in Ireland, was commissioned by Dean Odo, who died in 1461—and the presence of Patrick may mean that the portal was erected to commemorate the thousandth anniversary of his death, thought to have been in 461.*

BELOW: *Just inside the door on the Franciscan friary of Kilconnell in County Galway is a fine example of a canopied tomb, which is something of a specialty of the West of Ireland in the fifteenth and early sixteenth centuries. Where one might have expected an effigy, there is none; instead, a canopy resplendent with flamboyant tracery rises above, capped by a mitered figure and St. Francis showing his stigmata. Beneath is a well-carved row of named saints, including Louis and Denis of France, and the apostle James Major, suggesting that the unnamed person who commissioned the tomb had links with France and had probably gone on pilgrimage to Spain, where St. James is traditionally thought to have been buried in Santiago de Compostela.*

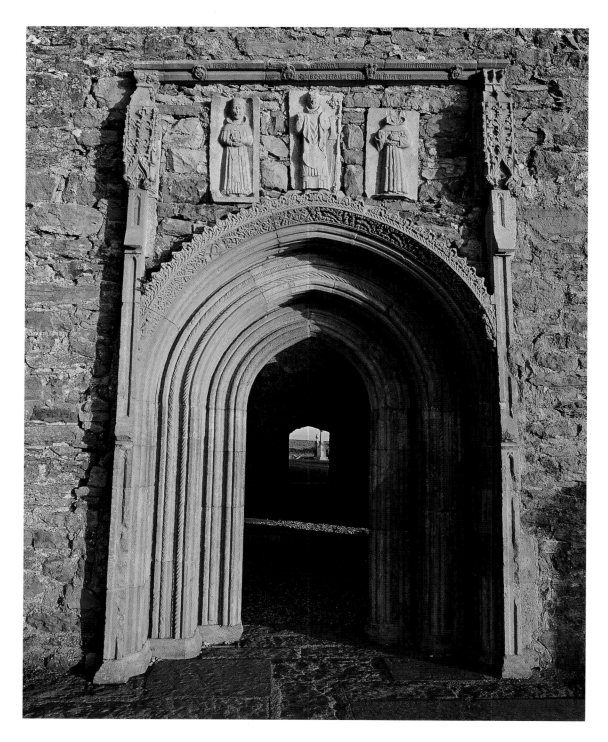

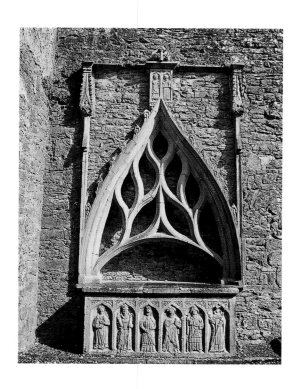

where originals still exist, and obviously also to the West of Ireland, where the Ennis copies of long-vanished originals were made around 1470 in much less destructible Clare limestone. A fine carved panel of the *Pietà* flanked by angels and kneeling figures at Strade in County Mayo may be some decades later. In the same Mayo church is a canopied tomb with a front carrying figures of Christ, a bishop, the apostles Peter and Paul, and the three Magi, suggesting that the person buried in the tomb may have gone on pilgrimage to Rome, and also to Cologne, where relics of the three kings were enshrined in the cathedral. These two carved panels at Strade emerge unexpectedly, without any antecedents, and surprise us with the high quality of carving in Connacht in the fifteenth or early sixteenth century, though they have recently been associated with Kilkenny carvings of the early sixteenth century.

However, the midlands not far away also demonstrate good quality in sculpture decorating both tombs and architecture in the fifteenth century. Prime

among these is the north doorway of the cathedral at Clonmacnois, which is crowned with three figures of Saints Patrick, Dominick, and Francis (the last of these also present at Ennis friary), while the doorway itself is decorated most intricately with foliage and animals around the finely worked moldings. The doorway is normally dated to around 1459 and attributed to the patronage of a man who died two years later, yet, given the presence of the national apostle among the figures, one wonders if this were not a millennium memorial to St. Patrick, erected in a year (1461) that people believed to have been a thousand years after his death. Another remarkable doorway carved only a decade or so later is that in the Augustinian priory of Clontuskert, County Galway, where we find figures including St. Michael the Archangel weighing souls, and St. Catherine of Alexandria, along with many symbolic carvings, to create a whole assemblage illustrating, among other things, the triumph of good over evil.

Not too far away, and of around the same period, is a fine canopied tomb in the Franciscan friary at Kilconnell in County Galway, where, beneath an arch filled with flamboyant tracery, figures stand in a row in niches. Carved in deep false relief, these happy, smiling figures draped in long garments with tubular folds represent, among others, St. James Major and Saints Denis of Paris and Louis of Toulouse, who suggest a French connection and possibly a pilgrimage taken to Santiago de Compostela by the unidentified person buried in the tomb. This canopied tomb is the most decorated of its type in the West of Ireland dating from the second half of the fifteenth century, the majority of others lacking the figure sculpture seen here. Somewhat earlier, in North Leinster, carvers had already been erecting tombs decorated with figures

BELOW: *The effigy of Pierce Fitz Oge Butler of c. 1526, clad in his knightly armor, lies now in a niche in the chancel of the Cistercian abbey of Kilcooley in County Tipperary, though it is almost certainly not in its original position. On the front of the tomb are a number of "weepers," apostle figures holding their various attributes that would help to identify them if their names were not carved overhead. The effigy is signed by Rory O'Tunney, head of the most famous atelier of sculptors active in the neighboring county of Kilkenny during the first half of the sixteenth century. The apostle figures are equally a product of the same workshop.*

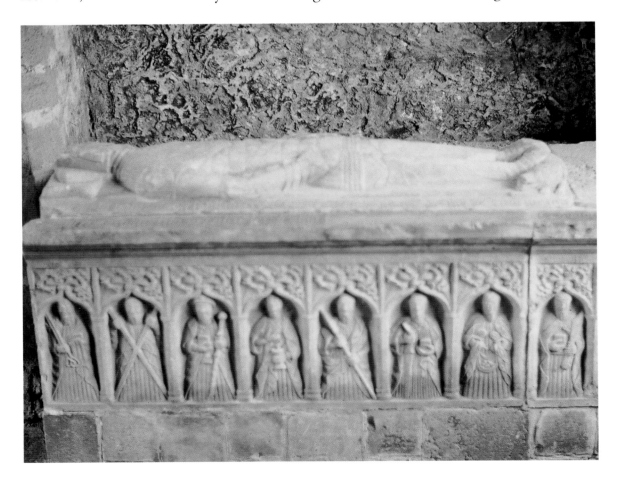

within arcades, but these formed the ends and sides of box tombs. It is the Plunket family of Meath and the St. Lawrences of Howth in County Dublin who should be credited with introducing into the country the type of tomb that was covered by the effigy of a knight, often accompanied by a rendering of his wife. Such figures show the knight wearing old-fashioned chain mail and other defenses, and often represented in a somewhat awkward, stiff pose, while, at the same time, the armor is delineated accurately. The ladies, carved with varying degrees of quality, are shown wearing an elaborate headdress that was obviously the height of fashion in the 1460s and 1470s. The carving of such tombs in North Leinster continued well into the sixteenth century. The effigies cover the period when Garret Mór FitzGerald, Earl of Kildare, was king of Ireland in all but name, and a member of one of those Anglo-Norman families who had, as the phrase went, "become more Irish than the Irish themselves." The Great Earl, as he was known, was a most cultured man, with an extensive library of books and manuscripts. It is all the more surprising, then, that his own county of Kildare is comparatively poor in knightly tombs of this period.

Instead, the lead that North Leinster gave in the fifteenth century was taken up farther south in the first half of the sixteenth in the Butler family lands in Kilkenny and east Tipperary. It is above all in St. Canice's Cathedral in Kilkenny that we see preserved the finest collection of late medieval tombs

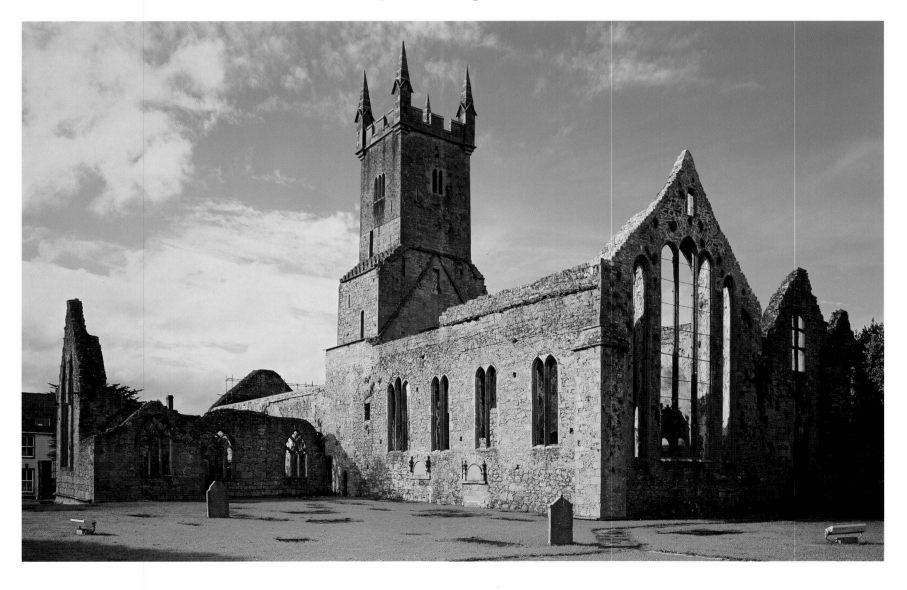

gathered together anywhere in Ireland. Destruction by Cromwell's henchmen has meant that very few of the tombs are in their original condition or position; they have been reconstructed with whatever pieces happen to fit best together. Nevertheless, the quality shines out, particularly in the effigies of the eighth and ninth earls of Ormond in the south transept, the former dressed in plate armor and mail, sword at his side and with a winning smile. He is accompanied by his wife Margaret FitzGerald, who has a voluminous headdress and hands held in prayer. Together, this pair present us with the best picture of the cultivated higher echelons of a prosperous and virtually independent Anglo-Norman population of the first half of the sixteenth century. The earl's family kept one anonymous Kilkenny workshop full with orders for tombstones, while at the same time, there was also a second one in the city, run by Rory O Tunney and his family. Here, the figures tend to become squatter and somewhat more stylized than in Meath of the fifteenth century, but the effect created by the figures on the tomb surrounds—usually apostles carrying their attributes, and sometimes even with names to make sure that we can identify them correctly—is one of comparative contentment in an ordered world. It is quite likely that these appealing figures—be they effigies or the so-called weepers in the arcades on the sides of the box tombs— would have been painted originally, which would have made them appear more lively and colorful as well.

The Irish climate has meant that what color there was—and there was probably much more than we imagine—has largely disappeared. However, some Cistercian abbeys have preserved traces of frescoes, showing us that late medieval Irish churches would probably have had scenes painted on their walls, as in many of their English and continental counterparts. One hunting scene is preserved in monochrome in the north transept of Holy Cross Abbey, and another, more colorful one survives in the church on Clare Island in Clew Bay, County Mayo. What was once obviously a most remarkable fresco—or line-painting, as it was more technically described— representing a crucifixion and portraying the old medieval morality tale of the Three Live Kings and the Three Dead Kings was painted on the chancel wall of Abbeyknockmoy in County Galway. But, sadly, again the Irish weather has played havoc with the colors, so that little of its former coloration survives today.

One unexpected find within the last few years has been the frescoes that have turned up on the walls of a tower house at Ardamullivan in County Galway. Frescoes are long known to have existed in tower houses, but it is their freshness and content that surprise at Ardamullivan. Yellow, black, red, and salmon pink are used in the depiction of a head of St. Michael, and a number of other figures—some with haloes and one a bishop with a crosier—are also present. The quality of draughtsmanship is absolutely remarkable, and what is also exciting—but also very surprising—is the clearly religious nature of the

RIGHT: *Standing against the wall of the south transept of St. Canice's Cathedral in Kilkenny is the effigy of a Butler knight, recognizable from the pair of shields beside his head that bear the coat of arms of his family. He wears a bascinet on his head, and his body is protected by both plate armor and chain mail. In his left, gloved, hand he holds a sword, while his feet rest on a faithful if somewhat indefinable animal. The carving is so similar to that of the nearby effigy of the eighth earl of Ormond, who died in 1539, that this may represent James Butler, the ninth earl, in which case it would be datable to around the time of his death some seven years later.*

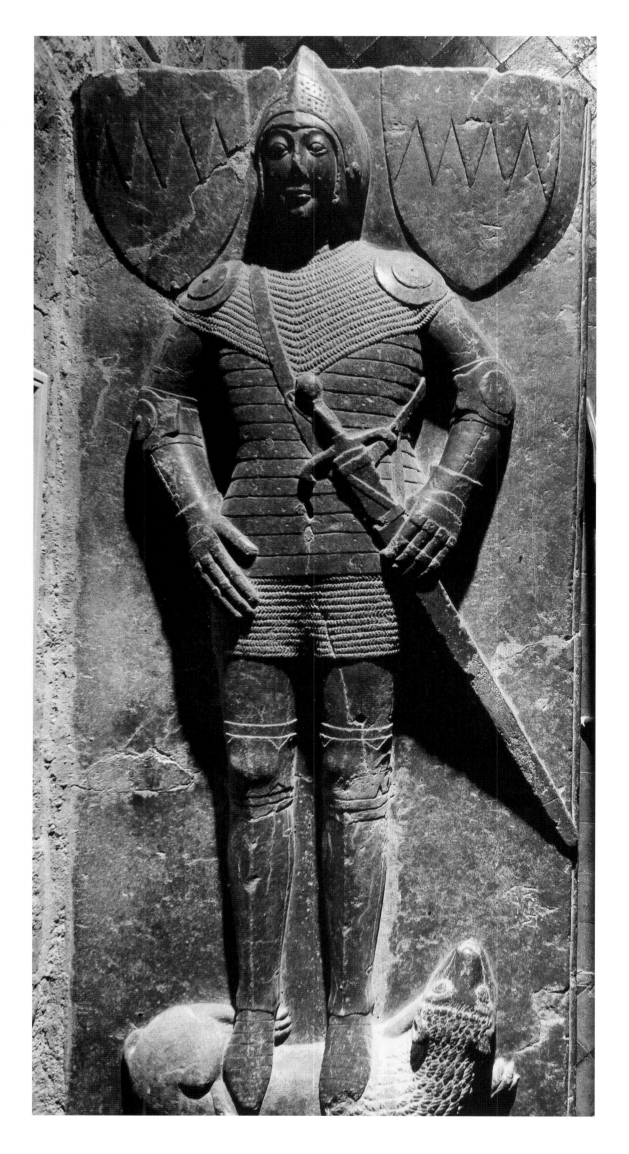

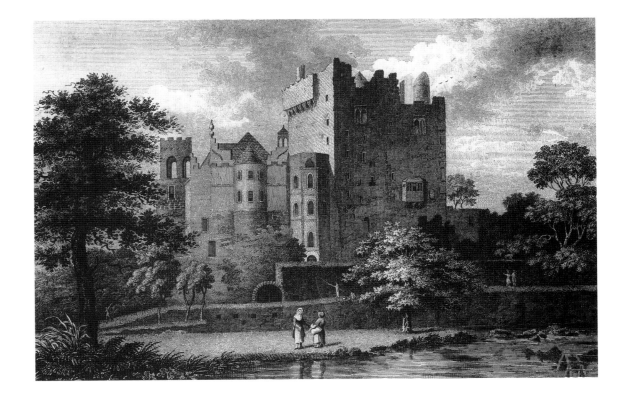

frescoes in the secular setting of a tower house. The revelations at Ardamullivan raise the question as to the inspiration for these pictures, and whether more remain to be discovered in other buildings of the type.

Tower houses were the homes of the better-off farmers in both Gaelic and Anglo-Norman Ireland, and were, therefore, a sign of comparative affluence. The O'Shaughnessy builders of Ardamullivan were the hereditary keepers of the shrine of St. MacDuagh's belt, which may help to explain how they had enough money to pay for one or more fresco painters to come and carry out work of such a high standard, and to account for the religious content of the painting.

Tower houses were the most typical kind of castle in fifteenth- and sixteenth-century Ireland. They came in various shapes and sizes, depending on the status of the builders and how many people they could press into service to help with the construction. One of the more imposing examples is the Butler castle at Cahir in County Tipperary—not because of the size of the tower, but because of the extensive and intricate defenses, curtain walls, and the towers that surround it. Taller and more impressive still are two of the best-known tower houses in Ireland whose fame has spread far beyond the country's boundaries. The first of these is Blarney, a mighty and intimidating five-story castle built by Cormac MacCarthy in 1446. One of the earliest reliably dated examples in the country, it stands upon a rock, seemingly impregnable, and shows that its builder really earned his epithet Láidir ("the strong"). Blarney has become famous through the "Stone of Eloquence" placed high up on the parapet, which has the reputation of bestowing eloquence on those who kiss its underside while lying on their backs. The castle's name entered into English language usage apparently from a MacCarthy owner whose silver-tongued words allegedly provoked England's Queen Elizabeth I to describe what he said as "all Blarney."

RIGHT: *Bunratty Castle was once at the center of a small but bustling medieval settlement. Now the castle alone remains, still dominating the landscape around it and impressing its awesome size on anyone traveling between Limerick and Shannon Airport. Originally built by Sioda Mac Conmara in the mid-fifteenth century, it was later appropriated by the O'Briens, earls of Thomond, who made it their chief residence in 1580. There they would have held great feasts in the lofty Great Hall, where today nightly reenactments of medieval banquets take place. Nowadays, the castle is decorated with furnishings of the period, which bring the castle alive again as it was four hundred years ago.*

Bunratty, built by the Macnamaras, belongs to roughly the same period as Blarney. Close to Shannon Airport in County Clare, this is a large tower that was restored almost half a century ago, its two extensive upper floors ideal for the medieval banquets that are staged there on many nights throughout the year. The uppermost of the two is a wonderfully spacious room that has a splendid oak roof support copied from that at Dunsoghly Castle near Dublin Airport, where wooden dowels rather than nails hold the individual wooden beams together. Spiral staircases within the corner towers link the individual storys, and there the lord of the castle would have climbed the steps to his bedchamber, which would have been on the top floor. Bunratty was an important stronghold because—together with Carrigogunnell on the other side of the Shannon estuary—it could supervise access by boat to and from the city of Limerick. When the castle was restored, the furnishings had to be imported, since virtually no medieval Irish domestic furniture survived the rigors of war and the centuries. A French visitor, Boullaye le Gouz, paints a rather stark picture of the paucity of furniture in Irish castles around the 1620s:

The castles or houses of the nobility consist of four walls extremely high, thatched with straw; but to tell the truth, they are nothing but square towers without windows, or at least having such small apertures as to give no more light than a prison. They have little furniture, and cover their rooms with rushes, of which they make their beds in summer, and of straw in winter. They put rushes a foot deep on their floors and on their windows, and many ornament the ceilings with branches.

However, aristocratic landlords such as the sixteenth-century O'Brien earls of Thomond would scarcely have done without some luxuries of life. A later scion of the family, Máire Rua, who lived through the Cromwellian era, is shown in her portrait wearing what looks like a Renaissance (probably Italian) brooch, demonstrating that noble Irish families must have been well aware of developments and fashion on the European continent. We know, too, that some of the doctors who were part of the family's retinue went abroad to medical schools at Montpellier, Padua, or Salerno to learn the latest methods and bring them back to practice in Ireland. Wine, too, was abundant, and was liberally poured out at great feasts that must have taken place—more than one having sadly ended in bloodshed, for the later Middle Ages were a time when animosity was still rife between the Anglo-Normans and the native Gaelic and

BELOW: *Aughnanure Castle, which raises its battlemented head above the trees close to the western shores of Lough Corrib in County Galway, was built by the "ferocious" O'Flahertys, one of Connacht's most notable families, who gave it its present form after 1572. The east side bristles with projecting defenses at the corners, gunloops in the walls to fire the newly developed musket, and machicolation at roof level from which stones could be dropped on unwelcome intruders trying to enter the doorway six floors beneath. The tower is further defended by an outer and an inner bawn wall, the round turret seen here belonging to the latter. On the extreme left is the only remaining wall of a sixteenth-century banqueting hall—the rest collapsed when the rock it stood on fell into the adjoining river!*

ABOVE: *Doe Castle stands on a small promontory jutting out into the waters of Sheephaven Bay in County Donegal, where it was built by the MacSweeney clan sometime before 1544. The tower, with battlemented hall attached, was defended by an outer wall, which gave temporary protection to some survivors of the Spanish Armada in 1588. Spain was also the country from whence the famous Owen Roe O'Neill came to land here with 100 veterans in 1642 before setting off to take charge of the Irish army in Ulster and to victory at the Battle of Benburb in 1646, when he defeated the Anglo-Scots' opposition defending the Protestant settlers in Ulster.*

Gaelic-speaking population, whose land had been taken away in the twelfth and thirteenth centuries.

Tower houses are spread widely throughout the country, on both sides of the political divide. Thousands were built between 1400 and 1600 as status symbols and defenses, but unlike the castles of the two preceding centuries, they were primarily family residences rather than barrack quarters for a small army. The usual arrangement in such tower houses was a vaulted ground floor where the servants lived and worked, above which there were two or three floors—one serving as a reception room—while the topmost was reserved for the family. Each story would have been provided with a fireplace—sometimes quite elaborate, with a carved mantelpiece—and the sleeping accommodation would have been located off the main rooms, as seen, for instance, in Aughnanure Castle on the western side of Lough Corrib in County Galway. Sadly, the families who built these tower houses either never kept records or their documentation has been lost, so that in many cases we scarcely even know the name of the families that built them. The state now owns a representative number of these structures, and private individuals have restored others for living purposes, but many have been so neglected since being abandoned four centuries ago that they are little more than shells today.

The origin of the tower house castle is not certain, but Kilclief in County Down, built around 1441, is one of the earliest recorded examples. Others, though undocumented, may be earlier. In 1429, the English government in Dublin promulgated a law offering £10 to anyone who was prepared to build a

LEFT: *The Lakes of Killarney are at the center of some of the most sublime scenery in Ireland, and beside their lapping waters stands one of the country's most romantic and picturesque tower houses. This is Ross Castle, a tower built by the O'Donoghue Ross chieftains sometime in the fifteenth century and defended by a high bawn wall with corner turrets, all recently restored by the state under the supervision of Grellan Rourke. The castle was taken by Cromwellian forces in 1652 by a boat brought overland and launched on the lake—which fulfilled an old prophecy that the castle could only be captured by a Man of War. As it turned out, this was the last Irish castle to capitulate in the disastrous Cromwellian wars of the 1650s.*

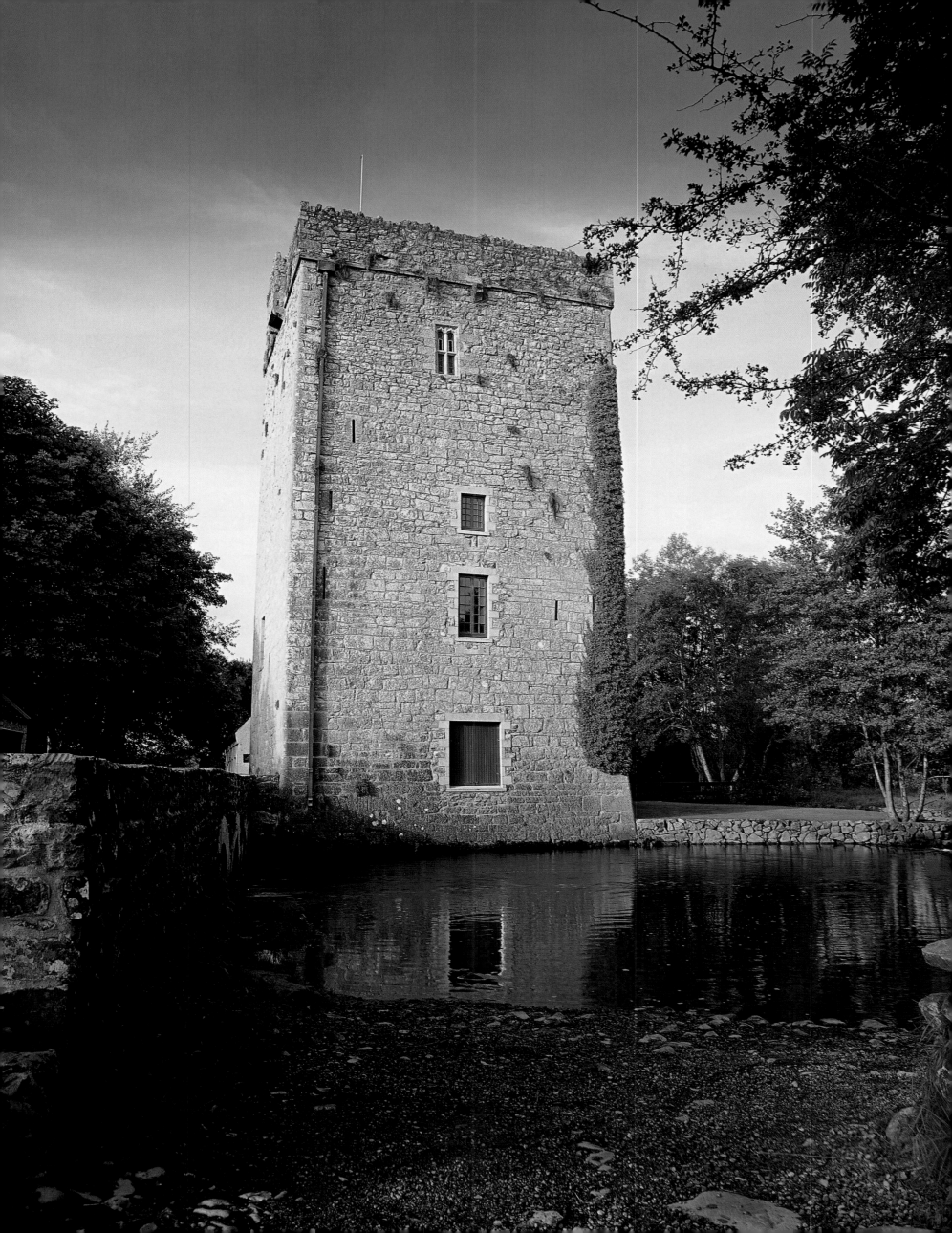

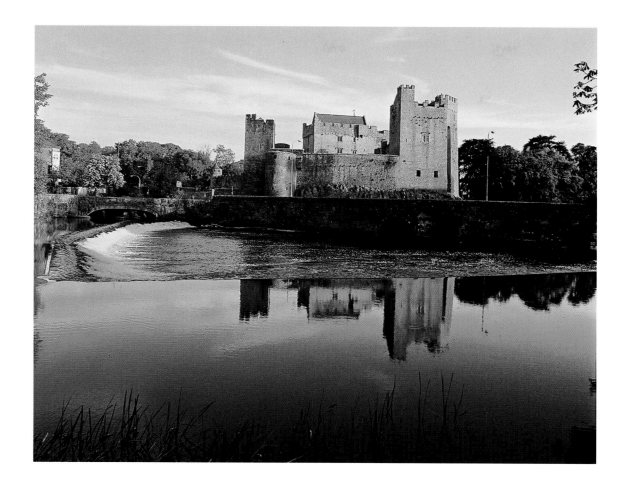

stone castle of a particular dimension in order to help defend the Pale, which was an ever-changing boundary between English and Irish that was usually more an imaginary than a practical defense. The majority of tower houses are located in what would have been almost entirely Gaelic-speaking areas. The more romantic waterside castles in this category would include Ross Castle on the Lakes of Killarney and Doe Castle in County Donegal. Another, Thoor Ballylee in County Galway, has a place in the literary tradition of Ireland because it was owned and lived in by the great Irish poet W. B. Yeats. Tower houses are very much a part of the Irish countryside—and as much a feature of the landscape as Round Towers or medieval friaries. They were obviously such a popular type of protective domestic accommodation that they continued to be built up to the 1640s, and Ross Castle, in fact, was the last Irish bastion to surrender to Cromwell's soldiers. By then, of course, cannon had become a staple part of any army's war machines, and no tower house would have been able to withstand a siege against such fire power for any length of time. Though most would not have been worth capturing anyway, given the difficulties of bringing cannon on wheels through woody and muddy terrain, Cahir Castle still has a cannonball embedded in its walls as a reminder of a siege that took place there in 1599.

The middle third of the sixteenth century was something of a turning point in the history and cultural history of Ireland. The Anglo-Normans, who had become so Irish, rebelled unsuccessfully against English rule only a few short years before King Henry VIII decided to suppress all the monasteries and friaries of Ireland in order to get his hands on their lands and possessions.

The Reformation zealots succeeded in burning "idolatrous" statues, which, had they survived, would have helped greatly in filling out our otherwise meagre picture of medieval wooden statuary. Fortunately, the iconoclasts did not succeed in destroying the misericords in Limerick Cathedral, which are witness to the high quality of native wood-carving that was reached by the second half of the fifteenth century. Worse was to come. To suppress political opposition from the Irish, Queen Elizabeth started introducing English planters into the Midlands and later into Munster. By the second half of the sixteenth century, more formal and horrific warfare had begun between the English and the Irish. As with any time of struggle, the war effort swallowed up much of the country's spare cash, and cultural and artistic commissions tended to take second place in Ireland for the next century and a half.

Political unrest did not, however, entirely stifle art in Ireland, though it was not necessarily the disadvantaged native Irish who were producing the art. Just as the monasteries were being suppressed, the priory of Great Connell in County Kildare was seeing the preparation of a remarkable effigy of its prior, Bishop Walter Wellesly, which has since been removed to Kildare Cathedral. Like a benevolent lord, he lies on the tombstone, blessing with one hand, holding his crosier in the other, flanked by angels in a Gothic niche and wearing vestments that show the sumptuousness of sixteenth-century brocade. While the effigy is Ireland's adieu to late medieval Gothic, the tomb surrounds in contrast betray the budding of Renaissance ornament in the form of columns and arcading surrounding the "weeping" figures. The harsh, suppressive regime of Queen Elizabeth I toward the Irish left little room, however, for the Italianate style to flourish in Ireland. The Miosach, an ancient metal reliquary from Cloncurry, County Donegal, was redecorated in 1534— the year in which Silken Thomas FitzGerald threw down the sword of state in St. Mary's Abbey in Dublin in defiance of Henry VIII, and only two years before the same monarch decided to close down the monasteries of his kingdom—but the stiffness and stylization of the shrine's figures is a far cry from the elegance of the continental Renaissance. Anglicized courtiers that decorate a sixteenth-century ivory bookcover bearing the arms of the earls of Desmond (now in the National Museum in Dublin) seem to be dancing in a garb and a fashion that looks distinctly un-Irish; the dragons incised on the ivory—one pierced by the lance of a mounted knight—seem to be permeated more by the spirit of the Gothic.

One remarkable book of family history survives from the Burkes of Connacht. It was begun for Seaán Burke, who became Chief MacWilliam Burke in 1571 and was appointed seneschal of Connacht in 1575. The book was probably designed to be a history of his family, combined with poems in praise of himself, but it was never completed. What it does have, however, is a series of color pictures of various Burke figures, including a knight on horseback,

Si ro pioboin piocanio moin in william cuizcun abupe
Jin insian pis ranan matain piocanio moin in willia cuize
Qt ire piocanio mon wo binis cai vinluaiiquio tt wo bizan a lain
yi pizeais episan venbuille clordpain. wo piiatoni in conprocalti
moin i concopain tt wo sab piocap mon baile yi leat shi sacain

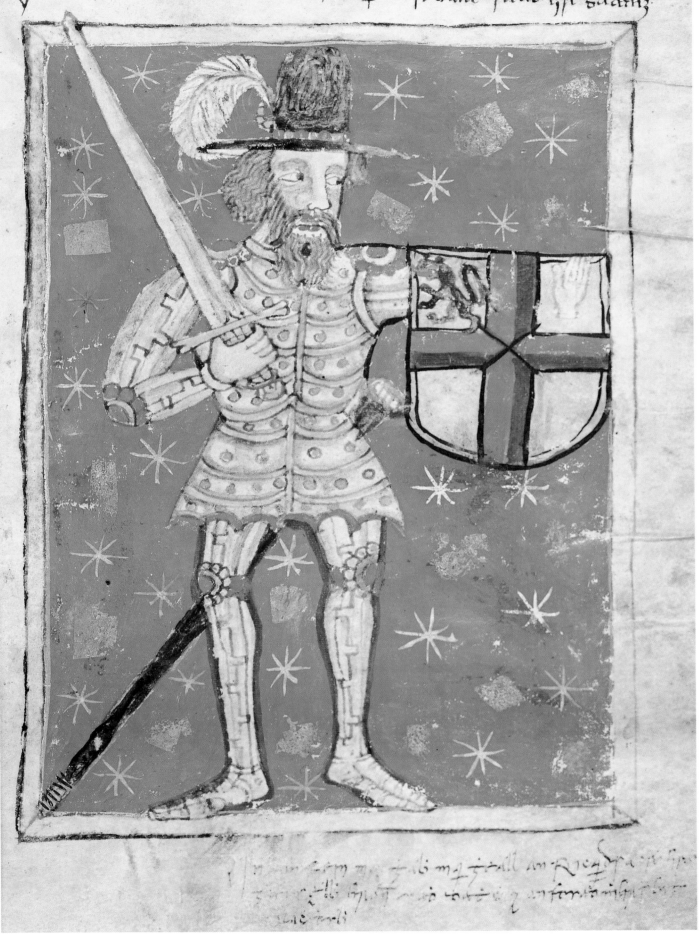

ABOVE: *Old and new meet in Carrick-on-Suir castle, County Tipperary, where "Black Tom," the tenth earl of Ormond, used a tall fifteenth-century battlemented family tower house as a backdrop for the mansion that he built in front of it sometime around 1570. The first of its kind in Ireland, it must have surprised many Irish of the time for its openness and lack of fortification, drawing from one Gaelic poet, Eoghan Mac Craith, the eulogy that it was handsome and superbly furnished. His comment that it was "so artistically stuccoed with sun-lit gables and embroidered walls" probably referred to the great sixty-three-foot-long gallery that takes up the full length of the first floor front of the building, its multi-mullioned windows letting in plenty of light to illuminate the interior of the three-gabled front.*

as well as four religious subjects—Christ of Pity, Christ before Pilate, the Flagellation, and Christ carrying his cross to Calvary. This manuscript, now in the Library of Trinity College, Dublin, shines out like a light in late medieval Anglo-Gaelic Ireland as an example of what the Irish illuminators of the period could achieve. "Large pictures, extremely crude and brutal in color, but arresting in their originality and their vehemence," was how Françoise Henry and Geneviève Marsh Micheli described them. The religious subjects were probably based on some woodcuts (possibly German) that were popular in Europe at the time, copies of which may have been circulated in Ireland. Since the time of the *Book of Ballymote* and the *Leabhar Breac* around 1400, there had been little attention paid to religious illustrations in manuscripts, though it should be said that the figure of St. Colmcille in the *Life* of the saint by Manus O'Donnell, preserved in the Bodleian Library in Oxford (Ms. B. 514), is a fine portrait quite unique in Irish manuscripts of the fifteenth or sixteenth centuries, showing the author's saintly hero in his full complement of Mass vestments, holding a crosier in one hand and blessing with the other. A rare survival, it demonstrates what an Irish scribe of around 1530 could do, though the floral decoration in the arch under which the saint stands suggests that there was some outside influence at work, for Manus O'Donnell was something of a Renaissance man himself.

While many of the native Irish had to struggle politically during the second half of the sixteenth century, a new spirit could be felt among the old

Norman families in various parts of the country who were inspired—largely by English models—to build elaborate homes that exuded a sense of gracious living, combined with some fortficatory protection. The first notable example was a structure of a rather different kind—the castle in Carrick-on-Suir in County Tipperary, built by "Black Tom," the tenth earl of Ormond around the early 1570s. He had been brought up at the court of Henry VIII and is known to have had a mild flirtation with the same Queen Elizabeth who was terrorizing his Gaelic-speaking fellow countrymen. From England he brought back home the latest architectural ideas, and in front of a fifteenth-century Butler stronghold, he created a new mansion with a long façade—two-floored with three gables enlivening the skyline. What is most remarkable is the sixty-three-foot-long front hall stretching the whole length of the first floor, now containing a fine fireplace of 1565. This great long gallery was decorated with stucco medallions of "good Queen Bess" in a classical frame and a stuccoed ceiling bearing Ormond arms and mottoes, all of which were expertly restored in the 1950s. Nothing so grandiose had been seen before in Ireland—and it was, perhaps, the inspiration for the Earl of Thomond to create an ambitious stucco ceiling for his chapel in Bunratty Castle, which represents the best expanse of stucco surviving from the period around 1600 anywhere in Ireland. The gable idea at Carrick-on-Suir was doubtless an influence on the street façade of Rothe House in Kilkenny City, of 1594, now the headquarters of Ireland's Heritage Council as well as of the Kilkenny Archaeological Society, which displays its costume collection there. The three-light oriel windows in the first floor ape those in Carrick Castle, but what is different here is the passage along the

BELOW: *The gable and the triple-mullioned windows on the first floor of Rothe House in Kilkenny city would appear to be modeled on the architectural details of the Ormond Castle at Carrick-on-Suir. The house was built by a rich citizen, John Rothe Fitz Piers, and bears the construction date 1594. The only surviving Tudor merchant's house in Ireland, it extends far back behind its façade on Parliament Street and has two interior courtyards, which, according to hearsay tradition, were added one after the other as the size of his family increased. Particularly attractive is the row of rounded arches that form an arcade on the ground floor frontage, which would probably have continued in the adjoining houses that have long since been replaced by more modern structures.*

BELOW: *The contrast in the style between castle and mansion, between ill-lit medieval interiors and more gracious sun-lit living, is well illustrated at Leamanegh Castle that guards the southern end of the Burren in County Clare. At its northern end is a typical medieval tower house with narrow arrow-slits, built by the O'Briens around 1480, and on to that Conor O'Brien and his legendary wife Mary Ní Mahon (better known as Máire Rua, "Red Mary") built the larger mansion in the 1640s. The castle's walls are almost more mullioned windows than masonry, which must have provided bright interiors before the darkness of the Cromwellian wars descended, in which Conor lost his life; his widow successfully retained the property for their children by marrying a Cromwellian cornet named Cooper.*

whole ground floor, joining the building to the street by an attractive arcade of five arches, the central one of which accesses two separate courtyards behind. The arcade idea was to be used to advantage more than a century later at the Royal Hospital in Kilmainham and also in Skiddy's Almshouses in Cork. Called after its founder, John Rothe Fitz Piers, Rothe House is the only survivor in Ireland of a Tudor merchant's house, of which there must have been many more. In earlier times, the merchants would have built towers for themselves within the protective walls of towns such as Youghal in County Cork, Dalkey outside Dublin, and Ardglass in County Down.

The seed that had been planted by the greater elegance and luminosity of the interior of Carrick-on-Suir Castle bore fruit of a slightly different kind in the late sixteenth and early seventeenth centuries. One very good example is Rathfarnham Castle, now in the suburbs of Dublin, which was built well outside the city's protection by Adam Loftus, archbishop of Dublin and first provost of Trinity College, Dublin. Erected around 1593 in the form of a square

with angular towers at the corners, it contained musket loops for shooting at unwanted intruders, while at the same time it had windows larger than those in older castles to allow light into its more commodious rooms within—the archbishop could retire safely at night without having to worry too much about being murdered in his bed. A rich merchant like Sir Walter Coppinger built another mighty manor for himself about thirty miles west of Cork city around the 1620s, which, however, managed to bristle with defensive possibilities in the event of attack. Less aggressive is Portumna Castle in County Galway, recently restored along with its fine surrounding gardens and entrance gate. A rather extended version of Rathfarnham Castle, it is approached up steps through a decorative Jacobean doorway, and the crenellations at parapet level have begun to take on a more decorative character. Following the lead of Carrick Castle, it, too, has more and broader windows to let in more light. Since it was no longer necessary to stack rooms one above the other, as in a medieval tower house, here the rooms could all be laid out spaciously on one or two levels within the extended walls of the castle, so that its builder, Richard de Burgo, fourth earl of

Clanrickarde, could enjoy a more enlightened and leisurely existence in his grand manor. (We do not know if he ever lived in the castle, because he built it while domiciled in England, sending his building instructions by messenger across the Irish Sea.) But the native Irish were not permitted to copy such grandeur; when Dermot Mac Donagh started constructing Kanturk Castle in County Cork, he was stopped by the privy council lest he should get ideas above his station. Restrictions seem to have lessened by the 1640s, when Conor O'Brien was able to imitate Black Tom of Carrick-on-Suir by adding a graceful mansion to a medieval tower house at Leamaneagh on the approach to the Burren in County Clare, as well as an expansive wall with imposing gate (now in the grounds of Dromoland Castle) and an enclosed deer park with fish pond. But, just as the *Book of the Burkes* can be taken as a last gasp of medieval Gaelic manuscript illumination, Leamaneagh Castle can be seen as the last architectural expression of the native Irish (though it was made after an English model) before Irish society buckled under to the destructive Cromwellian invasion of the late 1640s.

Later sixteenth-century tomb building tended to follow a pattern somewhat similar to that of architecture. Two box tombs of significance exist from the dying years of the sixteenth century—one at Lusk in North Dublin, erected in 1589 by Sir Lucas Dillon in memory of Sir Christopher Barnewall,

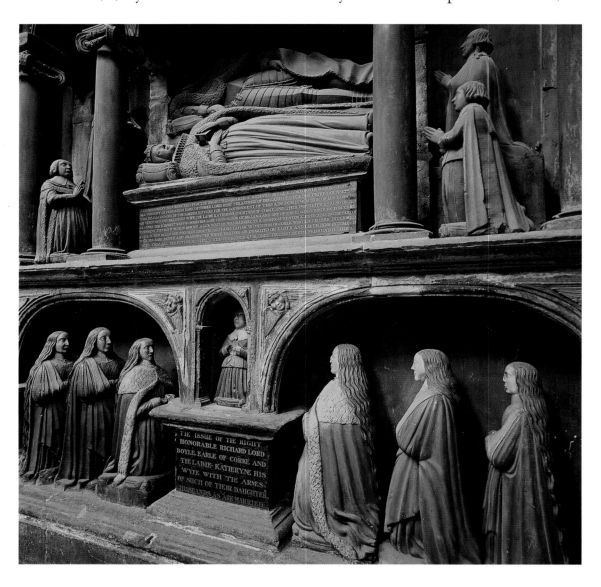

whose widow, Marion Sharl, he had married, and the other probably of the 1590s, erected by, or in memory of, the self-same Lucas Dillon. Both are remarkable for the presence of high-relief effigies of the respective knights and their ladies. Reflecting the building grandeur of the Anglo-Norman landed aristocracy in their Tudor manor houses, the knights are dressed in decorative plate armor of the period, while the lady is dressed in a loose-fitting gown and broad Elizabethan collar. The surrounds of both tombs display various coats of arms of the parties buried in the tomb, and, though both the armor and dress of the figures are in keeping with English fashion, and the general appearance of the tomb with some Renaissance ornament is probably modeled on an English prototype, Sir Lucas himself was a "recusant"—a man who refused to adopt Henry VIII's new church propagated by the king's daughter Elizabeth and held to the Catholic religion of his forebears.

One feature of note on the Newtown Trim tomb is the representation of an entire family—father and mother kneeling opposite one another in the center, with their children behind them. This featuring of a family group is seen on an English brass memorial to Sir Edward Fitton in St. Patrick's Cathedral, Dublin, and also on two large and vainglorious monuments put up by the same man over a hundred miles apart. This was Richard Boyle (1566–1643), an adventurer who came to Ireland in 1588 with very few pence in his pocket and, through shady dealings, was to become the largest landowner in the province of Munster for a decade and a half. In St. Mary's Cathedral in Youghal, one of the largest medieval parish churches in Ireland and the dominant building in the town from which he directed his nefarious operations, Boyle built a large tomb showing himself lying in splendor contemplating his world from a reclining posture, accompanied by his wife Katherine and parading his progeny beneath him. Long inscriptions and family coat of arms were designed to demonstrate that the opportunist had arrived and had become respectable in Irish society. In his driving ambition to climb ever higher socially, he then built a second and even larger tomb for himself in St. Patrick's Cathedral, Dublin. But by placing it on the site of the old high altar, he incurred the enmity of the lord deputy, Wentworth, to such a degree that Boyle was forced to remove it and reassemble the pieces elsewhere in the cathedral nave. Here he is also represented as recumbent, clad in his plate armor and wearing a fur cape and neck ruff, as does his long-robed second wife beneath him. Boyle had both tombs built during his lifetime to show off his new-found status, and he was buried in the one at Youghal because that was where he died. A ruthless rogue, whose only saving grace was to have a son who became one of Ireland's first and greatest scientists (the Boyle of Boyle's Law), Richard Boyle was one of those involved in diminishing the lands owned by the Gaelic Catholic Irish for the purposes of his own social and financial aggrandizement—presaging what was to happen to Ireland during the remainder of the seventeenth century.

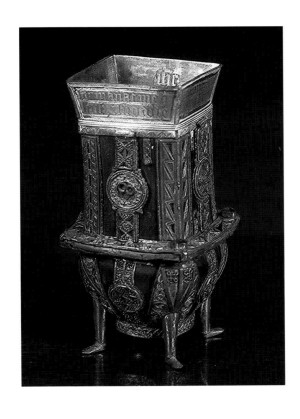

ABOVE: *Dunvegan Castle, the home of the MacLeod family on the Scottish island of Skye, preserves one of the few surviving pieces of late medieval Irish secular metalwork. This is a ceremonial cup with gilt silver mounts, and its square shape shows it to be a version of those Irish wooden drinking cups called methers, where four people could each have their own special corner for drinking. Though the wood may be older, the inscription on the rim states that the goblet was commissioned in 1493 by Catherine O'Neill, wife of the Maguire of Fermanagh, and the Scottish family tradition is that the O'Neills presented it to Rory Mór MacLeod of Dunvegan in 1595 in gratitude for help received from him in the O'Neill's fight against the forces of the English queen, Elizabeth I.*

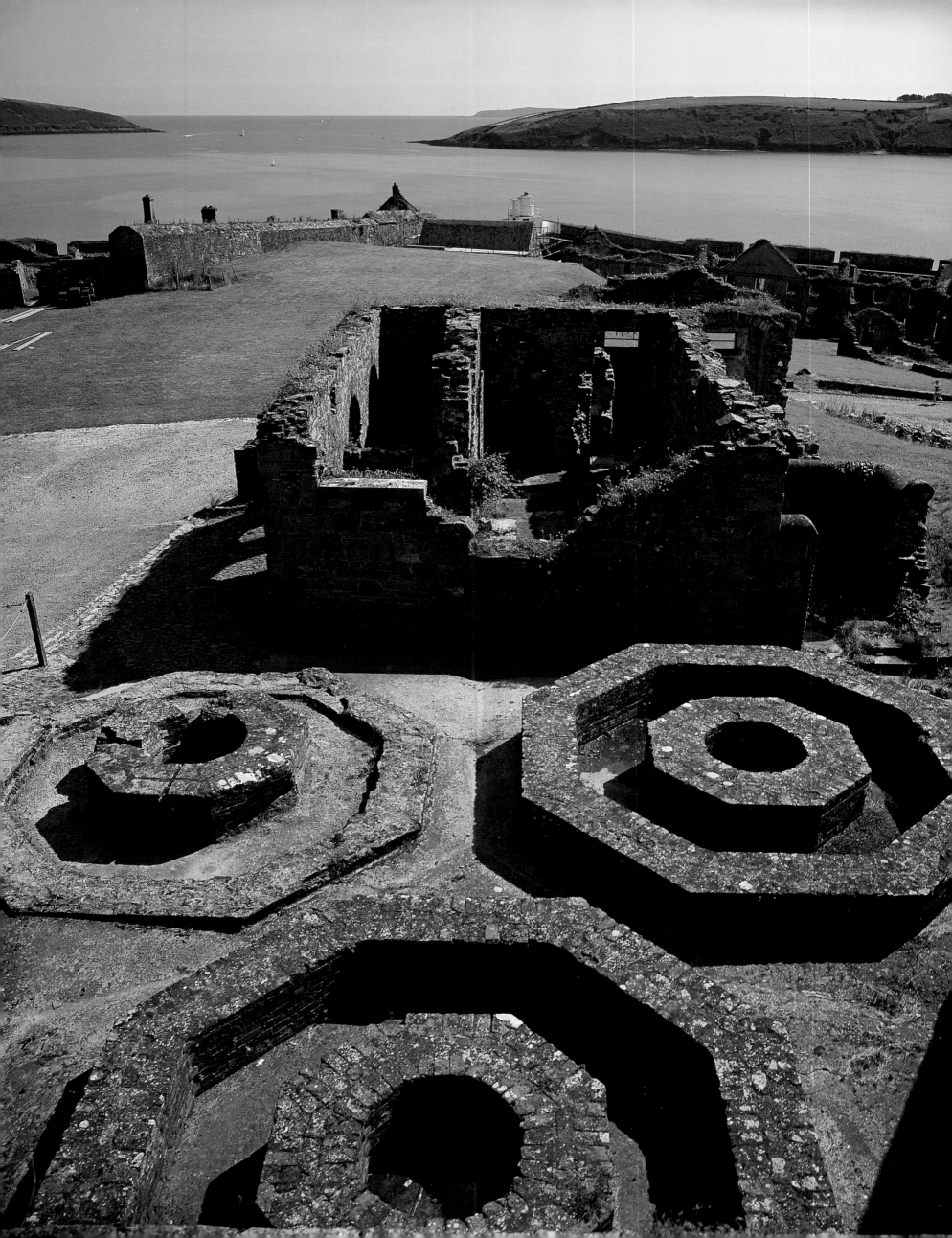

THE SEVENTEENTH CENTURY

The seventeenth century began badly for the Irish with defeat at the Battle of Kinsale in 1601, became even worse with the depredations and land seizures by Cromwell in mid-century, and ended disastrously with William of Orange defeating his Stuart father-in-law James II at the Boyne and at Aughrim in 1690/91, followed by the introduction of the penal laws against the majority Catholic population. The century saw the decline of Gaelic culture. The Brehon Laws, by which Gaelic society had lived for a millennium, were banned in 1606, and the poets whose livelihoods depended on patronage from Gaelic lords saw them leave the country with the Flight of the Earls in 1607. That did not, however, prevent the poets from practicing their craft. One of the finest Irish poets, Dábhídh Ó Bruadair, a man who brought the weight of learning and a knowledge of history to his work, lived through the second half of the century, expressing the disgust of the people over what was happening to them at the hands of English kings and the Commonwealth. As in the twelfth century and the second half of the fourteenth, there was widespread feeling that the lore of ancient Ireland, such as the sagas and the stories of Finn and the Fianna, should be recorded before they were wiped from folk memory. This was a period that saw the beginnings of a decline in the Irish language, people realizing that it was necessary to know at least a smattering of English in order to have any chance of succeeding in the English-speaking law courts. Cover was gradually taken from the rebellious Irish as trees were felled all over Ireland, leaving only one percent of the Irish countryside under wood by the year 1700. But it was not only the trees that were taken, it was also the land under their very feet. Around 1600, about one-third of the land was still in native Irish hands, whereas a hundred years later the percentage would have been in low single figures. With the exception of a brief respite under James II in the 1680s, the practice of the Catholic religion was not encouraged, and the Anglican church was very much in the ascendant.

How the balance of the scales turned in the course of the century is dramatically demonstrated in Tony Sweeney's statistics for surviving church silver plate (chalices, patens, etc.): 35 pieces for the Catholic church and only one-seventh of that for the Church of Ireland date from the reign of James I

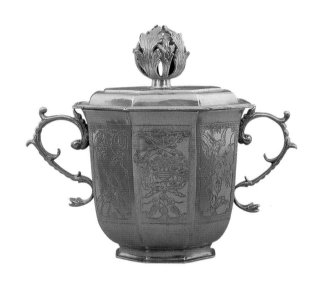

ABOVE: *Porringers are two-handled lidded silver bowls, usually broader than they are tall, made in Ireland between 1660 and 1700. This example, called the "Freke" porringer, made by John Cuthbert in Dublin in 1685, is now in the Ulster Museum, Belfast.*

OPPOSITE: *The natural harbor of Kinsale on the South Cork coast was the scene of the last military stand of the native Irish against the forces of Queen Elizabeth I in 1601, in which—despite the help of an army from the King of Spain—the Irish were defeated, the first of many blows inflicted upon them during the course of the seventeenth century. Nevertheless, Ireland's vulnerability against foreign invasion led England to fortify both sides of the harbor, with the added intention of protecting this last European victualing stop for its ships before they set sail westward for colonial America. The eastern side was defended by Charles Fort, seen here, whose guns—now silent and removed—were pointed at the entrance to the harbor.*

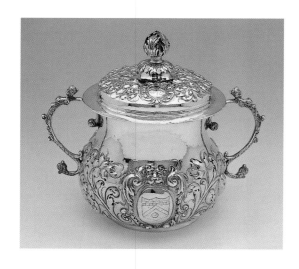

ABOVE: *In seventeenth-century Ireland, porringers such as the "Dopping" porringer, preserved in the Ulster Museum, Belfast, were used to keep food, particularly porridge, warm.*

BELOW: *This silver Catholic chalice from the seventeenth century offers a Crucifixion scene. The letters FTD are inscribed on the domed octagonal foot, which is joined to the cup by a facetted balustrade stem. The cup and stem could be unscrewed and fitted into the underside of the foot for ease of traveling. Below the rim of the cup are the maker's initials, EG, which are also found on the sword of the Corporation of Galway, suggesting that it was there that the chalice was made—probably in the early 1630s.*

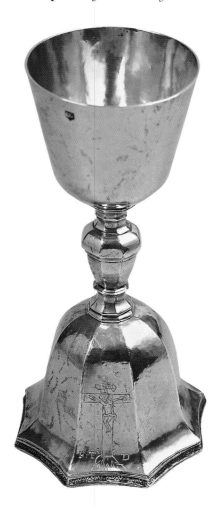

near the beginning of the century, contrasting with a swing to a count of 23 for the Roman Catholics and 165 for the Protestants by the reign of William III at the end. The earlier, Catholic chalices continue the Gothic style of decoration on the feet and knops on the neck, whereas the later, Protestant silver Communion vessels place a greater emphasis on simple lines, plain expanses of silver, and the absence of unnecessary ornament. But the same was not true of the municipal silver, in particular the maces of the various corporations that would have been carried in procession before the office holders as they strutted through their respective towns. Here, decoration—hammered in repoussé from behind—was an essential part of the object, with the customary addition of some emblems of royalty to show loyalty to the English king. By curious coincidence, the ceremonial regalia of two towns—Navan and Galway—came into the collection of William Randolph Hearst and have been repatriated, the first to the National Museum in Dublin and the second to the Corporation of Galway, the latter also including a great sword. The mace of Midleton in County Cork is on display in the Hunt Museum in Limerick. It was during the latter half of the seventeenth century that the silversmiths of towns like Dublin and Cork began to produce smaller items for use at table, a practice that was to become very common during the eighteenth century.

The last bastion of Gaelic Ireland to fall into English hands was the northwest of the country. Having retained its independence for centuries, the area finally fell prey to land seizure after its Gaelic nobility fled the country in desperation in 1607, leaving their subjects, whose ancestors had tilled the earth since time immemorial, to lose the land to settlers who had been brought in from England and Scotland to work it.

In the wake of this fundamental change, the new landowners developed their own style of architecture to defend their recently granted possessions, and this has strong echoes redolent of the lands from whence the planters came. Some structures were simple two-story houses overlooking a square garden-like bawn surrounded by high walls and with towers at the corners. Sometimes the bawn existed by itself, as at Dalway's Barn outside Carrickfergus. One example of the bawn being guarded by an imposing castle is at Monea in County Fermanagh, where three-story circular bastions protect the entrance to a rectangular tower, its corners further defended by turrets resting on corbels in the Scottish manner. One of the latest examples—still in use as a hotel—is at Ballygalley, County Antrim. So similar is it to architecture just across the North Channel in Scotland that it provides a vivid visual illustration of the takeover of Irish land.

More architectural evidence of the takeover of Irish land is found in Parke's Castle beside Lough Gill in County Leitrim, where Robert Parke built his Plantation castle around 1620, and in the castle at Enniskillen in County Fermanagh. Thanks to excavations carried out some decades ago, the foundations of an earlier castle belonging to the native chieftain Brian

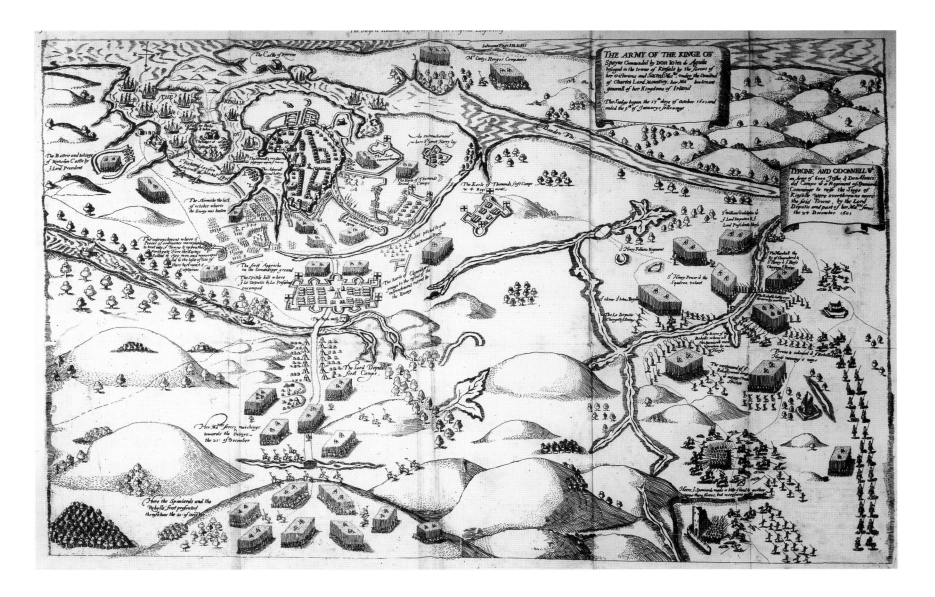

O'Rourke came to light in the courtyard of Parke's Castle. The original tower house had obviously been dismantled stone by stone to provide building material for the more recent castle that was being built around it.

At Enniskillen, William Cole did retain parts of the old Maguire Castle and made his own additions to it at around the same time. The planters' greatest show of strength was the construction of the walls of Derry—or Londonderry as it came to be called after James I gave the town over to the City of London in 1613. Extending seventeen hundred yards, these structures are the last, strongest, and best-preserved of all the town walls in Ireland that were able to withstand a famous siege in 1689. As if to reflect the origin of its inhabitants, but really to stake a claim of succession directly from the old Irish church, the cathedral built within the town walls between 1628 and 1633 was dedicated to St. Columb or Colum Cille, who is said to have founded a monastery on the site more than a thousand years earlier.

The only really decorative element found in these Plantation structures is in Donegal Castle, where, once again, a planter, named Basil Brooke, took over the O'Donnell fortification, added a decorative Jacobean wing to it, and then built a great fireplace into the side wall of the first-floor hall of the older castle. Inserted during the second decade of the seventeenth century, the fireplace is a great piece of swagger—hanging garlands and other motifs all within a

ABOVE: Pacata Hibernia, *first published in London in 1633, was exactly what its subtitle claimed it to be, "A history of the wars in Ireland during the reign of Queen Elizabeth." Not only does it provide graphic and gruesome details, but also maps to illustrate the victories. One of the most vivid of these is that illustrating the Battle of Kinsale, giving an impression of just how busy a war camp of the period must have been. The town of Kinsale is near the top left, with naval vessels guarding the route to the Atlantic Ocean in the extreme top left-hand corner. The cartouches on the top right tell succinctly the story of how the army of the King of Spain was besieged in the town by the English in 1601. When a combined army of Irish and Spaniards came to relieve the siege, they were defeated on Christmas Eve, 1601, by the Queen's Lord Deputy—a disaster that heralded the end of medieval Gaelic Ireland.*

classical framework—a real bravado piece of show-off. Meanwhile, farther south, Bandon in County Cork was being set up as a purely Protestant town, and Gaelic Ireland continued to build tower houses as if nothing had happened—as witnessed by the date 1643 attached to the castle at Derryhivenny in County Galway. At the same time, the O'Briens were building a rather more gracious mansion at Leamaneagh in County Clare, mentioned above. One most unusual building that is roughly contemporary, and thus dates from the reign of King Charles I (1625–1649), is Jigginstown near Naas in County Kildare. One of the first Irish houses built extensively of brick, with a façade 380 feet long, it consists of a suite of first-floor rooms supported by a fourteen-bay vault of brick. It was never completed and nothing like it was ever built again in Ireland because its builder, Thomas Wentworth, Earl of Strafford, was recalled back to England and executed.

The political decline of the native population in Ireland is mirrored in the quality of crafts reducing to the level of folk art by the first half of the seventeenth century, particularly in the field of stone carving. This is demonstrated by the charming but naive Crucifixion plaques found particularly in Connacht around the 1620s, most noticeably in the ruined cathedral at Kilmacduagh in County Galway. But there were also the exceptions. In the Kilkenny/Tipperary region, the Kerin family—notably Patrick and Walter—was keeping up a high standard of tomb sculpture in the 1620s and 1630s, and some tombs of the period display a marked preference for

ABOVE: *Maces, a symbol of the authority of town mayors and officials, became particularly popular in Ireland after 1660, when the restored Stuart monarch Charles II often bestowed urban charters and other favors in return for financial support. Probably from the Cork workshop of Robert Goble, this silver mace—with three knops typical of the reign of the later Queen Anne—bears the crest of the Brodrick family.*

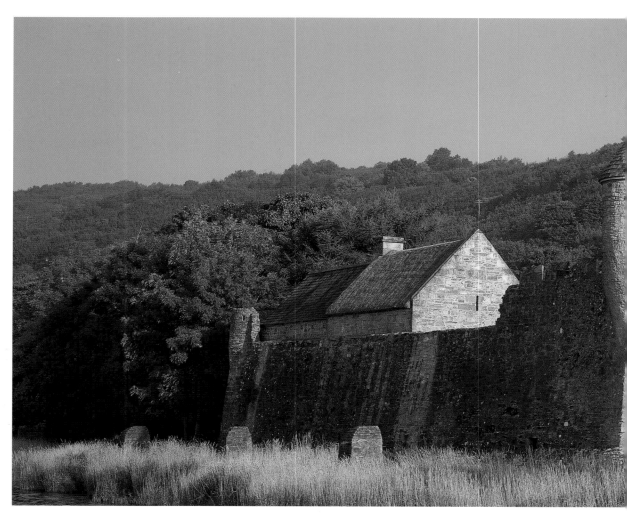

very delicate ornamentation in low relief. At the same time, particularly in southeast Galway, beautiful high-relief lettering on gravestones were developing, the old Franciscan friary at Meelick on the Shannon having some outstanding examples. One further piece of stone-carving deserves mention, even if its date within the century cannot be ascertained exactly. This is a cross at Athcarne, County Meath, with a figure of the crucified Christ with raised arms on one side that shows a real feeling for musculature, and a Virgin and child on the other that is continental in type, indicating that the models for the carvings clearly came from outside the country.

Ireland was thrown into turmoil with the arrival of Cromwell in 1649, and the ferocity of his politico-religious campaign no doubt destroyed much earlier art that had managed to survive the Reformation. One such was the stained glass window in St. Canice's Cathedral in Kilkenny, which was much admired—and coveted—by the papal nuncio Rinuccini in 1646 and which, if the Lord Protector's men had left it intact, would have provided us with a particularly fine example of medieval Irish stained glass. From the few fragments from other locations that have come down to us, some of which are displayed in the medieval section of the National Museum in Dublin, it is difficult to judge scale or style of what had formerly existed.

The restoration of the house of Stuart with Charles II (1660–1685) ascending the throne brought normalcy of a kind back to Ireland, though Cromwell's relocation of people to Connacht and reallocation of their land had

BELOW: *It was probably in the 1620s that Robert Parke built one of the most westerly castles of the Ulster Plantation in County Leitrim. Known as Newtown, it now bears his name, as it stands overlooking Lough Gill, on the opposite side of the lake to Yeats's "Lake Isle of Innisfree." It is symbolic of the takeover of Irish lands by the Ulster Planters in the early decades of the seventeenth century that Parke demolished an O'Rourke tower house of the previous century and used its stones to build his own castle around the spot where it had stood. This tower house was perhaps the location of a banquet—celebrated in song by the harper O'Carolan and in poetry by Jonathan Swift—that was hosted by Brian O'Rourke, who also gave succor to the survivors of the Spanish Armada before he was captured and brought to London to be executed.*

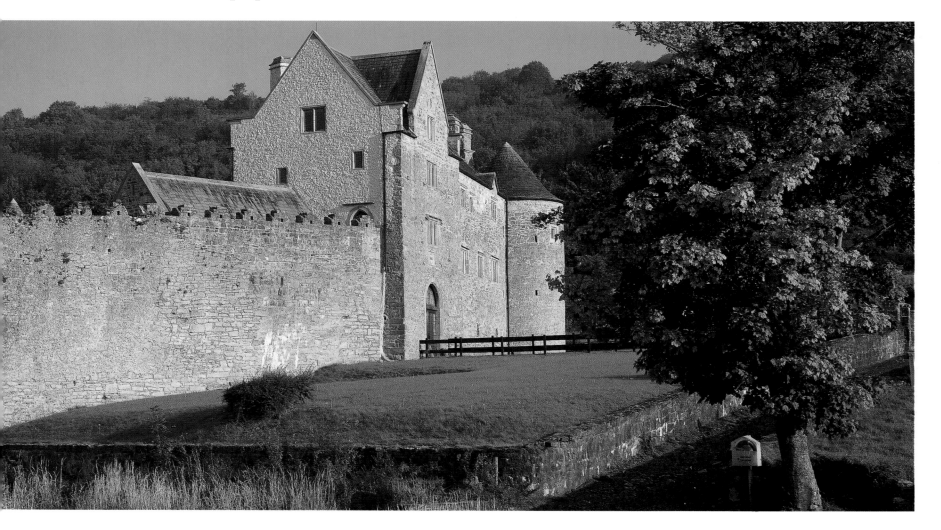

ABOVE: *Religious fervor must have been strong in the West of Ireland in the 1620s and 1630s, because it is a period that produced many stone-carved Crucifixion scenes that have a simplistic but touching quality. One of those at Kilmacduagh, County Galway, has a bearded Christ hanging his head to one side from a cross only indicated by the arms, and wearing a cutely curved loincloth around his waist. Beneath his nailed hands stand the similar figures of Mary and John, she with her arms crossed on her breast, and both clothed in unexpectedly similar garments with long, straight folds on top of which sit two round and veiled heads looking like carved corks on fluted bottles. The fine lettering framing the scene invokes the Lord and the Virgin in Latin to show mercy and compassion.*

RIGHT: *On a hill overlooking the western shore of the beautifully wooded Lower Lough Erne in County Fermanagh is Tully Castle, built by the Scottish planter Sir John Hume of Polwarth in Berwickshire, on lands that had been confiscated from the Maguires of Fermanagh, who had owned them from time immemorial. But the Irish took their bloody revenge on Christmas Day in 1641 when Rory Maguire massacred fifteen men and sixty women and children. The castle was burned and never occupied again. It is really a fortified house of three floors, T-shaped in plan, with the entrance on the side of the stem of the T. The house stands on one side of a square walled area with a rectangular tower at each corner, and with the open space now occupied by a garden that is growing plants and herbs of the kind that would have been popular during the seventeenth century.*

further impoverished the native Irish. Little more than their poetry and their music was left to lift the Irish above the harsh and humorless reality of working for other people land that had once belonged to them. Nevertheless, architecture started to revive. Structures like Richhill Castle in County Armagh demonstrated that defense was no longer a necessity, and Dutch gables were to become even more popular after the Netherlander William of Orange triumphed at the Battle of the Boyne in 1690 and became King William III of England. But it took two decades after the Restoration before larger projects were undertaken, and that was partially thanks to the viceroy at the time, the Duke of Ormond. To his own castle at Kilkenny he gave a most decorative gateway, introducing into Ireland a classical style with Corinthian pilasters and swags of garlands, which, with interruptions and variations, was to become popular during the following century. The castle's architect was probably William Robinson, who worked on rebuilding the Protestant cathedral at Lismore in County Waterford and Ireland's largest military fortification at Charles Fort near Kinsale. However, Robinson's most significant achievement was the construction of the Royal Hospital at Kilmainham (now the Irish

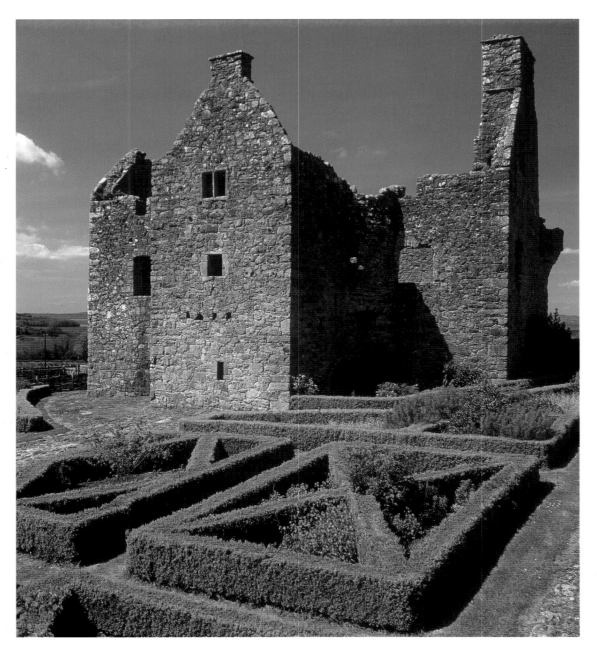

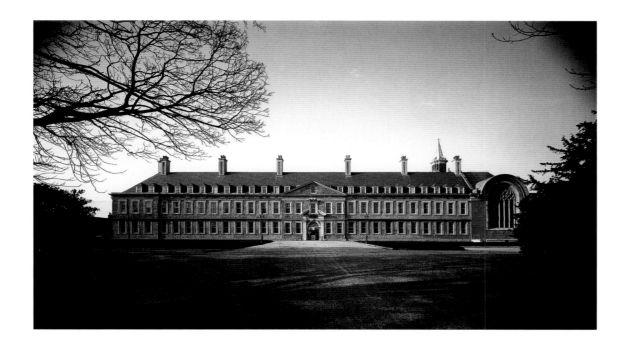

LEFT: *The Royal Hospital at Kilmainham is Dublin's first great classical building and its oldest secular structure still in use. Now the Irish Museum of Modern Art, its original purpose was as a home for veteran soldiers. Its architect was William Robinson, who also designed Charles Fort in Kinsale, and his layout consisted of a large square with a remarkable interior ground-floor arcade where the pensioners could reminisce and exercise in wet weather. Modeled on Louis XIV's Hotel des Invalides in Paris, it was built between 1681 and 1687, two years before its London counterpart. It has some remarkable stucco ornament, and also wood-carving, including military trophies, cannon, and sacks of gunpowder that can be seen in the tympanum of one of the outer doors.*

BELOW: *Penal crosses were popular in Ireland during the dark days of the Penal Laws from the late seventeenth to the early nineteenth century. Probably originating in Lough Derg, County Donegal, where they were produced as pilgrimage souvenirs, they offer the widest range of folk art of the period, the best that Catholic Ireland could rise to under difficult and repressive religious circumstances. This example is one of the few in Limerick's Hunt Museum known to have been made of lead. Though it could be regarded as degenerate, its round bell-like head of Christ, awkwardly crossed feet, and attractive rayed halo exude a special naive charm all their own.*

Museum of Modern Art). It is the capital city's earliest surviving building, erected to house war veterans and designed as a square with a ground-floor arcade opening out onto a central courtyard. One of the hospital's notable features is the stone and wood carving showing military paraphernalia, much of it probably by James Tabary and executed around 1685–1687, but there is also other classical woodwork with some baroque features. Tabary was an immigrant into Ireland and was probably the carver of the roughly contemporary wooden staircase saved from Eyrecourt House in County Galway, which is now sadly pining away in crates in a museum in Detroit and will hopefully someday be happily reunited with the land of its origin. Full of swirling foliage that leaves open spaces between the branches, it is by far the most exuberant piece of wood carving surviving from seventeenth-century Ireland. It contrasts with the stiff native efforts shown in the Cruise cross at Cruicetown, County Meath, erected around 1687 at a time when Catholic hopes had risen for a liberalization in the practice of religion after the accession of King James II to the English throne in 1685. In the same county, the re-erection of the Market Cross in Kells, carved some eight hundred years earlier, was an expression of a similar spirit, but one that was to be sadly dashed by the encounter between James and William of Orange (later King William III) at the Battle of the Boyne and the subsequent downfall of any remaining Irish aristocracy after the articles of the Treaty of Limerick of 1691 were broken by the new Protestant overlords. A harsh regime began for the majority Catholic population, with penal laws forbidding the open practice of their religion, among other restrictions, and no opportunity to produce anything of artistic significance, as exemplified by the penal crosses, probably produced as souvenirs for pilgrims to St. Patrick's Purgatory in Donegal's Lough Derg, which show the crucified Christ on a cross carved in such a simple style that, in some cases, it scarcely even deserves to be called folk art.

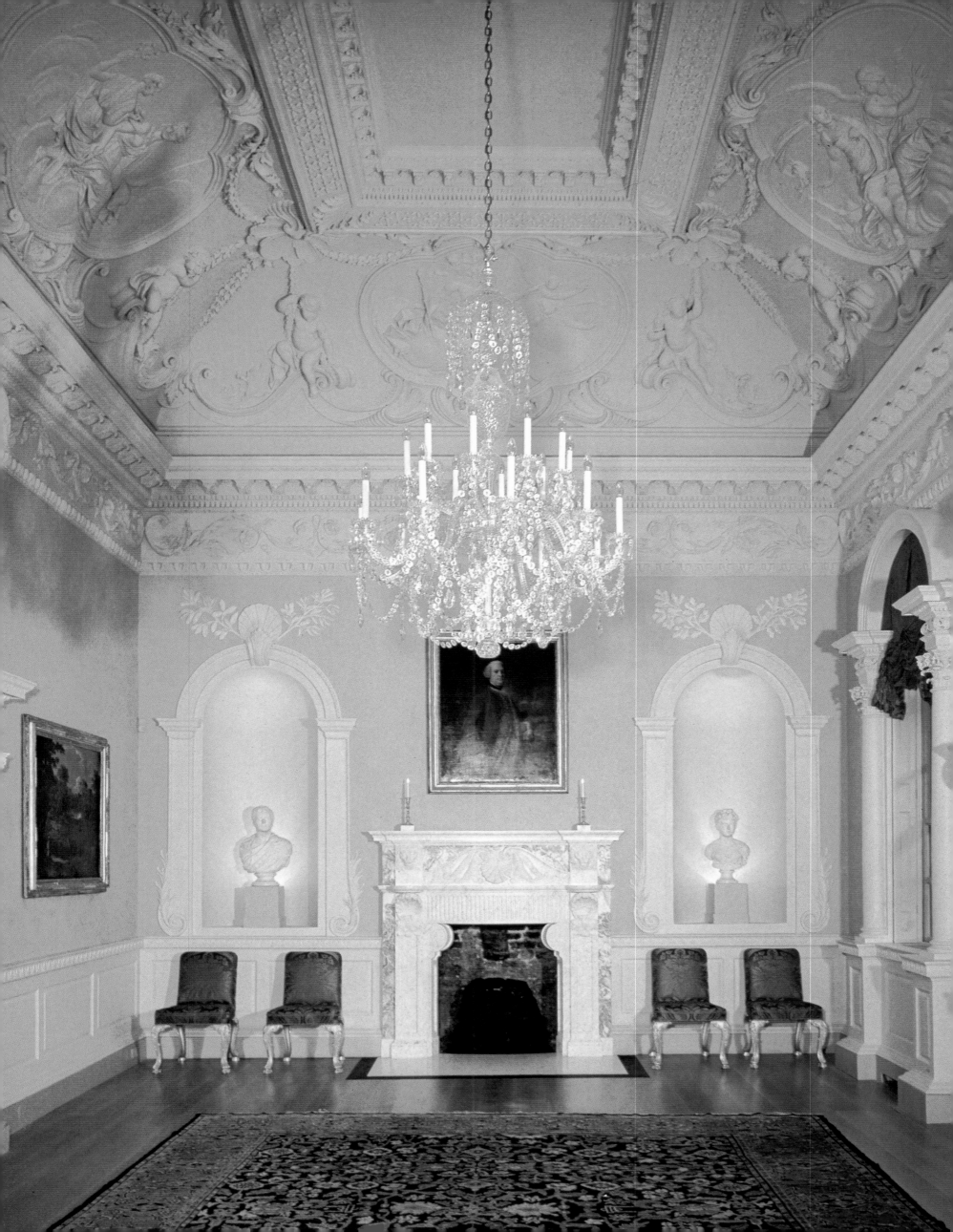

THE EIGHTEENTH CENTURY
An Age of Elegance

The eighteenth century was certainly the most elegant and undoubtedly one of the greatest centuries in Irish history. Native and foreign architects and craftsmen looked back not to earlier golden ages in Ireland but to ancient Greece and Rome for inspiration and created a style that was supported by a minority Protestant aristocracy, who combined taste with money to improve the face of Ireland. Though at first very Anglicized in their outlook, turning constantly to London and farther afield for their models, these upper echelons of society had, by the end of the century, come to identify themselves with their country and were immensely proud of its achievements.

Dublin was the center of government, where a parliament sat that had been long dominated by Westminster, but which, through the exertions of Henry Grattan, was finally able to cast off the shackles of London's "mother of Parliaments" in 1782 and make its own laws without fear of a veto. Dublin was also the center of architectural leadership and endeavor throughout the eighteenth century, and where Dublin led, the rest of the country was content to follow. The process can be seen by studying the careers of the various architects who dominated the building scene in Ireland during the period. William Robinson, whom we have already met in the Royal Hospital at Kilmainham, added another, smaller jewel to Dublin's treasure house of buildings in his Marsh's library of 1705–1707. But, by then, his job as Surveyor General had been given to Colonel Thomas Burgh, who was to build an even greater library, that in Trinity College, in 1712. Benjamin Woodward subsequently altered the library in 1858–1860 by taking out Burgh's first-floor ceiling and creating the splendid Long Room in Trinity College, where for many years the *Book of Kells* and other important manuscripts were displayed. Farther up the Liffey, Burgh also built Dr. Stevens Hospital and the more extensive Royal Barracks, which has now been renamed Collins Barracks and is open to an appreciative public as a branch of the National Museum, displaying material of the last three centuries.

Other than Burgh's Trinity Library, the other great architectural masterpiece of the first half of the eighteenth century is only a few steps away,

ABOVE: *In the salon at Carton, County Kildare, that was decorated in stucco by the Lafranchini brothers in 1739, the putti above the organ were appropriately given musical instruments to play with as they support the monogram of the Earl of Kildare.*

OPPOSITE: *No. 85 was one of the finest houses on Dublin's St. Stephens Green to be faced with stone, and its architect, Richard Castle, was fortunate enough to be able to engage the services of the stuccodore brothers Philip and Paul Lafranchini to adorn the first-floor saloon, which stretches the whole length of the building's frontage. Restored some years ago, it is a masterpiece of baroque ornamentation dating from 1738–1739, with the figures of* Justice *and* Prudence *keeping an eye on the four* Elements, *as putti ride playfully on waves of stucco in between.*

on the far side of College Green—the building we now know as the Bank of Ireland, but which was then the Parliament House, divided into an Upper and a Lower House. The House of Commons interior was demolished two centuries ago, but the House of Lords has been preserved by the present owners, the Bank of Ireland, which took over the building after the parliament voted itself out of existence in 1800. The architect of the southern front of this old parliament building was Edward Lovett Pearce, a young man who had traveled in France and Italy, was a cousin of the great English architect Vanbrugh, a friend of Lord

LEFT: *To pass through the gate of Marsh's Library in Dublin, and under the shamrock-bedecked grille, is to enter a world of ancient wonder and be transported back, as if by magic, to where books have been on the same shelves for three hundred years, some chained to the wall to prevent theft, others glossed by none other than Dean Swift, who lived next door and read here.*

BELOW AND OPPOSITE *Marsh's Library is the oldest institution of its kind in Ireland, founded in 1701 by Narcissus Marsh (1638–1713), archbishop of Armagh, Provost of Trinity College, and scientist credited with having invented "acousticks" and having been the first to use the word "microphone." The library is located next to St. Patrick's Cathedral in Dublin and was built with red brick in the style of Queen Anne, with tall, thin multi-paned windows. On the first floor is the library, containing three hundred manuscripts and 25,000 books relating to a variety of topics of the sixteenth, seventeenth, and eighteenth centuries alone. To visit is to be wafted back into the most perfect early-eighteenth-century time capsule preserved in Dublin, with original shelves and "cages," where readers were locked in so that they could not escape with the rare books inside.*

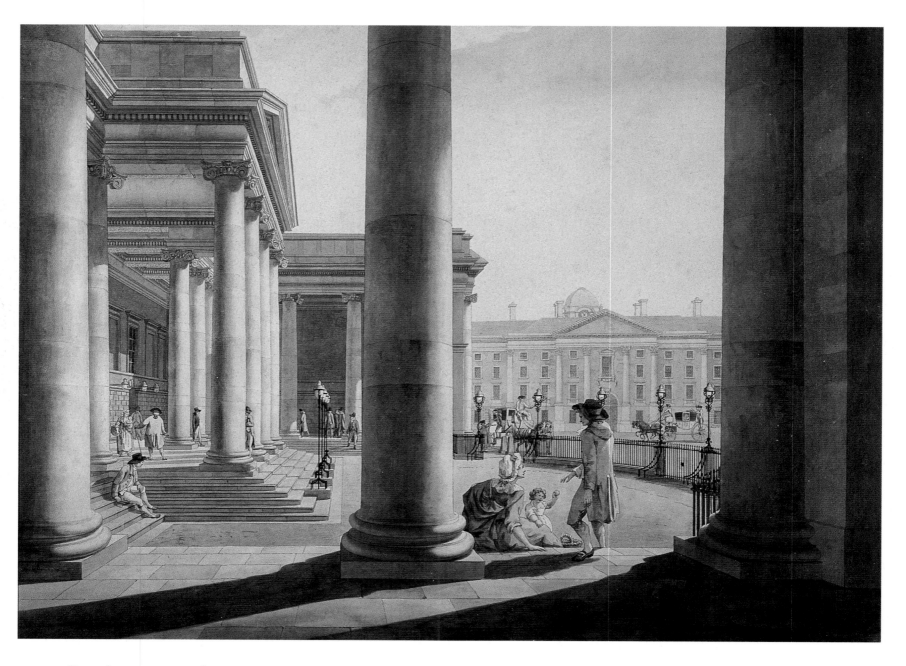

ABOVE: *Pearce's great piazza of 1729–1739 in the left half of the picture shines bright with Ionic columns of Portland stone and contrasts with the granite walling behind, which gave muted entrance to the Houses of Lords and Commons beyond. Seen in the distance is the façade of Trinity College, Dublin.*

Burlington (London's leader of taste), and whose friendship with the influential Speaker of the Irish House of Commons, William Conolly, was doubtless crucial in getting him the contract—to Burgh's great disappointment. But Pearce deserved it, the finished building being grandiose in scale and majestic in its design: a central Ionic portico is flanked by a colonnade of large columns that continue out to the two side wings jutting out well in front of the portico, and the whole is united by an entablature that runs all the way around the front. Its giant presence in College Green, contrasting with the many-windowed façade of Trinity College, which stands at an angle to it, is well rendered in the aquatint made in 1793 by James Malton, whose pictures of Dublin give the most noble impression of this eighteenth-century city.

Pearce was an admirer of the Italian Renaissance architect Andrea Palladio, who had adapted the buildings of ancient Rome to more modern requirements. Pearce's study of Palladio's works led him to design his own Irish adaptations, as in Bellamont Forest in County Cavan. It was Ireland's loss that Pearce died in 1733, when he was probably little more than thirty-five years of age. But before his death he managed to win for Ireland a very capable

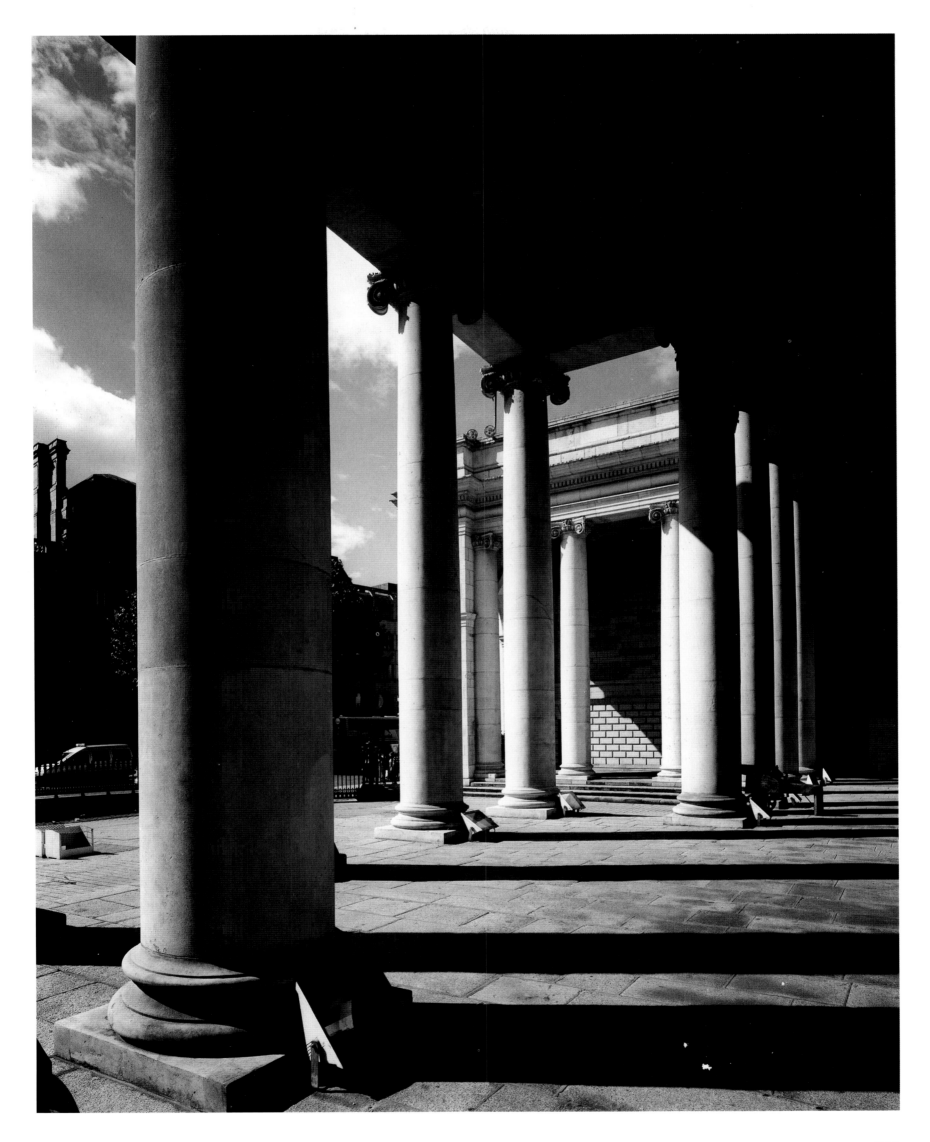

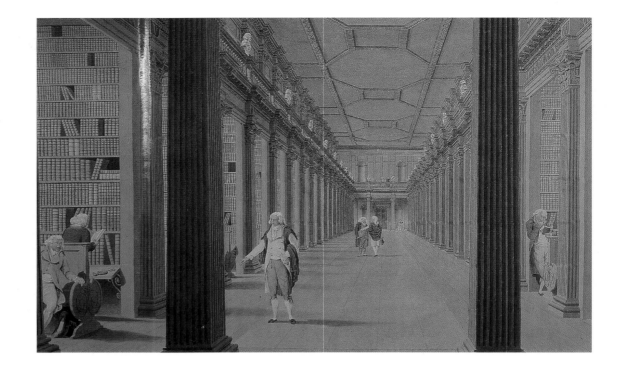

PREVIOUS PAGE: *The recessed portico (1729–1739) of the old Parliament Building, now the Bank of Ireland, in Dublin's College Green, is by Edward Lovett Pearce, who was rooted in classical antiquity, knew Greece through the writer Vitruvius, and had studied Roman buildings on his Grand Tour of Italy. He produced here a classical building of a grace and beauty that had never been seen in Dublin before.*

RIGHT: *The interior of Burgh's 1712 library in Trinity College, Dublin, as portrayed by James Malton in the 1790s, shows an extensive classically ornamented space lined with leather-bound tomes, being read by some and discussed or admired by others. A gallery runs all the way around beneath the flat ceiling that was removed in the later 1850s by Benjamin Woodward to create the great barrel-vaulted Long Room we know today. The marble busts of philosophers, divines, and learned scholars, ancient and modern, have since been brought down to earth from their perch in the gallery shown here and placed in front of the pilasters separating the individual bays.*

OPPOSITE: *The architect Richard Castle and the Lafranchini stuccodore brothers that produced the saloon of No. 85 St. Stephens Green in Dublin repeated their virtuoso performance on a slightly grander scale in 1739 at Carton in County Kildare, the home at the time of the nineteenth earl of Kildare. Here, soaring above an organ, are pairs of gods in courtship, accompanied at a respectful distance by six busts of classical poets, as two dozen putti add vitality to the somewhat formal adult figures.*

assistant, the German Richard Cassels or Castle, who was to dominate the Irish architectural scene both in and out of Dublin for the following twenty years. Pearce, who Maurice Craig characterized as Ireland's Inigo Jones and Lord Burlington all rolled into one, had more work than his office could handle, and this gave Richard Castle an opportunity to take on commissions for private clients, which were to remain his main area of activity. One of the most important of these was Leinster House, between Dublin's Kildare Street and Merrion Square. When the house was being planned, the area was just green fields. The Duke of Leinster, who commissioned the building, was rebuked by his peers for moving to what was then the unfashionable southern side of the city, but his retort, "Where I go, the rest will follow," was indeed prophetic, as today Leinster House is the home of the Republic's Dáil and Senate. Leinster House's classic design is often said to have provided inspiration for the White House in Washington.

Not far away is No. 85 St. Stephens Green, where Castle employed the Lafranchini brothers from southern Switzerland to decorate the premises with some superb rococo stuccowork, a style he also used in the Duke of Leinster's country house at Carton in County Kildare (where he died in 1751). But another of Castle's creations, the now vanished Music Hall in Fishamble Street, became world-renowned, not because of its architect, but because the building hosted the premiere of Handel's *Messiah* in 1742. Castle must have made his mark, too, on the Irish countryside, not just with Carton, but also with a number of other mansions, including Westport and Powerscourt. But the jewel of them all is probably Russborough, which consists of a long, low set of strung-out buildings—a central block joined to side pavilions by a curving colonnade— all in the Palladian style and beautifully decorated inside with stucco. It now houses the Beit collection of paintings, which match the interior so brilliantly, including some pieces that were originally acquired for the house. The Cobbe

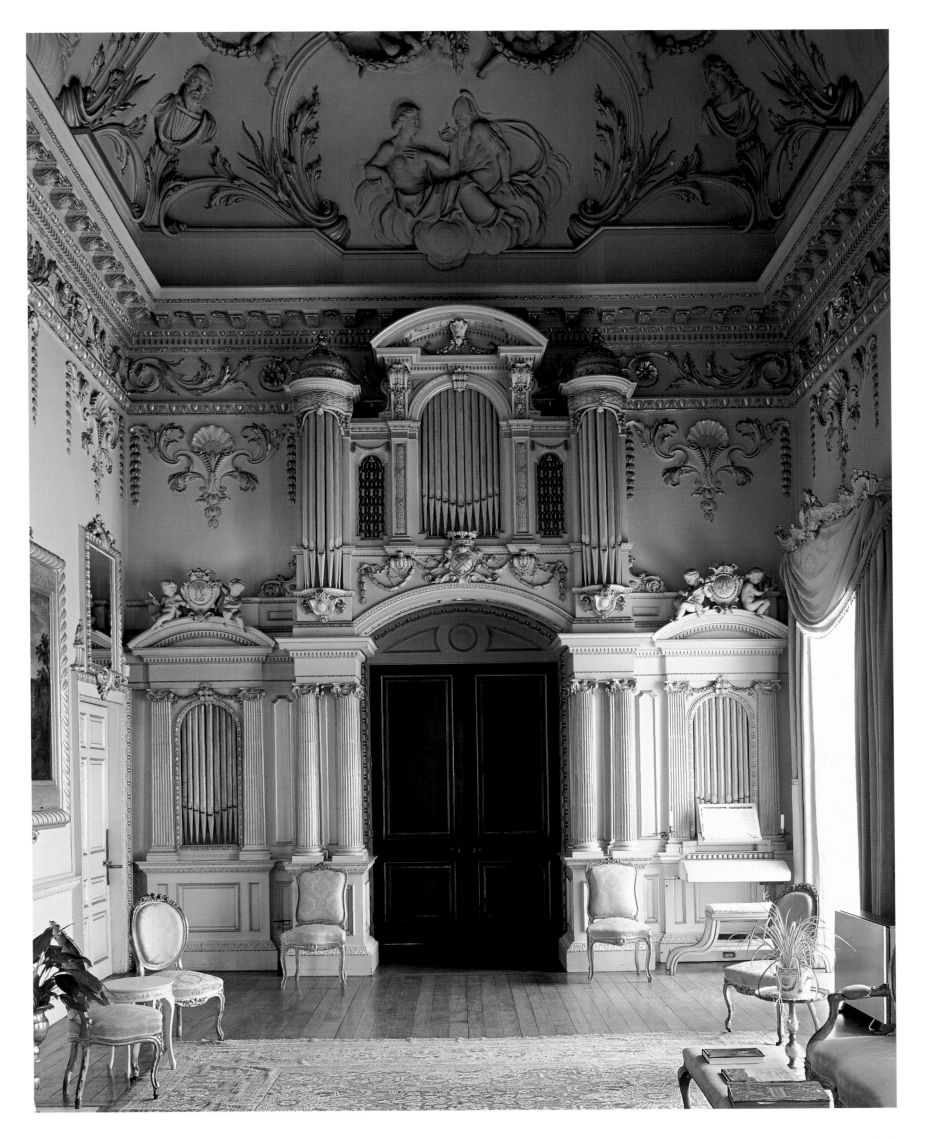

Powerscourt House stands among the wooded beauty of County Wicklow, the "Garden of Ireland"—and Powerscourt has its own splendid terraced garden seen here behind the house that the seventh viscount Powerscourt built for himself around 1740. He was lucky enough in having an architect in the person of Richard Castle who could do justice to the landscape setting. This is Castle's most successful façade, two side wings kept low enough to allow the central block to dominate. It is capped by a pediment, beneath which are five typically Castle niches filled with busts of four Roman emperors—and an unknown lady. Fortunately, this great frontage was not damaged in a disastrous fire in 1974 that gutted much of the interior, which has since been partially restored.

mansion at Newbridge in north Dublin, of c. 1730, is probably the only house where the original paintings are hung in the drawing room much as they were in the eighteenth century.

The Palladian style remained popular in Ireland for some time after Castle's death. It was practiced by Irish architects such as Francis Bindon and Nathaniel Clements and outsiders such as the Sardinian Davis Ducart, one of whose fine buildings is the former Custom House in Limerick that now houses the Hunt Collection. Provincial towns such as Limerick, but also Cork, Waterford, and Kilkenny, have either churches or houses that are good examples of Georgian architecture, so named for the reign of the four Georges, kings of England, from 1714 to 1820. Both the Catholic and Protestant cathedrals in Waterford were built by John Roberts, one of several notable local architects working in the Georgian style. Red brick is one feature found in Dublin and a number of provincial towns in the splendid collection of urban houses in the eighteenth century and well into the nineteenth. In Dublin, some of these are town houses grouped in squares for use by the country aristocracy, but the style is also found well outside the bounds of the capital. Typical of these homes are the paneled doors, sometimes accompanied by original furnishings such as door knockers, with graceful gossamer fanlights overhead. The houses usually rise three or four storys over the basement level, the

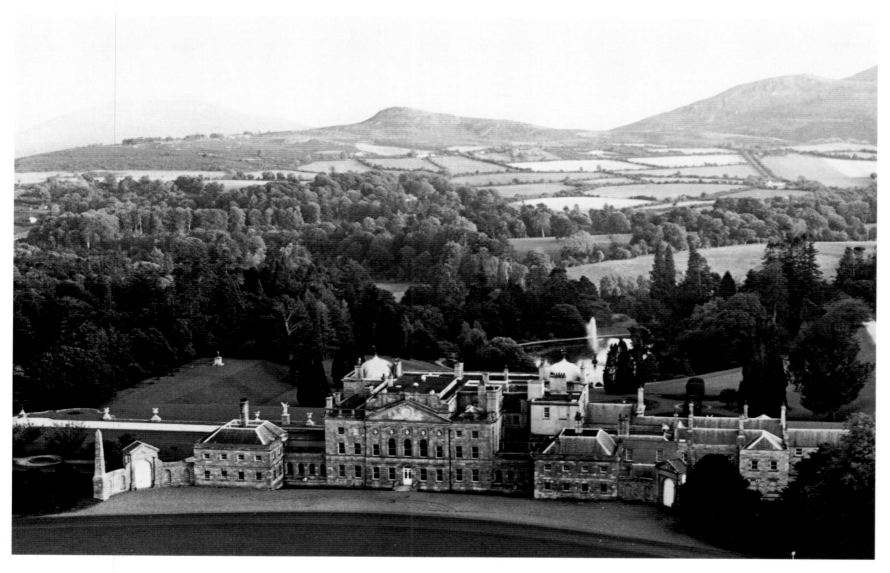

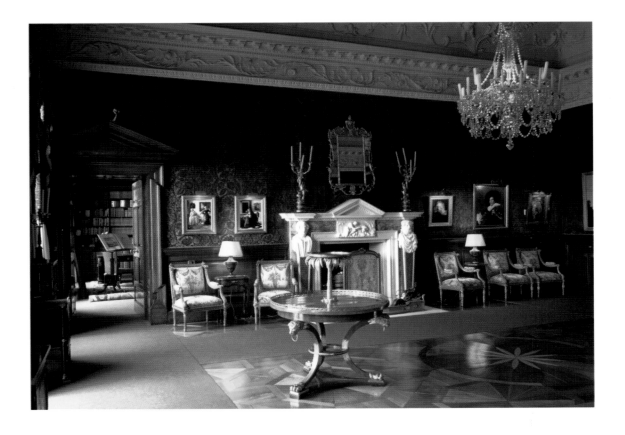

windows set back from the front surface, allowing for a painted reveal, which, in a terrace, creates a fine effect of depth and perspective. The largest windows were given to reception rooms on the first floor. It is these houses in Georgian streetscapes that constitute the most characteristic views of Dublin during the eighteenth century, though some have suffered destruction in recent decades. Many of the houses were constructed by building families such as the Darleys, the Semples, and the Ensors, who helped to fill the huge architectural gap left in the country after Castle's death.

Castle had not trained anyone to take his place, and in the third quarter of the century many of the important building projects were executed, once again, by foreign or English architects. The most notable of them was the Englishman William Chambers, who was employed by the very cultured earl of Charlemont to design two buildings, one in the city of Dublin—Charlemont House, now the Hugh Lane Municipal Gallery of Modern Art—the other known as the Casino at Marino in the green fields beyond the northern suburbs. Though Chambers probably never set foot in Ireland, the latter was his masterpiece and one of the most astonishing buildings ever constructed in Ireland. The name "casino" has nothing to do with our modern gambling dens, but stems, rather, from the Italian word for a house or small house. At first sight, Chambers's casino might seem like the latter, but little could be further from the truth. For a building that looks as if it contains only a single room, it includes a dozen times that number, spread over three floors (including the basement). Its plan is a square, within which a Greek equal-armed cross is placed, both elements set on a stepped plinth. The main reception room is on the ground floor, its parquet decoration made of woods from various continents, while the earl's bedroom would have been on the upper floor.

BELOW: *The Casino in the Dublin suburb of Marino is one of the few Irish buildings that must be spoken about only in superlatives. It is the jewel in the crown of its designer, Sir William Chambers, who assisted in the remodeling of what is now Buckingham Palace and was arguably the finest English architect of the middle of the eighteenth century. Its layout is superbly compact—who would ever think from the outside that it has two floors over basement?—its Portland stone sculpture refined, its taste (like that of its owner, Lord Charlemont) impeccable, and its copying of Roman classical detail absolutely inspired. Chambers had designed it originally for an English location. Thank heavens the deal fell through and he gave it instead to Charlemont, Ireland— and the world.*

Smoke from the fireplaces reached the open air through ornamental urns masquerading as chimneys. The highest quality of finish is seen on the urns and the guardian lions at each corner of the plinth, which were carved by Simon Vierpyl and Joseph Wilton. A pity that such a gem did not continue to be surrounded by the rural landscape for which it was designed and has, instead, been hemmed in by inferior modern housing. At least its view toward Dublin Bay has been preserved reasonably intact—a vista which must have greatly pleased His Lordship when the house was built in the 1760s.

Architecturally, the middle of the eighteenth century in Ireland was most notable for private houses, but the last third of the century saw public buildings coming into the limelight. Hand in hand with the change went a new style, the neoclassical, which heralded a more rigorous respect for the ancient Doric, Ionic, and Corinthian orders and a more direct reliance on those ancient Roman edifices that had been visited by every self-respecting nobleman on his continental Grand Tour. This new imitation of classical models swept Europe in the 1760s and was chosen for the design of a major new

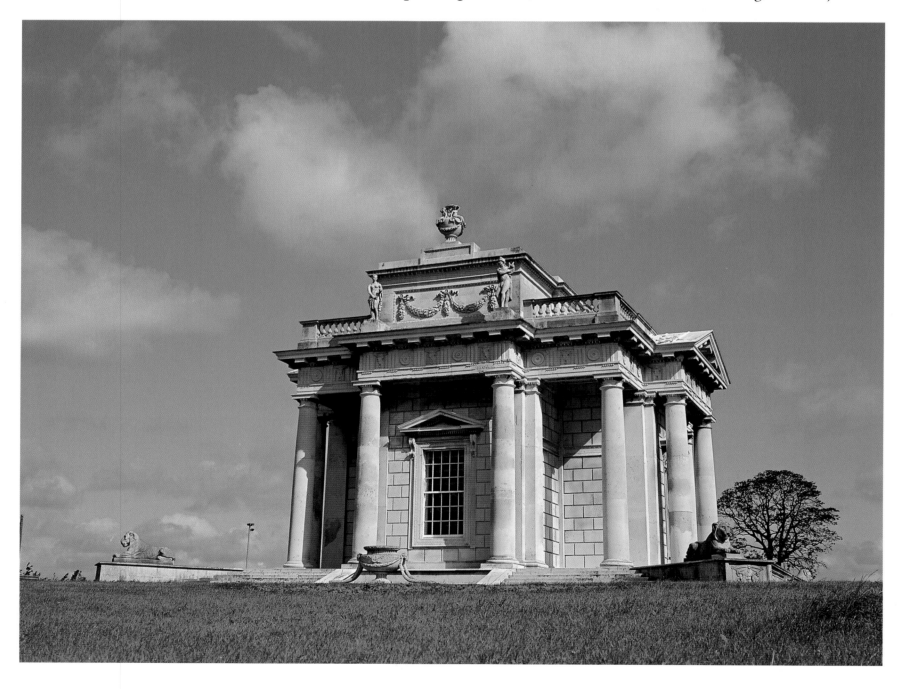

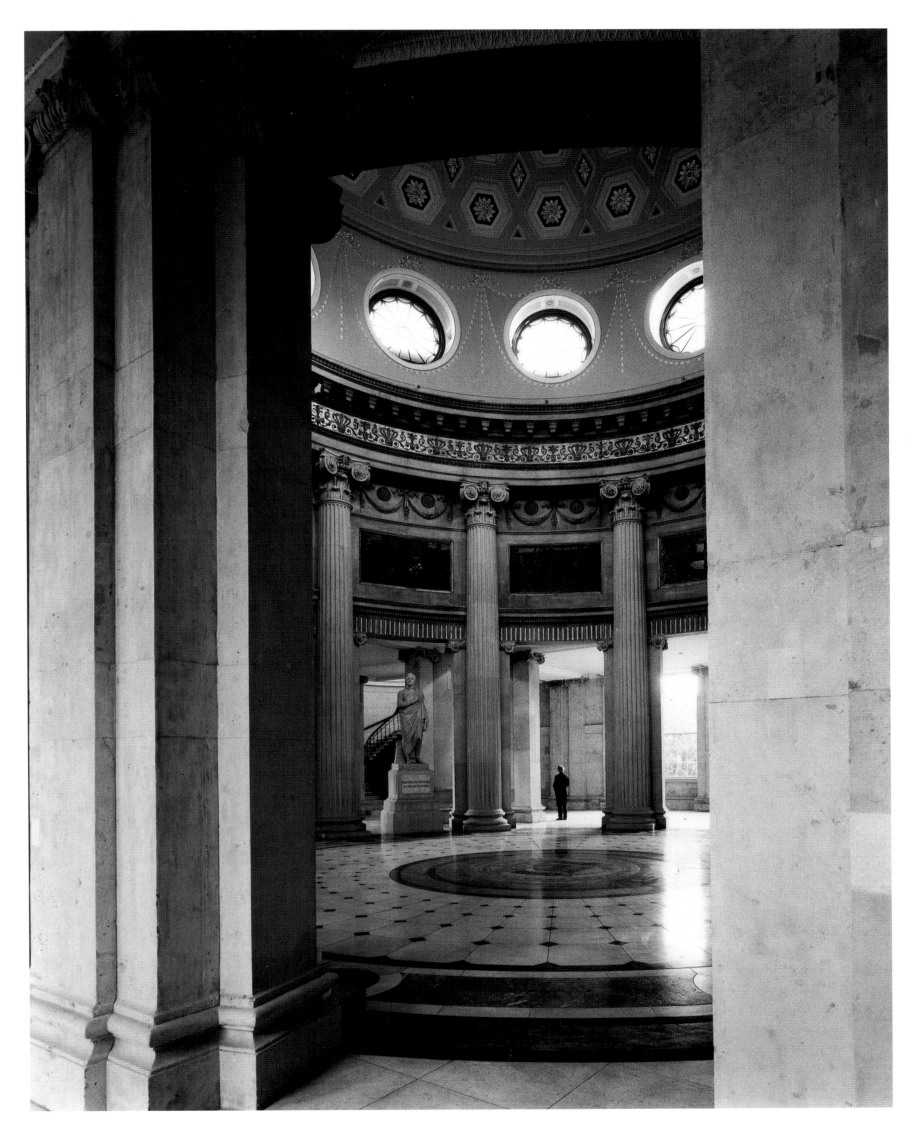

PREVIOUS PAGE: *What became Dublin's City Hall in 1852, located on Dame Street but best viewed from Parliament Street, started off its life as the Royal Exchange, a meeting place for bankers, merchants, and other citizens. Its grandest moment is the central hall, square in plan, into which were placed a ring of free-standing columns that supported a deep entablature, with a series of circular windows above, the whole surrounded by the only original eighteenth-century dome to survive in Dublin. It was probably the first building ever to have been opened to competition for architects from Ireland and Britain, which was won in 1769 by the Londoner Thomas Cooley. Recent splendid restoration has now returned it to its original glory.*

public building in Ireland's capital city, the Royal Exchange at the top of Dublin's Parliament Street. The powers that be apparently felt that the resident Irish architects of the time, even if born elsewhere, were perhaps too old-fashioned to build this new structure and, in the hotly contested competition for the best design, it was an English architect, Thomas Cooley from London, who was awarded first prize in 1769. The Royal Exchange is the only eighteenth-century building in the capital city to retain its dome virtually intact, with its echoes of the Pantheon in Rome. Its carved detailing inside and out is impeccable, and recent restoration by its present owners—Dublin Corporation, which uses it as the city hall—only helps to enhance its qualities. On the opposite side of the street is the old Newcomen Bank, also now in Dublin Corporation hands, which was by Cooley's rival, Thomas Ivory, and is another decorative building of high-quality finish. Ivory, a consummate draughtsman who had been defeated in the Royal Exchange competition, got his revenge on Cooley by defeating him in the competition to design the Blue-

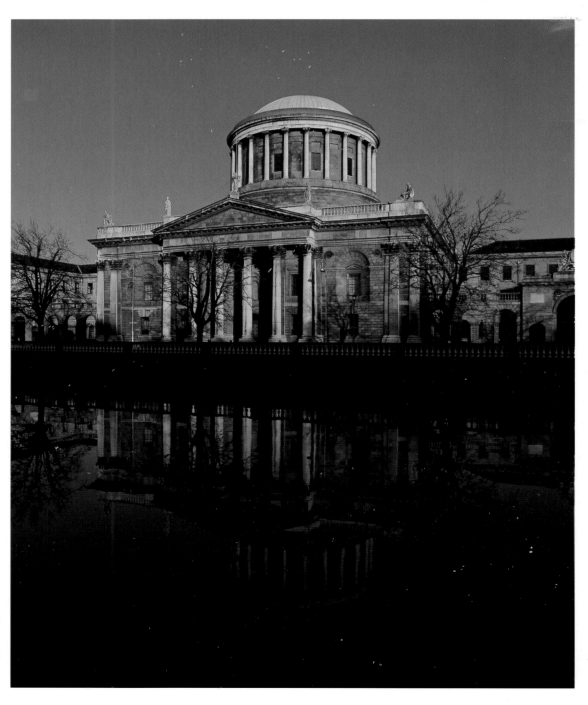

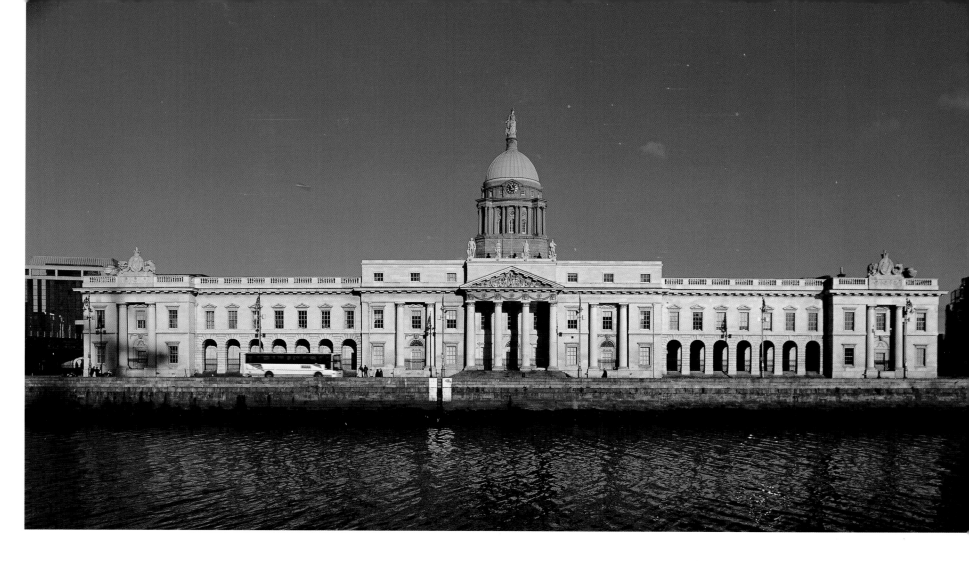

Coat School in Blackhall Place, now occupied by the Incorporated Law Society. Both of these Dublin buildings showed a direct link to the buildings of Rome, following the neoclassical fashion that Dublin saw in England and throughout much of the rest of Europe. It was to dominate the city's cultural scene for the remainder of the century.

Obviously, these architects were not confining their work to Dublin alone, and Cooley, for instance, busied himself with building a library for the archbishop of Armagh in the city of his episcopal see. Nevertheless, it was Dublin that was to lead the way architecturally during the last quarter of the century, when the star of her other great architect, James Gandon, was in the ascendancy. Gandon started his professional life in the office of Sir William Chambers in London and was smuggled into Dublin to build the Custom House on the north side of the Liffey, a massive undertaking that necessitated untold numbers of wooden stakes being driven into the ground before any building could ever take place. What Gandon created in the decade after 1781 was a long, noble neoclassical building with a central portico and pediment projecting out over the center toward the Liffey and with a bay at each end projecting an almost equal extent but with recessed columns. Center and end are joined by a series of arches on the ground floor and windows with capping pediments above. The skyline is rounded off by a dome with a statue of *Commerce* above, executed—as were the coats of arms above the end bays and the riverine heads above the building's ground floor doorways—by Edward Smyth of Navan, whose ability to create sculptures that would look correct when seen from below was particularly admired by Gandon.

ABOVE AND OPPOSITE: *The Empress Catherine the Great of Russia tried to get the English architect James Gandon to help her build palaces in St. Petersburg. Fortunately for Ireland, he chose Dublin instead and provided the river Liffey—and the capital city—with two great neoclassical buildings of the late eighteenth century. The first is the Custom House* (above), *of the 1780s, which, though now dwarfed by its modern neighbors, stands out for its grand design of raised central block with narrow dome, linked by a seven-bay façade to corner blocks, all beautifully adorned with large carvings by Edward Smyth. "The most explicit architectural and sculptural assertion of Irish national identity in the eighteenth century," in the words of Gandon's genial biographer, Edward McParland, the Custom House was burned by the I.R.A. in 1921. The following year, the same fate befell Gandon's other masterpiece, the Four Courts, of the 1790s* (opposite), *which has a much more massive central block dominated by a more rotund dome. Both buildings have been very well restored by the state.*

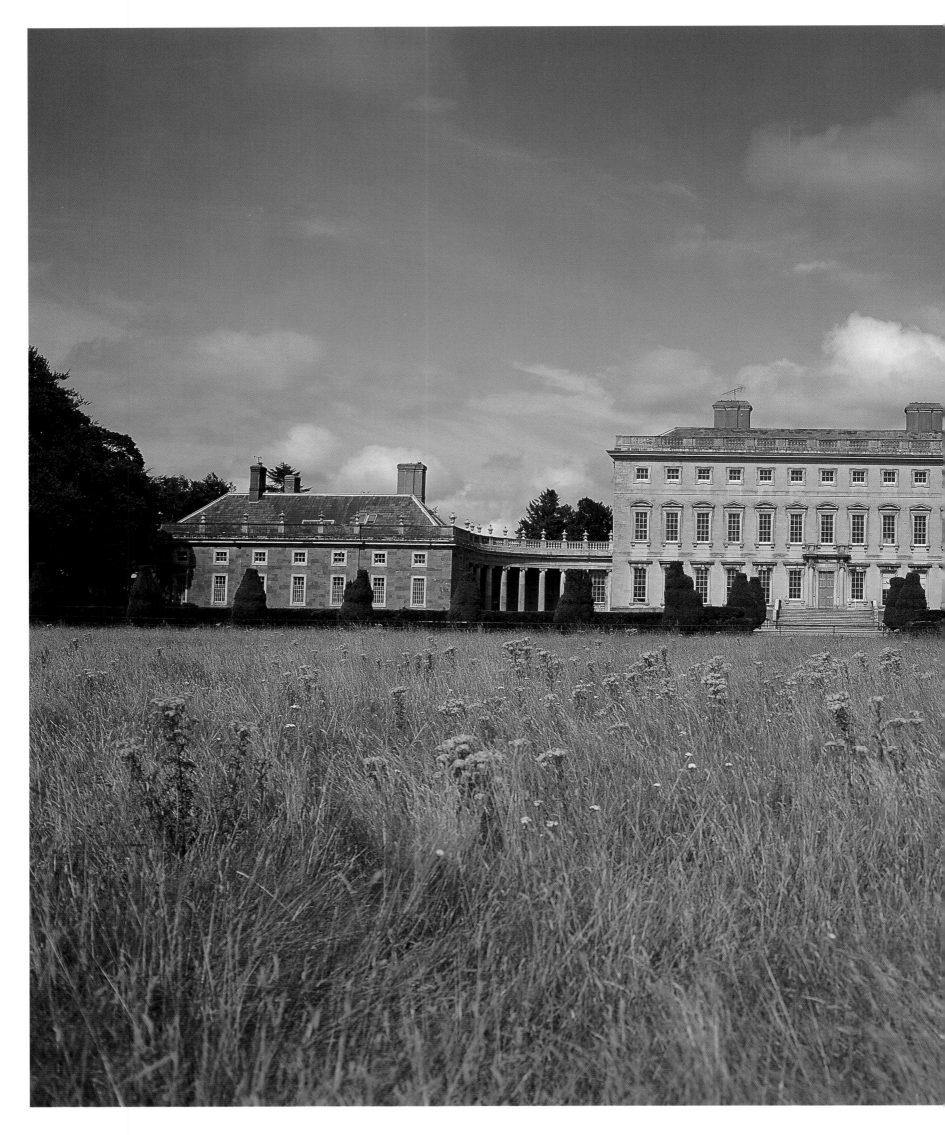

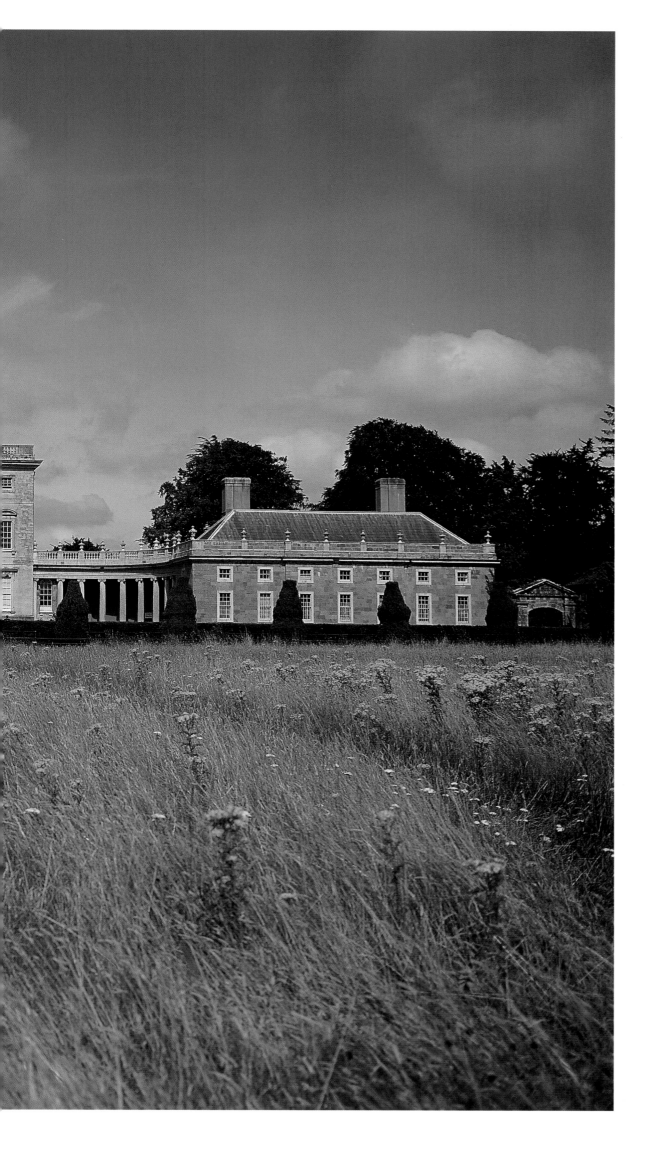

LEFT: *Castletown was the first of the great Palladian mansions to have been built in Ireland. Situated near Celbridge in County Kildare, it was the brainchild of William Conolly, Speaker of the Irish House of Commons, who had the taste to have his house designed by the Italian architect Alessandro Galilei, better-known internationally perhaps for his façade of St. John Lateran in Rome. However, the more local Edward Lovett Pearce must also have had a hand in the plans and probably helped to supervise the construction during the 1720s. Its arrangement of a tall and imposing central block joined by a curving colonnade to wing-blocks projecting like arms to clasp and welcome approaching visitors was one that was followed by a number of smaller Irish houses that were to follow in its footsteps.*

211

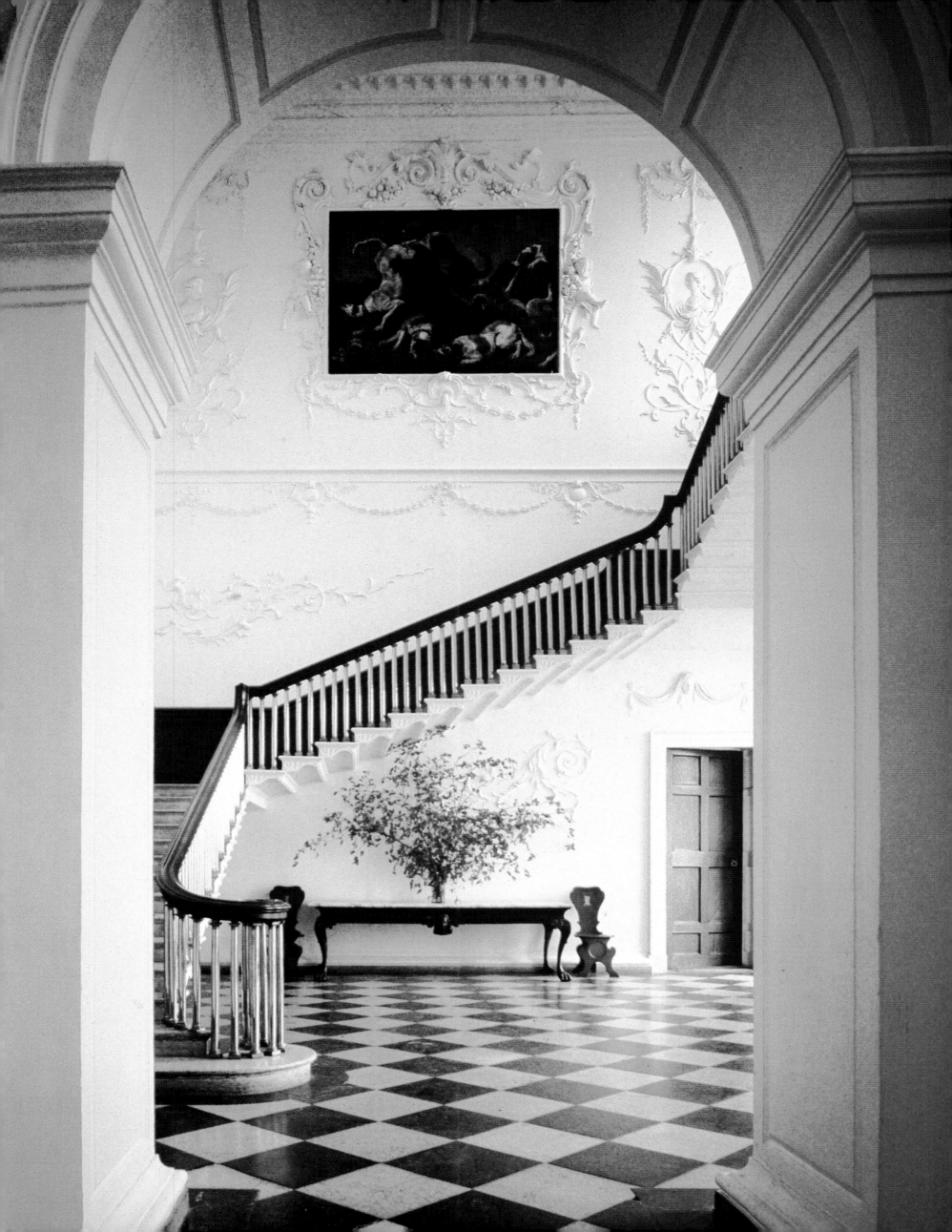

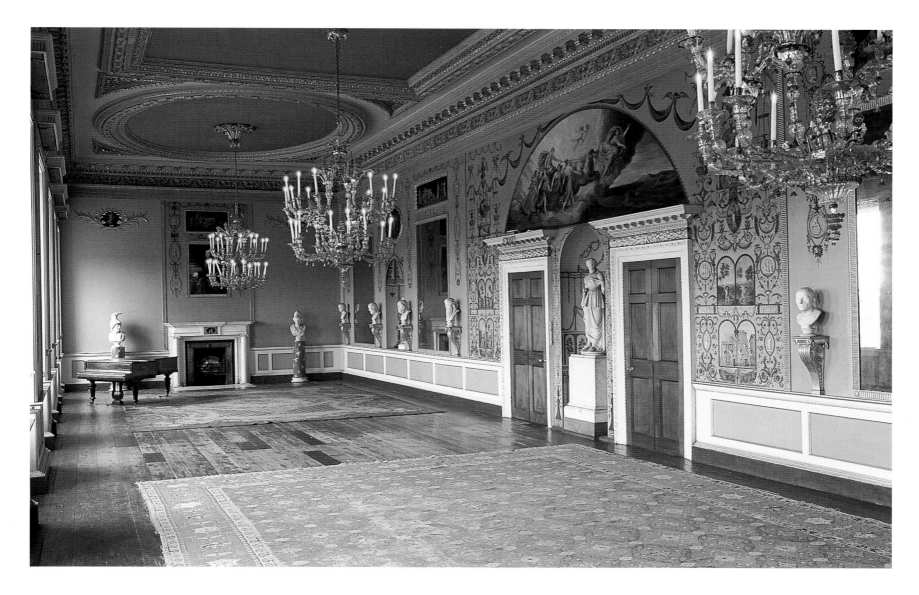

The Custom House was badly damaged in the civil war of 1922, and the same fate befell Gandon's other Liffey-bank masterpiece, the Four Courts—necessitating extensive restoration that was carried out on both buildings in the 1930s. In the Four Courts, Gandon was constrained by the prior existence of a public records office building executed by Cooley, but to this he was able to adapt and build a symmetrically similar wing on the other side of a central block entered by a portico on the river side that was dominated by a lower but much more impressive dome than that of the Custom House. Between the central block and side wings lay open, recessed courtyards approached by gateways decorated—as was the central block—by more sculptures by Edward Smyth. Gandon was to add still further feathers to his cap. To Edward Lovett Pearce's formidable portico for the parliament building, Gandon was to add a bold extension curving in a windowless wall with blind niches around to an east-facing portico, this time with Corinthian columns, differentiating it from Pearce's use of the Ionic. Gandon's addition is a fitting complement to Pearce's work and a celebration of the independence that the parliament had achieved in 1782, some dozen years before Gandon added his extension. Gandon was also able to build houses for private clients on an impressive yet slightly smaller scale, as at Abbeville, near Kinsealy, for his patron John Beresford; Sandymount Park (now restored) for his friend, the painter William Ashford; and Emo

ABOVE AND OPPOSITE: *When Speaker Conolly died in 1729, his great mansion at Castletown had not yet been entirely complete, and it was left to his grandniece-in-law, Lady Louise Conolly, to add the magnificent flight of stairs that is one of the grandest interior views that Castletown can provide. The staircase itself, of wood but with brass balustrades, is signed and dated "A. King, Dublin, 1760." Stucco by the Lafranchini brothers incorporates family portraits and is remarkably symmetrical for the Rococo period. It also frames a painting of* The Boar Hunt *by the Antwerp artist Frans Snyders. Lady Louise loved Castletown and brought her great zest and taste to bear on the decoration of the house, not just in the stairway, but also in the grand salon of a decade later. Though now bereft of its original furniture, it is still remarkable for its painted arabesques with Pompeian echoes, and the ceiling, probably designed by Edward Lovett Pearce. Thanks to Desmond Guinness and the Irish Georgian Society, the house was saved from vandalism in the 1960s, and it is now being fitfully restored by the state.*

213

Court in County Laois for the cultured earl of Portarlington, for whom he also built a classical church at Coolbanagher nearby.

Gandon was the colossus of Irish architecture in the final decades of the eighteenth century—and only just in time, for his building activity receded after the Act of Union took effect in January 1801 and many of the wealthy aristocracy moved to the seat of power in London. Even more so than his great predecessor Pearce, Gandon stamped his personality on the monumentality of eighteenth-century Dublin, a capital that would have been very much the poorer without the tremendous contribution he made to its embellishment. But compliments must also be paid to a group of far-seeing men, the Wide Street Commissioners—almost all of them members of Parliament, and some, at least, patrons of Gandon—who greatly enhanced the capital city by widening the streets, particularly what is now O'Connell Street. By building O'Connell Bridge with Gandon's help, they created the stem of a Y-pattern of streets, of which one arm, Westmoreland Street, led to the Parliament House. Without these eighteenth-century commissioners, Dublin's urban traffic today would be far worse than it is. Would that other parts of the city had had planners with such foresight! It was, as Maurice Craig pointed out, a curious paradox that men such as the Wide Street Commissioners felt obliged to introduce English architects to make Dublin a city of cosmopolitan taste to rival London and to provide the "second city of the empire" with an extended Parliament House that far outshone in quality England's Westminster.

While many of the great architects who erected buildings in Ireland during the eighteenth century may have been English, the men who decorated their buildings were, with few exceptions, native Irish craftsmen of talent and genius. With the increasing number of public buildings and private houses erected during the eighteenth century came the need for arts and crafts with which to decorate them—sculpture in wood, stone, and stucco, and furniture, silver, glass, and painting.

Sculpture in the preceding hundred years had been created to embellish the houses and tombs of the wealthy, much of it executed by local craftsmen who were using classical motifs they may have copied from designs in books. After the Restoration in 1660, the English king's representative in Ireland, the Duke of Ormond, had used classical designs and swags to decorate his gateway at Kilkenny Castle, and for his garden ornaments he may well have used foreign craftsmen. When, in 1697, Dublin Corporation commissioned a no-longer extant equestrian statue of the recently victorious King William III for College Green, the English sculptor Grinling Gibbons was employed for the job, and before that the Dutchman Willem de Keyser had been brought to Dublin to carve for the long-demolished Tholsel a statue of Charles II (now languishing in the crypt of Christ Church Cathedral in Dublin). This import of foreign sculptors suggests that local craftsmen were not considered good

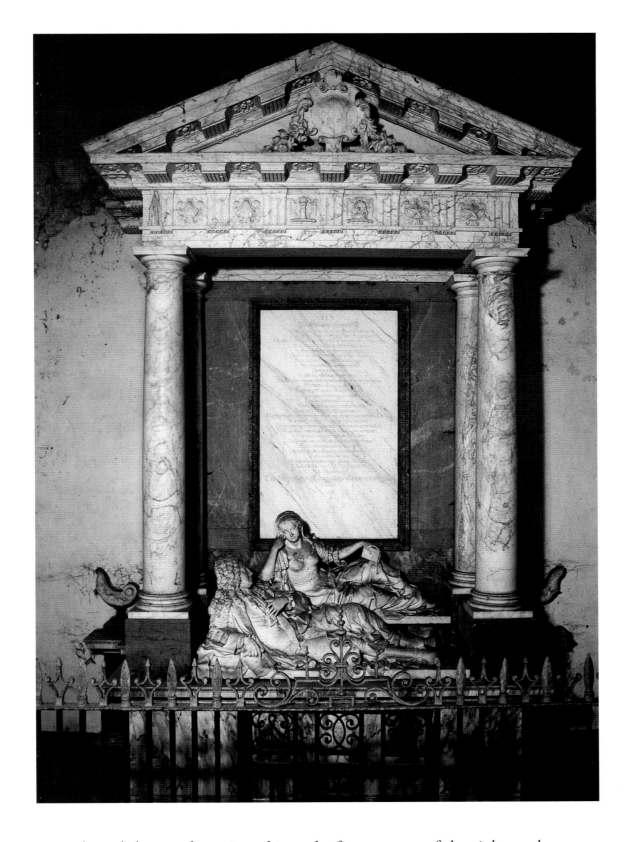

enough, and the trend continued into the first quarter of the eighteenth century, when the Englishman William Kidwell (1662–1736) came to Ireland in 1711 and spent the rest of his life in the country. His most important achievement was the monument to Sir Donogh O'Brien in the small church at Kilnasoolagh on the outskirts of Newmarket-on-Fergus in County Clare. Unlike the kneeling figures praying on fald stools of a century earlier, the bewigged Sir Donogh is reclining in contemporary dress, looking heavenward with hope, while playful cherubs hold drapes above his head in an almost theatrical setting, demonstrating that baroque art had finally come to Ireland. The same speaker Conolly, who was influential in getting the Parliament House contract for Edward Lovett Pearce, also had himself portrayed in

RIGHT: *Speaker Conolly's widow not only commissioned her husband's funerary memorial, she also erected Conolly's Folly, which stands to a height of 140 feet and closes the back vista from Castletown some two miles away. A folly is an ornament without necessarily having any practical function, but this one at least served the purpose of having provided employment for the poor and needy of the vicinity who had suffered badly in the severe winter of 1739/40. Its architect was probably Richard Castle, who was designing the neighboring mansion at Carton at the time.*

dramatic fashion in his (locked) memorial chapel in Celbridge, County Kildare, where—at Castletown—Pearce had supervised for him the building of Ireland's largest house, designed by the Italian Alessandro Galilei. Conolly's memorial was also by a London sculptor, Thomas Carter, who, as it happens, was probably a friend of Kidwell's.

Even more important to the development of sculpture in eighteenth-century Ireland was the establishment of the Royal Dublin Society School in the 1740s. Earlier, those interested in learning how to draw went to a school run by Robert West, but inspired by Thomas Prior, one of the founders of the Royal Dublin Society in 1731, the society set up its own school run by West, who was assisted by James Mannin. Its purpose was to raise the standard of design in Ireland, which was considered to be "the background of painting and so useful in manufactures," and its hope was that some geniuses would emerge. The plan was successful, and for the remainder of the century, most of the visual artists, sculptors, silversmiths, and other craftsmen were products of this Royal Dublin Society School, where Mannin (possibly a Venetian) was put in charge of landscape drawing and West the figure drawing. Further encouragement was given to the pupils through a system of annual premiums or prizes for drawing and statuary. The school in due course contacted John Van Nost (c. 1712–1780), a London sculptor of Dutch origin, who came to Dublin around the 1740s and set himself up successfully in business. He avoided the dramatic postures of Kidwell's baroque and was partially responsible for introducing neoclassicism into Irish statuary—perhaps best symbolized by replacing the use of contemporary clothing, such as on the Donogh O'Brien effigy, and using instead the raiment of a Roman emperor in his statue of George III in Dublin's Mansion House—pressing home his neoclassical inspiration. Van Nost

sculpted many busts, including some of members of the Royal Dublin Society, but his importance to Ireland is his creation of a native school of sculpture through pupils like Patrick Cunningham and Christopher Hewetson. The latter went to Rome, and in 1784 sent back a noble monument to Provost Baldwin for erection in the Examination Hall in Trinity College, Dublin—arguably the first great neoclassical sculpture by an Irish artist.

Van Nost had produced some architectural sculpture, as in the figures of *Justice* and *Mars* on the gate of Dublin Castle. Others before him had produced fine wood carving for architectural contexts, such as the fascinating panel of musical instruments on the organ case of St. Michan's church in Dublin of c. 1724, which Anne Crookshank tentatively attributes to Henry Houghton. But, as the century progressed, more and more buildings came to be decorated by sculpture that formed an integral part of the design. For his architectural gem, the Casino at Marino, the Earl of Charlemont commissioned Simon Vierpyl to come from Rome and carve the roof urns, the lions at the corners, and fine decorative work in the interior, as mentioned earlier. Vierpyl's pupil Edward Smyth, from County Meath, was to become the greatest Irish sculptor of the century. He came into contact with Gandon in 1781, the year that Gandon arrived in Ireland. Before doing so, Smyth had already carved a late-baroque full-length statue of Charles Lucas, now in Dublin's City Hall, where he had helped Vierpyl with some of the architectural decoration in the 1770s. Gandon immediately put Smyth to work on the Custom House, farther down the Liffey on the opposite bank. There, Smyth's carvings of the heads placed, as we have seen, above the doors symbolize the various Irish rivers, and soon his name became, in Gandon's words, "the equal of Michelangelo." Gandon paid him another—and perhaps more realistic—compliment when he said that Smyth's sculpture "was equal to any in the Three Kingdoms." Smyth's work on the Custom House also included the coats of arms, the

ABOVE AND BELOW: *Simon Vierpyl, the English sculptor, was heavily involved in the construction of the Casino at Marino for Lord Charlemont and may have carved the urns at ground level. But it was his fellow-countryman, Joseph R. Wilton, who carved the lions patiently guarding the corners of this gem of a building.*

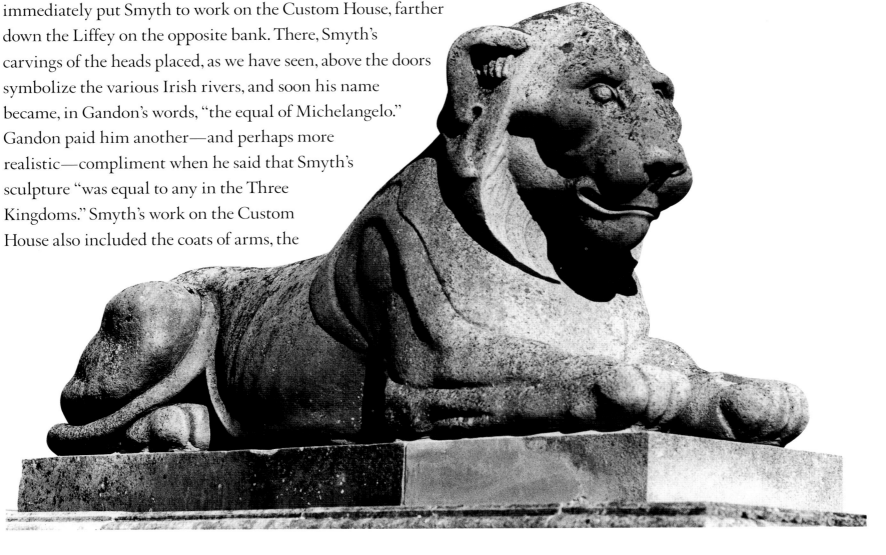

figures of *Plenty* and *Industry* for the portico, and the statue of *Commerce* on top of the cupola. These were damaged by fire in 1922, as were his sculptures for Gandon's Four Courts from around the 1790s. In both buildings, he is also known to have executed plasterwork, which did not survive the conflagration caused by the civil war. He also worked on other Gandon projects, including Carlisle (now O'Connell) Bridge and the eastern portico of the Parliament House, where his figures of *Wisdom*, *Justice*, and *Liberty* did not weather well and have had to be replaced. He also worked on the chapel in Dublin Castle, where he was joined by his son John (c. 1773–1840), who turned out to be a better tomb-sculptor than his father. But one of the elder Smyth's greatest accolades was being made first master of the Royal Dublin Society's Modeling School in 1811, where he was followed after his death in 1812 by his son John, who had the opportunity of training two of the important nineteenth-century Irish sculptors, John Henry Foley and Terence Farrell.

Edward Smyth's capacity to work in plaster as well as in stone not only shows a multimedia talent, but also demonstrates how the two genres should be seen in conjunction with one another—one largely practiced on the inside of the buildings, the other used to decorate the outside. Plaster, or stucco, is known to have been used as far back as the eighth or ninth century in Clonmacnois, and we have also encountered its use in the late sixteenth/early seventeenth century at the Ormond Castle in Carrick-on-Suir and in the chapel of Bunratty Castle. It is stucco that is the sculptural medium par excellence used to decorate house interiors throughout Ireland in the eighteenth century. Work executed in the early decades, as in the House of Lords in the old Parliament Building, or Pearce's Nos. 9 and 10 Henrietta Street in Dublin, follow the example given by

the Royal Hospital, Kilmainham, in illustrating flowers, fruit, and oak branches. But the crucial introduction of the human figure was brought about by the arrival of the two Lafranchini brothers, Philip and Paul, not from Italy, as is generally thought, but from the southern Swiss canton of Ticino, where the art of stucco had long been practiced. Having worked in England, their first Irish commission was probably Riverstown in County Cork, where allegorical figures in the ceilings were based on designs by Poussin. It was Richard Castle, however, who gave the brothers some of their best opportunities in Ireland, enabling them to execute work in the rococo style, which can be seen at Carton, County Kildare, or in the salon of No. 85 St. Stephens Green in Dublin, where allegorical figures balance on effusive clouds, and putti swing out of garlands amid a riot of foliate scrolls. Russborough, County Wicklow, is also one of their triumphs, but once its architect, Richard Castle, died in 1751, the two brothers went back to England, only to return to Ireland again later in the 1750s to weave their magic rococo lightness at Castletown, County Kildare, and at Kilshannig in County Cork.

BELOW: *If the Lafranchini brothers and Robert West dominate the rococo decoration of Irish houses during the first two-thirds of the eighteenth century, Michael Stapleton becomes the master of the last third. But he uses a very different idiom, the neoclassical, which is found as much in furniture and silver as it is in stucco. Stapleton is, indeed, the one responsible for introducing in stucco the style made popular by Robert Adam— the orderly world of symmetry, circles, garlands, etc., which, with variations, is expressed in Belvedere House, his masterpiece in the north side of Dublin's inner city. Each of the rooms and staircase has a different classical allusion, that illustrated here being at the center of the ceiling of the Diana Room, which gets its name from the figure of Diana the Huntress being pulled in her chariot by two deer, as putti sport in the clouds beneath.*

RIGHT AND BELOW: *Russborough in County Wicklow has one of the finest interiors of any eighteenth-century Irish country house, where the wonderfully inventive ceiling stucco—probably by the Lafranchini brothers—joyfully presides over comfortably sized and well-appointed rooms.*

The Lafranchinis were not the only ones influenced by French rococo design. Watteau's work was a model for an unidentified stuccodore who created a sensitively molded ceiling for the La Touche bank (now in the Bank of Ireland in College Green). Even more delicate are the ceilings from Mespil House in Dublin, which are now built into the President's residence at Áras an Uachtaráin in the Phoenix Park, and which has allegorical figures floating on clouds or earth, bundling up on one another to create a clever sense of depth, including one scene which could act as a motto for the eighteenth century—*Minerva Introducing the Arts to Hibernia.* Very different is a ceiling designed for the Áras building itself illustrating Aesop's fables in a gossamer-like framework of rococo cartouches that introduce an uncharacteristic symmetry into the rococo style, which characteristically prides itself on avoiding such balance.

The temporary departure of the Lafranchinis from Ireland's shores left the way open for the rise of a remarkable—indeed, the most remarkable—Irish rococo stuccodore, Robert West, who dominates much of the 1750s and 1760s. His work, best seen in his own house at No. 20 Dominick Street (now undergoing restoration) and No. 86 St. Stephens Green, is characterized by putti, fruit, and flowers in bunches or baskets and musical instruments and birds standing out in high relief. But West was not alone in his field. One other fine craftsman, Bartholomew Cramillion, a Belgian Walloon, worked for Dr. Bartholomew Mosse in creating in the 1750s the wonderful chapel in the Rotunda Hospital. Children's heads and putti so aptly abound among the stucco foliage and moldings of this maternity hospital where so many of Dublin's children have been born in the two and a half centuries since the building was begun.

Representations of the human figure began to retreat again with the advent of neoclassical designs introduced by the Adam brothers around 1765, apparently with the assistance of the architect James Wyatt. Their style was exemplified by an adherence to classical symmetry, a lightness of touch in garlands, and circular ornaments—all applied with the aid of repetitive molds. In Ireland its great practitioner was Michael Stapleton, whose pièce de resistance was Belvedere College, where he does, however, manage to introduce classical figures in vignettes, along with urns and honeysuckle patterns. Lucan House, now the home of the Italian ambassador, is another of Stapleton's achievements, his airy and delicate designs appearing against a light-colored background, as opposed to a dark background at Belvedere, reminding us that stucco was painted in the second half of the eighteenth century and thereby added much to the colorful decorative element of the interiors in these great Georgian houses. Most of these houses are not open to the public, but a walk along Dublin's Georgian streets and squares in winter's late afternoons will provide rewarding views of ground- and first-floor ceilings. The stucco work on these houses is one of Ireland's delights and shows how, together, foreign and native craftsmen added tremendously to the embellishment of a city that blossomed so wonderfully in the eighteenth century.

BELOW: *Glin Castle on the Shannon is the home of the Knight of Glin and Mme. FitzGerald, a name proving descent from one of the greatest of the Norman families that came to Ireland in the twelfth century. Some of its minor scions adopted the traditional and hereditary title of "knight." The present castle was built around the middle of the eighteenth century, and has much ceiling plasterwork in the Adam/ Wyatt style of the period, but was probably executed by talented local stuccodores. The drawing room, elegant and well-appointed as befits such cultured owners, has a number of good family portraits framed by a series of botanically painted plates. Over the central doorway is a decorative piece by Angelica Kauffmann (1740–1807) said to be of Nelson's Lady Hamilton posing as Hebe, and there is also a gouache of the Giant's Causeway by Susannah Drury. Nowhere else in Ireland will you find a more stately Bed, Breakfast, and Dinner feast than here in Glin Castle, surrounded by the best of Irish decorative arts and paintings!*

LEFT: *The best contemporary illustration of the interior of an eighteenth-century Irish house is found in a family portrait in the National Gallery of Ireland, formerly ascribed to Philip Hussey but recently, and probably correctly, attributed to Strickland Lowry (1737–c. 1788) by Nicola Figgis and Brendan Rooney. Lowry was English, but is known to have worked in the East of Ireland, which, however, does not help us in finding out the name of the family represented here. The father, mother, two children, and a pair of dogs are presented in the center of a carpeted room otherwise only furnished with chairs, which could presumably be drawn up to any dining room table that would have been brought in. The keyhole grate is a specifically Irish type, but what fascinates here is the pillar-and-arch wallpaper, particularly that over the grate. It is strikingly more decorative than that on the rest of the walls, which is of a type found on both sides of the Atlantic around the time the picture was painted (c. 1770).*

FOLLOWING PAGE: *The first important landscape painter in Ireland—William van der Hagen—was probably an Englishman who brought his skills with him to Ireland and spent the last twenty and more years of his life in the country before his death in 1745. Noted particularly for his paintings of maritime towns such as Derry and Waterford, he also depicted the landing of William III in Carrickfergus in a canvas that now hangs in the Ulster Museum in Belfast. The subject matter was the prelude to the Battles of the Boyne and Aughrim in 1690 and 1691 respectively, but also to the rise during the eighteenth century of the Protestant ascendancy, who may have been restrictive landlords to their tenants, but who also did a great deal for the culture of Ireland.*

223

The Landing of King William of Glorious Memory at
Carrickfergus. 1690.

The walls of the houses of the gentry and aristocracy in eighteenth-century Ireland must have been teeming with paintings. But it had not always been so. Up to the Cromwellian period, tapestries were more likely to have lined the walls of larger houses, and the lord lieutenant, the Duke of Ormond, was one of the first in Ireland to collect pictures, which he did for the decoration of his house in Kilkenny after Charles II had ascended the English throne and made Ormond his representative in Ireland. The duke would have employed artists of foreign origin, such as Sir Peter Lely, or sculptors like William de Keyser, who would have created statuary for his garden. Another, Gaspar Smith—of Dutch or German origin—probably had the distinction of teaching and training the first recognizable Irish-born artist that we know of, Garret Morphy. Morphy was conversant with styles current in England and the Continent at the time, and was well able to adapt them to his own purposes. In both England and Ireland, he concentrated on what was, for his home

BELOW: *Irish portrait painting began to develop in the later seventeenth century, starting with Garret Morphy, who enjoyed using landscape as a background for his sitters. One English contemporary of Morphy's who did much work in Ireland was Thomas Bate, whose portrait of Lord Coningsby, shown here, signed and dated 1692, now hangs in the Ulster Museum in Belfast. It shows Hampton Court in Herefordshire as part of the landscape in the background. Though Coningsby lived partially in the world of Romantic medieval fantasy, he wears classical dress of Roman inspiration here. Irish portraits of the eighteenth century showed nobility and gentry being even more showy in their attire.*

country, the novel genre of portrait painting and, though Catholic, he did not confine his sitters to his coreligionists, painting Jacobite and Williamite supporters in equal balance. One of his most popular works was an apparently posthumous portrait of St. Oliver Plunkett, hanged at Tyburn in 1681, and which is known only from a later engraving. A rough contemporary of Morphy's was Thomas Bate, who painted a fine portrait of Lord Coningsby in Roman dress, now in the Ulster Museum in Belfast.

Of the next generation of painters, a number went to Rome and returned to England rather than to Ireland. However, some of their contemporaries, such as Stephen Slaughter, came from England to Ireland, doing fine portraits of the over-dressed Irish aristocracy, such as of Wyndham Quin of Adare. Some Irish

talent did stay at home. One was Francis Bindon (1690–1765), an amateur who started his career as a painter—with the fine portrait of Dean Swift of 1739 in the Deanery of St. Patrick's Cathedral (placed in a beautiful frame with musical instruments by John Houghton)—and then went on to become a successful architect, working with Richard Castle at Russborough. Swift, who died in 1745, was of course the dominant personality of the age in Ireland, best known for his *Gulliver's Travels*, but he was also a brilliant political polemicist. During the later part of Swift's life, the foremost Irish painter was James Latham (1696–1747), who practiced in Antwerp, but came back to paint many Irish portraits, including one of another great clerical celebrity of the time, the philosopher Bishop Berkeley, which hangs in Trinity College.

Compared to portraiture, landscape painting took longer to develop in Ireland. Most of the better seventeenth-century examples of the genre were by foreign artists, and the same was true of the first half of the eighteenth century, when the scene was dominated by the Dutchman William van der Hagen, who came to Ireland via England around 1723. One of his paintings, now in the Ulster Museum in Belfast, shows the arrival in Ireland of his fellow-countryman, King William III, in Ireland, and he also painted some of the best Irish townscapes of the period, as in Derry and Waterford. One of van der Hagen's most surprising paintings, but one which gives us wonderful insight into the colorful dress of the Irish upper classes, is of a state ball in Dublin Castle in a room said to have been set up for the occasion by Sir Edward Lovett Pearce. Of the other contemporary landscapists of the period—Joseph Tudor, William Jones, and Anthony Chearnley, among them—one is worth special mention. Susannah Drury not only shared (with Tudor) the first Dublin Society premium for a landscape painting in Ireland, but is also the first Irish woman painter of renown, whose view of *The Giant's Causeway* of 1740 is an outstanding composition for any artist, male or female, and is one of the prize exhibits now in the Ulster Museum in Belfast.

As with sculpture, the appearance on the scene of the Dublin Society's schools around 1740 was to make a tremendous difference to arts and crafts in

Ireland. Design was to be the schools' main emphasis because of its importance in manufacturing, but the pure arts also benefited greatly. It is a curious paradox that although the schools never held advanced courses in oil painting, their pupils became some of the best landscape painters in Europe, at home and abroad. Even as far as Rome, a group of Irish artists were among the most important landscape painters in Italy in the third quarter of the century.

In the 1760s, the architect and exemplary draughtsman Thomas Ivory, mentioned above, became the first master of the architectural drawing school under the aegis of the Royal Dublin Society, where one of his pupils was James Hoban, who designed the White House in Washington. The society's schools were ahead of their time, and when London initiated a similar institution in the form of the Royal Academy School in 1765, it siphoned off some of the best Irish talents, who went to London with the hope of greater international recognition. Yet it is pleasing to note Anne Crookshank's comment that the problem in Dublin was not too few, but too many talented artists who

BELOW: *After the premature death of Thomas Roberts in 1778, the field of Irish landscape painting was dominated by William Ashford, who had come from England in 1764 and lived long enough to become first president of the Royal Hibernian Academy in 1823—the year before his death. He received many commissions to paint the large country houses that had been erected in great numbers during the eighteenth century, though, in doing so, he tended to paint the houses on the side and concentrate on his great love—trees. This is evident in his lovely 1781 evocation of a summer drive in an open carriage past the gates of the (now, sadly, demolished) Frescati or Frascati Park in the Dublin suburb of Blackrock, where the patriot Lord Edward FitzGerald (of 1798 fame) spent much of his youth.*

ABOVE: *The marvelous collection of musical instruments carved around 1724 on the organ case of St. Michan's church in Dublin has been attributed tentatively to Henry Houghton by Anne Crookshank, who describes it as "one of the finest examples of wood carving in Dublin." Its virtuosity reminds us that Dublin was an important musical center during the eighteenth century, experiencing the first performance of Handel's* Messiah *in 1742 and being home at times to the famous Italian violinist and composer Francesco Geminiani, who died there in 1762.*

RIGHT: *The eighteenth century saw the high point of Irish furniture manufacture. In the first two-thirds of the century, baroque and rococo predominated, with a notable presence of birds, fruit, and flowers among the carvings, and with well-modeled feet of various kinds. By the last third of the century, the more sober, Roman-inspired Adam style came into fashion, with inlaid patterns and classical designs, as on this table possibly by William Moore of Dublin, whose* floruit *was 1782 to 1815.*

exhibited with the Society of Artists, which had been founded in Dublin in 1764. Among these, there were some who excelled in pastel portraiture, such as Hugh Douglas Hamilton (1739–1808) and Robert Healy, who painted Speaker Conolly's family at Castletown and died at an early age. The specialist in oils was Robert Hunter (d. 1803), who often set his portraits in a landscape, including one of the La Touches out shooting (now in the National Gallery). A contemporary of his, Nathaniel Hone (1718–1784), the first of a long dynasty of talented artists, was among those who focused their careers more in England than in their native country. Another, even better-known expatriate who made his reputation in London was James Barry (1741–1806), whose *The Conversion by St. Patrick of the King of Cashel* is the earliest known painting of an Irish historical scene, though his portraits—which he himself thought little of— are superior in quality. In London, Barry met up with the great Irish orator Edmund Burke, who gave him introductions to provide him with work and, more importantly, paid for an extended tour of Italy in 1765–1771. On his return to London, Barry became professor of painting at the Royal Academy and

painted—without a fee—a series of murals on "the progress of human culture." While in Italy, he became fascinated with all traces of Roman antiquity that surrounded him and subsequently brought many classical themes to bear on his paintings, dovetailing beautifully with what we have already observed in the architecture of the period.

The fascination with antiquity in general permeated Ireland. One of the great patrons, Colonel William Burton (Conyngham) of Slane Castle, founded the Hibernian Antiquarian Society in 1779 and collected works by a wide variety of artists that illustrated ancient Irish monuments with the intent of issuing volumes of engravings that would make the world aware of the beauty, not of Rome's, but of Ireland's ancient churches, abbeys, and castles. The project did not come to fruition in its intended form, but it did provide much of the material for Grose's *Antiquities of Ireland,* which appeared in the 1790s. The English painter Paul Sandby had already made engravings of Irish antiquities after originals by Lord Carlow, later the Earl of Portarlington (who had commissioned Gandon to build Emo Court), and these were published in his *Virtuosi's Museum* in 1778. Of the artists in Burton's circle, three feature prominently as landscape painters in the second half of the century—George Barret, Thomas Roberts, and Jonathan Fisher—all of whom were at the forefront of landscape painting in Britain and Ireland. To reach that status, the drawing training in the Dublin Society's schools must have played an important role—as did Edmund Burke's treatise on *The Sublime and the Beautiful.* It was Burke who inspired the paintings of "terrible" scenes from nature, George Barret being among the first to paint Burke's words in pictures, producing dramatic scenery in County Wicklow in the 1750s, and going on to do justice to the dramatic Welsh and Scottish scenery in the 1760s. This left the

RIGHT: *After its first introduction to Belfast around 1688, Irish delftware took more than half a century to reach its peak in the products of Henry Delamain, who is described in his obituary of 1757 as "master of the Irish Delft manufactory, who, by the expense of a large fortune and unwearied application, brought that ware to such perfection." That can be seen in the spirit barrel now in the Hunt Museum in Limerick, which was considered to be of sufficient importance to be featured on a 9p Irish postage stamp in 1976. This rare example, bearing on its ends the heraldic crest of the Molyneux family of County Armagh, has attractively rustic scenes painted in manganese.*

way open for the meteoric rise of one of the finest of all Ireland's landscape painters, Thomas Roberts (1748–1778), who exhibited fifty-six works with the Society of Artists in Ireland between 1766 and 1773 and whose magisterial brush was able to capture the ever-changing atmosphere of the Irish countryside without even including the drama injected into it by Barret. Roberts's early death in 1778 in turn opened the way for the next major landscape artist, William Ashford (c. 1746–1824), who came from England at a young age and spent the rest of his life in Ireland. Ashford is famous for his views of his patrons' houses placed in a landscape, but usually off center so that the foliage becomes a central focus of his summer evening evocations.

The abundant talent that was present in painting in late-eighteenth-century Ireland extended also to various crafts. Ireland's capital had to be furnished, and craftsmen were encouraged to fill the need. The largest such item, of course, was furniture itself, little of which can be recognized as Irish before about 1730. For the following half century, graceful tables, chairs, mirrors, and beds became the purveyors of wood carvers' artistic fantasies, as they created decorative motifs such as birds, bird heads, lion heads, grotesque masks, flowers, and scallop shells. The middle of the century saw rococo elements emerging, particularly in mirrors, with a hint of chinoiserie, made popular by the English furniture style of Thomas Chippendale. But, as in stucco work, the neoclassical Adamesque style of decoration dominated the last few decades of the century, with instantly recognizable ovals, paterae, and festoons comprising very elegant additions to any house. However, by the end of the century styles tended to become less ornate. In addition, furniture became much more plain, examples of which are rarely found in Ireland today because most of it has crossed the Atlantic to be sold as "Early American"!

Eighteenth-century Irish tables must have looked very festive decorated

with the silver, porcelain, and glass that was such a prominent feature of contemporary Irish craftsmanship. Silver had been in use since Early Christian times, and a charter by King Charles I in 1617 granted the making of silver to the Dublin Goldsmiths Company. In time, the company was given a maker's mark, a date stamp indicated by a letter with a shield of a particular shape and a harp crowned (the head of the reigning English monarch was also added in the years from 1807 to 1890). Mention has already been made of ceremonial maces of the seventeenth century, but it was not until about 1670 that silver began to be used for domestic ware such as flagons and candlesticks. Teapots became common around 1700, preceded by chocolate pots, which remained in use until about 1750. A quarter of a century earlier, the Irish started putting cream in their tea, which was always sweetened, and both of these additives required separate containers. The rococo style was a blessing for the silversmiths, even if it necessitated greater skill, because it gave craftsmen the liberty to introduce figures and animals—often in rural scenes—on concave-cylindrical rings (wrongly called potato rings) to prevent hot vessels from making marks on the table. In contrast to the more formal silver of the preceding generation, which usually lacked any decoration, the rococo designs were often carried out by being hammered out from the back in repoussé style, with further decoration chased in. By the 1770s, the ubiquitous neoclassical style invaded the world of silver, often providing very elegant shapes and decoration that owe their inspiration to the world of Greece and Rome, made even more brilliant by engraved (or "bright cut") ornament that would flicker in the candlelight atmosphere of the dinner table. It was truly a dazzling period in the history of Irish craftsmanship and culture.

One form of table decoration also worthy of mention is delftware, the earliest Irish examples of which appear to have been made in Belfast around 1688, Dublin not following until about 1735. There, in the capital city, Irish delft's main exponent was Henry Delamain, who opened his factory shortly after 1750. He and his successors produced a prodigious variety of tableware painted with landscape and rural scenes reminiscent of Dutch tiles. Delamain's shapes, however, are often peculiarly Irish—barrels and cisterns, for example—which are not found outside the country.

Glass, too, was an important embellishment at every aristocratic Irishman's table, even if it did encourage his drinking habits. Being an easily breakable material, we probably have far fewer specimens surviving in comparison to silver, and the decoration of glass does not follow the rococo and neoclassical fashions practiced on other media. Most of the complete glass decanters are scarcely datable before the last years of the eighteenth century. Of course there was earlier glass, some of it beautifully engraved, as is the case with the Cobbe Loving Cup of 1745, illustrating King William on horseback

ABOVE: *This beautiful silver ewer of around 1750 in the Ulster Museum in Belfast would have contained rose water for washing hands after meals, and its rococo style would surely have been an ornament to any table.*

OPPOSITE, BELOW: *Tea was first imported into Ireland in the late seventeenth century, when it was regarded more as a medicine than as an enjoyable beverage. But its value as a thirst-quencher caught on sufficiently quickly to rival the more popular drink of chocolate, and to have special kettles made for it. As with this example made by the Dublin silversmith John Hamilton in 1736–1737 that is now in the Ulster Museum in Belfast, it was often mounted on its own stand, with a spirit lamp beneath to keep its contents warm. This kettle is unusually rich in decoration, and it bears a coat of arms suggesting that it was made to commemorate the marriage of Nicholas Loftus of County Wicklow and Mary Hume of Fermanagh.*

ABOVE: *High-quality lead crystal that was produced in Waterford and Cork from around the 1780s was heavily decorated with sharp diamonds of various depths and densities—a fashion that was carried on until the middle of the nineteenth century and revived again over fifty years ago. The diamond cutting alternates with plain bands on this preserve jar of around 1810–1820 in the National Museum of Ireland, in which fruit preserves would have been presented on the tables of the higher echelons of society.*

RIGHT: *Silver dish rings, often wrongly called potato rings, were used to hold hot dishes and bowls so that they would not damage the dining room table. They were an Irish invention and were also some of the most imaginatively ornamented silver pieces in eighteenth-century Ireland. This example in the Collins Barracks section of the National Museum of Ireland bears the maker's mark J. L., probably for John Locke. It is decorated in the style of the 1770s, with wreaths of flowers enclosing a bird or a squirrel, and filled out with arabesque lattice work.*

(though made more than half a century after his victory at the Boyne). The Fitz-Simon family had already established a glasshouse by the end of the seventeenth century, which kept up production until around 1760, and Dublin had a virtual monopoly until the last quarter of the eighteenth century when Belfast, Cork, and Waterford become important suppliers. This was brought about by the lifting of an embargo on the exportation of glass and the removal of a duty imposed on coal, which was necessary to blow it. The style was English, created by cutters who had come to Ireland because of taxes on English glass, but in time characteristically Irish shapes and designs emerged. A classical background can be seen in some of the bowls, but as the ancient Romans did not have glass decanters, the glassblowers were at liberty to develop their own outlines, often with two or three rings around the neck. Decanters often bore the name of their manufacturer on the base, aiding identification of provenance. Many of the Waterford glassworks products have a characteristically dense diamond cutting, which is still used with variations today.

The shamrock begins to make its appearance on engraved glass from a variety of factories around 1780, often combined with nationalistic toasts or mottoes of liberty and free trade, reflecting the political reality of the time when Ireland finally won the right to its own free trade and parliamentary liberty. These mottoes were encouraged by all those upper-class Irish who banded together as volunteers to defend the country against the French and Spanish in the absence of any apparent willingness by the English government to protect them. Gatherings of such volunteers, as exemplified at the meeting in Dublin's College Green in 1781 and immortalized in the English artist Francis Wheatley's large and popular canvas illustrating the event, finally led to the

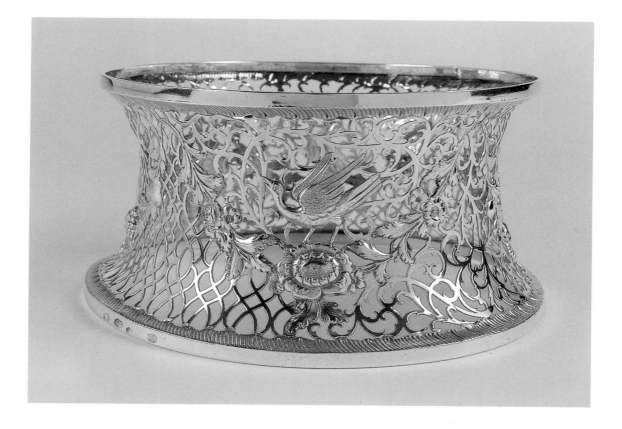

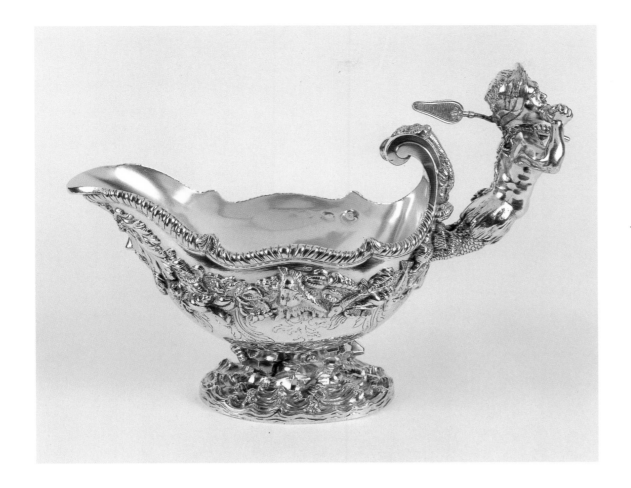

freedom gained in Henry Grattan's parliament in 1782. There followed eighteen years of liberty from England and the overriding laws of Westminster, and it is no coincidence that it was during that small window of time—between 1782 and 1800—that Dublin found itself adorned not only with great public buildings such as Gandon's Custom House, Four Courts, and King's Inns, but also with the great squares of red-bricked houses and the large mansions on the estates of the landed gentry, decorated by Irish workers and craftsmen. But the American Revolution of 1776 had made the British government wary, afraid that Ireland might be the next to gain its liberty from the English Crown. Then came the French Revolution of 1789, and London feared that the French citizenry's sedition against the aristocracy was a poison that could all too easily spread across the English Channel, or that Ireland would be used as a back door to penetrate England. This was followed a decade later by the Rising of 1798 in Wexford and elsewhere, which was led, surprisingly, by the Protestant upper classes with support from the long-downtrodden Irish peasants. Brutally put down with consequent loss of life, the rising prompted Westminster to bribe a majority of the Irish Parliament to vote itself out of existence through what is known as the Act of Union of 1800. Ireland was henceforth to have no parliament of its own under English jurisdiction. The old House of Lords and House of Commons building on Dublin's College Green was taken over three years later by its present owners, the Bank of Ireland, and the Lords who had debated within its walls were to move—along with power—to London, leaving Ireland very much the poorer. The effects of these political events were to linger long into the nineteenth century, and even into the twentieth.

THE NINETEENTH CENTURY

After the Act of Union of 1800, the departure of many of the Irish landed aristocracy for extended stays in London, where the power now lay, did not mean that architecture and the arts came to a standstill in nineteenth-century Ireland. There was, however, a change in emphasis. Patronage no longer came exclusively from the highest echelons of society. The free trade achieved in the last decades of the previous century facilitated the rise of middle-class merchants who wanted to make their mark on society by building fine villas for themselves in the newly created leafy suburbs of the cities where they had their businesses. Where in the eighteenth century church building played a secondary role to that of grandiose secular public buildings (particularly in Dublin) and of lavish mansions in the country, the nineteenth century saw an unprecedented rise in the number of churches built. At first, these were largely Protestant churches erected with financial support from the so-called Board of First Fruits. But the Catholic church was on the march after a relaxation of the Penal Laws and, more particularly, after the Catholic Emancipation Act of 1829. Neo-Gothic churches were built by the score, ensuring in every town and village that the Catholic spire, where possible, should be higher than that of the corresponding Protestant church, as a measure of the Catholics' new-found sense of security. The Presbyterian churches in Ulster also found a new lease on life, springing up in most towns and many villages in the province. Also unlike the eighteenth century, new building activity was not concentrated in Dublin. The creation of two extensive canals from the 1770s onward enabled the capital city to reach out to the West of Ireland by joining up with the Shannon—which was later, in turn, to be joined up with the Erne system. But even more remarkable in this respect was the arrival of the railway, whose speed of travel eventually forced the canals out of business. Starting with the line from Dublin to Dun Laoghaire (or Kingstown as it was known then), various railway companies worked hard to expand radially from Dublin, even linking provincial cities one with another so that, by the last third of the century, long-distance travel in Ireland had become commonplace with the octopus-like spread of the railway system. Wanting to impress investors with their value and

ABOVE: *Irish lace came to the fore in the nineteenth century, when schools were set up in major cities such as Limerick, Kenmare, Youghal, and Carrickmacross. Conditions after the famine were desperate, and it was the awards that the Royal Dublin Society gave in 1852 for artistic talent in Carrickmacross that led to the development of a lace industry that flourished there for more than a century. This fan, dating from about 1890, uses pearl blades and ivory sticks to provide the frame for Carrickmacross guipure lace, with needlepoint fills.*

OPPOSITE: *Frederick William Burton spent most of the 1840s in Germany and the 1850s in London with Pre-Raphaelites such as Burne-Jones. The combination of backgrounds led to one of his most striking works, the stunning watercolor of 1864, now in the National Gallery, entitled* Hellelil and Hildebrand: The Meeting on the Turret Stairs. *Inspired by a Danish ballad, it represents a passion-laden, fateful meeting between Hellelil and her bodyguard, the Prince of Engellend—the scene that one of Burton's famous sitters, the novelist George Eliot, described as potentially vulgar, but which the artist had raised "to the highest pitch of refined emotion."*

efficiency, the railway companies built imposing terminal buildings, Dublin having three of considerable architectural merit—Amiens Street (now Connolly) for the Great Northern line, Kingsbridge (now Heuston) for Cork and Limerick, and Broadstone (now a depot) for the west and northwest. All this meant that building activity grew in leaps and bounds outside Dublin, with important official buildings springing up in cities like Cork, Limerick, and Galway, as well as in larger towns such as Carlow and Dundalk. The most notable of these buildings were the courthouses, usually with grandiose classical porticos—severe, yet impressive, as the law itself was meant to be seen.

The classical style was a carry-over from the neoclassicism of the previous century—but with a difference. It was the Doric, the most Grecian of all the architectural orders, that was used in these porticos, a choice that was, to some extent at least, an Irish response to the craze for the beauty, orderliness, and simplicity of Greek architecture that became popular in England in the early years of the nineteenth century. This came about after the dilettante Grand Tourists turned their attention away from Rome and toward southern Europe and Asia Minor, looking for traces of ancient Greece—a fascination that we know best through Lord Byron. This Greek influence in Ireland is best personified in St. Stephen's church in Dublin's Mount Street Crescent, a building Dubliners love to call "the Peppercanister Church," and which has a tower above the doorway that is modeled on the Tower of the Winds and the monument of Lysicrates in Athens. Its portico is modeled on the Erectheion, and its beautifully carved anthemion motif does credit to its carvers, who copied the Greek original very carefully—though from drawings, of course. The church's location is wonderful because, when seen from the south side of Merrion Square, it forms the central end-piece of one of the best Georgian vistas in Dublin. Completed in 1827, St. Stephen's was not the first of Dublin's Protestant churches to be built in the classical style. That distinction probably goes to St. George's, Hardwicke Place, by Francis Johnston, a Wren-style building with an Ionic portico. Catholics, however, were also using the classical style in small country churches in places like County Carlow at the end of the eighteenth century, but the major example of the Doric order is the Pro-Cathedral in Dublin's Marlborough Street, of 1814/1815, where a Doric colonnade within leads to a most un-Greek but yet effective semicircle behind the high altar. The same style is used in Dublin's church of St. Andrew's in Westland Row of 1832. Belfast began to blossom at this time, and its nickname, "Athens of the North," reflects its favored use of Greek revival architecture in the Old Museum building, the Savings Bank, and the Academical Institution.

But it was Gothic that was chosen for the great majority of churches in nineteenth-century Ireland. Most of the seven hundred Church of Ireland churches built during the first three decades of the century were Gothic, with tall, thin spires and smaller spikes standing up along the skyline of the nave.

BELOW: *For its setting and its detailing, St. Stephen's Church in Dublin's Mount Street Crescent—designed by John Bowden in 1824 and completed three years later— is the finest Greek revival church in Dublin. Placed at the end of Lower Mount Street, it forms the background and the centerpiece of the incomparable Georgian vista looking eastward along Merrion Square South. The superb carved detail on its portico copies the Erectheion on the Parthenon, and two round Athenian monuments acted as models for the tower above that prompted the Dubliners to give the whole building its pet name of the "Peppercanister Church."*

The architect of a number of these "Board of First Fruits" churches was John Semple, whose "Black Church" on Dublin's north side is a particularly notable example, its interior having an unusual parabolic cross-section. Another architectural practice involved in their construction was that of the Pain brothers, who had come to Ireland to work with the Regency architect John Nash, and built the Cork County Gaol in Doric idiom before adopting the Gothic style in such prominent buildings as Blackrock Castle on the river Lee around 1840.

The Catholic church was quick to adopt Gothic as its favored style, since its conventions had a whiff of something non-English about them. But because

Gothic was the style in vogue immediately prior to the Reformation, its modern use could also be seen as the continuation of the Catholic faith—as if to pretend that the Reformation had never happened. So when the Catholic church did adopt the Gothic, it used little else. Because Catholic churches are so ubiquitous throughout Ireland, it is all too easy to overlook their fine structures and the high quality of their sculptural embellishment. One of the greatest church architects of nineteenth-century Ireland, the Englishman A. W. N. Pugin (1812–1852), a convert to Catholicism, was a great admirer of medieval Gothic, which he considered the only truly Christian architectural style and one that reflected the morally upright society of the Middle Ages as

compared to the nineteenth-century's urban squalor. He wanted to get away from sham ornament, with each part of the church functional and visible as such from both inside and outside. He built a considerable number of churches in the Wexford area, but one of his largest commissions was the Catholic Cathedral of St. Brendan in Killarney (the spire is a later addition, not his). All the individual elements are clearly articulated, and unusually tall lancet windows allow thin strips of light to illuminate the interior.

Pugin's most famous pupil was J. J. MacCarthy (1817–1882), though it was apparently Pugin who completed a design in St. Michael's in Ballinasloe initiated by MacCarthy. MacCarthy made an occasional foray into the neo-Romanesque style, as in the Chapel of Glasnevin Cemetery, but his métier was Gothic, in which he carried out some very fine work, as in his completion of St. Patrick's Cathedral in Armagh. Both it and the church in Ballinasloe just mentioned were interrupted by the terrible famine that struck Ireland in the years 1845–1847. Killing more Irish people than the Black Death ever did, the famine—caused by a potato blight in three successive years—halved the population of Ireland, from 8 million to 4 million, according to the census

returns. Precisely how many left for England and America is not easy to establish accurately, but it started a new wave of emigration that continued for more than a century.

It was the pennies of the comparatively poor Catholics of Ireland that paid for the erection of these Gothic churches, which they could ill afford, but of which they—and the parish priests who built them—were immensely proud. Not every village could pay an architect of the stature of J. J. MacCarthy, but the large number of Catholic churches built all over the land in the nineteenth century must have been a great boon for the architectural profession. The Church of Ireland, too, had its successes in buildings, like St. Fin Barre's Protestant Cathedral in Cork, built between 1867 and 1879 by the English architect William Burges (1827–1881) in a French Gothic style, with excellent decoration both within and without. It should be mentioned that one of the most brilliantly sited Gothic churches in Ireland stands just a bit farther down the bank of the river Lee in Cobh, situated on a site that slopes down to the river's tidal shore. Dominating the town, it must have been the last church seen by those who perished on the *Titanic* in 1912, as Cobh was its last port of call before venturing out into the North Atlantic. Cobh was doubtless also the last Irish town to have been seen by those emigrating to America throughout the nineteenth century. The cathedral in Cobh was designed by Pugin's son, Edward Welby, and George C. Ashlin, who also had a large practice in late Victorian Ireland, but it took more than eighty years before the church was finally completed in 1949.

The Victorians seem to have rarely tired of Gothic in their church buildings, but this was not necessarily the case with government buildings and private villas. Francis Johnston (1760–1829), the man who became Gandon's successor as the most important Irish architect of the first half of the nineteenth century, did use Gothic in Charleville Forest House near Tullamore in 1801, but preferred the more usual classical idiom, which provided a visual sense of security. He worked in counties Louth and Meath on private houses such as Townley Hall (with a splendid Pantheon-like dome covering a central and generously winding staircase), but he is perhaps best known for his General Post Office in Dublin, of 1814–1818, with statues by Edward Smyth's son John. Johnston was, in fact, the principal architect of the Board of Works and was therefore in the position of being able to design state buildings such as the Post Office, thereby leaving the field of private practice to other eminent practitioners.

One of those was Richard Morrison, who, in collaboration with his aptly named son William Vitruvius, executed one of the finest country houses of the Victorian era, Ballyfin in County Laois (c. 1829), which has a fine glass conservatory. Its gardens were later to be laid out by the famous English architect Edward Lutyens. The interior of the house was described by Jeanne Sheehy as being "of a richness unequaled in any other country house."

With the ascent of Queen Victoria to the English throne in 1837, fashion began to tire of the soberly classical decoration used under the four Georgian kings (1714–1830) who had preceded her, and a more exuberant taste began to emerge, where heavy decoration slowly replaced restrained classical elegance. It was Italian, rather than Roman, that became popular, as executed particularly by the well-known Belfast architect Charles Lanyon (1813–1889). He borrowed from Italian palaces and Renaissance villas, using architecturally sculptural elements, rustic quoins, and arcaded towers. Harbingers of the new style were his tall, deeply arcaded windows at the center of one of his masterpieces, the Custom House in Belfast, of 1857.

It was Italian architecture of a slightly different kind that acted as inspiration for the man who is, arguably, the most inventive Irish architect of the nineteenth century—Benjamin Woodward from Cork. It was he who removed the middle floor from Burgh's Trinity College Library, thereby joining the two upper storys and erecting the barrel vault that makes the library into one of the great interior architectural spaces in Ireland. The open square outside the eastern end of the same library—now decorated in the center by the spherical sculpture of the Italian Pomodoro—is also one of Ireland's most remarkable open spaces in the sense that three sides of the square are bordered by some of the best Irish architecture of three centuries—Burgh's Old Library of 1712 on the west, Paul Koralek's New Library adjoining it on the south and, on the eastern side, another of Woodward's great masterpieces, the New Museum Building in Trinity College, constructed between 1852 and 1854. Woodward's Museum Building looks like a Venetian palace, with stones of alternating colors as voussoirs in arches. The interior has a grand staircase under a set of three domes made up of colored tiles leading to an arched loggia that introduces the visitor to the upper floors. Woodward was an admirer of the eminent Victorian architectural critic John Ruskin, who—like his fellow-countryman, Pugin—was all against sham and argued that building materials should be for structural purposes rather than for show. Ruskin later admitted that Woodward's Museum Building was the structure that came nearest to fulfilling his ideals. The building looks across Trinity College's playing fields to another remarkable Woodward building, the former Kildare Street Club (now partly the Genealogical Office and Museum), which is even more colorful in its use of Venetian polychromy that contrasts with the red brick that is used on much of the exterior.

One of the most notable characteristics of both of these Woodward buildings is the quality of the carving, which greatly enhances the sculptural exuberance of both structures. The old Kildare Street Club is famous for its humorous ground-floor figures of animals playing billiards or monkeys strumming musical instruments. These are probably the work of two of Woodward's fellow-Corkonians, the O'Shea brothers (though C. W. Harrison

probably had a hand in some of the minor sculpture), and it was the O'Sheas who are widely believed to have been the sculptors of the wonderful foliage on the Museum Building. The story is told that, very much in fulfillment of Ruskinian ideals about natural materials, the brothers used to go out in the morning and pick fresh flowers and plants and bring them back to arrange on their workbench so that they could carve their details true to nature. The brothers went on to make a name for themselves in Oxford. The beautiful capitals in the interior of the Allied Irish Bank building on Dublin's Dame Street have been tentatively attributed to the O'Shea brothers, John and James, because of their beautifully carved naturalistic foliage, but the attribution remains uncertain.

The same C. W. Harrison mentioned above was an Englishman who came to Ireland in 1857; he became heavily involved in the carving of Protestant churches in Dublin, such as St. Bartholomew's, but also provided many a pulpit, font, and lectern. He also worked for banks that were some of the largest architectural projects in mid-nineteenth-century Ireland, built to stress solidarity for their investors. Others were involved in architectural sculpture outside Dublin, most notably Thomas Fitzpatrick, who produced the fine pediment sculpture on the Custom House in Belfast in 1857 — at the same time that the O'Shea brothers were working their magic in Dublin. Another fine craftsman who worked in Belfast was Samuel Ferris Lynn, brother of the

better-known architect W. H. Lynn, who carved the statue of Prince Albert in Belfast and the pediment of the Provincial Bank building in Dublin's College Green in 1864.

It is interesting to note how many of the architectural sculptors were part of family firms or dynasties. We have already come across the Smyths from Meath—one (who spells his name "Smith") who "beautified" the Balrath cross in 1727; Edward, Gandon's favored sculptor for the Custom House; and his son John, who worked with his father on the stone decoration of the Chapel Royal in Dublin Castle around 1810 and became the first master in the Dublin Society's School of Modeling and Sculpture in 1811, a position he retained until his death in 1840. Another sculpting family was the Kirks, Thomas (1781–1845) and his son Joseph Robinson Kirk (1821–1894). Thomas produced Ireland's tallest sculptures—Lord Nelson atop Nelson's Pillar in Dublin's O'Connell Street, which was blown up by "patriots" in March 1966, and the Duke of Wellington surmounting his own column in Trim, County Meath. But Kirk also did some good funerary monuments—a type much beloved in church interiors in the nineteenth century, particularly in memory of those who had been lost fighting on land or sea. Some of Thomas Kirk's work has a narrative element, as in *The Good Samaritan*, which is part of the Gillichen memorial of 1819 in Dundalk. Being of Cork origin, he was also involved in architectural sculpture for the courthouse in his native city. Joseph Robinson Kirk is probably best known for

RIGHT: *The Farrells were a popular and talented dynasty of sculptors in nineteenth-century Ireland. One of them, Thomas, was knighted and produced many memorial statues, particularly in Dublin. One of the most appealing of these represents Sir John Gray (1816–1875), doctor and journalist, who was a supporter of "The Liberator" Daniel O'Connell, and it is apt that this statue should stand in the Dublin thoroughfare named after his friend. Even more appropriate is that Dubliners should have raised a public subscription to erect this noble statue of Gray four years after his death, for he was the man responsible for giving the city its water supply from the Vartry reservoir. What his left hand clutches may be a rolled-up copy of the newspaper* The Freeman's Journal, *which he owned and which was the great voice of Catholic nationalism in his day.*

his Crosier monument in Banbridge, County Down, commemorating the Arctic explorer who is portrayed being supported by two polar bears.

The Farrells—Terence (1798–1876) and his son Sir Thomas (1827–1900)— comprised another family of sculptors. They, too, specialized in narrative relief on memorial tablets, such as that executed by Terence and erected in St. Patrick's Cathedral in Dublin to those who died in the China War of 1840–1842. While Sir Thomas's memorial to Archbishop Murray in the Pro-Cathedral is one of his finest, he became famous for his monumental public statues. The most elegant of these are perhaps those of John Gray, which stands in Dublin's O'Connell Street, and William Dargan, which is outside the National Gallery that he had helped to found.

But there were also, of course, individual sculptors who made a considerable name for themselves in both Ireland and England during the

mid-nineteenth century. One of these who also executed a fine monument in the Pro-Cathedral was Peter Turnerelli (1774–1839), whose Archbishop Troy memorial is in the best style of fifteenth-century Italy, and who was also responsible for the high altar in the same church, with angels in classical pose. Born in Belfast, but educated in Dublin and London, Turnerelli had a European reputation, his works being commissioned by various royal houses of Europe and admired by the great Canova in Rome. Turnerelli made quite a fortune for himself selling copies of his busts of Henry Grattan and "the Liberator," Daniel O'Connell, the former having won parliamentary freedom in 1782 and the latter Catholic emancipation in 1829. Another noteworthy sculptor was Christopher Moore (1790–1863), who spent most of his working life in England but kept sufficiently in touch with his native Ireland to get the commission for the statue of his—apparently unrelated—namesake, Thomas Moore, in Dublin's College Green and the memorial for the patriot John Philpot Curran in St. Patrick's Cathedral in Dublin. Two other stylish Irish sculptors who worked abroad, but whose oeuvre is nevertheless well

BELOW: Putting the remote past of Rome and ancient Greece behind them in turn, the Victorians of the mid-nineteenth century decided to go back to the more recent Renaissance period for inspiration for their buildings. In Belfast, this was best exemplified in the Custom House on Custom House Quay, designed and built in 1854–1857 by Charles Lanyon, one of the country's best mid-Victorian architects and later mayor of the city and Member of Parliament. His is an office building of Italian palazzo inspiration, with three sides of a forecourt facing inland, while the frontage facing the river Lagan is more richly ornamented, with sculptures by Thomas FitzPatrick in the pediment illustrating Britannia between two sportive sea gods, Neptune and Mercury. This was one of Belfast's first buildings to demonstrate the city's industrial and maritime prosperity.

ABOVE: *Overlooking the playing fields of Trinity College, Dublin, is the Museum Building by Benjamin Woodward (1816–1861), described by Maurice Craig as "the most original Irish architect in the nineteenth century." Designed somewhat in the style of a Venetian palace of around 1500, it is a two-story structure with round-headed windows largely grouped in threes and fours, some with balconies in front of them, and with Renaissance roundels between the groups. There are remarkably tall chimney stacks around the edges. The museum (now largely used for lectures) is also famous for the naturalistic stone carving of animals and foliage carved by the O'Shea brothers from Cork during the years of construction from 1854–1857. The style and decoration of the building was much admired by the English art historian John Ruskin.*

represented in their native land, are John Hogan and John Henry Foley. John Hogan (1800–1858) was born in Cork, where he was able to study the casts made of classical sculpture in Rome that were presented to Cork by the Prince of Wales. He was sent to Rome in 1824, from where he sent fine religious works back to Ireland, including *The Dead Christ* in the Discalced Carmelites church in Dublin's Clarendon Street (1829). His *Pietà* behind the altar of the church of St. Nicholas of Myra on the same city's Francis Street included angels to which the parish priest subsequently added wings! Hogan did a small *Transfiguration* for St. Andrew's church in Westland Row in Dublin, and another now in the parish church in Clarinbridge in County Galway. He also produced some classically inspired statues of a nonreligious nature, such as *The Shepherd Boy* in Dublin's Iveagh House and *The Drunken Faun* (1828–1829) in plaster in the Crawford Art Gallery in Cork.

Though John Hogan also did statues of public figures, the better man for that was John Henry Foley (1818–1874), who showed his caliber in England by being asked to carve the statue of Prince Albert for the great Albert Memorial in Kensington Gardens in London. Foley (who had a brother who was also a sculptor) worked on the statuary of the Houses of Parliament at Westminster,

but—like Moore—kept in contact with his homeland and executed not only the statue of the Apostle of Temperance, Father Matthew, in Cork, but also the extremely well-known and elegant pair of figures of Burke and Goldsmith standing outside the front gate of Trinity College, Dublin. Looking toward them from the north is another of his well-known creations, the O'Connell monument beside O'Connell Bridge, which unfortunately was left to others to finish after Foley's death. Foley's statue of Sir Benjamin Lee Guinness outside St. Patrick's Cathedral in Dublin (Sir Benjamin's brewery was a major contributor to the restoration of the cathedral) shows how the artist was able to combine dignity with the characterization of the personality.

Another member of the aforementioned Kirk family—William Boyden Kirk—worked for the most successful porcelain firm in Victorian Ireland,

BELOW: *Since it opened in 1857, Belleek pottery has always had a sentimental appeal for those with a love of Ireland, because its products often had a nationalistic feel about them. This became apparent already in the first six years of operation with the production of a Parian statue, almost a foot and a half high, entitled* Erin Awakening from Her Slumbers, *the female personification rising, like a phoenix, above the ruins of ancient Ireland—represented by the fallen High Cross and the old harp behind her—and starting anew on an old basis, as an expression of the Celtic Revival, her gestures being that of unveiling the first Belleek pot. The statue, now in the Ulster Museum, Belfast, was designed by William Boyton Kirk (1824–1900), a member of a noted Irish family of sculptors active throughout the nineteenth century.*

251

ABOVE: *James Arthur O'Connor
(c. 1762–1841) is one of the important Irish
landscape painters who fit into the Romantic
movement, while still retaining something of
the calm atmosphere of the previous century.
His depiction of a rural idyll of 1820,* Scene
in County Wicklow, *now in the Ulster
Museum in Belfast, leads the eye to the
brooding cone of the Great Sugarloaf in
County Wicklow on the right. What happens
in the foreground—figures, river, bridge, and
the castle in the middle ground—may have
been an idealized rather than an actual
composition, which demonstrates O'Connor's
mastery in ordering his material into a
pleasing whole.*

which opened its doors in 1857 and is still in production at Belleek in County
Fermanagh. The use of local clays and potters from Staffordshire contributed
greatly to the development of the distinctive translucence and ivory color of
this porcelain, which is often very thin and finely glazed. For its period,
Belleek was unusual in using sculpture in its pottery forms—Kirk's statuette of
Erin awakening from her slumbers is one of many such well-modeled figures.
As might be expected of a pottery, the majority of the firm's products were
tableware—teapots, jugs, plates, etc.—decorated sometimes with transfer
designs, but also with embellishment in sculptural relief. One of Belleek's
specialities is the use of criss-crossing basketweave in dishes and plates that
gives it a delicacy, usually combined with elaborate flowers in high relief and
pastel-like shades of color. The style is still commercially successful, and its
frequent use of the shamrock has always appealed to a wider public.

The shamrock was also widely featured on furniture of the second half of
the nineteenth century. Irish Victorian furniture tends to be laden with relief
decoration, which modern taste finds too heavy and too dark, but high quality

was produced in Killarney by cabinet-makers such as Jeremiah O'Connor and James Egan, whose desks and tables used the local arbutus wood inlaid with harps, shamrocks, and historic monuments, such as at Muckross, which tourists would instantly recognize.

The Act of Union of 1800 changed both the painter's clientele and his choice of subject. The wealthy aristocracy had, in many cases, moved to London, and their estates and mansions that had been featured by eighteenth-century artists such as Thomas Roberts and William Ashford were generally left unpainted in the new century. Now it was the beauty spots or places of historic interest that became the focus of attention and, while characteristic features of the peasant society became popular, portraits tended to be of the rising middle classes, professional men or merchants who were now the ones with the expanding bank balances. These new patrons also had an interest in education and the proliferation of art, and to this end set up institutions of art in various locations. The Royal Cork Society of Arts was established in 1815, and this later developed into what is now the Crawford Art Gallery. The Royal Hibernian Academy in Dublin was founded in 1823, with William Ashford as its first president, and when sales proved negligible at its exhibitions, the Royal Irish Art Union was set up in 1840 to turn that situation around successfully.

BELOW: *George Petrie (1790–1866), artist and archaeologist, combined his two interests into an atmospheric watercolor—The Last Circuit of Pilgrims at Clonmacnois of around 1838. Giving an accurate rendering of the Round Tower and other antiquities of this great monastic site, he touches religious heartstrings in depicting pilgrims doing their final round of the "stations" in the foreground before the sun sets romantically behind, as others pray in front of the Cross of the Scriptures near the cathedral on the left. But he is also appealing to a nascent sense of nationalism by including the ruins of Norman power in the form of a castle in the background, while placing in the foreground the treasures of ancient Ireland—the Round Tower and the High Cross—of a kind that were to become nationalistic symbols along with the shamrock and the Irish wolfhound. In the immediate foreground he paints two examples of Clonmacnois's splendid collection of memorial slabs, on one of which he has left his cape and drawing board to associate himself with the activities of the site.*

LEFT: *When aged about thirty, James Arthur O'Connor left Ireland in 1822, but he often returned "to the wild and beautiful scenery" of his native country, there to find renewed inspiration for his canvases. He wrote the words quoted above as he was about to undertake yet another return trip in 1830, and two years later he painted one of his masterpieces,* A Thunderstorm: The Frightened Wagoner, *now in the National Gallery of Ireland, in which he expresses with great drama the wildness of nature and man's powerlessness in the face of it. A sudden shaft of light illuminates a wagon, three frightened horses, and their driver, during a thunderstorm that suddenly breaks as they attempt to cross a bridge spanning a raging torrent.*

255

ABOVE: *Hugh Frazer may not be a household name in the world of art, but he was certainly a competent painter and serious academician, whose work spans the years from 1813 to 1861. His portraits are rare, but his main specialty was illustrating scenes of Irish life. One of these,* View of Belvoir House from the South, with the River Lagan in the Foreground, *now in the Ulster Museum in Belfast, is a good example of romantic landscape, a riverside scene above Belfast, with action being provided by a fisherman on the left and an oarsmen in the brightly lit center. Above what is probably a mill looms the Big House in the form of Belvoir, at the time probably owned by Robert Bateson, but demolished many decades ago.*

Belfast responded to developments by founding an association of artists in 1836. Painting took longer to scale the heights in nineteenth-century Ireland than did architecture or sculpture. Ashford's main work in landscape was becoming increasingly rare after 1801, and, at the same time, Hugh Douglas Hamilton was approaching the end of his career as a portrait painter.

One who continued Ashford's tradition of landscape painting was James Arthur O'Connor (1792–1841), who was one of the first to highlight the beauty of the West of Ireland, and—it being the age of romanticism—he managed to bring even greater drama to scenery than Barret had done in the previous century, as exemplified by his *Thunderstorm—The Frightened Wagoner* of 1832 in the National Gallery of Ireland. Another who created serene older style landscapes combined with a degree of drama is Francis Danby, who accompanied O'Connor on a tour of Britain in 1813, but never returned home afterward. A third member of that touring party was George Petrie (1790–1866), regarded by archaeologists as the founder of their profession in Ireland, but he was also a consummate watercolorist who combined both interests in his atmospheric view of pilgrims at Clonmacnois in the National Gallery in Dublin. A fellow artist, whose archaeological views did not always agree with Petrie's, was Henry O'Neill (1798–1880), who produced the first great book of illustrations of Irish High Crosses in 1857, showing the importance of ancient

monuments in boosting Ireland's confidence through the glory of its ancient heritage. One who contributed with both Petrie and O'Neill to *Picturesque Sketches* in 1835 was Andrew Nicholl (1804–1866), a Belfast-born artist who is justly celebrated for his watercolors with flowers in the foreground and wider vistas and sometimes ancient monuments in the background.

With the expansion of the British Empire during this period, it is no surprise that seascapes began to come to the fore, and Ireland produced good marine painters, one of whom was Richard Beechey (1808–1895), who contributed much to the genre, often in expansive canvases. Another popular subject in Ireland, not unexpectedly, was the horse, usually racewinners shown by themselves, without their happy and enriched owners.

Nineteenth-century Irish painting came down to earth from the classical heights of the previous century. No longer were there noble family portraits with everyone dressed in silk and brocaded finery. Now it was the simpler folk, "the deserving poor," the pipers, the blind girl, who were the subject of the painter's attention. Narrative and "improving" scenes became popular—Joseph

BELOW: *Joseph Patrick Haverty (1794–1854) from Galway introduces an attractive anecdotal element into Irish painting in the Victorian era. He is also very good at featuring children in his compositions, as he does here in* Father Matthew Receiving a Repentant Pledge-Breaker *with a young boy who stretches forth his right hand to a poor unfortunate who had broken his pledge to stay off alcohol. Known as the Apostle of Temperance, the priest, too, seen on the right, stretches forth his right hand, which the child just touches for reassurance as his mother averts her gaze from the offender. The picture is now in the National Gallery in Dublin.*

Patrick Haverty's *Father Matthew Receiving a Repentant Pledge-Breaker* being a good example. As with the sculptors, there were painting dynasties, such as the Brocas, Mulvany, and Sadler families, the works of each of the members not always easy to distinguish one from another, as they all seemed to paint along rather repetitive lines. On the whole, the middle third of the nineteenth century was a period when often competent artists painted rather mundane subjects, usually with a touch of Victorian sentimentality.

The terrible potato famine of 1845–1847 did not have as disastrous an effect on artists as it did on the poorer population, particularly in the western half of Ireland, but the subject itself and the concomitant emigration did produce some fine canvases, though their creators are not exactly household names. One such is the Cork artist Daniel MacDonald (1821–1853), whose dramatic picture of the *Discovery of the Potato Blight* in the Department of Folklore in University College, Dublin, is a stark evocation of the horror that must have

BELOW: *For over two centuries a tourist center because of its beautiful lake scenery, Killarney began around 1825 to sell high-class souvenirs made of bog oak and the local arbutus or strawberry wood. This, in turn, led to the development of a very good cabinet-making business using the arbutus and other woods to inlay ferns, flowers, shamrocks, harps, and the local scenic attractions and historic monuments, such as Muckross friary. Queen Victoria's consort, Prince Albert, gave it great publicity potential by buying a number of examples of this local industry. On her visit to Killarney in 1861, the queen herself was presented with this davenport or writing table which bears the coat of arms of the United Kingdom on top, and also on the doors—behind which are drawers with pictures of local historical monuments. Lift up the writing slab and you will find a charming inlaid harp underneath.*

OPPOSITE: *The Belleek pottery was founded in 1857 to harness the good local ceramic clays to artistic designs carried out by various craftsmen brought over from the English potteries of Stoke-on-Trent, and it continues to enjoy a considerable success today. One of the firm's unique products is this stag's head candelabra in the Hunt Museum in Limerick, which bears a second period mark that would date it to around 1895. It may have been inspired by the interest in the stag as a symbol of Scotland during the Victorian era.*

ABOVE: *Being an island, it is not surprising that Ireland was gifted with a number of marine painters during the nineteenth century, who usually show sailing or steamships weathering rough seas. But one who brings a more reflective mood to bear is Edwin Hayes (1820–1904), who decided early to become one of their number and sailed around the Irish coast in his own yacht, traveled around Britain and Europe, and took a job as a steward's boy on a ship to America and back just to get to know the sea in all its calms and storms. An Emigrant Ship, Dublin Bay, Sunset, now in the National Gallery of Ireland, is tinged with a touch of sadness, as it shows emigrants only six years after the devastating potato famine (1845–1847) being rowed out to the large sailing ship that is waiting to take them to their new homes in England, America, or elsewhere—the last time many of them would ever see their native land.*

struck so much of the population when their dietary staple first failed in the summer of 1845, and many realized that starvation and destruction lay ahead. Another Cork artist capable of touching the heartstrings was James Brenan (1837–1907), who was also well-known as a teacher. His *Letter from America* is a poignant reminder of how important it was for family members separated by the Atlantic to keep in contact with one another, the picture showing a young girl—apparently the only literate member of the family back home—reading a letter from a relative who was writing from America. How the letter-writer may have crossed the Atlantic is evoked by the maritime artist Edwin Hayes (1820–1904), whose *Emigrant Ship, Dublin Bay* is a fine rendering of the sad scene of emigrants being rowed out to the boat that will take them far away—most likely to America, via Liverpool—as the sky is aglow after a summer sunset.

Nineteenth-century portrait painting in Ireland was practiced by some gifted artists whose reputations only rarely reached beyond the shores of Ireland. Richard Rothwell (1800–1868), born in Athlone, was known outside of Ireland, however, because of his rather staid 1841 portrait of Mary Wollstonecroft Shelley, author of the terror-novel *Frankenstein*. Though this is his only well-known work, a number of others, mostly of the Macaulay family—including the romantic depiction of Anna Macaulay—

are in the Ulster Museum in Belfast. Dublin's leading portrait painter of the first half of the century was Martin Cregan, whose dates (1788–1870) show that his main work was completed before the time of the famine, though, like many other contemporary painters, he executed portraits that would not have reflected the terrible hunger that was affecting so many of his countrymen.

An almost exact contemporary of Cregan's was William Mulready (1786–1863), who left Ireland at the age of five, achieved his success in England, and was not even particularly proud of his Irish nationality. Mulready came from Ennis in County Clare, a few miles from Corofin, the birthplace of one of the best mid-century painters, Frederick William Burton (1816–1900), whose interest in Irish history and legend is not surprising, as he was a cousin of the William Burton (Conyngham), mentioned above as having inspired the Hibernian Antiquarian Society in 1779. Frederick Burton never painted in oils, concentrating instead on watercolors, like the antiquarian George Petrie, whose work Burton undoubtedly admired. Burton visited the West of Ireland shortly before the famine and painted a good subject picture entitled *Blind Girl at the*

ABOVE: *Frederick William Burton (1816–1900), born in Corofin, County Clare, was to become director of the National Gallery in London in later years. Together with his friend, the antiquarian George Petrie, he was one of the first artists to be captivated by the light and charm of the West of Ireland. On their trip to Connemara in 1839, Burton collected material for a painting that—after many trial sketches in pen and pencil—turned out to be the harrowing* Aran Fisherman's Drowned Child, *now in the National Gallery in Dublin. The mother bends low in grief, stroking the hair of her drowned daughter, as the puzzled father peers querulously at the artist coming through the door to pay his respects in the small cabin largely filled with keening women. The poignant scene, demonstrating Burton's sympathy and sensitivity, can scarcely have been inspired by some Aran experience the artist may have had, as he does not appear to have visited the islands until about twenty years after he painted the picture.*

Holy Well, and even more haunting is his remarkable *Aran Fisherman's Drowned Child* in the National Gallery. In the 1840s, he concentrated on portraiture, even executing the occasional miniature. The 1850s were spent largely in southern Germany, and after that Burton lived most of the time in England, where he became director of the National Gallery in London and befriended the Pre-Raphaelites, particularly Burne-Jones. It was the combination of his Bavarian experience with his Pre-Raphaelite connection that led to the creation of his most famous work, the romantic, emotional, and highly colorful *Hellelil and Hildebrand: The Meeting on the Turret Stairs,* which illustrated a Danish ballad that was translated for him by his great Celtic scholar friend Whitley Stokes, and which must have fueled his fascination for the Middle Ages, which was such a part of the High Victorian Gothic experience.

Probably the most notable émigré artist of the second and third quarters of the century was Daniel Maclise (1806–1870). He was only twenty-one when he went to seek his artistic fortune in London, but he was clever enough to paint portraits of famous people of the period, making his name by depicting Sir Walter Scott and going on to portray Charles Dickens, Thomas Moore, and Niccolò Paganini. By the 1830s Maclise changed tack to paint historical and biblical scenes, the best-known of which is the enormous tableau of *The Marriage of Aoife and Strongbow* in the National Gallery of Ireland. Maclise was, at heart, an Irish nationalist and here he depicts the daughter of Dermot

ABOVE: *Daniel Maclise (1808–1870) was born in Cork and, after a period of portrait painting, his preference for subject pictures began to manifest itself in the 1830s, culminating in his history paintings for the Palace of Westminster from 1858 onward. But by then he had already completed in 1854 what must surely be the largest canvas ever painted in Ireland, the symbol-laden* Marriage of Aoife and Strongbow, *which occupies one whole end wall of a very long hall in the National Gallery of Ireland. It betrays Maclise's nationalist sympathies only half a dozen years after an Irish uprising against English domination. This is represented in the painting by the Norman baron Strongbow marrying Aoife, daughter of the king of Leinster, who had invited Strongbow over to regain his lost kingdom, but which was soon to lead to the Normans taking over three-quarters of the country, as the Irish lie dejected and as voiceless as the harp that has lost its strings.*

LEFT: *Like many of his generation, Walter Osborne (1859–1903) was drawn to the world of continental painting and, after a spell in the Dublin Society's art school, he went to study in Antwerp in the early 1880s, while at the same time paying many visits to England, all of which helped him to forge his own individual style. He was fascinated by people and their daily lives, up and down the social scale, and felt quite at home depicting the less well-off in his native city of Dublin, as in this picture,* A Scene in the Phoenix Park, *in the National Gallery featuring a group of people sitting on a bench under a tree in the park. It is a lovely study of light flickering through the leaves and shedding a ray of hope for the sitters who do not have much joy in their lives—the depressed mother reflecting on the difficulties of bringing up her children, and the two old men stoically living out their remaining years.*

McMurrough being given in marriage to the Norman baron Strongbow, who had been invited to come to Ireland to help Dermot regain his throne—with the result that the Normans and their English successors took over the country. The painting is full of symbolism—the native Irish are lying as corpses in the foreground, accompanied by the Irish harper whose instrument has been silenced by the removal of its strings. The Normans are clearly the victors as they take over Ireland in the person of the hapless Aoife, who is placed in front of a ruined Irish church and Round Tower stump, symbols of the ancient Ireland that had come to an end under Norman and English domination. Maclise's attention to detail and the beautiful finish of the painting are remarkable in what must be one of the largest Irish canvases ever painted. Yet his nationalist feelings did not prevent him taking on what was to be the crowning achievement of his career—the equally large-scale frescoes in the House of Lords in the Palace of Westminster, which he worked on in the years 1858–1865, but which sadly have not fared well over time. Maclise was never allowed finish the frescoes and, refusing proffered honors, withdrew from society and artistic life.

Irish painting in the second half of the nineteenth century was dominated by three separate painters representing three different styles that roughly equate to realism, impressionism, and postimpressionism, particularly as

practiced in France. The first of these was Nathaniel Hone (1831–1917), the realist, who worked with French painters of the style who believed that everyday life and its trappings should be the main subject of artistic endeavor. Commonplace scenes such as cows grazing, or the seascape around Malahide, County Dublin (where he lived for most of his later life), are beloved subjects among Hone's many canvases that were presented to the National Gallery in Dublin after his death. But he was also capable of depicting more dramatic moments, as in his *Off Lowestoft* in the National Gallery in Dublin. Hone was only one of the many Irish artists who went to France in their formative years to study and soak up the atmosphere of artistic development there—and it was French painting that was to be a major influence on the direction that Irish art was to take in the last quarter of the nineteenth century.

Frenchman Bastien-Lepage's movement to paint on the spot and out of doors in order to retain the freshness of the open-air experience influenced young Irish minds such as that of Frank O'Meara (1853–1888), a gifted County Carlow painter who died young, but not before painting some fine pensive studies, particularly of women in the landscape. Another who took the same path was the Dublin-born Aloysius O'Kelly (1853–c. 1941), who studied in Paris, went to Egypt, where he painted exotic desert canvases, and returned home to paint peasant scenes in the West of Ireland. The rediscovery in Scotland of a

BELOW: *After seventeen years of observing the artistic scene in France, Nathaniel Hone returned to his native Ireland in 1872 and settled down in north County Dublin, where he spent most of the rest of his life. There he largely tired of painting people and became almost exclusively a landscape artist, as well as being professor of Painting at the Royal Hibernian Academy from 1894 until his death in 1917. Living close to the sea, it stayed in his mind wherever he traveled. His depiction of waves gently lapping up against low cliffs is not site-specific—it could be anywhere—but in this instance, the canvas* —A View of the Coast (? of Clare), *now in the National Gallery of Ireland—may have been painted near Kilkee in County Clare.*

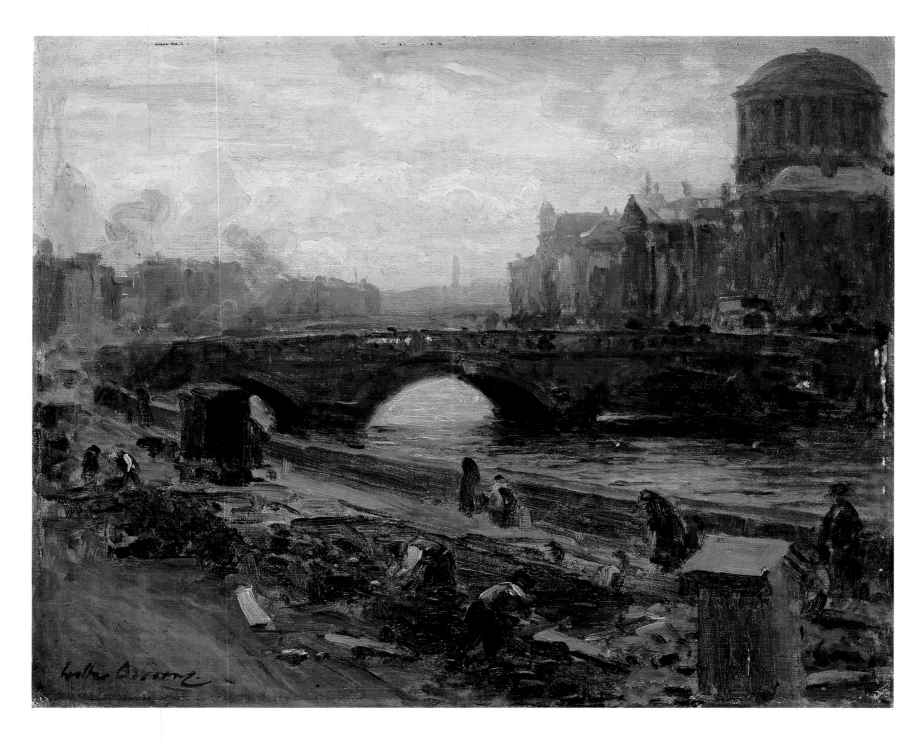

large canvas of *The Priest Saying Mass*, now displayed in the National Gallery of Ireland, has brought O'Kelly's name to the fore in the public eye. Most of his later work was done in the United States, as was also the case with Thomas Hovenden (1840–1895), who was born in Dunmanway, County Cork, studied in New York before going off to Paris (where he probably met O'Kelly), and later returned to the United States, where he taught in Pennsylvania. A gifted character painter who moved in the opposite direction was the American Howard Helmick (1845–1907), whose *News of the Land League* in the National Gallery of Ireland demonstrates his empathy with the Irish, among whom he lived for a decade around the 1880s.

Like Paris, Antwerp in Belgium was the other great center that attracted young Irish painters, one of the most noteworthy of whom was Walter Osborne (1859–1903). After his initial studies, Osborne went to and fro between Ireland and England, painting good open-air pictures dotted with human figures— including *A Scene in the Phoenix Park* in the National Gallery of Ireland,

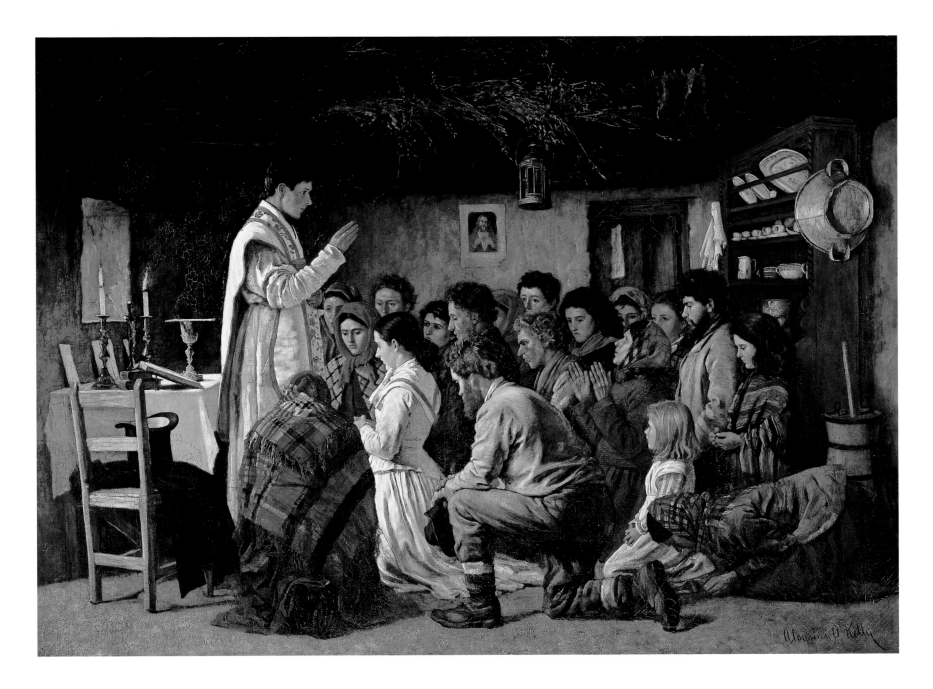

executed in comparatively dark colors, but with an interesting collection of young and old figures seated on a park bench amid light flickering through the leaves. He is one of the first Irish painters who played with the effect of light in his paintings, taking his cue from the French impressionists without following exactly in their footsteps. The French impressionist movement, which took discerning European and American collectors by storm in the last third of the nineteenth century, never really caught on in Ireland. Nor did the postimpressionism of Gauguin or Van Gogh, but a good friend of the former, and the only Irish painter to join the "international set," was Roderic O'Conor (1860–1940), Roscommon-based and Antwerp-trained. His work stands out because of his wonderful use of strong yet subtle colors bouncing off one another in juxtaposition, his landscapes giving an exotic French flavor, and his figure paintings a sensuousness that other Irish artists had not hitherto dared or aspired to achieve. While all of these outside influences, English or French, were having their effect on nineteenth-century Irish art, a movement was growing in the country that was to blossom late in the century and early in the century that followed.

ABOVE: *Aloysius O'Kelly (1853–c. 1941) has provided us with some of the liveliest crowd scenes in the West of Ireland Land War of 1880 in drawings that he published in* The Illustrated London News *of the time. Three years later he grouped more people together in a painting of a young priest giving his blessing after Mass—perhaps his first among better-off friends of the family— in a house that was obviously privileged by his visit. This large canvas,* Mass at Connemara Cabin, *was only recently rediscovered, and is now on loan to the National Gallery of Ireland from a presbytery in Edinburgh, where it hung, unrecognized, for a century.*

LEFT: Children Dancing at A Crossroads *by Trevor Fowler in the National Gallery depicts innocent entertainment by the younger generation. Boy and girl prance around barefoot to the music of a youthful instrumentalist in the background as others look on, awaiting their turn. It is a pleasant, if trite, subject—a popular peasant pastime— that was well painted in a lively fashion, with bright colors against a muted background, by an artist who flourished in the 1830s and 1840s, but whose work is rare and little-known because he died young.*

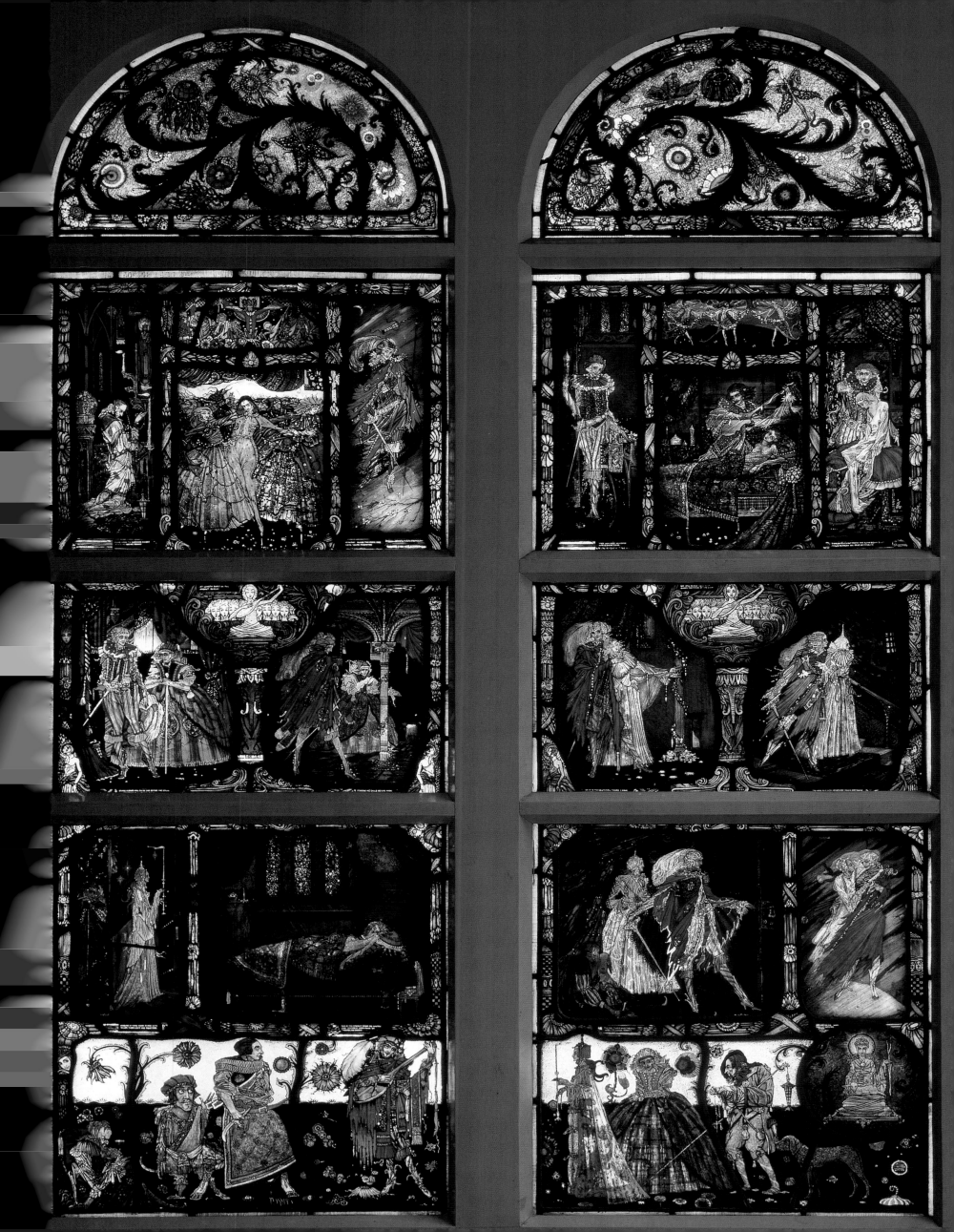

THE CELTIC REVIVAL

 ride in a national Irish identity reaches far back into the mists of the past, and has been engendered in literature for centuries. It was, however, not until the eighteenth century that it began to take on an organized form, when an English-speaking aristocracy (many belonging to families who, in time, "became more Irish than the Irish themselves") identified themselves with the glories of the Celtic past and set out to make people aware of Ireland's golden age of the pre-Norman monasteries. By the nineteenth century, the mantle of that vision was taken over by a largely Catholic middle class, many of whose immediate ancestors would have been Irish speakers, and who began to invest the nationalist notion with the goal of an Ireland free from English domination. The Catholic Emancipation Act of 1829, giving the majority population group the liberty to practice their religion openly, only reinforced the idea, which, initially, centered around the persona of "The Liberator" Daniel O'Connell, who wanted to achieve independence on the basis of parliamentary democracy. There were others—as there are today—who felt that independence could not be achieved without a military struggle. Even before the disastrous famine of 1845–1847, the widely read newspaper *The Nation* became the literary focus of the movement (one collection of pieces having a frontispiece by Frederick William Burton, mentioned previously).

The pen was the driving force in nineteenth-century Irish nationalism, but the pencil and the paintbrush were not far behind. Among the staff of the map-making Ordnance Survey, set up in 1824, were the eminent scholars John O'Donovan and Eugene O'Curry, whose expertise in the Irish language was to unlock the treasure trove of old Irish literature in the country's surviving medieval manuscripts. A close friend of theirs was George Petrie (1790–1866), whose essay on Irish Round Towers, published by the Royal Irish Academy in 1845, finally confirmed these tall structures to be a part of Ireland's Christian rather than pagan past. In the 1840s he wrote much in his *Irish Penny Journal* about Ireland's ancient monuments, illustrating his articles in many cases with his own drawings. For the Great Irish Exhibition held on Dublin's Leinster Lawn in 1853, High Crosses were brought for display from the locations where

ABOVE: *This settle in the National Museum in Dublin was made probably in Belfast around 1900 by Margaret E. G. Houston of the Decorative Arts Association. The high-backed seat could also be used to store bed linen beneath. On and in front of the seat are animal and interlace patterns clearly derived from manuscripts and metalwork from more than a millennium earlier, and the settle has groups of Irish words directed at its users:* Tosach Sláinte Scíth *("rest is the beginning of health") and, underneath the central figure,* Suan na Sídhe *("the rest of the fairies.")*

OPPOSITE: *Harry Clarke is widely known for his stained glass windows with religious subjects, but, in 1923, he happily took on a commission to do something totally different. This was for a pair of windows for a house in Dublin's Ailesbury Road owned by Harold Jacob. The windows Clarke produced, based on illustrations from John Keats's poem* The Eve of St. Agnes, *are an enthralling complement to the poem, reproducing its verbal magic in scintillating blues, reds, and yellows in a wonderful world of visual fantasy.*

ABOVE: *Lady Augusta Gregory (née Persse), who is seen here in a portrait of 1903 by John B. Yeats, combined with his poet son W. B. Yeats and Edward Martyn to initiate the Irish Theatre movement and, in 1904, she became a most useful director of the Abbey Theatre. Learning the Gaelic language in her widowhood, and collecting Irish folklore and writing some forty plays in her local Kiltartan dialect of English, she became an inspiration for the literary side of the Celtic Revival in the decades on either side of 1900. She made her house at Coole Park near Gort in County Galway into an important meeting place where authors and artists mingled freely and exchanged fruitful ideas with one another.*

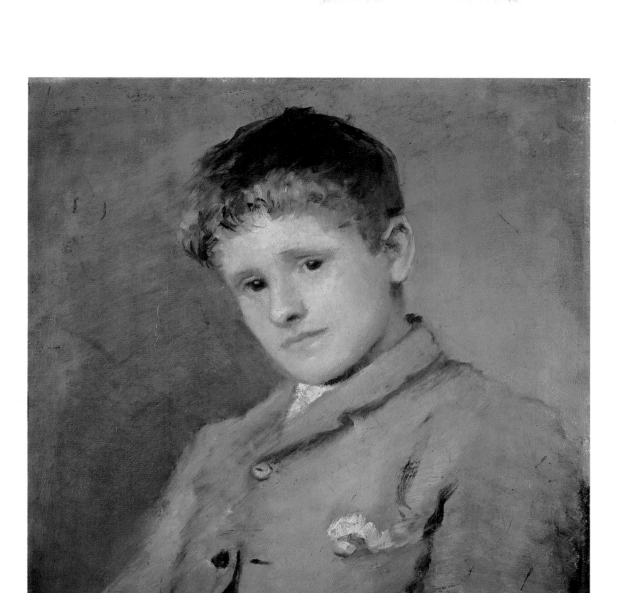

LEFT: *The artist John Butler Yeats (1839–1922) was father to two important figures in the Celtic Revival movement— the poet W. B. on the literary side, and Jack B. in the field of visual arts. His portrait of the latter,* Jack B. Yeats as A Boy, *now in the National Gallery, is one of the many pictorial records he made of people who played important roles in the Irish Renaissance. Jack B. was the designer of some important banners in Loughrea Cathedral illustrated at the end of this chapter.*

they had stood for centuries, and aroused considerable interest and imagination. Four years later, Henry O'Neill's large-format volume on High Crosses was doubtless one of the factors that made such crosses into models from which a myriad of gravestones were carved over the following century, and caused them to become one of the great symbols of nationalist Ireland, along with Petrie's Round Towers, the Irish wolfhound, and the shamrock. These, in turn, were to become the badges of being Irish on both sides of the Atlantic. The poet Sir Samuel Ferguson was to use motifs from the *Book of Kells* in the title page of his large-format book *The Cromlech on Howth* in 1861, and the architect W. H. Lynn was to build the first modern church in the ancient Irish style, complete with Round Tower, at Jordanstown, County Antrim, in 1865–1868. This was just before Daniel O'Connell's body was buried in Glasnevin cemetery under the country's tallest and most majestic Round Tower specially erected for the purpose. St. Patrick, though paradoxically a British immigrant, became the subject of nationalist sentiment in sculpture and stained glass windows around the country. Erin, the female embodiment of

ABOVE: *During the first half of the nineteenth century, a fashion for "archaeological jewelry" manifested itself throughout Europe, and Ireland had a plentiful store of ancient brooches which could be—and were—copied to satisfy the local demand, but also to pander to emerging nationalistic taste for reviving interest in old Celtic metalwork. One ninth-century brooch from County Cavan was imitated at the behest of the Provost and Senior Fellows of Trinity College, Dublin, to mark the visit of Queen Victoria to the college's famous library on August 7, 1849. Of Wicklow gold, and ornamented with a pearl surprisingly from Lough Eske in County Donegal, it was only about half the size of the original, and intended to be worn as a shawl pin. The queen kept it as an item of personal adornment for the rest of her life and, a year after her death in 1901, her son, Prince Arthur, presented the brooch to the National Museum in Dublin.*

Ireland, was portrayed in public monuments (commonly known as "Maid of Erin" statues), and even Queen Victoria was presented with a copy of an early medieval Irish brooch that had come from County Cavan.

The path had thus been well and truly prepared in the public mind for what is known as the Celtic Revival—a stimulating evocation and re-creation of the greatness of an earlier Ireland, the ultimate sign of Irish pride and self-confidence in the country's past and a gateway to an Irish present and future. Once again, it was the poets and playwrights who were to usher in this new phase in Ireland's cultural history, which was also bound up with the political aspiration for Irish freedom. The poet W. B. Yeats (1865–1939) drew on literary sources for his poems and plays, and to that Lady Gregory (1852–1932) added the local folklore of her native county, Galway—a source also used by John Millington Synge (1871–1909) on the Aran Islands. Many of these prominent people were to be portrayed by Yeats's father John B. The movement spawned the creation of a number of organizations that were designed to stimulate national pride: the Gaelic Athletic Association (1884); the Gaelic League (1894); the Irish Literary Theatre (1899); and, in the new century, Hugh Lane's Gallery of Modern Art, opened in 1908. This last was designed to complement the Old Masters displayed in the National Gallery, which had been founded in 1864, and to encourage Irish painting with new ideas derived from the best of European art, which Lane had diligently been collecting and had shown in an influential exhibition in Dublin in 1904. Growing out of the Irish Literary Theatre, the Abbey Theatre—founded in 1904—was associated with Lady Gregory, assisted by the poet Yeats and Edward Martyn (1859–1923). Martyn was a key figure in the Celtic Revival, not only because he was involved in the setting up of the Literary Theatre (and had a play of his performed there in 1899), but also because he was the driving force behind the establishment of a native stained glass industry, which can arguably be seen as Ireland's most important collective contribution to European art of the twentieth century. Martyn was disgusted that so much money should be spent on imported church glass and believed strongly that Irish artists should be trained and employed to furnish stained glass to Irish churches. To this end, he enlisted an English specialist artist, A. E. Child, to come to Dublin, where, with the help of an influential civil servant, T. P. Gill, he was able to create a class as part of the School of Art in Dublin, which opened its doors in 1903. On the first of January of that same year, Sarah Purser (1848–1943), inspired no doubt by Martyn, opened a cooperative studio known as *An Túr Gloine* (The Tower of Glass), which was to

continue to produce stained glass of very high quality. Like a number of painters already discussed, Purser, too, had studied in Paris and had returned to her native land where her contribution to art was felt most in her organizational ability in running *An Túr Gloine*, assisting Hugh Lane to set up his gallery of modern art, founding the Friends of the National Collections in 1924 to press for the return of Lane's pictures from London after his tragic death in the *Lusitania* disaster of 1915, and getting the government to set up the municipal gallery that now bears his name. Martyn had already hired Child and his teacher, Christopher Whall, to design windows for his own local church at Labane, not far from his home at Tullira in County Galway, and, more importantly, got the local bishop and clergy interested in giving commissions to *An Túr Gloine* for the windows for Loughrea Cathedral, which had been in construction since 1897. It may have taken fifty years to assemble the glass now seen in the cathedral, but it represents the showcase for the studio's work and, with the exception of Wilhelmine Geddes, displays all the Irish artists who worked for it, including Sarah Purser herself. Michael Healy (1873–1941) was one of the artists represented most prominently in the cathedral's windows, and his three-light *Ascension* and *Last Judgment* windows must be judged to be the climax of his output. Another contributor was the great female artist Evie Hone (1894–1955), whose rose window (1950) was one of the last windows to be inserted.

Independently of *An Túr Gloine*, there was one other major artist working in stained glass during the same period whose quality is of the highest and coloring superb. Harry Clarke (1889–1931), arguably Ireland's greatest artist of the twentieth century, studied under Child in the Dublin Art Schools, but he already had stained glass in the family, as his father Joshua had been supplying church glass for some decades before Harry joined the firm. Clarke had visited the Aran Islands with Seán Keating in 1914, but it was Aubrey Beardsley and a visit to Chartres Cathedral that were his guiding lights. That famous French cathedral encouraged him to turn to the use of reds and blues as the backgrounds for his figures, who have incredibly fine detailing in their clothes and skin. His first major commission came through Sir John O'Connell for the Honan Hostel Chapel attached to the university in Cork. When Clarke presented the design for one window, he made such an

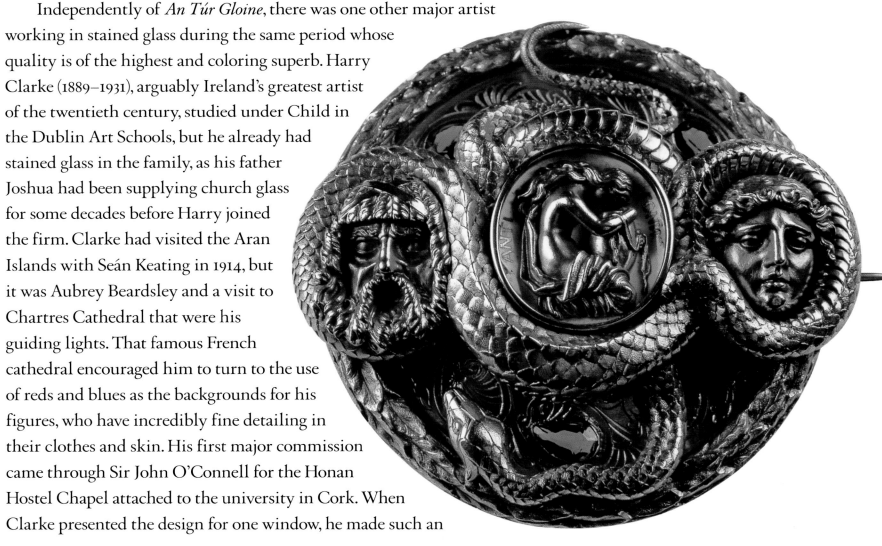

BELOW: *One of the Dublin craftsmen who contributed greatly to the revival of Celtic-style Irish metalwork in the middle third of the nineteenth century was Edmond Johnson, who worked for the Dublin jewelers West and Son, and whose products formed the centerpiece of a Celtic Revival exhibition in the Smart Museum in the University of Chicago in 1992. But this high-relief brooch of 1846–1847 in the National Museum shows how he had earlier excelled in reviving Greek sculpture. Made of Wicklow gold with emeralds, this brooch was a gift to the actress Helen Faucit for her portrayal of Antigone, who forms the center and right of the brooch, with the Greek heroine's brother Creon on the left, and all enmeshed by a serpent representing Cadmus, the founder of Thebes. The name "Burton Brooch" comes from its designer, Frederick William Burton.*

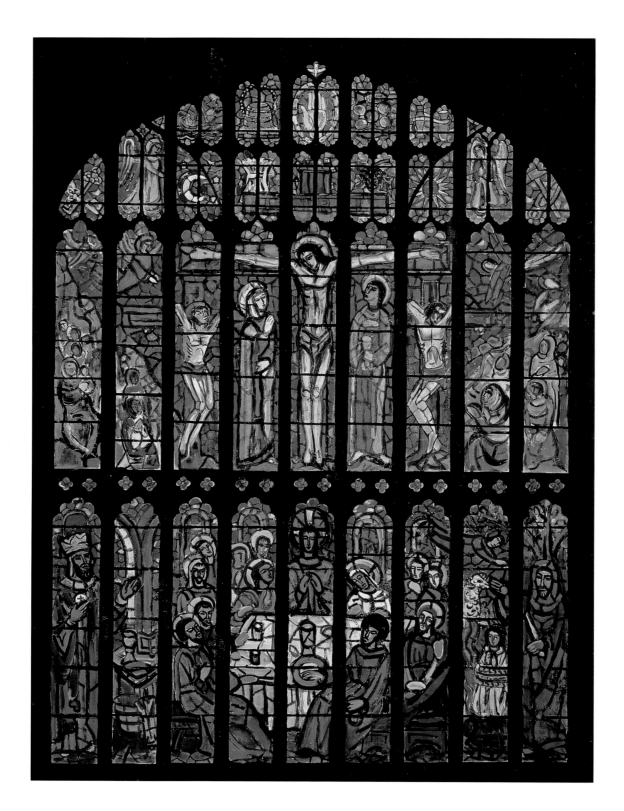

impression that he was given the commission to supply all eleven windows in a church that turned out to be one of the other great showpieces of the stained glass of the Arts and Crafts movement. Clarke's other major collections are in Ballinrobe, County Mayo, and Belcamp in North Dublin, the figures of saints usually the main item, with charming vignettes beneath. Before executing his windows, Clarke steeped himself in the subject he was to paint, and each window—and any accompanying vignettes—contain many details that are, almost subliminally, worked into the overall design. One of his masterpieces is *Crucifixion and the Adoration of the Cross by the Saints* in the Catholic parish church in the Dublin suburb of Terenure, and another is his last window, *The Last Judgment* in Newport, County Mayo, which is full of strange creatures that are products of his weird imagination and sexual innuendo after 1925. In his

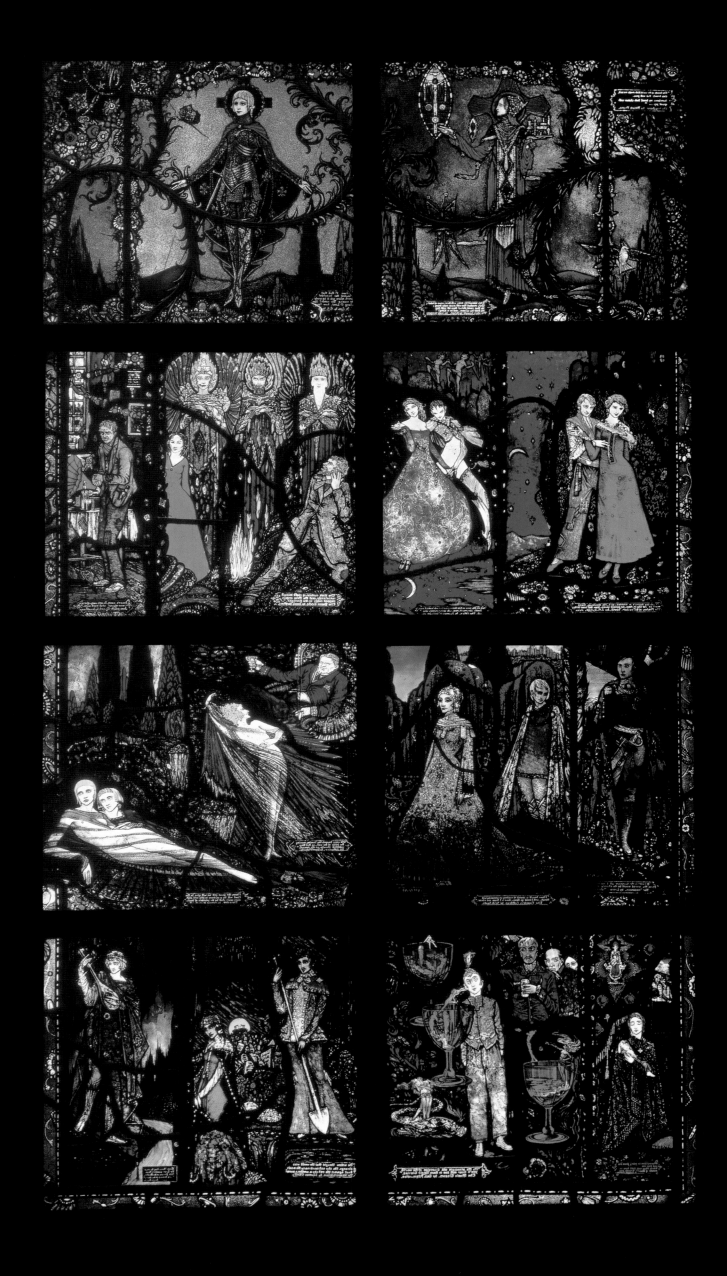

RIGHT AND OPPOSITE: *Loughrea Cathedral in County Galway was where the seed was sown for the beginnings of* An Túr Gloine *(The Tower of Glass), a stained glass studio founded in 1903 that was to make many remarkable contributions to the revival of Celtic styles in Irish art during the first half of the twentieth century. The largest collection of windows in the cathedral came from Michael Healy (1873–1941), who helped to adorn it over a period of almost forty years. Among his early works there is the attractive Rose Window of 1907 illustrating the Holy Family at the center of half a dozen angels. But more dazzling is the* Regina Coeli *window of 1932 that was commissioned by an American bishop of Concordia, whose mother came from Loughrea. Described recently by David Caron as a "symphony of blue and pink," this window of Mary, Queen of Heaven, has her wearing a brilliantly worked robe that masterly aciding techniques have turned into a sea of abstract ornament.*

final years, Clarke was greatly disappointed when what is arguably his most magical window—intended for the International Labour Court in Geneva—was not accepted by the conservative Irish government at the time, as its contents, with illustrations of the works of various Irish authors of the period—Yeats, Joyce, O'Flaherty, O'Casey, Pearse, and others—were irreconcilable with the image of Ireland that political authorities wanted to promote. The window languished in Dublin for years until it was bought by Mitchell Wolfson, in whose institute it now resides at the University of Florida. It is a sad reflection that Ireland was not prepared to recognize this genial prophet in his own land, but Ireland's loss is America's gain. It should be mentioned that Clarke's talent for complicated yet brilliant design, sometimes with the most macabre of details, reveals itself in his illustrations for books, including works of Edgar Allan Poe and an English translation of Goethe's *Faust*.

Stained glass is a medium in which Irish women artists have been able to excel during the twentieth century, and *An Túr Gloine* included many of them. Mention has already been made of Evie Hone (1894–1955), whose design and coloring won for her the contract for the great window of Eton College in England (1949–1952), which is widely regarded as her masterpiece. But she also succeeds at a much smaller scale, as at Kingscourt in County Cavan, or in the Jesuit Manresa House in the Dublin suburb of Dollymount. Wilhelmine Geddes (1887–1952) was something of an independent spirit within *An Túr*

Gloine and a great admirer of Sarah Purser. She often worked in England, and her reputation led to her making the Duke of Connaught's War Memorial window of 1919 in Ottawa. Other women involved were Beatrice Elvery (later Lady Glenavy), Catherine O'Brien from County Clare, and Ethel Rhind, who also produced the *opus sectile* stations of the cross in Loughrea Cathedral. The last major window to be inserted in that cathedral was the St. Brigid of 1957 by Patrick Pye (b. 1929), who is still working in the medium, demonstrating that stained glass remains very much a vibrant art form in Ireland. Patrick Pollen produced some fine glass for the Catholic church in the Dublin suburb of Ballinteer, and also for the church of St. Michael in Ballinasloe, County Galway. More recently, the Cork artists James Scanlan and Maud Cotter have been making some very attractive abstract glass, and George Walsh has been producing many notable windows that make the Catholic church at Johnstown, County Meath, look like a lantern in full color.

Other treasures in Loughrea Cathedral include the embroidered banners produced by the Dun Emer Guild. This organization was formed by three women in 1902 (only a few months before *An Túr Gloine* was founded)—Evelyn Gleeson and the sisters Elizabeth and Lily Yeats. Gleeson was born in England to an Irish father, and after training with disciples of William Morris and becoming friends with members of the English Arts and Crafts Society, she yearned to return to Ireland. There she met the two Yeats sisters, who, like herself, appreciated beautiful things and wanted Irish girls to produce them using Irish materials—wool for tapestries and carpets, linen on which to embroider, and paper for books. Their work was to be in the spirit and tradition of the country, and all three set to work on a shoestring (or, to be more precise, on borrowed capital) to produce a variety of craft items, including tapestries, some of which had been designed by the sisters' brother, the painter Jack B. Yeats, and his wife. In single broad swathes of color, they show various Irish saints in a heroic light. The Dun Emer Guild also produced the cope and altar antependium for the Honan Chapel in Cork, that great Celtic Revival monument mentioned above. (The Honan Chapel vestments were made by Barry Egan in Cork after designs by Ethel Josephine Scally, who died in 1915.) The guild also spread its wings across the Atlantic, where it found a fan in Monsignor Rogers in the church of St. Patrick in San Francisco, who ordered vestments for his parish. The Dun Emer Guild also produced metalwork, including a fine tabernacle door by Oswald Reeves for the Honan Chapel, and the same church has candlesticks designed by the architect W. A. Scott, who had done metalwork and woodwork designs for Loughrea Cathedral. However the finest metalwork of the Irish Arts and Crafts movement was provided by Mia Cranwill (1880–1972), whose parents had come to Ireland from St. Louis, Missouri. Her finest work is the gold, silver, and enamel tabernacle she created in 1926 for St. Michael's in

Ballinasloe, and she also provided Monsignor Rogers with furnishings for his church in San Francisco. The strong personalities of the three leading ladies of the guild led inexorably to its breakup, though each went on to produce fine work independently of one another. Evelyn Gleeson retained the name Dun Emer and the business of weaving tapestries, binding books, and working on enamels, while the Yeats sisters took over the printing end of the guild and reopened as the Cuala Press, which was to print many of the poems of their brother William Butler and the early broadsides of their artist brother Jack B. Meanwhile, the Arts and Crafts movement continued to hold exhibitions, Harry Clarke designing the cover for the 1917 exhibition catalog.

Before the Celtic Revival ran out of steam, it produced two more very different expressions of ancient Celtic ornament in a modern context. The first was a chapel of Dominican nuns in Dun Laoghaire, which was ornamented with interlace and animal designs inspired by, but not copied from, those of the first Christian millennium—all done by one person, Sister Concepta Lynch (1874–1939), who took from 1920 until 1936 to complete her remarkable work. The second astounding late expression of the movement by a single individual was the *Book of Resurrection*, commissioned in 1922 by the fledgling Irish State to celebrate independence. It was executed by Art O'Murnaghan, a solitary genius who died before he completed this extraordinary combination of *Book of Kells*–style decoration with touches of art nouveau and oriental mysticism— his was a mind that must have been able to function like those of the creators of the Kells manuscript over a thousand years earlier.

BELOW: *The building and furnishing of Loughrea Cathedral brought out many Arts and Crafts skills in the Celtic Revival—stained glass, sculpture, metalwork, and embroidered banners. Twenty-four banners were commissioned from the Dun Emer Guild, a group of craft ladies who named their Dublin base after the protected home of the wife of the mythical hero CúChulainn, famed for her skill in weaving and embroidery. The banners were designed by the painter Jack Yeats and his wife Mary Cottenham and embroidered in strong colors in silk and wool on linen by Jack's sister Lily in 1902–1903. Each illustrates an Irish saint, some identified by his or her name in Gaelic script and language—including St. Patrick banishing the snakes from Ireland, and St. Brendan navigating his boat..*

OPPOSITE *Mia Cranwill (1880–1972) was probably born in Ireland to parents who had come to the country from St. Louis, Missouri. Her career in metalwork started around 1917, and the political events going on around her at the time made her into an ardent nationalist, which suited her artistic leanings to the Celtic Revival element in the Irish Arts and Crafts movement. Born a Protestant who later became an agnostic, her best work was for the Catholic church of St. Michael in Ballinasloe, County Galway, a tabernacle that stands in the front rank of products from the Celtic Revival. Made of gold, silver, and enamel in 1926, its centerpiece is Christ appearing to the apostles at Emmaus, against the background of a partially obscured cross in a rectangular frame decorated with Cranwill's own personal adaptation of Early Christian manuscript and metalwork motifs.*

THE TWENTIETH CENTURY

The painter Jack B. Yeats (1871–1957) stands out as the great Irish artist of the first half of the twentieth century. During his lifetime, he witnessed his country go through many of the traumatic political events that led to the creation of the Ireland we know today. Yeats's early years in Sligo saw agrarian agitation, with the peasants' efforts to gain ownership of the land they tilled leading to an easing of their plight with various Land Acts. The Celtic Revival expressed in various artistic media had already been spearheaded by an analogous literary movement, both leading to ideas of home rule that had almost been accomplished by Charles Stewart Parnell. Ireland was on the brink of achieving that objective when it was halted by the advent of the First World War. Frustrated, the Irish took advantage of England's participation in the war and rose up in insurrection in 1916. The execution of the leaders of that uprising created martyrs whose death rallied many who had been skeptical of this republican movement, leading to the creation of a new Irish Parliament in 1919. The majority of people in the northern province of Ulster forcibly expressed their disapproval of this new secessionist movement, as they were staunchly in favor of retaining the region's participation in the United Kingdom. Negotiations between London and Dublin led to a treaty in 1921 that offered the other three provinces a Free State, leaving Ulster as part of the British Empire. The question of whether the Treaty should be accepted or rejected was one that split the country into two violently opposed camps, whose animosity was fought out in a bitter and bloody civil war, ending finally with the acceptance of the Treaty. It has taken a long time for the country to shake off the mental shackles of that conflict, but the twenty-six counties outside Ulster were set up into a Free State that was ideologically Celtic, yet economically conservative and largely antagonistic to the British. This distrust was to decline after the Republic was declared in 1949, but the poet Yeats, whose idealism had helped to bring this about, did not live to see its creation, nor to experience the rise of an industrialized Ireland in the 1960s, its Europeanization in joining what was then the Common Market in 1972, and its pluralist globalization that we see today.

ABOVE: *Jack B. Yeats thrills us with his strong blues and yellows in his later years, when his oils become more elusive in their details—yet one senses a deep undisclosed meaning to be present in each of them.* On Through the Silent Lands, *painted in 1951 and now in the Ulster Museum, Belfast, shows a large figure in the foreground walking resolutely toward a flimsy bridge His biographer, Hilary Pyle, suggested the title was from Christina Rossetti's poem "Remember," which echoes an analogous theme: "Remember me when I am gone away,/Gone far away to the silent land."*

OPPOSITE: *William Orpen (1878–1931) was an influential teacher, and a very fine artist. An exciting portraitist, he conveyed the atmosphere of the easygoing life of those halcyon days before World War I that he himself enjoyed during sojourns on the Hill of Howth, north of Dublin Bay. The man and woman in this painting—probably the artist and his wife, Grace Knewstub—are reclining, relaxing, and, as the title of the canvas says,* Looking Out to Sea. *With time on their hands, the pair would seem to embody the pithy Italian phrase* Dolce far niente *("It is sweet to do nothing").*

Jack B. Yeats (1871–1957) was a colossus in the world of Irish art during the first half of the twentieth century. In the earlier part of his artistic career, he drew and painted strong pictures of individuals he had come across in his travels through the Irish countryside. In 1913, Canon J. O. Hanney (the novelist, better known under his pseudonym George A. Bermingham) commissioned Yeats to paint a series of portraits depicting members of representational professions for a book entitled Irishmen All *that was published in 1913. The illustration for chapter 10 was this priest, who may have been modeled on a friend of the artist's who was a Church of Ireland clergyman. The 1913 painting, titled* A Cleric, *which now hangs in the National Gallery in Dublin, has the bony-faced behatted priest dominating the whole picture, conscious of his role and destiny as he strides along a seaside village street probably somewhere in the West of Ireland.*

Jack B. Yeats's early work, often in black and white, expresses the same simple heroism felt, for instance, in the Dun Emer Guild banners. Yeats used as his medium the world of sport and rural life in the West of Ireland. He created gentle heroes out of those he saw in the Irish countryside, making the marginalized take center stage and portraying them proudly as his own people. Yeats was a nationalist in his ideals without setting out to create a nationalistic art, and saw the best in Irish country life, acting as a counterbalance to his more suave contemporary, William Orpen (to be mentioned below). Yeats's enthusiasm for the rough-and-tumble of Irish life was expressed in his

drawings for J. M. Synge's books on Wicklow and the Aran Islands, and, in his own way, he thereby contributed to the Celtic Revival without really having been part of it. Even though he did not take up art seriously until he was about thirty, Yeats's talent was quickly recognized by Sir Hugh Lane, who exhibited his work in the great exhibition mounted in the Guildhall in London in 1904 that was designed to show off the best in modern Irish painting, and where Yeats was described as "the most distinctively Irish painter." Around 1905, Yeats changed over from watercolors to oils and became clearly affected by the events leading up to and after the 1916 Rising.

As the country settled down to an uneasy calm and humdrum life after the civil war in the mid-1920s, Yeats started to use primary colors more liberally. A meeting with the Austrian artist Oskar Kokoschka in 1928–1929 inspired him to squeeze more paint from a tube onto the canvas, leading to a period of remarkable color, at first with red tinges in the 1930s and then, at the age of seventy, he turned to yellows and blues to create a hazy and expressionistic world half-seen—a kind of Indian summer—full of equine nostalgia, movement, and drama. Yeats stands alone, a master of the brush and palette, and a member of what is arguably the most artistically influential and talented family Ireland has ever produced, including his gifted sisters of the

BELOW: *Jack B. Yeats cannot be said to have any one particular theme running through his paintings, which tend on the whole to record a scene rather than be portraits of individuals as such. If there be a story behind a picture, it is up to the viewer to seek it out, as Yeats rarely gave any clue as to what his pictures were about, and we are left with a cryptic title to fathom the master's intent. In this painting,* No Flowers, *of 1945, now in the National Gallery in Dublin, he seizes on a moment when a man who has come without flowers to a cemetery picks up a small branch and scatters its leaves on a newly dug grave. Behind him is the way he came and the route he must follow on his return, with brightness between the evergreens on the left and the deciduous trees on the right—the balance between a long and short life, perhaps, both of which will lead inevitably to the grave in the end.*

RIGHT: *John Lavery (1856–1941), born in Belfast and raised in Glasgow, was one of the most successful Irish portrait painters in the decades on either side of 1900. His ladies are full of the draped elegance of the time, and none more so than his American-born second wife, Hazel Martyn, whose tall, svelte beauty continued to captivate him so much that he painted her many times during their married life. One of the best in the series is* The Green Coat *of 1926 (Ulster Museum, Belfast), the light shimmering on her shoulders and dress, and her graceful body reflected in the mirror behind. The following year, he made her into the most famous American-Irish woman of the century by having his portrait of her representing Cathleen Ní Houlihan—the embodiment of Ireland—printed on Irish bank notes, and even acting as their watermark from 1927 to 1975.*

Dun Emer Guild and his brother William Butler, who went on to win a
Nobel Prize for Literature—all children of the artist John Butler Yeats, who
has left us a series of remarkable portraits, including some of his own family.

Jack B. Yeats had neither followers nor imitators (which would have been
difficult given his own very individualistic style), but he had many
contemporaries who painted in very different modes, sometimes nationalistic,
other times just conventional. One who stands above the norm is John Lavery
(1856–1941), whose visit to Grez in France in 1882 brought forth some of his best
work, including *Under the Cherry Tree* in the Ulster Museum in Belfast, which
demonstrates his mastery of light and water, a combination that frequently
recurs in paintings illustrating his sojourns in France and North Africa. After
1898, when he received the commission to paint Queen Victoria's visit to
Glasgow (where he had worked), Lavery moved in exalted, if not necessarily
always aristocratic, circles and, with the dawn of the new century, got frequent
requests for portraits. His favorite sitter was his second wife, Hazel Martyn, a
beautiful American lady whom he immortalized by portraying her as
Cathleen Ní Houlihan for the Irish bank notes, on which her image was
retained in the form of the watermark until 1975. Lavery came into contact
with many of the important political figures of his day when his wife made

ABOVE: *Mildred Anne Butler (1858–1941)
lived in idyllic surroundings at Kilmurry in
rural Kilkenny, where her watercolors exude
a world of ease, an unhurried life of beauty
and tranquility in a countryside setting.
A simple garden such as this,* The Lilac
Phlox, *now in the National Gallery in
Dublin, is made into a sea of color, each
plant carefully placed in an orderly
composition that is a joy to behold.*

ABOVE: *Paul Henry (1876–1958) was the quintessential artistic image-maker for the West of Ireland, showing us a rural Ireland of simplicity and hard work for the inhabitants, but also of puffy clouds that cover the sky like billows of smoke, as in this* Connemara Cottages *of 1926–1927, now in the National Gallery of Ireland. His "props"—thatched cottages, turf stacks, and an open, often treeless, landscape of bog or lake—are represented with endless variations in his works over a number of decades. They appeal for their freshness, creating a wonderful world apart, idealizing a clean and uncomplicated style of living and having strong swathes of juxtaposed blocks of color making the landscape lively and vibrant.*

their home in London a meeting place for both sides involved in the Treaty negotiations in 1921. This gave Lavery the opportunity to paint many of the events and personalities of the period, culminating in a portrait of the couple's hero, Michael Collins, lying in state, accompanied on the canvas by the words "Love of Ireland."

Lavery spent some time as an official artist during the First World War, as did William Orpen (1878–1931), who was also a fine portrait painter, among other things. Like Lavery's depictions of his wife Hazel, Orpen's portrait of his American mistress, Mrs. St. George, is a wonderful evocation of the fashion elegance of the last days of that halcyon world that was irrevocably shattered with the outbreak of war in 1914. Following the latest trends in England, Orpen portrayed Irish life and the desire of the Irish upper classes to be seen in gorgeous languid dresses—a far cry from the earthy peasants whose zest for life Yeats was characterizing at about the same time.

Though Orpen's world crumbled around him as the war progressed, he put much of his energy into teaching, and his influence as an academic painter was felt in Ireland for more than a generation after his death in 1931. His sympathies lay much more with England after the Treaty was signed in 1921, and he passed on his technique more than his politics to his pupils, who were more inclined toward the nationalist cause—Seán Keating (1889–1978), Leo Whelan (1892–1956), James Sleator (1889–1950), and Patrick Tuohy (1894–1923). Keating went to the Aran Islands (with Harry Clarke) in 1914 and created out of them a heroic, patriotic image. Some of his best work was done at the end of the 1920s, when—as a "socialist-realist"—he portrayed the building of the giant electricity power station on the Shannon at Ardnacrusha, expressing his faith in this giant leap forward in the early industrialization of Ireland. Tuohy, one-handed, was a gifted painter, his talent exuding the immediacy of the impatient-looking Stanislaus Joyce (father of James), now in the University Library in Buffalo. Another fine artist who portrayed many of the major figures of Irish society in charcoal sketches of the 1930s and 1940s was Sean O'Sullivan (1906–1964).

Keating was, however, not the first to discover the artistic romance of the western islands. Four years before he went to Aran, the Belfast-born painter Paul Henry (1876–1958) visited another western island, namely Achill in

BELOW: *Among the interesting collection of Irish paintings displayed in Dublin's plush Merrion Hotel is a Paul Henry entitled* Fishermen on the Beach, *depicting two men mending their nets prior to going fishing in the currach in the background. The currach is a boat made of canvas laid over a wooden frame and then tarred, and is a craft that is extremely maneuverable even in the stormiest of seas, as anyone who has seen the film* Man of Aran *knows. Henry uses it as a vessel to symbolize man's struggle against nature, and his conquest of the sea in the timeless and immemorial lifestyle of the West of Ireland, which he recorded before it disappeared.*

County Mayo, where a fortnight's holiday led to a nine-year stay during which he created a whole new idealized world that so hauntingly embodied a rural idyll of the West of Ireland that the Luxembourg in Paris snapped up one of his paintings at an international exhibition there. British Rail produced colorful posters that included his paintings, which prompted many travelers to take railway trips to the West of Ireland. At first, Henry placed one or more strong figures in a simplified landscape—a few basic elements (mountains, turf stacks, and the inevitable thatched cottage) all painted in large areas of color massed against one another, as in *The Potato Digger* in the Ulster Museum in Belfast. Later, he tended to omit the figures and concentrate on the landscape, sometimes in an almost monochrome image, following the fashion of Whistler, who, together with the French artists Millet and Daumier, were his major inspiration. In his early years, he was also a remarkable portraitist, as a recent Dublin exhibition revealed. His landscapes were not designed to create, or re-create, a heroic Ireland, but rather to show the real Ireland, as he saw it. Henry's Ireland was a land full of pale and puffy cumulus clouds that became more fluffy as his career progressed and a landscape occasionally punctuated by gnarled trees blown sideways in Atlantic gales reminiscent of Japanese woodcuts. Others who were to paint, and to a certain extent idealize, the West of Ireland were Charles Lamb (1893–1964) and Maurice McGonigal (1900–1979).

The Paris of the fin de siècle enthralled Paul Henry and many others, and its later cubism was to be an inspiration to some fine Irish female painters, Mainie Jellett (1897–1944) and Evie Hone (whom we have already encountered), who tried—though not with great success—to introduce Ireland to the latest modern movement in Paris. They were only two of a host of talented women

painters of their generation, which included Sarah Cecilia Harrison (1864–1941), an admirer of Sir Hugh Lane whose portrait she painted; Mildred Anne Butler (1858–1941), whose rural watercolors are a delight; May Guinness (1863–1955); Rose Barton (1865–1929); and Estelle Solomons (1882–1968). One of the most versatile was Mary Swanzy (1882–1978), who successfully changed her style many times over during her lifetime, rather than sticking to one particular mode of expression. Though not a painter, the designer Eileen Gray was one who went to France and stayed there, producing a remarkable body of furniture in a modern idiom that is now honored by a special permanent display in the Collins Barracks section of the National Museum of Ireland.

Other painters worth mentioning here are John Luke (1906–1975), who hailed from Ulster, William Conor (1884–1968), James Humbert Craig (1877–1944), and Frank McKelvey (1895–1974). Another fine artist of the same generation was William John Leech (1881–1968), best known in Ireland for his *A Convent Garden, Brittany* in the National Gallery in Dublin—a charming evocation of light and elegant serenity in natural surroundings—but his influence on Irish painting was small because he emigrated to England not long after the completion of his studies under Osborne at the Royal Hibernian Academy.

BELOW: *Mainie Jellett (1897–1944) was a groundbreaker in Irish art. Having gone to Paris with Evie Hone in the early 1920s to study the latest developments, she returned as the harbinger of a new, Cubist style, which, even if it did not catch on in conservative Ireland, was nevertheless the first swallow in a Modernist summer that was to introduce a novel element of abstraction. This is seen here in her* The Virgin of Eire *in the National Gallery, which dates from 1943, and in which she revolutionizes old religious themes into new exciting shapes within an Irish context and gives a fresh impulse with strong and vibrant colors that would culminate that same year in the breakthrough that was the first Irish Exhibition of Living Art.*

J. LUKE, 1944.

ABOVE: *The reputation of the Belfast artist John Luke (1906–1975) has come on in leaps and bounds in recent years because of the poetic and lyrical quality of his tempera paintings, which have a surrealistic, almost otherworldly, character to them. His* The Road to the West *(1944) has a less earthy and more ethereal quality than what we would expect from a similar scene by Paul Henry, and his sense of rhythmic movement in the undulating terrain, curving lines of roads and fields, and the buildup of masses from turf stacks to mountains, is impressive enough by itself without the addition of his often brilliant dreamland colors.*

OPPOSITE: *The art of portrait painting— good portrait painting—was one that has not too often been achieved successfully in the second half of twentieth-century Ireland, but one of its undoubted masters was Edward McGuire (1932–1986), who surrounded his sitters with striking and unexpected settings. Birds pop out of foliage in the window behind* Seamus Heaney *(Ulster Museum, Belfast), where horizontals and verticals converge around the solid form and face of the relaxed and congenial poet, who was awarded the Nobel Prize for Literature in 1995.*

That academy had become rather conservative by the Second World War, and when a modernistic painting by the young Louis Le Brocquy was rejected for the annual exhibition in 1942, he and his mother, supported by Mainie Jellett, Evie Hone, and Norah McGuinness (1903–1980), established the Irish Exhibition of Living Art the following year, so that budding artists would have an alternative showcase for their works. The new organization became a vital force in Irish art for the next two decades—though the annual exhibition of the Royal Hibernian Academy is now once more the main artistic event of the year, where the best of Irish art is displayed on an annual basis.

Norah McGuinness was a formidable artist who, like many of her friends, had studied in Paris. But the most important artist to emerge from the Living Art Exhibition was Louis Le Brocquy, mentioned above, who, in the 1950s and 1960s, developed his ethereal wraith-like figures in reds and whites and later went on to do fascinating heads of well-known figures alive and dead, which seem to emerge mysteriously from a background but yet give great insight into the nature of the (usually literary) figures portrayed. Another who produced masterly characterizations of major figures, again executed with great clarity and insight, was Edward McGuire (1932–1986). Belfast's answer to all of this Dublin-based activity was a group of talented artists—Gerard Dillon (1916–1971), Daniel O'Neill (1920–1974), Colin Midleton (1910–1983), and George Campbell (1917–1979)—the last of whom painted grey scenery in the West of Ireland and contrasting bright colors in

RIGHT: *Now the much-revered doyen of modern Irish painting, Louis Le Brocquy (b. 1916) was also one of the introducers of the Modern movement in Ireland way back in the 1940s. The rejection of two of his paintings for the annual Royal Hibernian Academy exhibition of 1942 was the catalyst for the alternative and competitive Irish Exhibition of Living Art, the first of many of which was held the following year. Here a stage was offered to artists of all hues and schools, and a whole new world was opened up. In this, Le Brocquy was to the fore, creating his own instantly recognizable style, which has gone through various stages, wraith-like figures, disembodied heads, processions, etc., all painted in a style that is intellectually stimulating and uplifting to behold. His penetrating re-creation of heads of the past and present includes that of the writer James Joyce (pictured here,* Images of James Joyce, *1977), who was the most internationally known of all the Irish authors of the twentieth century. His latest portrait is that of Bono, the lead singer of the U2 band.*

Andalusia, and whose humorous sketches, I am proud to say, illustrated the first edition of my *National Monuments Guidebook* in 1970!

The Irish painters of the second half of the twentieth century are a myriad of talented artists, but each so individual that it is difficult to characterize or group them. As it would be invidious to single out some and not others, it is perhaps best left to posterity to see which is going to make a lasting impression on the twenty-first century.

The shadow of solid neoclassical architecture at the end of Queen Victoria's reign hung over the early years of the twentieth century. This can be seen in two important building projects, one in each of the island's two major cities—the Belfast City Hall (1896–1906) by Sir Brumwell Thomas, and the former College of Science (now Government Buildings) in Dublin (1904–1913)

by Sir Ashton Webb and Thomas Deane. Both were designed to impress and to demonstrate reliability through their solid proportions. But the new century was also bringing fresh breezes from across the seas both east and west. The aptly named Sunlight Chambers on Dublin's quays (1899–1901) by Edward Ould brought the Mediterranean brightness of an Italian palazzo to a Liffey-side building decorated with a brightly colored frieze advertising the advantages of using (Sunlight) soap. From Central Europe came the fresh breath of art nouveau, which made a fleeting appearance in the Earl of Iveagh's social housing development to the north of Dublin's St. Patrick's Cathedral. From England came the noted architect Sir Edward Lutyens, whose imaginative scheme to locate Sir Hugh Lane's planned modern art gallery on a bridge spanning the river Liffey called forth sighs (like its Venetian progenitor) when it was found to be unacceptable, though he did design the all-too-little-visited National War Memorial Gardens farther up the river at Islandbridge.

America, too, was providing interesting architectural input during the first two decades of the new century. One aspect was more ideological, in the form of money from the Carnegie Trust to build a series of libraries around Ireland

BELOW: *Norah McGuinness (1903–1980) was as much an organizing force as a painter, having been one of those heavily involved in the creation of the Irish Exhibition of Living Art in 1943, and later its president for many years. She was just the right kind of forceful personality to push the influx of new ideas from outside Ireland when the country was rather isolated during the Second World War and, having herself studied in Paris, she was a good conduit for keeping up artistic links with the French capital. Born in Derry, she settled in Dublin in 1939, producing over the next three decades a number of decorative, yet forceful, canvases of the city and its environs, including this 1940 painting in the Ulster Museum illustrating nostalgically one of the old Guinness barges going up the river to the brewery past the Four Courts, which gives the painting its title,* The Four Courts, Dublin.

to further reading and education among the masses, the varied designs, usually by local architects, adding interesting variety to the otherwise commonplace buildings in the towns and suburbs of Ireland. But American influence was also felt in the introduction of steel-framed buildings inspired by the Chicago School, as seen in structures such as the Store House erected by Messrs. Arthur Guinness in 1903–1904 to facilitate the production of its famous brew.

Totally independently, and possibly by pure coincidence, Chicago was also the home base of the architect Barry Byrne, who designed the one modernist church that broke the mold of the more traditional neo-Gothic style practiced by the Catholic church in Ireland during the first half of the twentieth century. Stepped sideways both within and without, the church—in the Cork city suburb of Turner's Cross—used a combination of steel and concrete to create a large unpillared interior entered through a double door protected by the outstretched arms of a large exterior statue of Christ the King, who gives his name to the church. Though obviously more conservative in reaching back to Romanesque roots in the twelfth century, the Honan Hostel Chapel, built much earlier (1915–1916) on the grounds of the same city's university, was a showcase of how the effects of the Arts and Crafts movement combined with the Celtic Revival could be used to beautify the ecclesiastical architecture of

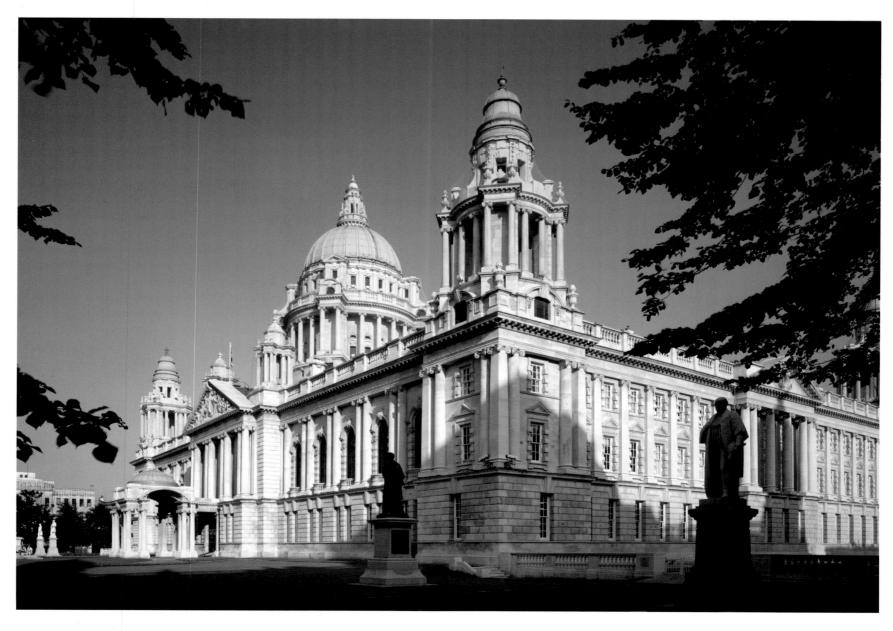

LEFT: *Just over one hundred years ago, Italy came to Dublin—by no means for the first time—in the form of a Florentine palazzo that was completed on the corner of Parliament Street and Essex Quay in 1901. It was designed by the English architect Edward Ould for Lever Brothers, the English manufacturers of Sunlight Soap, which has given its name to the building— Sunlight Chambers. The first three floors are separated on the exterior by a multi-colored frieze, full of figures at work, ploughing, gathering olives, fetching water from a well—and washing clothes, for this was a celebration of the joys of using soap. It certainly helps to brighten up the Liffey quays.*

Ireland in a most unique and satisfactory way by using the best in metalwork, wood, weaving—and, above all, stained glass.

The founding of the new state in the 1920s meant that much of the government money that had been invested in buildings went to provide social housing for the needy and hospitals for the sick, some of the latter in particular showing how the International Style was beginning to creep in and create chinks in the otherwise rather old-fashioned designs prevalent in the country at the time. These were stark and functional buildings, eschewing ornamentation, though in a very different way to that being developed at the Bauhaus in Germany in the 1920s. However, it was the German firm of Siemens that constructed the greatest Irish engineering project of the first half of the century, the Shannon Hydroelectric Scheme, which harnessed the waters of the river Shannon to provide Ireland with electricity—a project symbolized by the artist Seán Keating in a series of paintings indicating what a giant step forward this was toward developing the country's industrial potential—and providing the people of Ireland with light to replace the old gas or paraffin lamp. The other major national building project of the period was the construction of the first Dublin Airport terminal (1937–1941), known then as Collingstown. Designed by Desmond FitzGerald, it had the form of a graceful arc in plan and was finished in an intentionally international style as befitted a structure that was to waft people to and from other countries. It still manages to retain its individuality, though now it is dwarfed by larger terminal buildings that have far less character.

ABOVE: *Seán Keating (1889–1977) saw the building of the electricity-generating station at Ardnacrusha in County Clare in 1926–1929 as a symbol of Ireland rejecting its recent bloody past and, now through industry, looking to a more productive, optimistic future. In* Night's Candles are Burnt Out, *now in the Oldham Art Gallery in Lancashire, we see the strung-up skeleton of Ireland's past being illuminated by a young engineer on the left, while on the right, the father (a Keating self-portrait) shows his two young children and the great concrete dam being raised to provide electricity for the nation. In the center foreground, a gun-man bows in deference to the portly project director, who looks far into the distant future.*

The International Style, using flat roofs, and white-painted walls interspersed with metal-framed windows, was used by architects in domestic schemes, including their own houses, as was the case with Michael Scott, the most committed modernist architect of the century, whose long-vanished Pavilion at the New York International Trade Fair of 1939 was a visual statement of his beliefs. His team, which included Kevin Roche, who later went on to greater things across the Atlantic, designed Dublin City's first major modernist building, Busáras, the central bus station (1944–1953), which introduced double glazing and concrete box-frame construction, as well as air conditioning, which may have seemed revolutionary in Ireland at the time. But it had already been introduced half a century earlier in the Royal Victoria Hospital in Belfast in 1900–1903, one of the world's first buildings to have been ventilated in this way. Scott was also involved in designing one of the many examples of that novel class of International Style building so typical of the 1930s, the cinema, of which the Belfast architect John McBride Neill was the most notable

practitioner. The advent of television has sadly brought about the demise of so many of these buildings that added a lustre of romance to many an Irish country town in the astringent decade leading up to World War II.

Scott's office team also embraced a number of important contributors to the Irish architectural scene, particularly during the 1960s and 1970s, including Robin Walker and Ronald Tallon. Both had worked with Mies van der Rohe (again, Chicago) and had adopted his steel-and-glass cladding techniques in factory buildings such as Carroll's in Dundalk (1967–1969) and the Bank of Ireland head office (1975) in Dublin's Baggot Street. Slightly later, the latter's main competitor, Allied Irish Banks, got Robinson Keefe Devane to design their more low-slung concrete headquarters, now attractively draped in plants, in the city suburb of Ballsbridge. All of these, and many others of the kind, gave a great boost to Irish arts and crafts by commissioning major sculptures, paintings, and tapestries to adorn the large, new buildings.

Another well-known Irish architectural practice was producing some striking Dublin buildings at around the same time—Sam Stephenson designed the controversial Central Bank (1975), which dominates the skyline of central Dublin with its precast concrete floor slabs held in place by bronze-clad cables, while his professional partner, Arthur Gibney, produced the more muted but well-modeled Irish Management Institute in the Dublin suburb of Sandyford two years earlier.

BELOW: *The major banks enlivened the Dublin architectural scene by building competing headquarters in the 1970s. Out in the suburb of Ballsbridge is the head office of Allied Irish Banks, completed in 1979 to designs by Andrew Devane (1916–2000), of Robinson Keefe Devane, and regarded as one of the most successful architectural buildings of twentieth-century Ireland. Extending outward rather than upward, the bank center has two arms angularly expanding to enclose a well-landscaped garden with its centerpiece the almost forty-foot-high stainless steel sculpture* Freedom *by Alexandra Wejchert. Also well-planted are the projecting balconies, whose horizontal emphasis is an echo of Frank Lloyd Wright, with whom Devane worked in the 1940s. The low blocks receding perspectively from the street form an imposing whole that fits so neatly into the suburban skylines of the locality.*

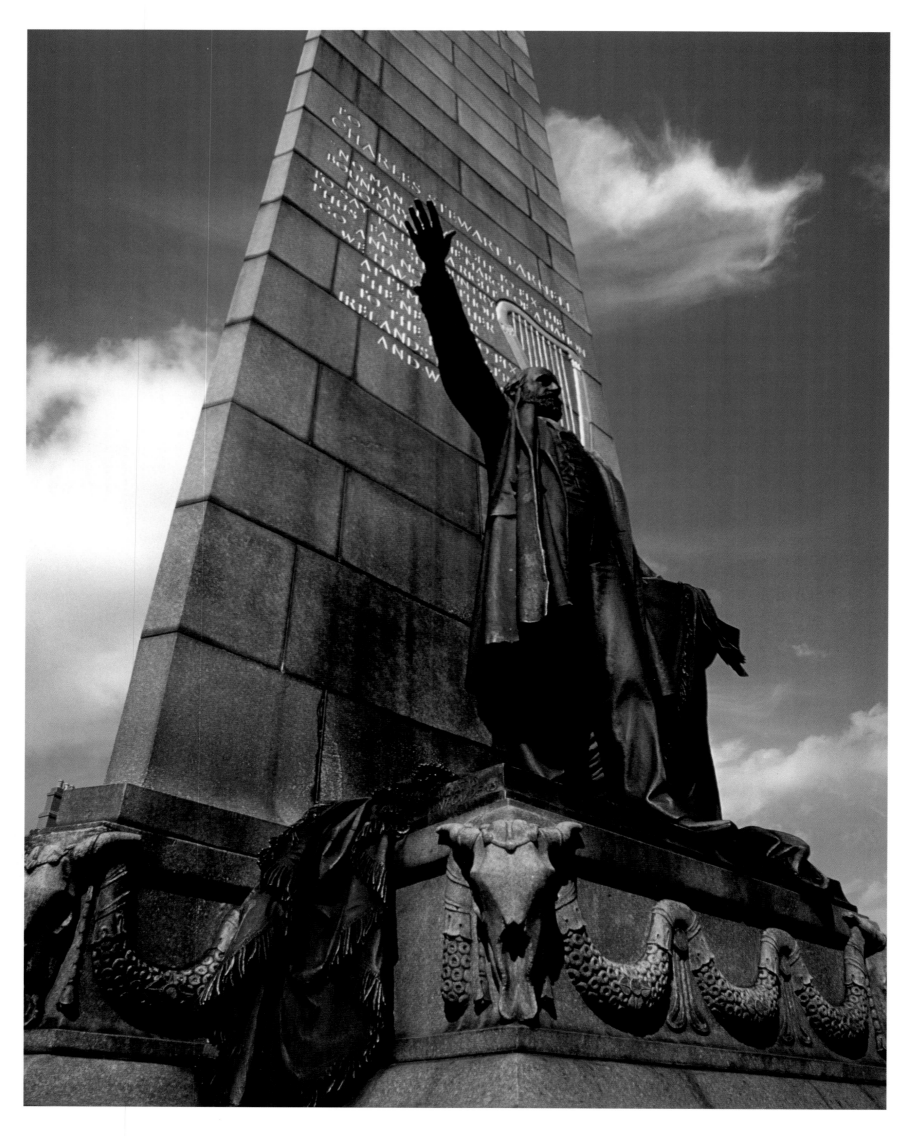

The 1970s to 1990s saw valuable efforts being made to restore older buildings for effective modern use, such as Percy le Clerc's restoration of the medieval Cistercian abbeys of Holy Cross, County Tipperary (1975), and Graiguenamanagh, County Kilkenny (1980). While the number of individual secular instances would be too numerous to list here, particular mention should be made of the rejuvenation of Temple Bar in Dublin's inner city, which, within a decade, has been converted from a run-down area to one full of trendy youthful life in the daylight, and at night, Dublin's teeming "left bank" on the right bank of the river Liffey. Building complexes where young people also congregate are the various third-level educational establishments around the country, Universities and Institutes of Technology, all of which have benefited greatly from government funding in creating their imaginative

BELOW: *Oliver Sheppard (1865–1941) was one of the dominant sculptors in Dublin during the first four decades of the twentieth century. His masterpiece is* The Death of Cúchulainn *of 1911-1912, illustrating how the great Irish mythical hero tied himself, mortally wounded, to a stone so that he could die standing up, and no one could approach him until his death was signaled by a bird landing on his shoulder. The details of the tale Sheppard could have learned from the re-telling of the old Irish epic by Standish O'Grady and Lady Gregory, and, while involved in the Celtic Revival movement, he also had a sympathetic ear for the notion of linking the past and the present in his friend Padraig Pearse's ideas that Ireland could only be redeemed by blood sacrifice. The artistic embodiment of such a concept, the five-foot-high statue remained unsold until 1935 when the Irish government bought it, had it cast in bronze, and then erected it in the General Post Office on Dublin's O'Connell Street, where it is displayed as a memorial to the 1916 Rising, which started in the building.*

OPPOSITE: *When he died in 1891, Charles Stewart Parnell had almost achieved Home Rule for Ireland, and so highly was he regarded by the Irish that he had one of the greatest funerals in Glasnevin Cemetery that Dublin had ever seen. It was fitting, therefore, that a suitable memorial should be put up to him, and this took the form of an obelisk at the northern end of Dublin's O'Connell Street. It was designed by the New York architect Henry Bacon, best known for his Lincoln Memorial in Washington, and, because much of the money for the monument was raised in the United States, it was an Irish-born sculptor working in America, Augustus St. Gaudens (1848–1907), whom he chose to execute the fine bronze statue of Parnell, which was finally completed in 1911 for the twentieth anniversary of the parliamentarian's death.*

BELOW AND OPPOSITE: *Oisín Kelly (1915–1981) was a sensitive sculptor who was well able to work at various scales and in a variety of media. Influenced by the German expressionist Barlach and the English sculptor Henry Moore, he was as much at home in wood and clay as he was in bronze, and as happy molding life-size birds as he was doing them on a vast scale, as was the case with his sculpture of the mythical* Children of Lir *for the Garden of Remembrance, opened in Dublin in 1966 to commemorate the fiftieth anniversary of the Rising of 1916. The story tells of how a spell was cast upon the children that made them turn into swans, and that section of the sculpture illustrated here shows the moment when the children were losing their human form to be turned into swans, which fly up above them. Four years later, Oisín Kelly's sense of humor came to the fore in the statue of* Two Working Men *standing at the foot of the County Hall on Carrigrohane Road in Cork, looking up in amazement at the height of such a tall building.*

campus architecture. Nowhere is this more apparent than in Trinity College, Dublin, where Paul Koralek's Berkeley Library of 1961–1967 is a masterpiece in its functional yet decorative use of concrete, and where the Atrium of De Blacam and Meagher is a highly successful adaptation of an old stone structure fitted out inside with a multi-story gallery of wood, executed to the highest standards.

A number of architects mentioned in the preceding paragraphs have also turned their talents with advantage to the field of ecclesiastical architecture. But in this sphere one name stands out above all the others in the second half of the century—Liam McCormick. He started designing churches in the early 1950s, but in the following three decades provided the country—and particularly County Donegal—with a string of wonderful modern churches, perhaps ultimately inspired by Le Corbusier's Ronchamps, but with a special character of their own—including the transparency of the east wall to provide

a view past the altar to God's creation in land- and seascape behind. As with the Honan Hostel Chapel discussed earlier, church architecture also gave great scope for employing a range of artists in decorating the churches, be it with stained glass, sculpture, altars, or fonts of stone, tabernacles of metal (e.g., by Ray Carroll) and batiks (e.g., by Bernadette Madden). These churches are, in my view, some of Ireland's most original contributions to the architecture of Europe during the last half century, but it must be said, of course, that there are many other inventive Irish architects, too numerous to mention, who have added to the treasury of the nation's recent churches and, indeed, other kinds of buildings that are regularly featured in the pages of *The Journal of the Royal Institute of Architects of Ireland*.

In the same way that Loughrea Cathedral ushered in the twentieth century in stained glass and Dun Emer tapestries, it also ushered in fine religious carving of the period, of which there is sadly very little in the first half of the century. The sensitively modeled Loughrea sculpture comes from separate hands, those of John Hughes (1865–1941) and Michael Shortall (d. 1951). Hughes's *Madonna and Child* is full of grace and gentle movement that he must have found in Renaissance Italy, which he greatly admired. Elsewhere, his largest sculpture was that of Queen Victoria, a ponderous statue with interesting supports that once stood in the grounds of Leinster House in Dublin, but which was removed for obvious reasons and is now in Australia. Other secular works by Hughes include the Charles Kickham memorial in Tipperary town and the Provost Salmon statue in the front square of Trinity College, Dublin. He was heavily involved in teaching, as was his contemporary Oliver Sheppard (1864–1941), who, like Hughes, had studied in Paris and London. Sheppard created some of the best nationalistic sculpture of the first three decades of the twentieth century, most notably the figure of the *The Death of CúChulainn* (1911) in the General Post Office in Dublin, which has a fine sense of rhythm, and the romantic figure of *The Pikeman* of the 1798 Rebellion in the Bull Ring in Wexford town.

America features in the story of twentieth-century Irish sculpture through two artists who created memorable monuments. The first is Augustus St. Gaudens (1848–1907), who was born in Dublin to French and Irish parents and brought to the United States when he was only six months old. There he was to be awarded commissions to provide monuments to Civil War heroes, but in Ireland he was asked to provide a statue of Charles Stewart Parnell (1846–1891) at the base of an obelisk at the northern end of Dublin's O'Connell Street. It is a stern portrait combining realism (the contemporary costume) with a dramatic arm gesture as the statesman stands beside a table full of papers, which, being bronze, obligingly do not flutter in the wind. The second artist is Jerome Connor (1876–1943), who, though born in Kerry, spent much of his life in America. On his return to his native land, Connor worked on the memorial

commemorating those who died in the sinking of the *Lusitania* in 1915. Sadly, the monument remained unfinished at his death—he had completed the very naturalistic mourning fishermen, but the figure of the Angel of Peace had to be cast posthumously from a plaster model. A more satisfying and attractive witness to his work in Ireland is the statue of the patriot Robert Emmet in Dublin's Stephen's Green, dating from 1912–1917, though not erected until the 1990s. It is as romantic an evocation of this tragic figure as Emmet himself would have wished. A third figure with American links is Andrew O'Connor (1874–1941). O'Connor was born in Massachusetts with Irish blood in his veins and—like St. Gaudens—produced memorial sculpture in America, including the *Lafayette on Horseback*, done on a large scale for Baltimore, though there is a smaller version in the Hugh Lane Municipal Gallery in Dublin. His

ABOVE: *F. E. MacWilliam (1909–1992) was one of the most versatile of Irish sculptors in the second half of the twentieth century. Though he lived most of his adult life in England, he always kept in touch with events back home. He was so outraged at the bombing of the Abercorn Tea Rooms in Belfast in 1972 that he created a series of bronzes with the general title* Women in Bomb Blast *(1974) (Ulster Museum, Belfast), each representing—as here—the horror of a woman caught in the blast. In his own words, "These sculptures are concerned with violence, with one particular aspect, bomb-blast—the women as victims of man's stupidity." They must surely be seen as some of the most compelling artistic responses to the violence in Northern Ireland, which still sees no end after thirty-five years.*

OPPOSITE: *Conor Fallon (b. 1939) is one of the most exciting sculptors working in Ireland today. While he has done a number of portraits, his great strength lies in his animal sculpture, executed usually in bronze or stainless steel. His superb stylization, and his ability to grasp the essence of beauty in animal movement, immediately appeals and, in his* Singing Bird *of 1989 (opposite, top) he dispenses with solid mass and gives the bird a weightlessness to soar if it wishes. .*

Rodinesque *Christ the King*, originally designed as a monument for those who died in World War I, was found to be unacceptable by the Catholic church, but has now found an honorable, if insufficiently well-known, showplace overlooking Dun Laoghaire harbor. Lying almost equally unnoticed in Dublin's Merrion Square is another of his statues, *The Victims*, erected in 1976; it looks like a gripping representation of the famine, the figures calling for our attention in their despair.

Albert Power (1882–1945) was more Irish-based, a pupil of Sheppard's with whom he worked on the statue of *Science* on top of what was formerly the College of Science in Dublin, but is now Government Buildings. His large-scale works, as seen for instance in the pediment of Mullingar Cathedral, are not nearly as successful as his more intimate creations, such as *The Fall of Icarus*, or *Leenane, Connemara Trout* of 1944, which integrates figure and fish respectively so well into the natural surroundings.

Of a slightly younger generation was the gentle Oisín Kelly (1915–1981), who is one of the few Irish sculptors of the twentieth century to have succeeded at both a large and a small scale. He has a wonderful series of joined wooden panels carved with a representation of the *Last Supper* (1963) in Knockanure church, County Kerry, its figures clad in gracefully flowing robes and with the apostles' heads stylistically recalling medieval tradition, but yet unmistakably modern. He returned to the same theme on an extremely large lintel above the entrance to the Catholic church at Sion Mills in County Tyrone, where the scene goes right across the whole width of the church, as it almost does at Knockanure. The Sion Mills representation is as if etched into a flat surface,

and again shows a most graceful flow of lines. Kelly's *Children of Lir* in the Garden of Remembrance in Dublin's Parnell Square of 1966 is a vast, evocative bronze of three children who were turned into swans, according to an old Irish legend, Kelly showing the swans rising in aspiring flight as they are transformed from living children. His sense of humor and occasion is brought out in his statue of *Two Working Men* who gaze up in wonderment at the seventeen-story County Hall in Cork (1970). But Kelly was also very good doing life-size birds of a much smaller scale in terracotta, which were produced commercially by the Kilkenny Design Workshops, for which he worked. These workshops were set up as a result of a government enquiry into the poor industrial design in Ireland during the middle third of the twentieth century, and have been extraordinarily beneficial in improving the standards of industrial design while at the same time spearheading the establishment of a number of smaller craft works and shops in and around Kilkenny. The workshops are run by both Irish and foreign craft-people and produce a great variety of objects from pottery to jewelry, but also include weaving and other crafts. Their influence has spread far beyond the bounds of Kilkenny.

Mention of Cork brings one automatically to another gentle figure, Seamus Murphy (1907–1975), whose training as a stonemason decorating churches around his native Cork led him to write a most amusing book, *Stone Mad*, one of the few works written about Irish sculpture from the inside. Murphy's talent developed into large-scale sculpture, as in his St. Gobnait in

BELOW: *The elusive* Hawk *by Conor Fallon of 1978 in the Arts Council Collection is shown as if in search of prey, beautifully balanced with outstretched legs, halfway between reality and the world of fantasy. Fallon is a master and a craftsman combined into a genius.*

Ballyvourney and the St. Patrick bust in Maynooth. He was one of the few successful portrait sculptors of the mid-century, with statues of Michael Collins and others. What distinguishes him also is his superb lettering, which he practiced on a number of stone memorials. Two other artists have fortunately followed in his footsteps in this regard. Michael Biggs did the inscriptions at Arbour Hill in Dublin commemorating heroes who had given their lives for their country, and also the plaque in the General Post Office in Dublin commemorating the Easter Rising. He also did some very fine chunky granite altars and baptismal fonts that are some of the most memorable of their kind in Ireland. The second superb letterer is Ken Thompson, a Cork artist like Seamus Murphy, who, like Michael Biggs, has many religious works to his name, including the tombstone of Cardinal Basil Hume in Westminster Cathedral, his most recent sculpture being a statue of St. Patrick the Pilgrim at Lough Derg in County Donegal.

The art of church furniture fared badly in Ireland up to the middle of the

twentieth century. The Reformation had done away with all but a few of the medieval religious statues (which must have been plentiful), so that when the time came to provide statues and stations of the cross for the multitude of Catholic churches that sprang up in every town and village during the nineteenth century, there was no native tradition to supply the inspiration for new furnishings. Instead, the clergy, with their new-found freedom and power, imported material en masse from Italy, and not always with the greatest of taste. This situation persisted until the 1950s, but it was then that architects like Liam McCormack, mentioned above, started building modern churches furnished with a whole new range of statuary that suddenly brought church art into the twentieth century. Biggs was certainly one who benefited from the new commissions, but of greater importance was the contribution made by the German-born Imogen Stuart (b. 1930). She was able to mold together the tradition of medieval woodcarving of her native land with the earlier Christian art of her adopted country to make statues, crucifixes, and other

ABOVE: *Ken Thompson (b. 1946) is one of the most gifted Irish stone carvers of his generation, with a talent for sculpture and fine lettering. One of his most recent statues, representing St. Patrick not as a venerable mitered bishop but as an energetic young pilgrim walking toward his goal, was erected in 2002 near the quay where pilgrims embark for Station Island in Lough Derg, County Donegal.*

LEFT: *"Purgatorio" from Dante's* Divine Comedy *was the inspiration for this 1991 wall hanging,* Voyage, *by Cork-based art-quilt artist Evelyn Montague. Now in the collection of the Ulster Museum, Belfast, this evocative work combines mixed studio- and commercially dyed fabrics with machine-piecing, hand appliqué, and quilting to create a stunning vision of a boat under billowing sail beneath time stopped at early evening.*

figures over a period of more than fifty years. Her crucifix for Armagh Cathedral is remarkable for its message of peace, and her Madonnas have a warmth that is inspiring. Some of her finest efforts have gone into the stations of the cross, for Muckross in Killarney in the 1950s, Ballintubber Abbey in the 1970s and, finest of all, those at Firhouse in Tallaght from the 1980s. Her oeuvre, however, also includes secular work, such as the *Pangur Ban and His Cat* grouping in University College, Dublin, the Old IRA memorial in the form of children on the village green at Tyrellspass, County Westmeath, or *The Fiddler of Dooney*—a piece of street sculpture outside the shopping center in Stillorgan. Imogen also worked well in metal, as did Brother Benedict Tutty, O.S.B., of Glenstal Abbey, whose crucifix figures in particular have so much enriched the churches of Ireland.

F. E. MacWilliam was a powerful Belfast sculptor whose work is well represented in the Ulster Museum, but who stayed mainly in England. Gerda Fromel and Alexandra Wejchert, both of whom had come from continental Europe, joined Imogen Stuart is making an important female contribution to Irish sculpture, as has Melanie Le Brocquy. Secular figure sculpture was well represented in Ireland of the second half of the twentieth century by men like John Behan and Patrick Delaney, but it was abstract art that began to win the day as the century ground toward its close. Michael Warren in wood, John Byrne in metal, and Deborah Brown in plastic have all worked

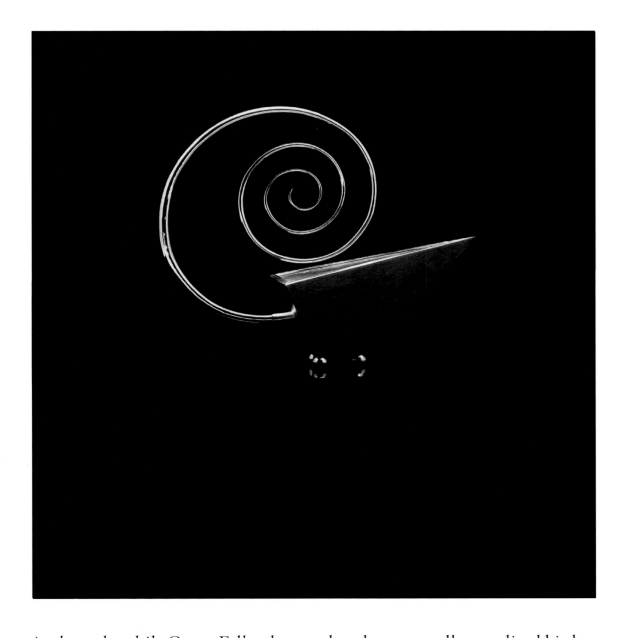

in the style, while Conor Fallon has produced some excellent stylized birds and figures in stainless steel. In bronze, Carolyn Mulholland made a lovely chair for the collection of sculpture commissioned by Dublin Corporation to celebrate its spurious millennium in 1988. It is sometimes difficult to describe sculpture of recent centuries as being specifically Irish (except for nationalist shamrock-bedecked statues of the "Maid of Erin" variety erected around 1898 to commemorate the 1798 Rising). Each sculptor has developed his or her own style, not groupable into any particular "school." Each one is an individual, creating the great variety that characterizes recent Irish sculpture.

Ireland's most visible contribution so far to the twenty-first century is the 120-meter-high spire on Dublin's O'Connell Street, a tall, thin aluminum structure intended to provide the widest thoroughfare in the country's capital with a new vertical emphasis to replace Nelson's Pillar, which was blown up in 1966 by patriotic "idealists"—and let us hope that it embodies, too, our aspirations for Ireland's arts, crafts, and architecture to reach for the skies in the future.

INDEX

Page numbers in *italics* refer to
illustrations.

314

PHOTO CREDITS

of Ireland, Dublin. Pages 270–271: Reproduction of *Children Dancing at A Crossroads,* by Trevor Fowler, courtesy of the National Gallery of Ireland, Dublin.

THE CELTIC REVIVAL

Page 272: Hugh Lane Municipal Gallery of Modern Art, Dublin, Davison & Associates Ltd., Dublin, photographer. Page 273: The National Museum of Ireland, Dublin. Page 274: Reproduction of *Augusta Gregory, Dramatist,* 1903, by Jack B. Yeats, courtesy of the National Gallery of Ireland, Dublin. Page 275: Reproduction of *Jack B. Yeats as a Boy,* by John Butler Yeats, courtesy of the National Gallery of Ireland, Dublin. Page 276: The National Museum of Ireland, Dublin. Page 277: The National Museum of Ireland, Dublin. Page 278: Reproduction of *The Crucifixion and Last Supper,* by Evie Hone, courtesy of the National Gallery of Ireland, Dublin. Page 279: The Wolfsonian-Florida International University, Miami Beach, Florida, Bruce White, photographer. Pages 280, 281 : Cameo Photography, Loughrea. Page 282: The Irish Picture Library. Page 283 (both): Cameo Photography, Loughrea.

THE TWENTIETH CENTURY

Page 284: Reproduction of *Looking Out to Sea,* by William Orpen, courtesy of the National Gallery of Ireland, Dublin. Page 285: *On Through the Silent Lands,* 1951, by Jack B. Yeats. ©2004 Artists Rights Society (ARS), New York/DACS, London, Photograph reproduced with the kind permission of the Trustees of the National Museums & Galleries of Northern Ireland. Page 286: *A Cleric,* by Jack B. Yeats. ©2004 Artists Rights Society (ARS), New York/DACS, London, Reproduction courtesy of the National Gallery of Ireland, Dublin. Page 287: *No Flowers,* by Jack B. Yeats. ©2004 Artists Rights Society (ARS), New York/DACS, London. Reproduction courtesy of the National Gallery of Ireland, Dublin. Page 288: *The Green Coat,* by John Lavery. By courtesy of Felix Rosenstiel's Widow & Son Ltd., London, on behalf of the Estate of Sir John Lavery. Photograph reproduced with the kind permission of the Trustees of the National Museums & Galleries of Northern Ireland. Page 289: *The Lilac Phlox,* by Mildred Anne Butler. ©Courtesy of the Artist's Estate. Reproduction courtesy of National Gallery of Ireland, Dublin. Page 290: Reproduction of *Connemara Cottages,* by Paul Henry, courtesy of the National Gallery of Ireland, Dublin. Page 291: *Fishermen on the Beach,* by Paul Henry. Reproduction courtesy Merrion Hotel. Page 292: *The Potato Digger,* by Paul Henry. ©unknown. Photograph reproduced with the kind permission of the Trustees of the National Museums & Galleries of Northern Ireland. Page 293: *The Virgin of Eire,* by Mainie Jellett. ©Courtesy of the Artist's Estate. Reproduction courtesy of the National Gallery of Ireland, Dublin. Page 294: *The*

Road to the West, by John Luke. ©Mrs. Sarah McKee. Photograph reproduced with the kind permission of the Trustees of the National Museums & Galleries of Northern Ireland. Page 295: *Seamus Heaney,* by Edward McGuire. Photograph ©Ulster Museum, Belfast, Photograph reproduced with the kind permission of the Trustees of the National Museums & Galleries of Northern Ireland. Page 296: *Image of James Joyce,* 1977, by Louis Le Broquy. ©Louis Le Brocquy. Photograph reproduced with the kind permission of the Trustees of the National Museums & Galleries of Northern Ireland. Page 297: *The Four Courts, Dublin,* by Norah McGuiness. ©Miss Rhoda McGuinness. Photograph reproduced with the kind permission of the Trustees of the National Museums & Galleries of Northern Ireland. Page 298: The Irish Image Collection, Christopher Hill, photographer. Page 299: The Irish Image Collection, George Munday, photographer. Page 300: *Night's Candles are Burnt Out,* by Séan Keating. Original Painting on Loan to ESB. Reproduced with kind permission of Oldham Art Gallery & Museum. Page 301: The Irish Image Collection, Gerry Geoghegan, photographer. Page 302: The Irish Image Collection, Richard Cummins, photographer. Page 303: *The Death of CúChulainn,* by Oliver Sheppard. Courtesy The Irish Tourist Board. Page 304: *Children of Lir,* by Oisín Kelly. The Irish Image Collection, Ken Welsh, photographer. Page 305: *Two Working Men,* by Oisín Kelly. The Irish Image Collection, Peter Zoeller, photographer. Page 307: *Stations of the Cross,* by Imogen Stuart. The Irish Image Collection, Tim Hannen, photographer. Page 308: *Women in Bomb Blast,* by F. E. MacWilliam. ©Estate of F. E. MacWilliam 1909–1992. Photograph reproduced with the kind permission of the Trustees of the National Museums & Galleries of Northern Ireland. Page 309 (above): *Singing Bird,* by Conor Fallon. Courtesy of the Artist. Photograph courtesy Peter Harbison. Page 309 (below): *Hawk,* by Conor Fallon. Courtesy of the Artist. Photograph courtesy Peter Harbison. Page 310: ©Anne-Marie Robinson 1993. Photograph reproduced with the kind permission of the Trustees of the National Museums & Galleries of Northern Ireland. Page 311(above): Photograph courtesy Peter Harbison. Page 311 (below): *Voyage,* by Evelyn Montague. ©Evelyn Montague 1991. Photograph reproduced with the kind permission of the Trustees of the National Museums & Galleries of Northern Ireland. Page 312: ©Kevin O'Dwyer 2003, James Fraher, photographer. Page 313 (above): ©Kevin O'Dwyer 2003, James Fraher, photographer. Page 313 (below): The Irish Image Collection, Liam Blake, photographer.

Back cover (clockwise from top left): The National Museum of Ireland, Dublin; Courtesy The Irish Tourist Board; The Wolfsonian-Florida International University, Miami Beach, Florida, Bruce White, photographer; Michael Diggin Photography.